ELECTRONIC FLASH,
STROBE

ELECTRONIC FLASH, STROBE

Second Edition

HAROLD E. EDGERTON

The MIT Press
Cambridge, Massachusetts, and London, England

First MIT Press paperback edition 1979
New material © 1979 by The Massachusetts Institute of Technology.

Original edition © 1970 by McGraw-Hill, Inc. All Rights Reserved.
Printed in the United States of America. No part of this publication may
be reproduced, stored in a retrieval system, or transmitted, in any form
or by any means, electronic, mechanical, photocopying, recording, or
otherwise, without the prior written permission of the publisher.

Library of Congress catalog card number: 79-84332
ISBN 0-262-55008-3

CONTENTS

Preface xi
Preface to the second edition xiv

1. INTRODUCTION . **1**

2. THEORY OF THE ELECTRONIC FLASH LAMP **6**

Flash lamps and circuits 6
Breakdown–starting 10
Starting characteristics 15
Triggering circuits 17
Arc growth 18
Flash lamp life 20
Electrical characteristics of flash lamps 24
Resistivity of the plasma 29
Light output 29
Flash duration 30
Control of the flash duration 30
Capacitor discharge 31

Inductor-capacitor discharge 32
Peak light 32
Efficiency 32
Shapes and forms of flash lamps 35
Design of flash lamps by comparison 36
Optimum design of a 37.5-watt-sec flash lamp 38
Characteristics of a large xenon flash lamp, FT-617 40
Characteristics of a small xenon flash lamp, FX-12 40
Lamp cooling methods 43

3. SPECTRAL OUTPUT OF FLASH LAMPS 48

Spectral output of xenon lamps 48
Spectral output of rare gas flash lamps 55

4. CIRCUITS FOR ELECTRONIC FLASH EQUIPMENT 61

Electronic flash circuit 61
The capacitor 62
Comparison of capacitors 66
The electrolytic capacitor 67
Equations of the capacitor 67
Energy stored in a capacitor 70
The time constant 70
Energy lost in the charging resistor 71
Outlet power 71
Battery power 72
The dry battery 72
The lead storage battery (wet) 74
Lead battery, sealed type 78
Nickel-cadmium battery (sealed type) 78
Silver-zinc wet battery 78
Zinc-air battery 78
Power required for a flash unit 79
Charge indicator 79
Inductive charging circuit 80
Inductive charging with a diode 81
AC charging circuit, half-wave 81
AC full-wave rectifier and voltage doubler 84
The trip circuit 85
Thyratrons, glowtubes, krytrons, and SCR trigger devices 86
Circuit troubleshooting 91

5. ELECTRONIC FLASH LIGHTING REQUIREMENTS FOR PHOTOGRAPHY . 96

Guide factor 97
Multiflash photography requirements 100

6. ELECTRONIC FLASH EQUIPMENT (SINGLE FLASH) 103

Development of the xenon flash lamp 103
The Kodatron 108
Portable Kodatron 111
High-power professional flash equipment 114
The sunflash 115
Electronic flash today 117
Portable flash units 118
Studio flash units 122
Short duration xenon flash lamps 123

7. ELECTRONIC FLASH EQUIPMENT OF SHORT EXPOSURE TIME . . 128

Short flashes of light (less than 1 μsec) 128
The microflash equipment 131
Shadow source 133
Very short flashes (10^{-7} to 10^{-8} sec) 133
Field lens silhouette photography 136

8. ELECTRONIC FLASH EQUIPMENT FOR NATURE PHOTOGRAPHY 140

Strobe for bird photography 140
Condition for acceptable flash duration 141
The flash duration 141
Condition for light output 143
The reflector 144
Lamp-capacitor combinations for nature photography 145
Tests with special electrolytic capacitors (low ESR) 149
Greenewalt's equipment 152
Photoelectric shutter tripping 153

9. THE STROBOSCOPE . 158

A. The stroboscope instrument 158
 Photography with the strobotac, electronic stroboscope 165
 The stroboconn 166
B. High-speed stroboscopes 167
 The arc "holdover" limit of frequency 169
 Deionization conditions 171
 Minimum resistance in the charging circuit 172
 Maximum Flashing Frequency and minimum time between flashes 173
 High-frequency strobe circuits 174
 Hydrogen thyratron modulator 177
 Light output and flash duration 179
 Guide factor of the high-speed stroboscope type 501 180
 Maximum operating time 181
 Special small lamps 182
 Cameras 185

C. Double-flash equipment 189
Silhouette photography 189
Flash circuit 191
Reflected light double flash 194
Flash lamp 195
D. Multiflash photography 198
Rapid-flashing sources 199
A multiflash (20) equipment 200
The multiple-spark light source 205
Photographic results 207
An AC multiflash circuit 209
Strobe lamp 212
Power and discharge circuit 212
Control circuit 212

10. EXPOSURE CALCULATIONS AND SPECIAL PHOTOGRAPHY . . . 219

Derivation of the photographic guide factor 219
Closeup photography light requirements 221
Guide factor for closeup photography 223
Film exposure calculations 223
Speed of photographic negative materials 225
Silhouette photography 226
Direct image of a source 227
Exposure of a point source 228
Field lens silhouette photography 229
Scotchlite background 229
Schlieren photography 232
H & D curves for films 233

11. TECHNIQUES OF LIGHT MEASUREMENT 235

Phototube measurements of light 235
Spectral sensitivity of a phototube 235
Photocathode surface of pure metals 237
Practical phototube surfaces 237
Spectral sensitivity of a phototube 237
Electrical design of a practical light measuring device 238
Transient response 241
Spectrai response 243
Calibration 244
The output of a flash lamp 246
Integrating meter for light measurement 247
Practical integrating meters 248
Measuring the output of a flashtube 253
Measuring the output of a flash lamp in a reflector 255
Flashtube efficiency 256

12. SPECIALIZED APPLICATIONS . **259**

A. Underwater photography with strobe lighting 259
Underwater light requirements 261
Inclusion of light absorption in the light calculation 263
A handheld underwater flash lamp 268
The flash unit 269
Phototrigger 272
Photographic arrangement 273
Electrical circuit 274
Exposure calculations 275
Deep-sea underwater photography equipment 276
Positioning of the photograph 285
B. Night aerial photography 286
Two systems of night photography 287
Early development work 289
Early tests of electronic flash equipment 289
Photographing the desired objective 291
C. Beacons, lighthouses, buoys, and signals 294
Satellite strobes 295
Aircraft anticollision beacons 297
Runway approach lights 297
Aids to navigation, airport beacons, lighthouses 298
Balloon-borne beacon 300
D. Laser stimulators 301
E. Cloud and bubble chamber illumination 306
F. Sensitometer with xenon lamp 309
Xenon flash lamp sensitometer 309
G. Elapsed-time motion pictures 311
Microscope 312
H. Copy techniques 313
I. Small subject photography (microscope) 315
Photography of small subjects 315
Microscope lamphouse 316
Bare lamp illumination 320
Combination lamp for flash and continuous use 320
Small lamp with high energy at a high flash rate 321
J. The photon phototypesetting machine 322
K. Photochromic goggle system 325

Appendix I EXPERIMENTS AND EXPERIENCES **332**

1. The stroboscope 333
2. Photography with a stroboscope 334
3. High-speed single-flash photography 335
4. Electronic flash unit 337

5. Vacuum phototube characteristics 338
6. Spectral response of vacuum phototubes 339
7. Flash lamp light-time relations and efficiency 340
8. Flash lamp starting characteristics 341
9. Flash lamp current-voltage relations 342
10. Shadow photography from a spark source 342
11. Scotchlite screen silhouette photography 343
12. Silhouette and schlieren photography by the field lens method 344

Appendix II **MANUFACTURERS AND SUPPLIERS OF ELECTRONIC
 FLASH EQUIPMENT** . **346**
Appendix III **PATENTS** . **348**

Index 353

PREFACE

When I was a boy, I read with great interest but skepticism about a magic lamp which was used with success by a certain Aladdin. Today I have no skepticism whatsoever about the magic of the xenon flash lamp which we use so effectively for many purposes. We do not need to rub our lamp as Aladdin rubbed his. Lo and behold, we stimulate it with a trigger signal, and the energy stored in our electrical circuit is instantly transformed as if by magic into radiant light of tremendous power and of very short flash duration with precise control of the instant of flash.

In many respects our modern flashes are similar to the lightning flashes that result in nature during electrical storms. The main differences are that (1) our flash is contained inside of the lamp at places that we control and (2) the instant of the flash or flashes is

arranged at our command. Therefore, the electronic flash system can be used by us since we operate it to suit our purposes.

The first photo taken with the flash of a spark was apparently made by Fox Talbot [1] in 1851 almost at the birth of photography. An article in the *British Journal of Photography*, September, 1864 had this comment: "Mr. Talbot's object was to apply this method to instantaneous portraiture so as to represent persons talking, laughing, quarrelling, etc., but he found that the electric means which he had at his disposal were insufficient to achieve his result, for which it would be necessary to employ an electric flash capable of lighting up a whole apartment, and that nearly equally in all parts . . . there seems reason to think that *further progress in this direction would not be* difficult." The italics are mine! It took one hundred years for this prediction to come true.

Töpler [3] seems to have been the first to use sparks and photography for scientific research. Soon afterwards Mach [5] obtained shock wave photos showing the phenomena in air that accompany objects traveling faster than sound. We hear his name mentioned often in this day of supersonic aircraft and rockets since the *Mach* is the unit of velocity.

A host of early workers in many countries, such as Rayleigh [6], Boys [7], Worthington [8], Cranz [9], Schardin [10], Bull [11, 12], Wood [13], Quayle [14], LaPorte [15], and Glatzel [16] have made developments and improvements. (References are listed at the end of Chap. 1.)

Presently, there are many people making further developments in electronic flash and its applications, for example, a recent two volume edition by Früngel [17], books on the stroboscope by Rutkowski [18], by Kivenson [19], and one in Russian by Marshak [20]. Books have been written by Chesterman [21], Hyzer [22], Rebikoff [23], Jones [24], Aspden [25], Snow [26], Luray [27], Saxe [28], Harashima [29], and others, including the author and James R. Killian, Jr. [30]. Technical articles exist in great abundance. I shall not try to make the bibliography, which appears in parts at the end of each chapter, inclusive of everything written on the subject. Most of the books referred to above have extensive bibliographies. For example, Früngel's book gives 1,006 and

Marshak's 354 references. Several excellent bibliographies on high-speed photography were compiled in 1956 and 1960 by the Eastman Kodak Company. Anyone who specializes in electronic flash should return at frequent intervals to the works of the past for ideas and inspiration.

Recently a high school boy visited the Strobe Lab at M.I.T. When he was leaving, he remarked that he wished that he had been born earlier so that he could have had some of the excitement of developing electronic flash. He gave me the impression that he thought that everything had been done! How wrong he was. There are plenty of new ideas just waiting to be recognized. What are they? If I knew I would stop writing this book, rush out into the lab, and become productive. Maybe tomorrow I will get the "big idea." I hope this book will inspire someone to make some new progress.

I have made considerable effort in this book to keep the material practical and realistic. The reader will notice that theory is kept to a minimum and that I return again and again to actual devices and circuits.

The theory of gaseous discharge devices has not reached a stage where it is comprehensive in the design and exploitation of the electronic flash system, but this will come. Perhaps the problems presented here will incite others to delve deeper into the physics of the flash lamp.

I am indeed indebted to my many students, associates, friends, family, and others who have contributed to the development and use of electronic flash, and I wish to thank them here and now.

Comments will be appreciated for corrections, additions, annotations, etc. for the next edition. I will be glad to hear from you, especially of your successes!

Harold E. Edgerton
Cambridge, Massachusetts

PREFACE TO THE SECOND EDITION

Almost ten years have elapsed since *Electronic Flash, Strobe* (McGraw-Hill, 1970) was published. The goal of this edition is to make the book more available to students and to others who will be applying the theory of electronic flash (strobe) to technical tasks in photography, engineering, and science. The basic theory is covered in a form that can be readily understood and used by people with backgrounds in physics and electrical engineering. Some of the new developments and applications of the past nine years will be covered, and an additional bibliography has been included.

Many items have become commonplace since 1970. One of these is automatic exposure control, which is mentioned briefly on page 119 and is now used on many portable battery-operated flash units [1]. The first automatic circuit unit that was developed drained the remaining energy

from the flash capacitor quickly at the instant the exposure was correct, as measured by a light-measuring optical pickup circuit. The second type of automatic circuit interrupted the capacitor-flash-lamp discharge circuit when the exposure was correct. This second system is more efficient because the capacitor is not completely discharged; therefore, more flashes can be obtained from a given battery, an important feature for portable battery-operated equipment.

The photography of bullets and rapidly moving objects continues to be an important area of interest. For such photography, the exposure time must be short enough to produce blurless images. The circuit shown on page 133 (fig. 7-3) has since been modified somewhat to take advantage of available components. For example, the EG&G hydrogen thyratron 6130/3C45 has been replaced by a krytron, KN-2. The point light source (fig. 7-4) has been improved, as described in a technical article [2]. A complete unit is available from EG&G, Inc. (35 Congress Street, Salem, Mass. 01970), with an effective exposure time of less than a microsecond.

David Eisendrath pointed out to me that I did not emphasize the reciprocity effects with short flashes of light—that is, with short exposure times. I now do so briefly. Those who use strobe lights with short flash duration should do one of three things, or all of them, to obtain better contrast and tonal rendition of black and white films:

1. increase the exposure;
2. increase the development time;
3. use a developer that is stronger or has a higher temperature.

The reciprocity effects are evident when H&D curves are plotted for photographic materials. These effects were noticed years ago when photographers switched from tungsten-lighted scenes to strobe-lighted ones. The pictures taken with electronic flash were flat, lacking contrast, until the development process was changed to compensate.

The color temperature of electronic flash lamps has been found to vary, depending upon current density, as pointed out briefly on page 56 (fig. 3-5). It is also influenced by the reflector, the tube envelope, and the plastic window. The color temperature of a xenon flash lamp is bluer at the start of the flash where the current density is greatest. It has been observed that short flashes of light from flash units with automatic cutoff by the "phototube" exposure method usually are slightly bluer than the light from the entire flash. A filter will correct this (see film manufacturing recommendations).

Photographic films have improved in the past decade, and up-to-date information is available from many sources.

The xenon lamp has found many uses in sensitometry for the evaluation of photographic materials. A specialized flash unit for exposing films is described on page 309, and other units have been made for unusual applications.

Light-measuring devices (page 235) have progressed. Reference should be made to currently available light-measuring devices, such as those of EG&G, Inc., and other sources. Several convenient battery-operated handheld meters are available, such as the Gossen Ascor Mark II wide-range electronic flash meter by Berkey Marketing Company, (Dept. 33J, Box 1102, Woodside, New York).

Today it is commonplace to see airplanes, day and night, with bright xenon flashing strobe lights used for identification and to attract attention (page 298). An active program is also underway to mark tall chimneys and radio towers with strobe lights so that they will be prominently visible in all kinds of weather. The xenon flash system when made powerful enough for hazy daytime use is then too bright for nighttime use. Automatic methods are employed to reduce the output of the flash lamps when the ambient light diminishes.

Tall buildings continue to be marked with flashing red tungsten lamps. I believe that this is partly due to federal regulations. Although the xenon flash lamp is preferred due to efficiency, reliability, long life, and its ability to attract attention, it cannot be used in many applications because of regulations that were written about tungsten lamps many years ago. I predict that these regulations will change someday so that improved technical systems will not be eliminated because of legal rules that have not kept up with the times.

Flash illumination for microscope photography is a very important technique destined for great use in the future and is described on page 316. Several methods of obtaining focusing light before the flash are also described. Ron Graham combines the two applications by using the same lamp as a continuous light strobe source and also as a single flash lamp for such photography [3]. His examples are excellent, especially the motion pictures taken with the strobe.

Schlieren photography in color has been accomplished in the M.I.T. Stroboscopic Light Laboratory by J. Kim Vandiver with special filters and flash lamps. Details of the optical and electrical arrangements have been published [4,5].

The complete circuit of an elapsed-time motion picture camera and

special strobe, described on page 311, has been published in a technical paper [6]. The same material was presented, and later published, at the 8th International Congress on High Speed Photography, in Stockholm, Sweden [7].

Phototypesetting with xenon flash illumination is briefly described on pages 322–325. A recent summary article by Jacques Murachver, in EG&G's 1976 Yearbook, *Monitor,* indicates the tremendous worldwide application of the strobe system to phototypesetting today. The key device is the small, bulb-type, xenon-light-source flash lamp, which was originally developed by Kenneth Germeshausen (EG&G, Inc., 45 Williams Street, Wellesley, Mass. 02181) for use in the GenRad Company (West Concord, Mass.) stroboscopes. Semiautomatic facilities are now in use in EG&G's Electronic Components Division (Salem, Mass.) for the production of this lamp. At least a dozen companies use the lamps for photocomposition.

The U.S. Census Bureau is preparing for a comprehensive census in 1980. Xenon-illuminated, high-speed copy machines are being developed to reduce the data from the information forms to microfilm. Ray Radford has described details of the document illumination system in the Jan. 1, 1979, issue of the *EG&G Monitor,* EG&G, Inc. Xenon flash lamps with a flash duration of 15 microseconds will aid in the awesome task of documenting information from 86 million dwellings and 220 million people. The newly developed copy machines can microfilm the standard 1980 census forms at a rate of 135 to 140 per minute. The forms are photographed with high resolution as they flow continuously by the camera at a rate of 7 feet per second. Seventy-five copy machines are to be made ready for the flood of paper scheduled for 1980.

The bulb-type xenon flash lamp has numerous sizes, types, and applications, as described in a technical article by Newell and Edgerton [8].

Night aerial photography (page 286) has been perfected with the use of infrared energy so that it is almost invisible. Howard Beauchamp (EG&G's 1976 Yearbook, *Monitor*) describes an infrared flash system that is used on the Saab-Scania S35E Draken Aircraft and the Saab 37 Viggen Aircraft, operated by the Royal Swedish Air Force. Nighttime aerial reconnaissance photographs, covering 120°, can be taken in stereo at altitudes of 300 to 1000 feet and at speeds up to 750 miles per hour at 10 flashes per second, according to this article.

Underwater photography with xenon flash lamps, treated on pages 259–285, has found increasing application since 1970. The equipment

for deep use has been employed extensively in the ocean for evaluating mineral deposits called magnesium modules. Maps of the areas, with concentrations of minerals, have been made. The Benthos Company (Edgerton Drive, North Falmouth, Mass.) has taken over the EG&G line of underwater cameras and strobes. Extensive engineering improvements have been made in the casings, optics, and data recording.

Numerous xenon flash lamps for shallow photography with conventional underwater cameras are commonplace and are listed in magazines such as *Skin Diver*. Some of these flash units are conventional ones housed in watertight cases and others are designed specifically for underwater use.

Underwater sound devices such as pingers are essential partners to deep underwater photography because they help to locate the position of the equipment with respect to the bottom. The Benthos Company and others have such devices. Side-scan sonar is most helpful in making widescale searches for underwater targets of exploration and photography. EG&G (Environmental Equipment Division, 151 Bear Hill Road, Waltham, Mass. 02154), Klein Associates (Rt. 111, RFD #2, Salem, N.H. 03079), Edo Corporation (Salt Lake City, Utah), Wesmar (905 Dexter Avenue North, Seattle, Wa. 98109) are some of the suppliers of side-scan equipment.

An application of the underwater photography and sonar devices is described in the January 1975 issue of the *National Geographic,* where John Newton discusses the finding and photography of the *USS Monitor,* the long lost and eagerly sought historic Civil War ship. A current TV program by Jacques-Yves Cousteau shows an EG&G side-scan sonar that located the *HMS Britannic,* which was sunk in Greek waters during World War I. The *Britannic,* a sister ship of the *Titanic,* went down after striking a mine laid by a German submarine. The *Titanic* offers a challenge for sonar exploration and photography. It will not be long before there will be some action there.

The development of laser applications (page 301) of xenon flash lamps since 1970 has been spectacular and still seems to continue. By far the largest dollar volume of xenon flash lamps is used for laser devices. To my knowledge, the biggest laser equipment at this moment is being used in the SHIVA experiment at the Lawrence/Livermore Laboratory, Livermore, California, where the goal is to create useful fusion [9,10]. Some twenty laser beams are focused simultaneously on a small pellet of D-T and may raise the temperature and pressure enough to create energy by the fusion process. A total of 2080 flash lamps (44-in. arc

length, 15mm diameter, 2mm wall thickness) are used in 20 disc amplifiers and 244 flash lamps of 15-in. length in other parts of the system. The energy storage bank consists of 7600 capacitors of 14.5mfd and 800 capacitors of 25mfd totaling 0.13 farads at 20,000 volts. A larger proposed system, SHIVA NOVA, calls for an increase of energy. Another class of laser developments has extended short pulses of light production into the nano (10^{-9} sec.) and pico (10^{-12} sec.) values of time [11]. These are used in physics and chemistry experiments.

Photography of small subjects, such as plankton, by silhouette photography is an exciting application of the small xenon strobe lamp and will find increasing applications [12,13].

Closeup photography of the human eye, in color and in stereo, is an accomplishment of Dr. David Donaldson of the Massachusetts Eye and Ear Infirmary (Boston, Mass.) who uses xenon flash lamps to obtain the exposures [14]. Other research on blood circulation, photographing the eye's conjunctiva, has been made by Wells, Gallagher, and others [15,16].

Robert Gilka was requested to itemize some of the uses of xenon flash lamps at the National Geographic Society, and his staff has produced numerous examples such as slide duplication (xenon flash lighting that gives consistent color quality and exposure) and deep sea photography (numerous applications of the xenon flash lamp in the exploration of the depths). A recent example of such photography has been produced by divers from the Woods Hole Oceanographic Institution's submarine *Alvin*. The National Geographic Society's magazines and books cover a variety of photographs made with the help of the electronic flash system. Other underwater equipment helped with the search for wildlife in Loch Ness, Scotland. Further efforts are scheduled for under-ice photographs at the North Pole, with the aid of the Canadian government.

Large output strobes were used to make the photographs of the Congress and Senate chambers that were published in the National Geographic Society's book about Washington, D.C. Some other uses are

Measurement of the speed of objects by multiple exposure

Unmanned underground exploration by flash photography in Etruscan tombs in Italy

Multiflash studies of the click beetle action

Studies of malfunctions of presses and binding machinery in production

Popcorn studies using infrared to trigger the strobes

Studies of insects in flight using infrared to trigger the strobes
Measurement of the speed of the venom ejected by a cobra
Multiflash images of a pole vaulter
Strobe displays of water drops
Multiple images of fashion shows
Infrared photography to obtain unnoticed photocoverage
Film testing equipment for evaluation of color film, studio uses, and field uses of strobe lights
"Typesetting" with the electronic flash lamp method

This interesting list is from only one organization. I am sure that others could add numerous additional examples.

The American National Standards Institute (ANSI), at 1430 Broadway, New York City, 10018, has the following standards:

PH3.40 For Photographic Electronic Flash Equipment
PH2.4 Determining Guide Numbers of Photographic Lamps
PH3.18 Classifying and Testing Internal Synchronization of Front Shutters
PH2.21 Method for Determining Speed of Color Reversal Films for Still Photography
IEC491 Safety Requirements for Electronic Flash Apparatus for Photographic Purposes
UL 122 Underwriters Lab Safety Standards on Photographic Equipment
ISO 1230-1973 Photography, Determination of Guide Numbers
ISO 2827-1973 Photography, Determination of Light Output of Electronic Flash Equipment
Z7.1 Nomenclature and Definitions for Illuminating Engineering

Developments in batteries are being made for both primary cells and storage cells. There are reports of new lithium batteries that store four times the energy that an alkaline battery does. Edward Farber has written a series of reports in *Photo Methods* about the many technical problems of batteries and their applications to xenon flash units. William Hyzer also has a monthly column in *Photo Methods* about high-speed photography and instrumentation [17].

Photography of self-luminous subjects such as flames, arcs, firecrackers, explosives, and atom bombs brings up special problems that require high-speed shutters or specialized electronic flash units or both together. Fast exposures can be made with the Faraday magneto-optic shutter, the Kerr cell shutter, the pulsed image converter systems, and with various

optical devices involving rotating mirrors, prisms, and so forth. The exposure due to the fast shutter and the self-lumination is first determined to be minuscule, and then the required external illumination is calculated for the photograph to be exposed by the strobe light [18].

The circuits used on the magneto-optic shutter are capacitor discharge types greatly similar to strobe circuitry [19]. The stored energy in the capacitor is switched into the coil of the shutter at the desired moment. For examples, see photographs of atomic explosions in *Moments of Vision* [20].

Charles Miller informs me that strobe lighting with video equipment has made possible microsecond processing with video tapes and discs. Immediate playback is one application important for many problems.

Camera shutters with "X" synchronization contacts for electronic flash are now commonplace, whereas twenty years ago they were rare. Today almost everyone knows that a focal-plane shutter must be "wide" open when the flash occurs. The maximum speed for this condition used to be 1/30 of a second. Now some focal-plane shutters synchronize at higher speeds such as 1/100 or even 1/125.

The nine-year-old list of manufacturers and suppliers of electronic flash equipment (pages 346–347, Appendix II) is historical since some have gone out of business and new ones have not been included. Reference should be made to in-date lists.

I hope that I have covered adequately the developments since *Electronic Flash, Strobe* was published in 1970. May the next ten years or so see a further blossoming of the strobe lighting method so that a new list of applications will be needed again.

I repeat with emphasis my sincere thanks to my students, friends, associates, family, and others who have contributed to the development and uses of electronic flash lighting. As in the first edition, I now repeat my appeal for corrections, additions, and suggestions for the next revision. I will be glad to hear from all of you and to know of your problems and successes.

Harold E. Edgerton
February 2, 1979

REFERENCES

1. Vieth, G., mentions strobe lights in the *J. of Applied Phot. Eng.*, vol. 4, no. 2, pp. 57–61, Spring 1978.

Mannheim, L. Andrew, The Thyristorized Flash Photographic Application, *Science Technology and Medicine,* pp. 39-47, November, 1973.

Moore, D. H., Automatic Electronic Flash Units, *Photographic Business and Product News,* pp. 40-44, December, 1972.

Norman, Bill, Are Automatic Strobes the Answer? *The Professional Photographer,* pp. 64-66, August, 1975. (See comments by Joseph W. Engels and Fred Walker in the December, 1975 issue.)

Perazella, Thomas, The Case for Automatic Strobes, *The Professional Photographer,* pp. 42-43, January, 1976.

2. Edgerton, H. E., V. E. MacRoberts, and K. R. Crossen, Small Area Flash Lamps, *Proc. 9th Intern. Congr. on High Speed Phot.* SMPTE, New York, pp. 237-243, 1970.

3. Graham, R. W., A 0.2 msec. Second Strobe Lamp for Flash-Photomicrography, *J. of Photographic Science,* vol. 18, pp. 244-250, 1970.

Graham, R. W., Xenon Strobe Lighting for Flash Cine Micrography, *Medical and Biological Illustration,* London, vol. 22, no 4, pp. 226-237, October, 1972.

4. Strong, C. L., The Amateur Scientist: An Air Flash Lamp Advances Color Schlieren Photography, *Scientific American,* vol. 231, no. 2, pp. 104-109, August, 1974. (Describes color schlieren photography of J. Kim Vandiver and H. Edgerton with two parabolic mirrors.)

5. Vandiver, J. K., and H. E. Edgerton, Color Schlieren Photography of Short Duration Transient Events, in P. J. Rolls (ed.), *Proc. 11th Intern. Congr. on High Speed Phot.,* Chapman and Hall, London, 1975.

6. Edgerton, H. E., V. E. MacRoberts, and K. R. H. Read, An Elapsed-time Photographic System for Underwater Use, *National Geographic Society Research Reports, 1966 Projects,* pp. 79-81, Washington, D.C., 1973.

7. Edgerton, H. E., V. E. MacRoberts, and K. R. H. Read, An Elapsed-time Photographic System for Underwater Use, in N. R. Nilson and L. Hogbery (eds.), *Proc. 8th Intern. Congr. on High Speed Phot.,* John Wiley and Sons, New York, 1968.

8. Newell, P. B., and H. E. Edgerton, Xenon Flash Lamps on the Bulb Type, in P. J. Rolls (ed.), *Proc. 11th Intern. Congr. on High Speed Phot.,* Chapman and Hall, London, 1975.

9. "Energy and Technology Review," Lawrence/Livermore Laboratory Pub., Livermore, California, August, 1977.

10. *Physics Today,* April, 1978. A review of the laser fusion experiments at Lawrence/Livermore and the University of Rochester by B.G.L.

11. Shapiro, S. L. (ed.), "Ultrashort Light Pulses," Springer Verlag, Berlin, 1977.

12. Edgerton, H. E., and J. S. Wilson, High-Speed Silhouette Photography of Small Biological Subjects, in M. C. Richardson (ed.), *Proc. 12th Inter. Congr. on High Speed Phot. and Photonics* (Toronto), SPIE, vol. 97, pp. 486-490, 1977.

Edgerton, H. E., Silhouette Photography of Small Active Subjects, *J. of Microscopy,* vol. 110, pt. 1, pp. 79-81, May, 1977.

13. Ortner, P., H. E. Edgerton, S. R. Cummings, and P. Aftring, Silhouette Photography of Oceanic Zooplankton, *Nature,* January, 1979.

14. Donaldson, D., Stereophotographic Systems, *Ophthalmic Photography,* vol. 16, no. 2, pp. 109–131, Summer, 1976, Little, Brown and Co., Boston, Mass.

15. Wells, R. E., E. R. Schildkraut, and H. E. Edgerton, Cinephotomicrography of Blood Flow in Man, *J. SMPTE,* vol. 73, pp. 627–628, August, 1964.

Wells, R. E., E. R. Schildkraut, and H. E. Edgerton, Blood Flow in the Microvasculature of the Conjunctiva in Man, *Science,* vol. 151, no. 3713, pp. 995–996, February 25, 1966.

16. Gallagher, P. N., V. E. MacRoberts, H. E. Edgerton, R. E. Wells, and S. B. Rees, Measurement of Capillary Blood Flow Using an Electronic Double Flash Light Source, *Rev. of Sci. Instruments,* vol. 36, no. 12, pp. 1760–1763, December, 1965.

17. *Photo Methods* magazine carries monthly columns by Edward Farber, "Photographic Lighting," and William Hyzer, "High Speed Photography and Instrumentation" (for examples, see July, 1973 issue on battery developments and July, 1975 on portable flash units).

18. Miller, C. E. and H. E. Edgerton, Luminous Subjects Photographed with Auxiliary Light, in P. J. Rolls (ed.), *Proc. 11th Intern. Congr. on High Speed Phot.,* Chapman and Hall, London, 1975. Distributed in the USA by the S.P.I.E., Box 10, Bellingham, Wa. 98225.

19. Edgerton, H. E., and C. Wyckoff, A Rapid Action Shutter with no Moving Parts, *J. of SMPTE,* vol. 56, pp. 398–406, April, 1951.

Edgerton, H. E., and K. J. Germeshausen, A Microsecond Still Camera, *J. of SMPTE,* vol. 61, pp. 286–294, September, 1953.

Edgerton, H. E., Photography of Very Early States of Nuclear Explosions, *J. of SMPTE,* vol. 68, pp. 77–79, February, 1959.

20. Edgerton, H. E., and J. R. Killian, Jr., "Moments of Vision," MIT Press, Cambridge, Mass. 1979.

21. Edgerton, H. E., Techniques and Applications of Xenon Flash, *13th Intern. Congr. on High Speed Phot. and Photonics* (Tokyo, Japan), August, 1978 (To be published 1979 or 1980).

22. Dalton, S., "Borne On the Wind," Reader's Digest Press, distributed by E. P. Dutton, New York, 1975 (insects in flight).

23. Bleitz, Don, "Birds of the Americas," scheduled for publication in 1979 by *The Bleitz Wildlife Foundation* (5335 Hollywood Avenue, Los Angeles, California).

24. Leen, Nina, "The Bat," Holt, Rinehart & Winston, New York, 1976.

25. Leen, Nina, "Snakes," Holt, Rinehart & Winston, New York, 1978.

26. National Geographic Society (books of birds).

Proceedings of the International Congress on High-Speed Photography:

I Washington, D.C. (October, 1952). Most of the papers appeared in the *J. SMPTE,* 55 West 42nd St., N.Y., 1954 ($4.50).

II Paris, France (September, 1954). *2eme Congres International de Photographie et Cinematographie Ultra Rapides,* ed. Naslin, published by Dunod, 92 rue Bonaparte, Paris 6, France, 1956 ($17.25) (Out of print).

III London, England (September, 1956). *3d International Congress on High Speed Photography*, ed. R. B. Collins, published by Butterworths, 14 Curity Ave., Toronto, Ontario ($15.40).

IV Koln, Germany (Septmember, 1958). *IV International Congress on High Speed Photography*, ed. H. Schardin and O. Helwich, published by Verlag Dr. O. Helwich, D-61 Darmstadt, Germany, Hoffmannstr. 59, 1959 ($22).

V Washington, D.C. (October, 1960). *V International Congress on High Speed Photography*, ed. J. S. Courtney-Pratt, published by SMPTE, New York, 1962 ($23.45).

VI Hague, Nederland (September, 1962). *VI International Congress on High Speed Photography*, ed. J. G. A. DeGraaf and P. Tegelaar, published by Tjeenk Willink & Zn., Box 113, Haarlem, Nederland, 1963 ($30).

VII Zurich, Swiss (September, 1965). *VII International Congress on High Speed Photography*, ed. O. Helwich, published by Verlag Dr. O. Helwich, D-61 Darmstadt, Hoffmannstr. 59, Germany, 1967.

VIII Stockholm, Sweden (June, 1968). *VIII International Congress on High Speed Photography*, ed. N. R. Nilsson and L. Hogberg, published by John Wiley and Sons, 605 Third St., N.Y., 1968 ($31).

IX Denver, Colorado (August, 1970). *IX International Congress on High Speed Photography*, ed. W. G. Hyzer and W. G. Chace, published by SMPTE, New York, 1970 ($35).

X Nice, France (September, 1972). *X Congres International de Cinematographie Ultra-Rapide*, ANRT, Paris, 1973.

XI London, England (September, 1974). *High Speed Photography, 11th International Congress*, ed. P. J. Rolls, Chapman & Hall, London, 1975.

XII Toronto, Canada (August, 1976). *Proceedings of the 12th International Congress on High Speed Photography (Photonics)*, ed. M. C. Richardson, SPIE, 405 Fieldston Rd., Bellingham, Washington 98225, USA, (1977).

XIII Tokyo, Japan (August, 1978). *13th International Congress on High Speed Photography and Photonics* (to be Published in late 1979).

NOTE: These volumes are listed under Library of Congress Catalogue System number, TR593.161.

ELECTRONIC FLASH, STROBE

1 INTRODUCTION

The object of this book is to present information on the electronic flash system of producing radiant energy and on its applications in science and engineering as well as in conventional and research photography.

Flashing lamps of controlled light output, flash duration, and instant of flash have proven to be a very useful technique for basic research. Foremost among the instruments based upon the electronic flash system are the stroboscope and the high-speed camera system. These are used to overcome our inherent inability to "see" and therefore to study fast motions as they occur. It is a common experience that the eye does not have the ability to resolve or the mind the ability to store each discrete element of a rapidly moving subject or rapidly changing event. With the stroboscope and high-speed photography we can slow down or actually stop rapid action. Then from the recorded results velocity, acceleration, distortion, and other information can be determined by a detailed

study of the photographs. Many useful facts and precise measurements are thus made available that might not otherwise be possible.

High-speed photographic methods thus serve as extensions of our eyesight, enabling us to observe things that are normally a blur to our unaided eyes. As the microscope enlarges small subjects so that they can be seen, likewise, the high-speed camera and the stroboscope slow down fast subjects so that they can be seen.

Considerable investigation of scientific phenomena has been conducted on events occurring in the millionth-of-a-second time region. Although the conventional mechanical camera shutter is incapable of obtaining such short exposures, it is possible to achieve them with controlled flashes of light. Both the eye and the camera require light energy to record a scene, and for each there is a certain minimum energy level below which no discernible image can be obtained. The shorter the observation time becomes, the higher the peak light energy must be if the effective integrated exposure (light vs. time) is to reach the required minimum value. Extremely high-peak light output is needed for exposure times in the millionth-of-a-second range to produce either a useful observation or a photographic image.

The energy used to illuminate a subject is normally obtained from a power system or from batteries at a relatively low rate, too feeble to furnish the high-peak light needed for vision or for photography with very short exposures. An energy storage device is needed which will permit the slow accumulation and then rapid utilization of the high-peak power upon demand. The electrical capacitor is the classical electrical device for this storage role since it can supply power at megawatt rates for short periods of time. Quick conversion of the stored energy from the capacitor to useful light is possible in gaseous lamps such as the open spark or in the modern, efficient xenon lamp. In addition, accurate control of the flash instant is possible.

The technical applications of high-speed photography to science and industry are of most interest to me. In fact, as a graduate student at M.I.T., it was through the stroboscope that I became interested in high-speed photography while studying angular transients of synchronous motors with variable loads. With the strobe and camera, using accurately timed flashes of light, I could gather much information about things that happened in a brief moment. I could then study the data at my leisure and prepare plots and curves of the rapid events.

There is hardly a scientific or engineering area of effort in which the stroboscope or high-speed camera is not in active use today. For example, refer to the booklet "Handbook of Stroboscopy," by Frederick Van Veen [31].

The xenon flash lamp was used as the optical pumping source in the first experimental laser by Maiman [32]. Since then the laser has undergone great development, with much of the effort directed toward perfection of the xenon flash lamp and the coupling of the optical output of the lamp into the ruby rod or other material.

It is encouraging that many schools, even high schools, are using the strobe system in experimental work in the study of physics. The new generation will see what is going on in the world of motion with the help of strobes.

Ever since electronic flash became available in a practical form it has been accepted for sports and nature photography. In these fields the short exposure is most important for stopping action. Often there is a requirement for many photographs to be taken quickly in a situation in which the photographer does not have time to change his expendable flashbulb. The electronic flash system is excellent for this use since nothing needs to be done but wait for the capacitor to be recharged. The recharge cycle can be shortened if ample power is available.

Studio photography, especially of children, has been tremendously benefited by electronic flash, and an increasing number of studios are adopting the system. Once a photographer has started with electronic flash equipment, he seldom returns to the old shutter exposure system with continuous lighting.

Long ago some news photographer or headline newspaper writer used the word "strobe" to describe the electronic flash system of photography. Many have argued that stroboscopic photography means multiple-exposed pictures, and thus "strobe" is used incorrectly to describe single-exposure pictures. However, their semantic pleas have not been heeded, and so strobe is a word of common usage today to describe the single flash equipment.

The object of this book is, first, to present the theory and applications of the electronic flash system and, second, to give a description of the typical electronic flash systems in general use today. Some of the unusual and interesting applications of electronic flash in industry and science will be reviewed, followed by a discussion of light measurement techniques and other related topics. Information is given to instruct those who need to use electronic

flash and to guide those who will further develop the system. A few experiments are included at the end so that those who wish to do more than read will have a guide to a few of the techniques that are becoming commonplace.

REFERENCES

1. Talbot, W. H. F., Spark Photography, British Patent 13,664, June, 1851.
2. Talbot, W. H. F., On the Production of Instantaneous Images, *Phil. Mag.*, vol. 34, pp. 73-77, January, 1852. (See comments in *Brit. J. Phot.*, September, 1864.)
3. Töpler, M., Beobachtungen nach einer neuen optischen Methode, *Ann. Physik*, 1864, 1867, vol. 131, p. 33.
4. Töpler, M., *Pogg. Ann.*, vol. 127, p. 556, 1866.
5. Mach, E., *Nature*, vol. 11, no. 2, pp. 250-251, July, 1890. (This is an English summary of a series of articles published in the 1887, 1888, and 1889 issues of the *Akad. Wiss. Wien.*)
6. Lord Rayleigh, Electricity on Colliding Water Drops, *Proc. Roy. Inst. G. Brit.*, February, 1891.
7. Boys, C. V., Electric Spark Photography ⁻lying Bullets, *Nature*, vol. 11, no. 7, pp. 415-421, 1893; *Smithsonian ι....itution Report*, pp. 165-182, 440-446, 1893.
8. Worthington, A. M., "A Study of Splashes," Longmans Green, London, 1908.
9. Cranz, C., "Lehrbuch der Ballistik," vol. 3, chap. 9, Springer-Verlag, Berlin, 1927.
10. Schardin, H., and W. Struth, Neuere Ergebnisse der Funkenkine-matographie, *Z. Tech. Physik*, vol. 18, no. 11, pp. 474-477, 1937.
11. Bull, L., *Travaux Assoc. Inst. Marey*, vol. 2, p. 51, 1910.
12. Bull, L., *Compt. Rend.*, vol. 138, p. 755, 1904.
13. Wood, R. W., "Physical Optics," 3d ed., p. 44, The Macmillan Company, New York, 1934.
14. Quayle, P., "Spark Photography," *Natl. Bur. Std. Sci. Papers*, 508, June 15, 1925.
15. LaPorte, M., "Les lampes à éclairs lumière blanche," Gauthier-Villars, Paris, 1949.
16. Glatzel, B., "Elektrische Methoden der Momentphotographie," Friedr. Vieweg & Sohn, Braunschweig, 1915.
17. Früngel, F., "High Speed Pulse Technology," vols. I and II, Academic Press, New York, 1965. (A bibliography of 1,006 articles and books is listed.)
18. Rutkowski, J., "Stroboscopes for Industry and Research," Pergamon Press, New York, 1966.
19. Kivenson, "Industrial Stroboscopy," Hayden Book Companies, New York, 1965.
20. Marshak, I. S., in R. B. Collins (ed.), Some Physical and Technical Aspects of Gas Discharges in Flash Tubes, *Proc. 3rd Intern. Congr. High Speed*

Phot., pp. 30-41, Academic Press, New York, 1957 (Butterworths, London, 1957); "Electronic Flash" (in Russian), Moscow, 1963.

21. Chesterman, W. D., "The Photographic Study of Rapid Events," Clarendon Press, Oxford, 1951.
22. Hyzer, W. G., "Engineering and Scientific High Speed Photography," The Macmillan Company, New York, 1962.
23. Rebikoff, D. I., "Der Elektronen Blitz," Heering-Verlag, Munich, 1952.
24. Jones, G. A., "High Speed Photography," Chapman & Hall, Ltd., London, 1952.
25. Aspden, R. L., "Electronic Flash Photography," The Macmillan Company, New York, 1959.
26. Snow, P., "Electronic Flashlight Photography," Fountain Press, London, 1961.
27. Luray, H., "Strobe, the Lively Light," 3d ed., Barnes & Noble, Inc., New York, 1963.
28. Saxe, R. F., "High Speed Photography," Focal Press, Inc., New York, 1966.
29. Harashima, A., "Stroboscope Photography" (in Japanese), Kodansha, Tokyo, 1966.
30. Edgerton, H. E., and J. R. Killian, Jr., "Flash, Seeing the Unseen," 2d ed., Charles T. Branford Company, Newton Centre, Mass., 1954; 1st ed., Hale, Cushman and Flint, Boston, 1939.
31. Van Veen, F., "Handbook of Stroboscopy," General Radio Company, West Concord, Mass., 1966.
32. Maiman, T. H., *Nature*, vol. 187, p. 493, 1960.

2 THEORY OF THE ELECTRONIC FLASH LAMP

Flash Lamps and Circuits

An electronic flash lamp [1] with its associated electrical driving circuit is shown in Fig. 2-1. All of the circuit elements are identified on the diagram and detailed descriptions of some of their functions are given in the following text for the benefit of those who are new to this field. Those who are experienced with flash equipment will skip, undoubtedly, much of the material in this chapter since it is written for the beginner.

The "filament" that glows in a flash lamp is a small amount of gas, usually xenon. Unlike a metallic tungsten filament, the gas has a very small heat capacity and can become heated very quickly. For example, the conventional tungsten lamp may require almost one-tenth of a second to become hot and a much longer time to cool, whereas xenon gas can reach full peak light output in a few microseconds with an equally rapid decay. Even the large xenon lamps with so-called long-duration flashes have a rise time of a fraction of a millisecond and a decay time of a few milliseconds.

The flash lamp sketched in Fig. 2-1 consists of a transparent glass or quartz tube with two internal metal electrodes which may be of the same material in simple lamps. The electrical connections are brought out through vacuum-tight seals at the ends of the lamp.

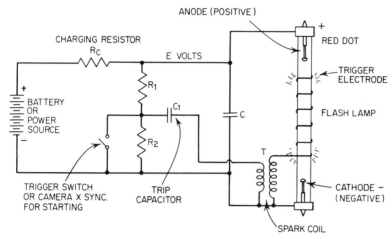

Fig. 2-1 *Basic electronic flash lamp and circuit showing a simple direct-switch type of trigger circuit.*

After the air has been exhausted, the lamp and electrodes are heated in vacuum for degassing and then filled with xenon gas before sealing. Lamps, especially those needed for high power and long life, are supplied with special cathodes (negative end) containing small amounts of electron-emitting materials, such as barium which causes less darkening of the lamp walls with use than plain metal electrodes. The anode or positive terminal is often made of pure tungsten and is marked with a red dot or with a + sign to ensure proper connection from the circuit to the lamp.

Since the anode heat is usually greater than that of the cathode, some of the larger flash lamps, for example, those used at very high energy and long pulse operation for laser stimulators and for large lighthouses, require a large, smooth tungsten anode to withstand the heating effects of the arc. Figures 2-2 and 2-3 are photographs of several types of flash lamps of the xenon-filled type. Other examples are shown elsewhere in the book.

A power source, such as the battery shown in the diagram, is always required. Between the power source and the energy storage capacitor C is a charging resistor R_C to limit the current from the

power source. The capacitor C is the necessary and important circuit element in the electronic flash circuit to supply the high instantaneous power required to light the lamp to its brilliant peak. It is known that the electrical capacitor has tremendous peak-power

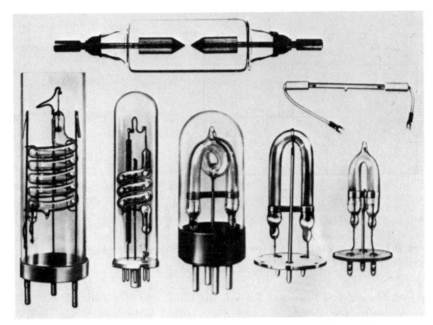

Fig. 2-2 *Typical xenon flash lamps (GE Co.). Bottom row: left to right— FT-524, FT-506, FT-120, FT-110, and FT-106. The gap lamp is FT-230.*

capability when discharged into a low-resistance load, such as a flash lamp. The battery is unable to supply the high power needed to flash the lamp directly in a short time. Instead the battery power flows gently into the capacitor through the resistor R_C at a rate determined by the charging circuit. The accumulated energy in the capacitor then produces the flash in a very short time. Further details of the circuits will be given later.

Figure 2-1 shows a directly switched trigger circuit that is charged to a voltage V_s which is a fraction of the battery voltage set by the ratio of the resistances to which the trip capacitor is connected. In this case $V_s = E[R_2/(R_1 + R_2)]$. A "trigger switch" is shown which causes the flash lamp to operate according to the explanation given below. This switch can be the "X" shutter contacts of a camera shutter. In this manner, the flash can be made to occur when the shutter is open. The trip energy in the capacitor C_1 is pulsed into the

step-up spark coil in order to excite the gas in the flash lamp by means of the external trigger wire. The main flash then occurs when the main capacitor C discharges its energy into the gas in the lamp.

These glass and quartz electrical discharge lamps, filled with one of the rare gases (Ne, Ar, Kr, or Xe), exhibit very unusual starting and electrical characteristics especially at high current densities. Xenon is usually preferred since the efficiency of conversion of electrical input to radiant energy is greatest and the color distribution of the light can be made to approximately match that of daylight. This last requirement is especially important for outdoor color photography which uses both daylight and flash illumination.

The classical theory of the electrical breakdown of a gas in a tube with *plane parallel electrodes*, given by Paschen's law,* states that the sparking potential is a function of the product of the gas pressure and the gap length. The above function is nonlinear except for high pressure or long gap conditions. There is critical pressure for each gap distance at which the breakdown voltage is a minimum. For low pressures, the breakdown voltage will *increase* when the pressure or the gap is decreased. Because the light-producing efficiency is very poor at low pressure, most flash lamps have a pressure and length considerably above that which is critical for minimum breakdown.

*For more theory of gases see James D. Cobine, "Gaseous Conductors," McGraw-Hill Book Company, New York, 1941 (paperback edition, Dover Publications, Inc.). This is one of many books on the conduction of electricity in gases.

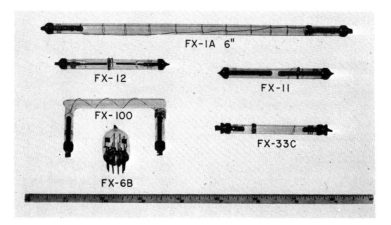

Fig. 2-3 *Xenon gas-filled electronic flash lamps of quartz with soldered seals (EG&G, Inc.). The FX-6B xenon gap lamp is used as a stroboscope source.*

The criteria of Paschen's law are inaccurate and inadequate to describe the self-breakdown of long, narrow flash lamps since (1) the electrodes are not parallel plates and (2) the charges on the lamp walls play a very important role in the self-starting, triggering, and operating phenomena.

The efficiency of a flash lamp for producing useful radiation is increased as the gas pressure is increased in most discharges up to about 10 cm pressure. The efficiency does not increase materially for pressures above 10 cm, but the lamp becomes increasingly difficult to start. Practical flash lamps in use today are considered to be of the "high-pressure" type when viewed as gaseous discharges. The pressure in most xenon flash lamps is approximately one-tenth of an atmosphere but can be as high as several atmospheres in special lamps of small size. The number of mean-free-path (mfp) lengths between electrodes is many thousands, even ten thousand or more, and the voltage per mfp is a very small fraction of the ionization potential of the gas molecule. Initial ionization of the gas is caused through the lamp wall by the sudden application of a high voltage on the external electrode.

Breakdown-Starting

The electrical self-breakdown voltage of a xenon-filled tubular flash lamp, such as the EG&G, Inc. FX-33 (3.8-cm gap × 0.4-cm bore, xenon gas at 25-cm Hg pressure, Fig. 2-3) or the FX-1 (15-cm gap × 0.4-cm bore, xenon at 20 cm), is erratic (1,000 to 6,000 volts) from flash to flash depending upon unknown factors. The breakdown voltage with a *pulsed* circuit is usually reduced when an external wire is wrapped around the outside of the lamp and connected to the pulsed end of the lamp. A reduction of the gas pressure in a flash lamp from the normal xenon lamp pressure will enhance easy self-starting, but there may be a loss of light-producing efficiency. At present there are very few applications of the self-starting xenon flash lamp in which the lamp starts by the direct application of the circuit voltage to the lamp.

A commonly used *externally triggered* mode of operation of a xenon lamp will now be described. Consider the EG&G, Inc. FX-33 type of xenon flash lamp which has been mentioned above. A spiral (Fig. 2-4) or other external electrode or wire is wrapped around the outside of the lamp. This starting wire electrode is energized by a high-voltage spark-coil secondary for electrical triggering by means of

a voltage surge. A pulse of about 5 to 10 kV is required to cause ionization of the gas on the inner surface of the flash lamp depending upon the frequency or, more correctly, upon the voltage rate of change with time.

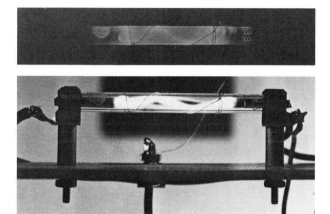

Fig. 2-4 *Top photograph shows multiple exposure at f/4.5 due to spark only for 1 min at 10 fps (600 flashes). Lower photograph made with 40-watt lamp at 1 ft. Exposure 2 sec at f/11 and flashed from 0.5 μF at 650 volts. Plus X film used for both.*

When a charged capacitor is connected to the main electrodes of a triggered xenon flash lamp, nothing happens (or should happen!) without the triggering electrical pulse. There is no current and no light output since the normal applied voltage is not sufficient to start the electrical discharge. The starting action is caused by ionization of the gas on the inner wall surface of the tube by the external third electrode. This procedure is detailed in the following explanation.

Figure 2-4 shows a flash lamp containing a starting wire which is stimulated by a high voltage at the instant at which the tube is required to flash. Ionization of the xenon gas in the flashtube results when a high voltage is suddenly applied. The upper photograph of Fig. 2-4 was exposed from the dim ionization caused by the spark voltage. Some 600 superimposed pulses were used in order to obtain the photograph. As seen by the eye, the observed tube in the dark actually shows a more coronalike or filamentary discharge. This effect has been partly lost by the multiple exposures.

The pulse of voltage must be greater than some minimum value [3, 4, 5, 6] for starting to occur. This minimum voltage is influenced

by the following factors:

1. The pressure of the xenon gas. A lamp with a lower pressure is easier to start, but the lamp may be less efficient for producing light.

2. The type of spark electrode and the thickness of the lamp wall. An external electrode that extends the length of the flash lamp will require a smaller starting voltage and capacitor voltage than a less complete electrode, for example, a single turn of wire at the center of the lamp.

3. The frequency of the spark voltage. In general, if the peak voltage is the same, a high-frequency spark voltage will start a flash lamp easier than a lower-frequency spark.

4. Both gaseous impurities in the lamp and sputtered metal on the walls markedly influence the starting. Usually a lamp becomes more difficult to start as it ages and becomes contaminated with impurities. However, an old lamp can experience self-starting due to the reduction of gas pressure and conducting surfaces on the inner wall.

5. The lamp temperature. Apparently the glass or quartz becomes a semiconductor which tends to reduce the spark potential. A glass flash lamp may puncture because of local glass melting if the lamp is operated repetitively at high power input.

The dim light from the spark trigger voltage alone was used to self-expose the discharge in the top photograph of Fig. 2-4 as previously mentioned. Some 600 flashes were put into the starting electrode, and the total light was exposed on film in a time exposure camera. The lower photograph shows a one-second time exposure of the lamp made with a 40-watt tungsten lamp 1 ft from the light-colored background, and with the self-light from the flash lamp, which was excited by a 0.5-μF capacitor charged to 650 volts. Note that the discharge tends to be adjacent to the lamp wall that is opposite the external starting electrode.

Because of the importance of xenon lamp starting, we have considered in detail the performance of the circuit of Fig. 2-5 as observed by a cathode-ray oscilloscope. The spark-coil secondary voltage V'_s as applied to the starter wire, is shown in trace A. The frequency of the pulse voltage is determined by the distributed capacitance of the spark coil and its self-inductance. A "kink" observed in the voltage wave on the positive rising side is believed to result from the ionization current [6] which suddenly flows inside

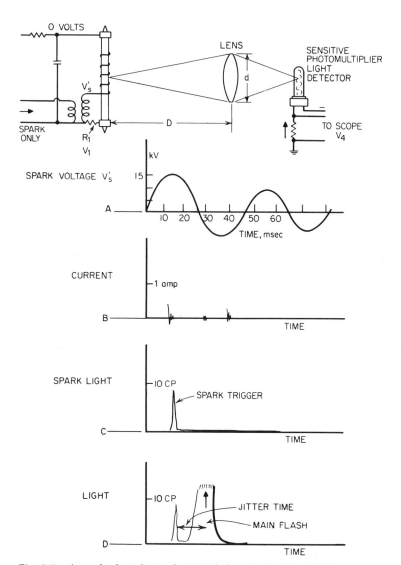

Fig. 2-5 *A method studying the initial electrical and optical conditions in a flash lamp at the instant of starting.*

the lamp when ionization starts. This is confirmed by measuring the current in the cathode lead (trace B) across resistor R_1. The peak current is considerable (amperes) and the measurement is difficult because of rapid change with time and short duration. As mentioned previously, a dim glow can be seen and photographed in the lamp if it is observed in a darkened room (Fig. 2-4).

Trace C (Fig. 2-5) shows the light as observed by a photomultiplier (PM) tube. A light-collecting lens is used for two reasons. First, the PM tube cannot be placed close to the spark coil because of electrical pickup; and, second, the very dim light output requires the excellent light-gathering ability of the lens. The use of a lens permits the PM tube to be removed from the flash lamp although the PM tube receives the light collected by the lens. There is a pulse of light from the FX-33 of about 5 or 10 candela for a microsecond or less when the internal discharge caused by the ignition occurs (see curve C). If a charged capacitor across the lamp discharges, then a much larger flash will occur as shown in trace D. A time delay (0 to 20 μsec) is observed between the ignition pulse and the buildup of the main flash.

For the above tests, the entire image of the FX-33 was incident upon the cathode of the PM tube. Even though the flash capacitor was very small, for example, only 0.0015 μF (1,000 volts), the light caused by the trigger spark voltage is completely negligible compared to the main flash. Marginal starting conditions should be carefully avoided by using ample triggering voltage. Even if a new lamp starts easily, it may require considerably more voltage for reliable operation, especially after heavy overloads. A very small gas contamination, coming from the walls or from the electrodes and caused by large energy discharges, plays an enormous role in the starting phenomena. A lamp with impure xenon gas will exhibit hard-starting difficulties and may skip flashes.

Time jitter and amplitude jitter, as indicated in curve D of Fig. 2-5, may be very important for marginal cases for special applications. The time jitter in starting remains the same when the flash lamp capacitor is increased in full energy of 100 watt-sec. However, the jitter of 10 μsec or so is negligible compared to the duration of the flash which may be more than 100 μsec. Thus, there is comparatively very little time or amplitude jitter in a fully loaded lamp. However, time jitter can be serious in an underloaded flash when short-time information is being sought. Starting-time jitter is

apparently due to the variation of the starting conditions in the gas and the initial conditions on the inner wall surfaces of the lamp. Jitter time can be decreased by increasing either the trigger or anode voltage or both. Radioactive and ultraviolet light sources in the vicinity of the lamp have been used to reduce jitter, as well as feeble internal electrical discharges.

Starting Characteristics

The experimentally measured starting characteristic of a flash lamp is shown in Fig. 2-6. The voltage across the main terminals of the lamp is given as the abscissa. As the main lamp voltage is increased, the lamp will eventually break down electrically into a discharge without a starting trigger voltage on the external electrode. This condition is called "self-flash" and is indicated in Fig. 2-6. The lamp will not self-flash at exactly the same voltage each time, probably because of

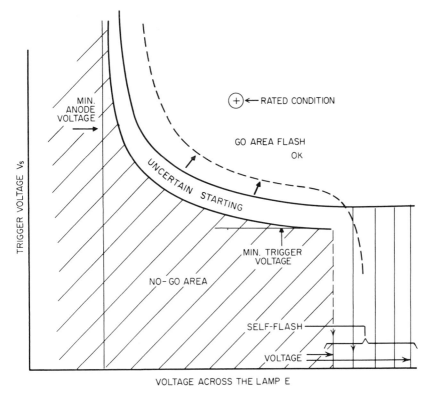

Fig. 2-6 *Idealized starting conditions for a flash lamp.*

inconsistent residual electrical charges on the inner walls of the flashtube and because of other irregular factors.

A boundary curve between the flash and the nonflash areas can now be made experimentally. This curve will have the form indicated in Fig. 2-6 with the starting voltage as the ordinate. The *minimum* starting voltage on each tube is very important since a misfiring tube is almost worse than one that does not flash at all. The rated condition is shown as a point determined by the anode and spark voltages where the point is well above the critical value so that starting will be certain.

The complete, idealized plot of the starting conditions for a flash lamp is shown in Fig. 2-6. The graph is divided into areas: (1) a FLASH region area in which the conditions are always right for the tube to start, and (2) a NO-GO area in which the tube does not start. There is an intermediate area between these two where starting is uncertain. Operation within this region should be avoided since a "skipping" flash lamp is not acceptable. As a tube ages, the starting conditions may wander as indicated by the dotted line bounded by arrows pointing to the direction of drift. If the "rated condition" point becomes engulfed by the area indicated by the dotted curve, starting will become erratic, causing the tube to skip or miss. The condition is intolerable and marginal starting conditions should always be avoided by using ample spark voltage. In other words, there must be ample energy in the triggering circuit and operation must be well above the points of critical performance.

A few photographs of an actual flash lamp (EG&G, Inc. type FX-33) are shown, giving the total integrated light effects using different voltages and capacitors. As discussed before, Fig. 2-4 shows the dim glow in the flash lamp caused by a spark voltage which in most examples is completely negligible compared to the main flash. Ionization caused by the spark trigger voltage excites the gas that is adjacent to the tube wall, and streamers conduct to the electrodes. Once the gas is excited or ionized, the main condenser discharge can start. Figure 2-7 (upper curve) shows the discharge from a 0.5-μF capacitor at 650 volts. The flash is over in a very brief time since the small capacitor discharges quickly into the flash lamp. The arc follows roughly the inner surface of the flash lamp adjacent to the spark trigger wire on the outside of the lamp. The arc will not develop and fill the diameter of the lamp when a small amount of energy is used. The middle photograph shows that a broader arc

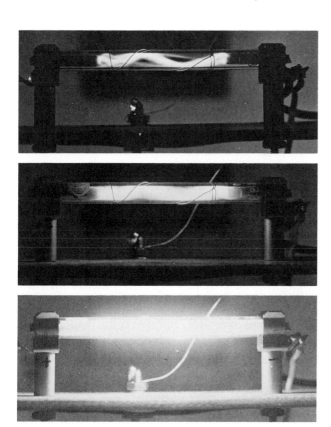

Fig. 2-7 *Photographs of an FX-33 flash lamp under three conditions. Upper: 0.5 μF, 650 volts; middle: 4 μF, 900 volts; Lower: 21 μF, 1,500 volts.*

develops in the lamp when it is excited by the energy stored in a 4-μF (900 volts) capacitor. The arc still follows the spark trail, but it has opened into a discharge with a larger cross section than that in the upper photograph but still not enough to fill the entire lamp with light. The bottom photograph shows a completely filled flash lamp which was the result of using 21 μF at 1,500 volts. All three photographs were exposed on Plus X film at $f/11$. The bottom photograph was badly overexposed in the image, and the film had an overall fog caused by scattered light from the flash lamp.

Triggering Circuits

The "direct" triggering circuit (Fig. 2-1) requires sturdy switch contacts to operate the spark-coil circuit directly from the trigger

capacitor. Many "X" contacts in camera shutters are inadequate for this duty, especially if the spark circuit energy is purposely large for reliable starting. A strobotron, thyratron, or SCR trigger circuit overcomes this difficulty in that the main trigger energy is not switched directly by the delicate "X" shutter contacts. The triggering devices also have the capability of being pulsed from electrical signals from photocells, microphones, and other sensors. Specific examples of practical trigger circuits are given in Chap. 4.

The logical place for the physical location of the spark coil is near the flash lamp in order to reduce the circuit capacitance of the high-voltage secondary circuit. The frequency of the trigger voltage is a function of the square root of the total capacitance in the spark-coil secondary circuit.

Arc Growth

The question now arises as to how fast the initial bright filament of light develops into a column which will fill the entire lamp. Figure 2-8 shows a series of 1-μsec-exposure photographs made during *different* flashes and each with a different and longer delay time. An FX-33 flash lamp was operated from a 250-μF electrolytic capacitor charged to 900 volts (two 500-μF capacitors in series). The luminous arc completely fills the flash lamp about 10 μsec after starting.

Once the starting glow and streamers created by the trigger electrode voltage (Fig. 2-4) have transferred to a solid filament joining the anode to the cathode, the main arc builds up in intensity at a rapid rate [7]. Usually the first initiating filament is in contact with the lamp wall. If the buildup is rapid, as it will be with high voltage on the terminals, then the arc will be on or very close to the wall. Intense local heating and pressure evaporate the inner wall surface and cause thermal stresses which may burst the lamp. These effects are mostly observed on lamps with a short gap or high-voltage operation or both. A small inductance can be used to slow the buildup of current during the initial growth of the arc. In this way the arc will have a few microseconds to move away from the wall. The overall flash duration will not be appreciably increased since the buildup time is usually quite short compared to the time required for the remainder of the discharge.

A series of kerr-cell-shuttered photographs, taken on a rotating mirror camera by Ackerman [8] (Fig. 2-9), show the buildup on the xenon arc in the FX-47A flash lamp (2,000 volts, 1,440 μF). Note

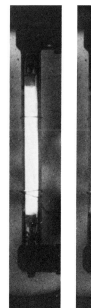
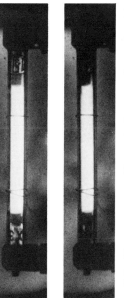

FIG. 2-9 *Series of high-speed photographs taken of an FX-47 flash lamp flashed from 1,440 μF at 2,000 volts. The photo interval is 8.6 μsec except photos 4 and 5 where it is 4.3 μsec.*

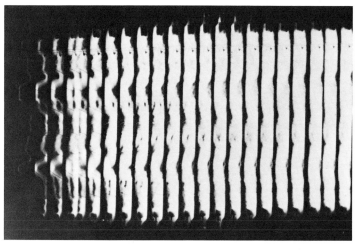

Fig. 2-8 *Short exposure (1 μsec) photographs made with an image converter camera system at different delay times. The flash lamp (FX-33) was excited from two series 500-μF electrolytic capacitors charged to 900 volts. Delay time top to bottom: 1, 2, 4, 10, and 50 μsec.*

Fig. 2-10 *A series of pictures exposed with a Kerr cell shutter on a moving film. FX-47 flash lamp, 3,500 volts, 1,440 μF; time interval 8.6 μsec top, 12.9 μsec bottom; 370 μsec cut at break.*

that the volume of the small filament increases during the first 8 to 10 exposures and almost fills the lamp with plasma. The interval time between exposures is 8.6 μsec except for 4.3 μsec between photos 4 and 5.

Figure 2-10 shows a more rapid arc development with 3,500 volts and 1,440 μF. The time interval between exposures is 8.6 μsec. The photographs show that the lamp exploded at the cathode end. Some 370 μsec of pictures were cut out between the top and bottom records. A hot spot develops at the left-hand side (cathode) where the quartz break initiated. The crack front velocity is about 2,000 meters per sec. Note that the initial discharge in a large diameter lamp as shown does not follow the starting wire position, especially at high anode voltage.

Flash Lamp Life

Once equipment with a xenon flash lamp has been found to be satisfactory for output, jitter, flashing rate, etc., there remains the question of how long the lamp will last. In at least one case, that of a

large schlieren apparatus in which a great quantity of light is needed, a xenon flash lamp (FX-12) was sacrificed for each photograph. Although the life was only "one flash," the photographic result justified the action.

On the other end of the scale, there is the aircraft or lighthouse beacon which must be going strong after many millions of flashes. One of the strongest technical reasons for the use of the xenon lamp as a beacon is its almost infinite life when used correctly. The xenon flash lamp usually does not fail suddenly and completely, as does the tungsten lamp when its filament burns out. A xenon lamp is usually changed after a given number of flashes or time because it becomes inefficient due to electrode evaporation with subsequent deposits on the wall that absorb the light. It is obvious from Fig. 2-10 that the FX-47 lamp has reached its limit of operation! Other lamps progressively become less efficient due to electrode evaporation and sputtering and must be replaced if efficiency is important.

The problems of lamp life were presented at the Sixth International Congress on High-Speed Photography, the Hague, the Netherlands, by Goncz, Jameson and the author [11]. A curve from this paper is reproduced as Fig. 2-11 for the FX-38A flash lamp (0.4-cm ID and a 7.6-cm arc length). Notice that a 300-μH inductor is used to reduce the initial pulse of current and thereby prevent the ill effects of an initial high-peak current. The life of flash lamps is discussed also in [3-5].

A second curve for the performance of the FX-38A is given in Fig. 2-12. This shows the results upon a series of lamps in which the capacitance C and the inductance L were varied as well as the voltage. Values of C and L were chosen to give a certain pulse duration, and then the voltage on this circuit was increased in steps for a series of flashes. For example, if the flash duration was 1 msec, the peak current was 1,200 amp when the first sign of wall evaporation became apparent. With 1,700 peak amp, the electrodes began to evaporate; and finally the lamp exploded at 2,000 amp.

An increase of the series inductance L causes an increase in the pulse duration; and as the data (Fig. 2-12) show, the lamp damage occurs at a lower peak current.

Goncz gives further information [10] on the ultimate strength of flash lamps as a function of flash duration and energy for various sizes of quartz tubing that are available for flash lamp production. He concludes that the following empirical expression describes the

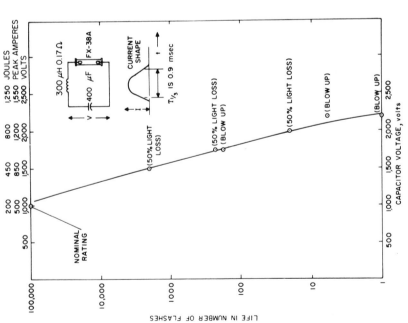

Fig. 2-12 *Level of peak current at which symptoms of distress appear in the FX-38A flashtube. The peak current that can be tolerated drops approximately as \sqrt{T}. The approximate flash-tube life is given for the loading conditions producing the distress symptoms noted.*

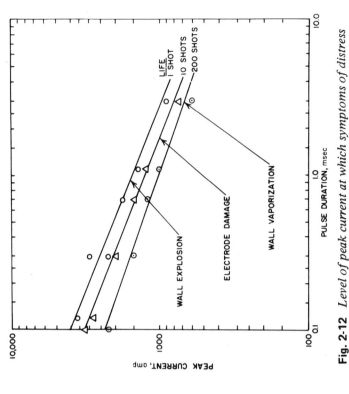

Fig. 2-11 *A plot of the "life" of a type FX-38A flash lamp as a function of voltage (or energy).*

ultimate limit of linear flash lamps.

$$\frac{U}{L} = kD\sqrt{T}$$

where

U = limit in watt-seconds
L = arc length in inches

and k has a numerical value of 90 when the bore diameter D is expressed in millimeters and the duration of the current pulse is expressed in milliseconds. The above equation can be tried with the FX-38A flash lamp whose "blow up" condition is shown in Fig. 2-11 to be 2,300 volts, 400 μF at a 0.9-msec flash duration.

$$\frac{U}{L} = \frac{1{,}060 \text{ watt-sec}}{3 \text{ in.}} = 353$$
$$= 90 \times 4 \times \sqrt{0.9} = 342$$

It is seen that the FX-38A data fits well into Goncz's empirical equation.

The lamp life information, such as contained in Fig. 2-11, can also be given in table form (as given by Goncz) for a rough design guide.

There are at least two important exceptions to the lamp life data. These are the helical flash lamp and the linear flash lamp in a reflecting cavity. In both examples, the optical radiation from the lamp effectively increases the watt-sec per inch.

Therefore, the flash lamp in a closed reflecting cavity, as used for pumping laser crystals, must be derated because of the reflected

Table 2-1 Expected Lamp Life

Flash energy, percent of ultimate limit	Flash lamp life, number of flashes to 50 percent efficiency
100	0–10
70	10–100
50	100–1,000
40	1,000–10,000
30	10,000–100,000

energy absorbed by the lamp. In some cases the lamp acts as though it were loaded by an additional 30 percent of energy. Experience with the FX-47A has shown that, at a flash loading of 70 percent of the ultimate energy, the tube may explode within a few shots. In open air, the same lamp, under the same conditions, will operate for more than 100 flashes.

Electrical Characteristics of Flash Lamps

The typical voltage and current-vs.-time transients in an electronic flash lamp are shown in Fig. 2-13 for an FX-1 flash lamp when flashed from a 70-μF capacitor charged to 1,500 volts. The trigger pulse is applied at time zero. Shortly thereafter, as the arc develops in the flashtube, the flash lamp current rises to its peak of 700 amp. Meanwhile, the capacitor voltage drops as the capacitor supplies energy to the lamp. Series inductance and resistance, if present in the discharge circuit and in the capacitor, may cause a further drop in voltage at the flash lamp terminals depending upon the magnitude of the circuit elements. Every effort should be made to reduce the series impedance mentioned above if a very short flash is desired. However,

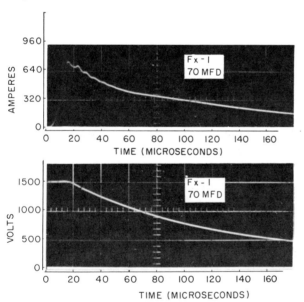

Fig. 2-13 *Top trace: current; bottom trace: voltage across an FX-1 (EG&G, Inc.) flash lamp during discharge from a 70-μF paper capacitor. There could be a 10- or 15-μsec delay in the voltage-time axis.*

for the usual high-resistance efficient flash lamp, such as the FX-1 with a lamp "resistance" of about 2 ohms, considerable series wiring can be tolerated in the discharge circuit.

The current after a few small oscillations gradually decays until it reaches zero. The voltage across the lamp does not usually reach zero, especially with the high "resistance" flash lamps. In some cases, with low resistance lamps and an inductive discharge circuit, the voltage may be negative at the end of the discharge cycle.

It is informative to reconnect the oscilloscope to show directly the current-voltage information as illustrated in the curve of Fig. 2-14.

The volt-ampere oscillogram trace is dim at the start of the discharge because of the rapidity of the transient. Notice that the trace stopped before the current became zero due to the cutoff of the oscilloscope beam. The "residual" voltage across the capacitor was about 150 volts when the current became zero.

Of special interest is the flash lamp "resistance" definition which can be given as

$$R = \frac{E}{I_{max}} = \frac{\text{initial capacitor voltage}}{\text{peak discharge current}}$$

The flash lamp "resistance" is a very useful concept although it must be used with caution and understanding. The "resistance" of a flash lamp is a function of the energy that is discharged into it. However, in the normal, fully loaded, efficient range of values flashtube resistance is fairly constant over a range of energy input values.

For a specific example, consider the EG&G, Inc. standard lamp FX-1 which has a linear 15-cm arc length enclosed in a quartz tube that has an inside diameter of 4 mm. The lamp is filled with xenon gas at 20 cm

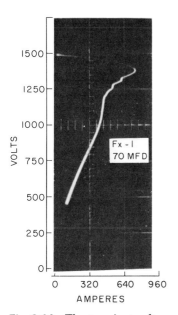

Fig. 2-14 *The transient volt-ampere curve as measured when a 70-μF capacitor was discharged through an FX-1 flash lamp. The bottom part of the curve continues to zero current and a residual voltage of about 150 volts.*

pressure. The transient peak current that flows in the FX-1 flash lamp is plotted in Fig. 2-15 as a function of initial capacitor voltage. Curves for several values of capacitance are shown. It is observed that the peak current does not increase proportionally to capacitance.

The following values, as read from Fig. 2-15 for 2,000 volts, show that the increment of peak current is smaller when large capacitances are used.

Capacitance, μF	1	5	13	50	100	200
Current peak, amp	240	630	920	1,080	1,200	1,350

If the flash lamp acted as a conventional resistor, the peak current would be the same regardless of capacitance. From the above data one can see that the so-called resistance of a flash lamp is only a very rough approximation. However, the concept is a good one for engineering calculations of performance.

One way to define "resistance" of a flash lamp, as mentioned before, is to divide the initial capacitor voltage by the peak current.

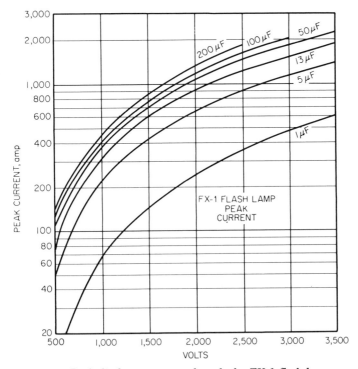

Fig. 2-15 *Peak discharge current though the FX-1 flash lamp as a function of voltage for several capacitors.*

By this definition, the "resistance" of the FX-1 at 2,000 volts and 100 μF is

$$R = \frac{2,000}{1,200} = 1.6 \text{ ohms}$$

Flash lamp "resistance" can be used to *estimate* the flash duration in the following manner. If the lamp did act as a resistor, the *power* time constant would be $T = RC/2$ seconds, and the light time constant would be the same value if the efficiency of light production was constant. For the FX-1 at 2,000 volts and 100 μF condition, the power time constant is

$$T = \frac{1.6 \times 100 \times 10^{-6}}{2} = 80 \ \mu\text{sec}$$

The FX-1 flash lamp has a flash duration with a buildup time, and the efficiency of power-to-light conversion is not a constant. "Flash

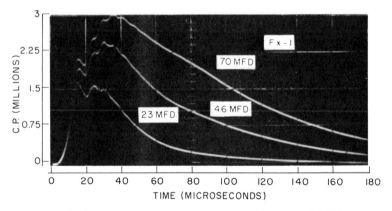

Fig. 2-16 *Light output in millions of candelas from an EG&G, Inc. FX-1 flash lamp when excited from 23-, 46-, and 70-μF capacitors charged to 1,500 volts.*

duration" is conventionally given as the time between the one-third peak points on the rise and decay of the light from a flash lamp. This is different than the $1/\epsilon$ concept of the time constant method for a fixed resistor. For a comparison consider the measured flash duration (one-third peak) of the FX-1 with 100 μF at 2,000 volts, as shown in Fig. 2-17. The "flash duration" is 125 μsec compared to 80 μsec as calculated by the time constant method.

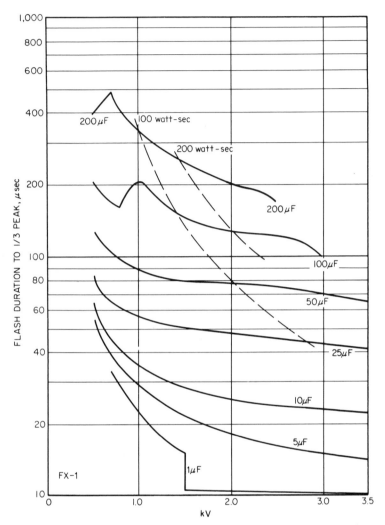

Fig. 2-17 *Experimentally measured flash duration as a function of capacity and voltage.*

The glowing arc in a flash lamp, such as the FX-1, appears as a filamentary discharge that does not fill the cross section of the flash lamp for small values of capacitance. The arc develops in size with energy input and eventually fills the entire inner diameter. When this occurs the "resistance" seems to level off to a fairly constant value. Taking the FX-1 as an example at 2,000 volts, the minimum capacitance for the arc to fill the tube is about 15 μF.

Resistivity of the Plasma

Since the "resistance" of a long, slender flash lamp is relatively constant for conditions where the arc fills the flash lamp, a "resistivity" can be calculated from the equation $R = \rho l/\text{area}$, where ρ = resistivity of the plasma (ohm-cm), l = arc length in centimeters, and area = cross-sectional area in square centimeters of the flash lamp. The resistivity of the FX-1 standard lamp is calculated to be 0.014 ohm-cm from the equation $R = \rho(l/\text{area})$, since R for the FX-1 at 100 μF and 2,000 volts is 1.6 ohms. The arc length is 15 cm and the inside diameter of the lamp is 0.4 cm.

LeCompte [7] and the author have observed experimentally that the resistivity of a filamentary discharge is approximately a constant when the area of the discharge is considered instead of the area of the lamp. Other flash lamps will react also as approximate resistors if the energy density is greater than about 15 watt-sec per cm^3 and the arc fills the full cross section of the lamp. The value of resistivity [2-5] is about 0.01 to 0.02 ohm-cm as given by several investigators over ranges covered in the design of practical flash lamps. Goncz [9, 10] with further experiments at high constant current densities has refined the above measurements. He concludes that the resistivity decreases as an inverse square root function of the current density from values of 400 to 10,000 amp per cm^2.

Light Output

A complete description of the light output, except for spectral properties, can be found in a light-time oscillogram, as measured with photoelectric tube and oscilloscope. The actual light output must be measured experimentally by a photodetector that is *linear* in response, has the *visual* spectral response, and a *short time constant* of operation. Technical details of such measurements are given in Chap. 11. Three superimposed oscillograms of the light output from the FX-1 excited by capacitors of 23, 46, and 70 μF at 1,500 volts are shown in Fig. 2-16. First, there is an initial time delay after application of the trigger voltage. Next, there is the buildup in which the arc grows from the inside of the lamp, adjacent to the external trigger electrode, as illustrated before. Finally, the light reaches a peak with possibly one or more oscillations as the arc and expanding gases interact in the lamp. Then the light decays in an exponential-like manner to zero.

Flash Duration

Flash duration is best defined by the entire light-time curve, such as the oscillographic records of Fig. 2-16. For most applications, the user is interested in a number which can be used to estimate the blur in photographs of a moving object. One of the common definitions of duration was mentioned earlier as the "time between one-third of peak-light times." This flash duration time is longer than the flash duration as calculated by the $RC/2$ equation given previously for practical conditions with efficient flash lamps. Performance curves of (one-third peak) flash duration for the FX-1 flash lamp are shown in Fig. 2-17.

Carlson [12] has shown experimentally that the flash duration for a flash lamp follows the equation, flash duration $t = K(C^{0.69}/V^{0.625})$ where K is a constant, C is the capacity, and V is the voltage for the specific lamp and test conditions

Control of Flash Duration

The following paragraphs are from [10].

The duration of the light flash is a critical design parameter in many xenon-flashtube applications. In addition to the image-definition requirements imposed by high-speed photography, three other prime examples come immediately to mind. In optical pumping of laser crystals, it is wasteful to use a flash whose duration is longer than the relaxation time of the optically active material (about 3.0 msec for ruby and about 30 μsec for neodymium-doped glass). With present-day airplane speeds and altitudes, night aerial photoreconnaissance photographs must be taken with flashes of 1.0 msec or shorter duration to prevent image blur. Finally, flash photolysis experiments require the generation of large amounts of light in the 5-μsec duration range.

There are four system parameters which may be manipulated by the systems designer to achieve a flash of a specified duration-voltage, capacitance, arc length, and bore diameter. However, although the designer has some degree of flexibility in choosing the values for these parameters, frequently, at ieast two of these parameters—arc length and bore size—are fixed by the concurrent demands upon energy per flash, tube life, and efficiency. Thus, one usually has freedom in choosing only the voltage and capacity.

The calculation of the duration of the light flash depends upon knowledge of the resistance of the flashtube. This calculation is made somewhat difficult, however, because a single value of resistance usually cannot be ascribed to a flashtube. In most cases, the resistivity of the

xenon plasma varies inversely as the square root of the current density [7], and this operating-parameter dependence must be determined before flash duration is calculated. This dependence is given by

$$\rho = 1.13/\sqrt{J} \tag{2}$$

where ρ is the xenon plasma resistivity (ohm-cm) and J is the current density (amp/cm^2). Flashtube resistance is given by

$$R = \rho L/A \tag{3}$$

Substitution of equation (2) into equation (3) yields

$$R = 1.13L/\sqrt{IA} \tag{4}$$

where L is the arc length, A is the cross-section area, and I is the instantaneous current.

Since calculation of the resistivity requires a knowledge of the current density, the discharge circuit must be examined. Flashtubes are operated most commonly in any one of the following three types of discharge circuits: capacitor discharge, inductor-capacitor discharge, and pulse-forming network. These are considered in the following paragraphs.

Capacitor Discharge

This is the simplest flashtube discharge circuit in common use. In this circuit configuration, the flashtube acts as its own switch and no further circuit complexity is involved. The duration of the flash in this case is arrived at as follows: Equation (4) is used to determine the resistance of the flashtube at the peak current during the discharge. If the flashtube were to maintain this resistance constant throughout the discharge, the power and, consequently, the light function would be given by

$$P = (V^2/R)e^{-2t/RC} \tag{5}$$

and the light flash would have a time constant $T = RC/2$ associated with it. However, R calculated this way is the lowest resistance—corresponding to the maximum peak current during the discharge—and, since R is actually greater than this during part of the time of the discharge, the flash duration is actually longer than that calculated by $RC/2$. In practice, it is found that the flash duration can be predicted to within a factor of 2 by

$$RC/2 < T < RC \tag{6}$$

Inductor-Capacitor Discharge

In many cases, it is highly desirable to reduce the peak current of a simple capacitor discharge, to lengthen the pulse duration, and, as stated earlier, to increase the life of the flashtube. This can be done most simply by introducing an air-core inductor in the discharge path. The problem then is one of calculating the duration of the discharge in an R-L-C discharge, a subject well-treated in a number of electronic-engineering handbooks. Although the circuit may be either under- or over-damped, it is most common to use a nearly critically damped circuit so that there is no reverse current. In this case, the flash duration is given by

$$T = \pi \sqrt{LC} \tag{7}$$

While this expression is valid, strictly speaking, only when R is constant, it can be used to compute flash duration with only a small error. In actual practice, the damping is somewhat greater than that predicted by a circuit calculation using the R corresponding to the peak discharge current. In fact, one can observe a change from non-oscillating discharge to oscillating discharge in the same circuit by simply increasing the voltage on the capacitor. This increase raises the peak current, lowers the flashtube resistance, and reduces the damping.

Goncz [10] gives a solution to the pulse-forming network peak current with a flash lamp on page 33 of his paper.

Peak Light

The peak-light output from a xenon flash lamp is often a useful quantity to know. Experimentally measured values of horizontal candela (HCP) have been measured from the side of the FX-1 flash lamp as a function of voltage and capacitance. The oscilloscope presentations are similar to Fig. 2-16. The peak values of HCP are then read from the oscillograms and have been plotted in Fig. 2-18.

Efficiency

The average efficiency over the entire discharge cycle of a flash lamp is shown for the FX-1 flash lamp in Fig. 2-19. Efficiency is defined as the ratio of the integrated light output in horizontal candela-seconds (HCPS) to the capacitor stored energy input in watt-seconds. The light output can be obtained by integrating the light-time oscillogram as a function of time, or it can also be measured directly with an integrating light meter. The meter reading, which is the incident foot-candle-seconds (lm-sec per ft^2), is

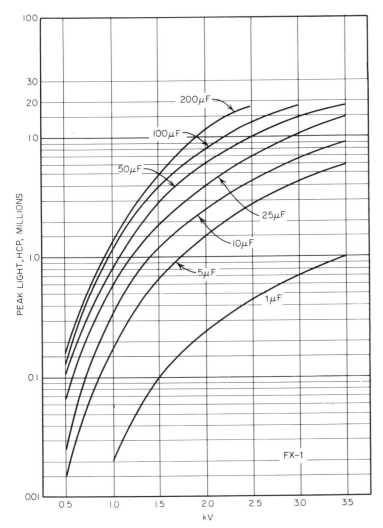

Fig. 2-18 *Peak light from the FX-1 flash lamp as a function of capacitance and initial voltage, measured by a phototube with an S-4 surface and Kodak Wratten filter No. 106.*

multiplied by the square of the meter-lamp distance. Details of meters and measurements of light and integrated light follow in Chap. 11.

The output of a flash lamp in a given direction with respect to the lamp is given in integrated form as the horizontal candela-seconds. Thus, let HCPS represent the output of a point source (small lamp). The input is calculated from the energy storage equation, where

$$W = \frac{CE^2}{2} \quad \text{watt-sec}$$

C = capacitance (farads) of the capacitor that discharges into the lamp

E = voltage before discharge

The efficiency (or efficacy) n = HCPS/$(CE^2/2)$ (horizontal candelas per watt). Efficiency n (or efficacy) is then the ratio of these two values. The units will be candelas per watt since time cancels from the relationship. Note that the maximum efficiency of the FX-1 flash lamp, about 5 candelas per watt, compares favorably with the most efficient light producers known.

A word of caution should be injected here about electrolytic capacitors which, although they have the marvelous ability to store a large quantity of energy per pound (and per dollar) compared to other types of capacitors, also have several serious defects. One is the internal series resistance which is associated with the capacitor. This is called the ESR resistance where ESR stands for "Effective Series Resistance." Therefore, the peak current, in brief-duration flashes,

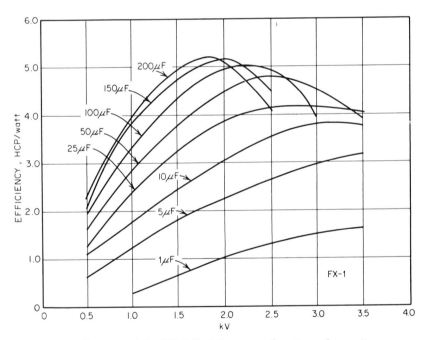

Fig. 2-19 *Efficiency of the FX-1 flash lamp as a function of capacitance voltage.*

may cause considerable loss of energy in the capacitor. In other words, the flash lamp will not receive the entire amount of stored energy from the capacitor, depending upon the relative effective resistance of the flash lamp and that of the capacitor. A second defect of the electrolytic capacitor is the leakage current which depends upon temperature and other factors. This current is serious for applications in which long sustained operation from batteries is desired. A third defect is that the capacitor becomes ineffective when cold since the electrolyte freezes. In spite of these problems, the electrolytic capacitor is widely used in electronic flash applications because of favorable size, weight, and cost factors.

Shapes and Forms of Flash Lamps

The straight tubular flash lamps (Fig. 2-3) are not convenient for many applications. Therefore, a large variety of lamps have been developed for special purposes. At this date there are still new requirements that need to be met. Studio photography requires control of the light by reflectors so that the photographer can achieve the desired results. A tungsten lamp is required at the same place as the flash so that the lighting can be evaluated and adjusted. This tungsten lamp is called a modeling lamp. Around it is spiraled or looped the xenon flash lamp. Several of these are to be seen in the lamp illustrations that are shown.

The first Kodatron xenon flash lamp for studio photography had a built in tungsten lamp, which proved to be unsatisfactory since the tungsten lamp had a very short life compared to that of the xenon lamp. Then a new design made it possible to replace the tungsten lamp after it had burned out. There was some trouble due to the heat of the tungsten lamp affecting the starting of the xenon lamp. A hot xenon lamp may misfire!

One type of lamp is still to be perfected, a point source of light. At one time the open gap (GE FT-230) was thought to be the answer. Actually, the discharge in this lamp opens up into a ball of light which increases in size when more energy is used. Constricted lamps, such as the FX-12, are unsatisfactory since they blow up when the energy becomes too great! The problem of an intense source of light of small dimensions has been discussed at length by Vanyukov and Mak [13].

The pictures of lamps that accompany this chapter show some of the interesting and unusual shapes that have been made. There will be many more special flash lamps designed in the future.

Design of Flash Lamps by Comparison

The performance of a new flash lamp or a proposed flash lamp can be predicted approximately from data taken experimentally on a similar flash lamp by the following procedure. Two rules can be followed:

1. *The initial voltage gradient of the flash lamps is the same.* In other words, the initial lamp voltage divided by the length between electrodes is the same in both lamps. The gas pressure* is assumed to be the same in both lamps.

2. *The energy per unit volume of the flash lamps is the same in the two lamps.* The electrodes are at the ends of the lamp so that the volume of gas is excited electrically.

These two criteria result when the effects of the gradient and the energy are the same on individual xenon molecules in the two lamps. Wall effects and electrode effects are ignored in these calculations. In some cases, for example very short lamps of large diameter, the results of using the theory presented here will be far from the actual performance. From the first rule the following can be written:

$$\frac{V_1}{l_1} = \frac{V_2}{l_2} = \frac{V_3}{l_3} = \frac{V_n}{l_n} \qquad \text{(rule No. 1)}$$

where V_1 is the voltage initially across lamp No. 1 and l_1 is the length between the electrodes. Subscripts 2, 3, etc., are for other lamps. Similarly, from the second rule regarding energy we obtain

$$\frac{C_1 V_1^2}{l_1 d_1^2} = \frac{C_2 V_2^2}{l_2 d_2^2} = \frac{C_3 V_3^2}{l_3 d_3^2} = \frac{C_n V_n^2}{l_n d_n^2} \qquad \text{(rule No. 2)}$$

where C is the capacitance and d is the inside diameter. The above relationships are meaningless if the spark is below the minimum sparking voltage or if the energy is insufficient† to "effectively fill" the lamp with plasma over the entire cross-sectional area.

*Perhaps the voltage per mean free path would be a more universal criterion if lamps having different pressures are compared.

†The minimum condition for the plasma to effectively fill the FX-1 flash lamp is about 15 μF at 2,000 volts. The length of the FX-1 arc is 15 cm, and the inside diameter is 0.4 cm. The energy is 30 watt-sec in about 2 cm^3 giving the minimum energy density of about 15 watt-sec per cm^3.

Consider the EG&G FX-1 as a standard flash lamp whose characteristics are to be measured completely. Then these characteristics will be extrapolated to the new unknown flash lamp by the use of the above rules. As an example, suppose that one wishes a flash lamp of 45-cm length and 0.4-cm inside diameter. The length is

Table 2-2

Quantity	Standard lamp No. 1, FX-1 l_1 = 15 cm (6 in.) d_1 = 0.4 cm ID	Factor Expression	Value	Lamp No. 2, FX-1 type, 3X longer l_2 = 45 cm d_2 = 0.4 cm
Voltage	2,000 volts	$\dfrac{l_2}{l_1}$	3	6,000 volts
Capacitance	100 μF	$\dfrac{l_1 d_2^{\,2}}{l_2 d_1^{\,2}}$	1/3	33 μF
Energy	200 watt-sec	$\dfrac{l_2 d_2^{\,2}}{l_1 d_1^{\,2}}$	3	600 watt-sec
Peak candela	8×10^6 CP	$\dfrac{l_2 d_2^{\,2}}{l_1 d_1^{\,2}}$	3	24×10^6 CP
HCPS	1,000 CPS	$\dfrac{l_2 d_2^{\,2}}{l_1 d_1^{\,2}}$	3	3,000 CPS
Efficiency	5 CP per watt	$\times 1$	1	5 CP per watt
Peak current	1,000 amp	$\dfrac{d_2^{\,2}}{d_1^{\,2}}$ (area ratio)	1	1,000 amp
Lamp resistance	2 ohms	$\dfrac{l_2 d_1^{\,2}}{l_1 d_2^{\,2}}$	3	6 ohms
Duration	120 μsec	$\times 1$	1	120 μsec

Table 2-3

Quantity	Lamp No. 1 l_1 = 15 cm d_1 = 0.4 cm	Factor from lamp No. 1	Lamp No. 3 l_3 = 15 cm d_3 = 0.8 cm
Voltage	2,000 volts	1	2,000 volts
Capacitance	100 μF	4	400 μF
Energy	200 watt-sec	4	800 watt-sec
Peak CP	8×10^6 CP	4	32×10^6 CP
HCPS	1,000 CPS	4	4,000 CPS
Efficiency	5 CP per watt	1	5 CP per watt
Peak current	1,000 amp	4	4,000 amp
Resistance	1.6 ohms	¼	0.4 ohms
Duration	120 μsec	1	120 μsec

exactly three times longer than the length of the FX-1 (15 cm), but the inside diameter is the same. From rule No. 1, the voltage of the new lamp will be three times that of the FX-1 at the comparison point on the data curve. Likewise, the capacitance across the new lamp will be one-third that of the FX-1 as computed from rule No. 2. Now take 2,000 volts and 100 μF as the standard load for the FX-1 and tabulate the performance of the new 3X length FX-1 using the two rules. (Table 2-2.)

The above "factor" multiplied by the quantity in question for the FX-1 gives the same quantity for the new tube. In the above example, tube No. 2 is three times longer than the FX-1 (tube No. 1).

As another example consider a lamp of the same length of the FX-1 but with an inside diameter twice as large. (Table 2-3.)

Optimum Design of a 37.5-watt-sec Flash Lamp

Eckhardt [16] considers the design of a 37.5-watt-sec (500 volts, 300 μF) xenon flash lamp for portable electronic flash equipment. He presents the output (lumen-seconds) of a series of flash lamps as a function of gas pressure, length of arc, inside diameter of the flash lamp, starting conditions, and series circuit resistance.

Figure 2-20 is reproduced from Eckhardt's Fig. 3. After discussing the lamp resistance, the spectral output, and color temperature, the energy for the starting pulse, the electrode resistance R_e, the capacitor, and circuit resistance R_v, Eckhardt concludes that the optimum lamp design should have the following values:

Optimal design values for 350 volts (starting)

If $R_e + R_v = 0.45$ ohms, then
 $d = 3$mm
 $l = 50$ mm, length of arc
 $p = 450$ torr (45 cm Hg)
 $Q = 1,300$ lm-sec
If $R_e + R_v = 0.25$ ohm, then
 $d = 3$ mm
 $l = 30$ mm
 $p = 700$ torr
 $Q = 1,475$ lm-sec

Eckhardt then gives a comparison of calculated and experimental optimal values for circuits with a greater resistance than 0.5 ohms, which result in a longer lamp with a lower pressure.

	Measured	Calculated
Length (optimal)	70 mm	75 mm
Q_{max}	930 lm-sec	960 lm-sec

It will be noted that most portable flash equipment in the 37.5-watt-sec size has a flash lamp of about this size and dimension. Refer to [16] for further information.

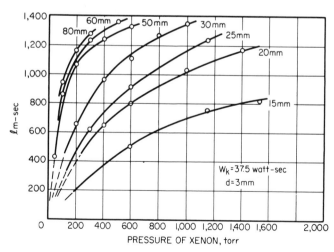

Fig. 2-20 *Curves of the lumen-second output of 3-mm ID xenon flash lamps as a function of pressure and length for 37.5 watt-sec.* (From Eckhardt, p. 3, fig. 3.)

Characteristics of a Large Xenon Flash Lamp, FT-617

The General Electric FT-617 (4½-turn quartz spiral) and the FT-617A (5½-turn quartz spiral) were developed for use in large light-producing systems for night aerial photography [17]. The FT-617 lamp is used in large studio flash equipment where special optical effects are required and will be described in Chap. 6.

Figure 2-21 shows the current, voltage, and light output as a function of time for capacitors of 96, 573, 1,125, and 3,265 μF charged to 4,000 volts. The horizontal candela is about one-tenth of the output in lumens.

Characteristics of a Small Xenon Flash Lamp, FX-12

A small bright flash lamp [18] is often desired in application work with optical arrangements, such as shadow photography or schlieren photography. One such lamp is the quartz capillary lamp FX-12 (EG&G, Inc.) with an inner diameter of 1.2 mm and a 6.35-mm length which holds the arc in a line shape particularly useful for optical systems involving a knife edge, such as schlieren.

There is always a temptation to overload the FX-12. To do so is disastrous since the walls melt and erode, the electrodes melt, and the tube may be split wide open. If a full load on the FX-1 is considered to be 200 watt-sec at 2 kV, then the full load for the FX-12 should be about 0.072 watt-sec as calculated from the volumes of the two lamps. At 500 volts the capacity for this load is about 0.5 μF.

The FX-12 flash lamp has pure tungsten electrodes of about 1 mm diameter inserted into a tightly fitted quartz tube. The tungsten from the electrodes may darken the walls of the light-emitting section when the load is light. It was found that the darkening could be cleaned by operating the lamp a few times at high energy. The tungsten and some of the quartz wall are thereby evaporated and blown into the electrode-quartz wall by the expanding gas from the discharge. Care must be exercised since a too vigorous discharge will split the lamp along the axis.

The gas pressure in the FX-12 is about an atmosphere of xenon. Figure 2-22 shows the influence of the pressure on the arc starting condition for an average spark arrangement. Note that the self-flash voltage and the minimum starting voltage both increase with

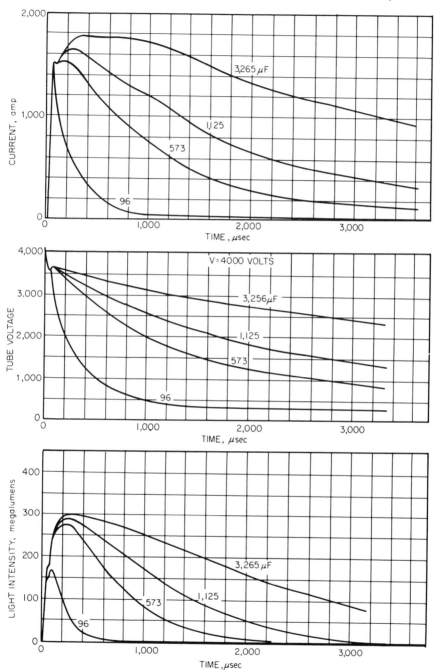

Fig. 2-21 *Current voltage and light output of the GE FT-617 flash lamp as a function of time. Voltage = 4,000 volts.*

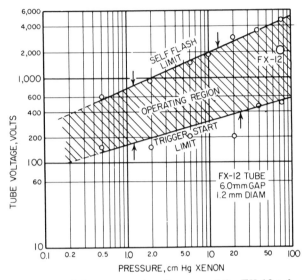

Fig. 2-22 *Voltage-operation diagram of the FX-12 tube as a function of xenon gas pressure.*

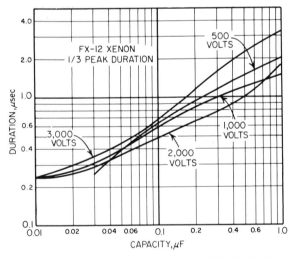

Fig. 2-23 *Flash duration data for the FX-12 flashtube as a function of capacity and voltage.*

pressure. Flash duration of the FX-12 at several voltages as a function of capacity is shown in Fig. 2-23. Figure 2-24 gives the peak horizontal candela, Fig. 2-25 the efficiency, and Fig. 2-26 the horizontal candela-seconds (HCPS) per square centimeter.

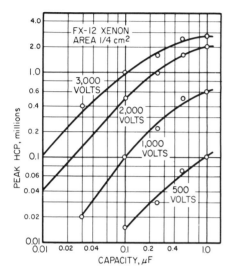

Fig. 2-24 *Peak candela ouput of the FX-12 flashtube as a function of capacity and voltage.*

Lamp Cooling Methods

The power input of a flash lamp can be estimated by the following equation:

$$\text{Power input} = \frac{CE^2}{2} f \quad \text{watts}$$

where C = capacitance in farads

E = voltage to which the capacitor is charged

f = the frequency of operation

A flash lamp can be operated intermittently at a very high overload since the thermal inertia of the lamp will prevent damage. However, a long sustained or continuous load may overheat the lamp walls, the electrodes, or the lead-in seals.

Experience ([10, p. 35]) indicates that a lamp by free convection air circulation is limited to a load of about 5 watts per cm². Other methods of dissipating the heat are listed below.

1. Convection air cooling permits a load of about 5 watts per cm².

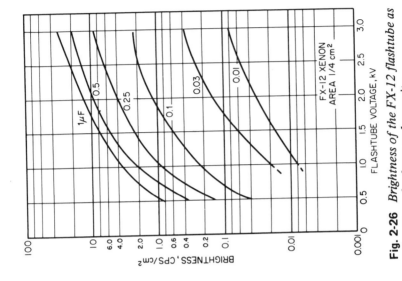

Fig. 2-26 *Brightness of the FX-12 flashtube as a function of voltage and capacity.*

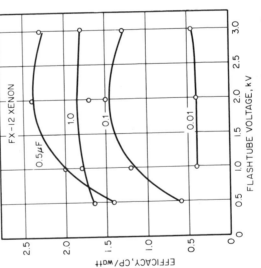

Fig. 2-25 *Flashtube efficacy as a function of voltage and capacity.*

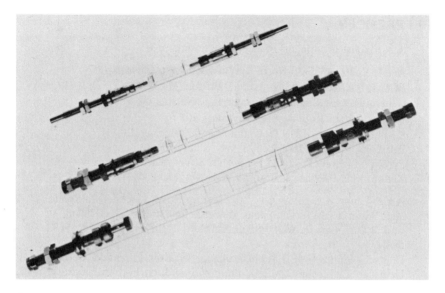

Fig. 2-27 *Linear water-cooled xenon flash lamps. From top to bottom: FX74C-1.5 rated 100 watt-sec at 0.35 msec flash duration, long-term average power rating of 500 watts. FX62C-3.0 rated 600 watt-sec at 1.0 msec flash duration, long-term average power rating of 4,000 watts.*

 2. Forced air cooling permits a load of about 40 watts per cm².
 3. Liquid cooling permits a load of about 300 watts per cm².

Apparently the best transparent heat conducting fluid known is distilled water. Many other types of liquids have been tried, such as oil, which becomes colored gradually by the action of the intense radiation. Hydrogen gas as a cooling medium has excellent properties but is seldom used because of the explosion hazard.

Figure 2-27 shows three water-cooled flash lamps which were designed for high-power laser equipment. The copper electrode supports serve as the inlet and outlet for water. The design shown in Fig. 2-27 incorporates a reusable water jacket since the assembly relies on rubber O rings for a seal. The lamp can be disassembled for cleaning and for installing a replacement lamp. The flash lamp in a reflecting cavity cannot under some conditions be started by an external trigger wire since the trigger wire may vaporize or become excessively hot. However, a water-cooled trigger bar can be considered, and series triggering circuits are an excellent solution since the trigger wire can be eliminated.

REFERENCES

1. A partial list of suppliers of electronic flash lamps:

 Amglo Corp., 4325-33 North Ravenswood Ave., Chicago, Ill.
 EG&G, Inc., 160 Bookline Avenue, Boston, Mass.
 General Electric Company, Nela Park, Cleveland, Ohio
 I.I.I., 610 Vaquerous Ave., Sunnyvale, Calif.
 Kemlite Lab. Inc., 1819 W. Grand Avenue, Chicago, Ill.
 Pek Labs, Inc., 825 East Evelyn Ave., Sunnyvale, Calif.
 Sylvania Lighting Products, 60 Boston Street, Salem, Mass.
 Xenon, Inc., 10 Wheeler Court, Watertown, Mass.

 A.E.I. Lamps & Lighting Co., Ltd., Melton Road, Leicester, England
 Max Braun, Frankfurt am Main, Russelsheimerstrasse 22, Germany
 Carl Braun, Camera-Werk, 8500 Nurnburg, Muggenhoferstrasse 122, Germany
 Deutsche Philips GMBH Subbelratherstr. 17, Koln-Ehrenfeld, Germany
 Deutsche Elektronic GMBH., Berlin-Wilmerdorf, Forckenbecstrasse 9-13, Germany
 Elmed GMBH, Essen, Herkulesstrasse 3/5, Germany
 Elomag SPRL, 2 Ave. Wellington, Bruxelles 18. Belgium
 R & E. Hopt Kg., Hamburg-Lemsahl, Kihredder 61, Germany
 Impulsphysik GMBH, 2 Hamburg 56, 400 Sulldorfer Landstrasse, Germany
 Walter Jacob, Vakuumtechnik, 5 Koln-Ehrenfeld, Philipstrasse 25-27, Germany
 Kako International Corp., No.4, 3 Chome Kanda, Kajicho Chiyodaku, Tokyo, Japan
 Kako Products, Inc., 5733 Oh-I Itocho, Shinagawaku, Tokyo, Japan
 Dr.-Ing. D. A. Mannesmann, MBH, 505 Porz-Westhoven, Oberstrasse 59, Germany
 Metz Apparatewerke, 8510 Fuerth-Bavaria, Germany
 Paffrath & Kemper, 5 Cologne-Lindenthal 1, Weyertal 59, Germany
 Physikalisch-Technische Werkstätten, Am Kohlheck-Gehrnerweg 15, Wiesbaden-Dotzheim, Germany
 Osram, Windenmacherstrasse 6, München 2, Germany
 Regula-Werk King Kg., 7267 Bad Liebenzell, Schwarzwald, Germany
 Loewe-Opta, Aktiengesellschaft, Berlin, Germany

2. Murphy, P. M., and H. E. Edgerton, Electrical Characteristics of Stroboscopic Flash Lamps, *J. Appl. Phys.*, vol. 12, no. 12, pp. 848-855, December, 1941.
3. Marshak, I. S., Some Physical and Technical Aspects of Gas Discharges in Flash Tubes, in R. B. Collins (ed.), *Proc. 3rd Intern. Congr. High Speed Phot.*, pp. 30-41, Academic Press, New York, 1957.
4. Marshak, I. S.; Limiting Parameters and Generalized Characteristics of Xenon Lamps, *Appl. Opt.*, vol. 2, p. 793, August, 1963.
5. Marshak, I. S., "Electronic Flash" (in Russian), Moscow, 1963. (A

comprehensive book on the subject of flash lamps and their uses, with many references.)

6. Edgerton, H. E., Applications of Xenon Flash, in O. Helwich (ed.), *Proc. 7th Intern. Congr. High Speed Phot.* (Zürich, Switzerland), pp. 3-16, Verlag Dr. Othmar Helwich, Darmstadt, Germany, 1967.

7. LeCompte, G., and H. E. Edgerton, Xenon Arc Transients, Electrical and Optical, *J. Appl. Phys.*, vol. 27, no. 12, pp. 1427-1430, December, 1965.

8. Ackerman, S., A Programmed Kerr-cell High Speed Framing Camera, *SPSE News*, vol. 7, no. 4, pp. 8-11, July/August, 1964.

9. Goncz, J. C., Resistivity of Xenon Plasma, *J. Appl. Phys.*, vol. 36, no. 3, pt. I, pp. 742-743, March, 1965.

10. Goncz, J. C., New Developments in Electronic Flashtubes, *ISA Trans.*, vol. 5, no. 1, pp. 28-36, January, 1966.

11. Edgerton, H. E., J. C. Goncz, and P. W. Jameson, Xenon Flash Lamps Limits of Operation, in DeGraaf and P. Tegelaar (eds.), pp. 143-151, *Proc. 6th Intern. Congr. High Speed Phot.*, H. D. Tjeenk Willink & Zoon, N. V., Haarlem, The Netherlands, 1963.

12. Carlson, F. E., Flashtubes—A Potential Illuminant for Motion Picture Photography?, *J. SMPTE*, vol. 48, no. 5, pp. 395-406, 1947.

13. Vanyukov, M. P., and A. A. Mak, High Intensity Pulsed Light Sources, *Usp. Fiz. Nauk*, pp. 137-155, 1958.

14. LaPorte, M., "Les lampes à éclairs lumiére blanche," Gauthier-Villars, Paris, 1949.

15. Glaser, G., Zur Lichtemission stromstarker Funktenentladungen, *Optik*, vol. 7, pp. 33-53, 1950.

16. Eckhardt, K., "Über die elektrischen und optischen Eigenschaften von Xenon-Funkenentladungen zur Lichterzeugung," *Lichttechnik*, vol. 17, no. 6, pp. 70A-76A, 1965.

17. Edgerton, H. E., and B. F. Logan, Jr., Characteristics of a Flashtube for Aerial Night Reconnaissance, *Phot. Eng.*, vol. 6, no. 2, pp. 110-115, 1955.

18. Edgerton, H. E., and P. Y. Cathou, Xenon Flash Tube of Small Size, *Rev. Sci. Instr.*, vol. 27, no. 10, pp. 821-825, October, 1956.

19. "Flashtube Data Manual," General Electric Company, Nela Park, Cleveland, Ohio.

20. Edgerton, H. E., and J. R. Killian, Jr., "Flash, Seeing the Unseen," 2d ed., Charles T. Branford Co., Newton Centre, Mass., 1954.

21. Buck, A., R. Erickson, and F. S. Barnes, Design and Operation of Xenon Flashtubes, *J. Appl. Phys.*, vol. 34, no. 7, p. 2115, July, 1963.

22. Buck, A., R. Erickson, and F. S. Barnes, An Investigation of Confined Arc Discharges in Xenon, *Proc. 3d Intern. Conf. Quantum Electron.*, Columbia University Press, New York.

23. Rosolowski, J. H., and R. J. Charles, Wall Deterioration in Flash Lamps, *J. Appl. Phys.*, vol. 36, p. 1792, May, 1965.

24. Emmett, J. L., A. L. Schawlow, and E. H. Weinberg, Direct Measurement of Xenon Flashtube Opacity, *J. Appl. Phys.*, vol. 35, p. 2601, September, 1964.

3 SPECTRAL OUTPUT OF FLASH LAMPS

Spectral Output of Xenon Lamps

The spectral distribution of energy of radiation from a gas-filled electronic flash lamp or from a spark gap that has been excited from a capacitor discharge has received considerable attention for years. One of the most complete experimental studies of many types of high-pressure gases under short gap conditions was published by Glaser [1] in 1950. Tables 3-1 and 3-2 show Glaser's data, as translated in [2].

A recent paper by Goncz and Newell [3] discusses the spectral output and efficiency of xenon discharge and continuously burning xenon lamps over the wavelength range of 0.35 to 1.1 μm. A spectroradiometer (EG&G model 580/585) was used to measure the incident radiation from the entire source at a distance that is large compared to the lamp (greater than 10X), The radiation detector was a planar vacuum photodiode (with type S-1 photoelectric surface) which subtended the entire exit beam from a B&L Monochromator. The output current was measured directly for the continuous sources

Table 3-1 Optical Results Achieved with Various Gases at Different Discharge Parameters in High-pressure Spark Gaps

Gas	Gas pressure p, atm	Electrode distance d, mm	$p \times d$, atm × mm	Voltage V, kV	Capacitance C, μF	$\frac{1}{2} CV^2$, watt-sec	Inductance, μH $L = Li + La$	Yield $\eta = \frac{M_{\lambda 1}^{\lambda 2}}{\frac{1}{2} CV^2}$ in % between 250–300 nm	300–380 nm	380–520 nm	520–760 nm	760–900 nm	Σ
Ar	11	5.6	62	10	0.1	5	0.1	1.26	1.44	1.99	1.80	1.79	8.28
Ar	11	9.5	105	14	0.1	10	0.1	1.54	1.72	2.22	2.05	0.35	8.48
Ar	11	2.72	29	6	0.1	1.8	0.1	0.88	1.23	1.64	1.59	0.71	6.05
Ar	11	2.3	25	10	0.1	5	0.1	0.98	1.21	1.31	1.07	0.51	5.08
Ar	7.2	3.6	26	10	0.1	5	0.1	0.73	1.18	1.40	1.18	0.60	5.09
Ar	4.0	6.5	26	10	0.1	5	0.1	0.61	1.09	1.61	1.82	0.93	6.06
Ar	1.5	14	21	10	0.1	5	0.1	0.50	1.22	1.85	2.06	1.10	6.73
Ar	10.7	5.8	62	10	0.1	5	2.97	0.50	0.92	1.40	1.53	0.85	5.20
Ar	10.7	5.8	62	10	0.1	5	27.9	0.32	0.52	0.91	1.21	0.81	3.77
Ar	10.7	5.8	62	10	0.1	5	263	0.23	0.29	0.53	0.93	0.82	2.80
Xe	13	6	78	10	0.1	5	0.1	2.28	2.06	2.50	2.77	0.56	10.17
Kr	14	3.2	45	10	0.2	10	0.1	2.08	1.58	1.95	1.81	0.70	8.12
H_2	10.3	10	10.3	10	0.1	5	0.1	0.014	0.019	0.048	–	–	0.081
H_2	10.3	10	10.3	10	0.1	5	10	0.021	0.034	0.105	–	–	0.160
H_2	11	0.75	8.4	5	5	62.5	100	0.185	0.075	0.104	0.101	0.021	0.486
N_2	11.6	2.2	26	10	0.1	5	0.1	0.68	0.65	0.61	–	–	1.94
N_2	11.6	3.1	36	14	0.1	10	0.1	1.02	0.92	0.99	–	–	2.93
CO_2	9.8	1.2	11.8	10	0.1	5	0.1	0.36	0.42	0.50	–	–	1.28
	11	1.8	20	14	0.65	65	0.1	0.40	0.32	0.35	0.35	0.12	1.54
Hg	8	5	40	10	0.2	10	0.1	0.20	1.07	1.08	1.08	0.16	3.59

Table 3-2 Spark Width, Radiation Density, and Light Density (for Various Gases at Different Discharge Parameters in High-pressure Spark Gaps according to Glaser)

Measure No.	Gas	Gas pressure p, atm	Electrode distance d, mm	pd, atm × mm	Voltage V, kV	Capacitance C, μF	Outer self-inductance La, μH	Oscillation time T, μsec	Radiation, quantity per solid angle 250–900 nm, 10^{-2} watt-sec per (solid angle)2	Light quantity per solid angle, CPS
209	Ar	11	7	77	10	0.1	0	1.2	5.5	5.2
212	Ar	11	14	154	10	0.1	0	1.2	7.9	7.6
215	Ar	11	7	77	10	0.1	1.0	2.3	5.2	5.4
226	Ar	11	7	77	10	0.1	9.1	6.1	3.7	3.3
228	Ar	11	14	154	14	0.1	0	1.2	8.9	7.9
231	Ar	11	14	154	14	0.1	2.8	3.5	7.9	8.1
235	Ar	11	1.8	20	6	0.1	0	1.2	1.0	0.87
237	Ar	11	1.8	20	6	0.1	2.8	3.5	0.68	0.65
255	Ar	11	14	154	14	0.65	0	3.2	39.5	34.2
259	Ar	11	14	154	14	0.65	2.8	9.1	34.7	36.4
238	Ar	4	19	77	10	0.1	0	1.2	7.6	7.8
244	Ar	4	19	77	10	0.1	2.8	3.5	5.2	4.8
251	Ar	11	1.2	13	5	2	0	5.3	3.8	3.3
250	Ar	4	3.2	13	5	2	0	5.3	5.7	6.6
271	H$_2$	4	3.8	15	14	0.65	0	3.2	0.37	0.29
276	H$_2$	4	3.8	15	14	0.65	9.1	15.6	1.28	1.56
280	CO$_2$	4	2.5	10	10	0.1	0	1.2	0.45	0.46
282	CO$_2$	4	2.5	10	10	0.1	2.8	3.5	0.28	0.23
283	N$_2$	4	2.5	10	10	0.1	0	1.2	0.28	0.24
285	N$_2$	4	2.5	10	10	0.1	2.8	3.5	0.19	0.20

Measure No.	Total radiation quantity, watt-sec	Electric energy $\frac{1}{2}CV^2$ watt-sec	Optical effectiveness, %	Max. spark width, mm	Max. spark width computed mm	Max. spark area, cm²	(Spark duration $1/b$)/(oscillating damping T)	Adaption, $1/b \times T$	Max. radiation density S_{max}, 10^5 watt/steradian	Max radiation density S_{max}, 10^7 stilb	Computed radiation density S_{max}, 10^5 watt/steradian
209	0.52	5	10.4	3.6	3.4	0.25	0.35	0.62	3.5	3.3	6.1
212	0.75	5	14.9	3.0	2.8	0.42	0.38	0.55	3.2	3.0	5.3
215	0.49	5	9.8	3.3	3.1	0.23	0.30	0.40	1.8	1.9	4.2
226	0.35	5	7.1	3.0	2.3	0.21	0.25	0.30	0.75	0.67	1.5
228	0.84	10	8.4	3.6	2.9	0.51	0.35	0.64	2.6	2.3	5.7
231	0.75	10	7.5	3.3	2.5	0.46	0.28	0.48	1.1	1.1	2.7
235	0.094	1.8	5.2	2.3	2.8	0.042	0.30	0.48	4.1	3.6	5.1
237	0.064	1.8	3.5	1.65	2.1	0.030	0.25	0.35	2.0	1.9	2.1
255	3.7	63.5	4.7	7.5	6.2	1.05	0.35	0.75	1.63	1.4	6.0
259	3.3	63.5	5.0	7.5	5.1	1.05	0.30	0.50	1.03	1.1	2.2
238	0.72	5	14.4	3.3	3.7	0.62	0.30	0.42	4.0	4.0	2.9
244	0.49	5	9.9	3.0	2.6	0.57	0.25	0.30	1.0	0.92	1.2
251	0.36	25	1.4	4.3	6.7	0.052	0.25	0.30	4.7	4.0	3.6
250	6.54	25	2.1	5.0	7.5	0.16	0.25	0.30	2.4	2.7	1.8
271	0.035	63.5	0.055	11	1.4	0.41	0.25	0.22	0.125	0.097	0.9
276	0.12	63.5	0.19	12	2.4	0.45	0.25	—	0.013	0.016	0.35
280	0.042	5	0.84	2.6	2.7	0.06	0.25	0.30	2.0	2.1	1.7
282	0.027	5	0.53	3.0	1.8	0.075	0.25	0.25	0.54	0.44	0.73
283	0.026	5	0.52	2.6	2.0	0.065	0.25	0.30	1.27	1.1	1.4
285	0.018	5	0.36	2.6	1.4	0.065	0.25	ca.0.25	0.24	0.26	0.62

and integrated by a capacitor over the entire flash duration for the flash lamps. The spectroradiometer was calibrated with continuous radiation from an NBS standard lamp (GE T4Q/1cL, 300-watt iodine quartz). The overall accuracy is about 8 percent, including the drift in the phototube sensitivity.

The data on four diversified types of xenon lamps are presented [3] as a ratio of total watts output from the entire lamp in a wavelength band of a nanometer to the total watts input. For the flash lamps the watt-second ratio as integrated over the entire flash duration is measured. The following lamps were studied and the spectral output presented:

Figure 3-1. Spectral energy distribution from a continuous xenon lamp (EG&G, Inc. experimental tube, similar to XFX-62A) 1.7 atm,

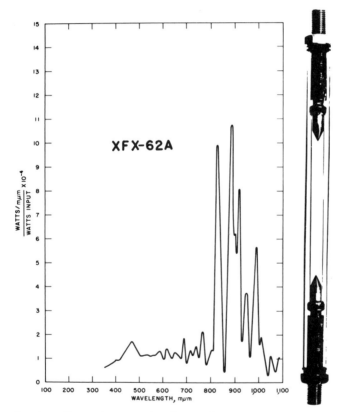

Fig. 3-1 *Spectral energy distribution from a continuous xenon lamp (EG&G, Inc. experimental tube, similar to XFX-62A) 1.7 atm, 37 amp/cm², 3.8-cm arc length, 1.1-cm bore.*

37 amp per cm^2, 3.8-cm arc length, 1.1-cm bore. Notice the strong radiation in the infrared portion of the spectrum from 800 to 1,000 nm.

Figure 3-2. Spectral energy distribution from a flash lamp (EG&G Inc. type FX-76) strobotac unconfined arc (0.8-cm gap) with 0.71 atm xenon and 0.12 atm hydrogen excited from 10 μF at 1 kV, 2,500 amp peak current. Observe the greatly increased efficiency in the visual and ultraviolet portions of the spectral output as compared to the low current-density continuous current lamp of Fig. 3-1.

Figure 3-3. Spectral energy distribution from a flash lamp (EG&G, Inc. type FX-79) helical (15.2-cm gap, 0.4-cm bore) 0.26 atm xenon, 2,870 amp per cm^2 peak current from a 1,125 μF electrolytic capacitor at 900 volts.

Figure 3-4. Spectral energy distribution from a flash lamp (EG&G, Inc. type FX-47A) straight laser stimulator 16.5-cm arc length, 1.3-cm bore, 0.4 atm xenon gas. The lamp was excited from square current pulses formed by two section pulse-forming networks for 1,700 amp per cm^2 and 5,300 amp per cm^2 from 1,000-joule and 5,000-joule storage capacitors. Observe that the infrared output of the highest-current-density lamp is reduced, probably due to self-absorption of the radiation by the heated xenon gas.

The following data [3] were integrated from the spectral distribution curves.

Lamp	Spectral efficiency, percent					Color temperature °K
	Wavelength range				Total range	
	0.35-0.5 μm	0.5-0.7 μm	0.7-0.9 μm	0.9-1.1 μm	0.35-1.1 μm	
Experimental dc lamp 37 amp per cm^2	1.7	2.4	7.0	4.6	15.7	5,200
XFX-62A dc 91 amp per cm^2	–	–	–	–	29.2	5,000
FX-76 2,500 amp peak	2.7	1.5	1.1	0.7	6.0	40,000
FX-79 2,870 amp per cm^2 peak	11.5	12.8	13.1	10.7	48.1	7,100
FX-47A 1,700 amp per cm^2	18.4	18.4	16.3	11.5	64.6	7,000
FX-47A 5,300 amp per cm^2	27.3	20.2	11.2	6.1	64.8	9,400

Further spectral information on the FX-47A has been given with current density values up to 23,000 amp per cm^2 [4]. Figure 3-5 is a

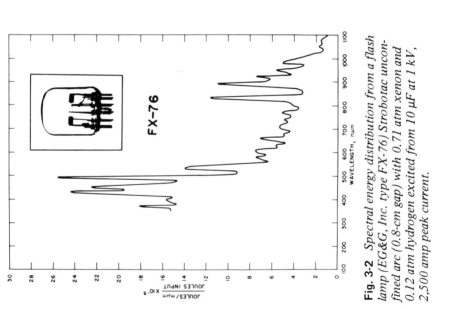

Fig. 3-3 *Spectral energy distribution from a flash lamp (EG&G, Inc. type FX-79) helical (15.2-cm gap, 0.4-cm bore) 0.26 atm xenon, 2,870 amp/cm² peak current from 1,125-μF electrolytic capacitor at 900 volts.*

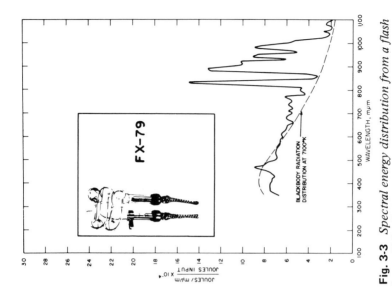

Fig. 3-2 *Spectral energy distribution from a flash lamp (EG&G, Inc. type FX-76) Strobotac unconfined arc (0.8-cm gap) with 0.71 atm xenon and 0.12 atm hydrogen excited from 10 μF at 1 kV, 2,500 amp peak current.*

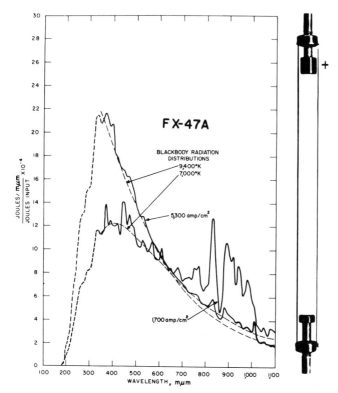

Fig. 3-4 *Spectral energy distribution from a flash lamp (EG&G, Inc. type FX-47A) straight laser stimulator 16.5-cm arc length, 1.3-cm bore, 0.4 atm xenon gas. Square current pulse from two section pulse forming networks for 1,700 amp/cm² and 5,300 amp/cm² from 1,000-joule and 5,000-joule storage capacitors.*

copy of [4, Fig. 4]. It is observed that the blue light is almost a linear function of the peak current whereas the green light tends to level off at a current of about 22,000 amp per cm². The infrared emission decreases for the high current-density condition.

These experiments show that the efficiency of a xenon lamp is greater with high current density and the continuum masks the line structure. Efficiencies up to about 65 percent have been obtained from flash lamps over the 0.35- to 1.1-μm range [3].

Spectral Output of Rare Gas Flash Lamps

Two questions often asked are why rare gases other than xenon are not used as light sources and why an appropriate mixture of neon

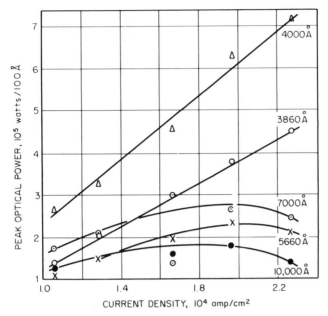

Fig. 3-5 *Peak spectral optical power as a function of the peak current density in a FX-47A flash lamp.*

(red) and argon (blue) cannot be made to obtain a blend of colors to match any desired spectral distribution? The complete answers to these and associated questions are not known, but a few guidelines have been found and are given below.

First, a mixture of neon and argon will give mostly an argon spectrum since the ionization potential of argon is 15.69 volts compared to 21.47 for neon. Thus, the argon gas becomes ionized first. Possibly under extreme excitation conditions, the neon will become more involved in the light-producing mechanism. Thus, for mixtures of gases, the gas with the lowest ionization potential will be the most important factor in the transformation of energy into light. The physics of this mixture problem as a function of partial pressure of each gas plus the electrical excitation conditions needs a thorough and comprehensive experimental study. In fact, this last conclusion also applies to the study of all the individual gases by themselves. This should make an area of research that may have important conclusions and applications.

Figure 3-6 is a collection of spectral distributions as recorded on Panchromatic film with a step density filter. A Cenco grating

spectrograph was used to disperse the light according to the wavelength scale indicated on the bottom of the figure. The top record shows neon gas with strong red lines grouped from 5800 to 6500 Å. There is also a faint continuum centered at 4300 Å.

The second record from the top shows the blue argon spectrum. There are a few strong lines in the blue around 4300 Å with a continuum over the entire spectra.

Krypton gas was used in the third spectrum from the top. This krypton may have been a mixture of krypton and xenon gas since some of the xenon lines are easily identified from the spectra in the fourth and fifth records from the top. In a mixture of this sort the xenon spectrum will be stronger than the krypton since the ionization potential of xenon is less than that for krypton. The xenon ionization potential is 12.08 volts whereas the krypton is 13.94 volts. A small amount of xenon gas will be completely ionized before there is much ionization of the krypton gas.

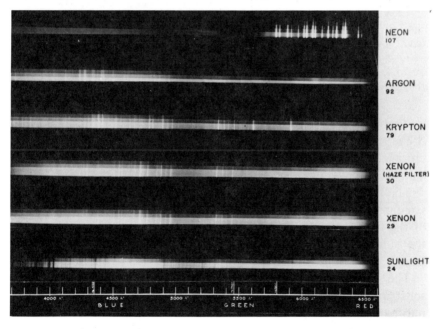

Fig. 3-6 *Grating spectrograms from a flash lamp (51 cm long, 0.8-cm ID) excited by 180 μF at 2,000 volts. A stepped density filter was used in a vertical position. Energy and gas used from top to bottom: No. 107 neon 12.5 cm, No. 92 argon 12 cm, No. 79 krypton 3 cm, No. 30 xenon 5 cm, No. 29 xenon 5 cm, No. 24 sunlight—Noon, Dec. 16, 1941, Boston.*

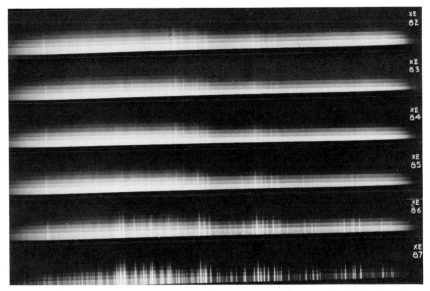

Fig. 3-7 *Grating spectrograms with a vertical stepped density scale to show the xenon spectra under different conditions of gas pressure. Lamp dimension: 51 cm long, 0.8-cm ID, 2,000 volts, capacitance 180 μF. Top to bottom: pressures are 25.4, 10, 6, 3, 1.5, 0.75 cm of mercury. The wavelength scale is the same as Fig. 3-6.*

Xenon gas was used in the fourth and fifth records from the top. A haze filter on the fourth record shows the extent to which the near ultraviolet can be absorbed in an attempt to match distribution of light from daylight.

The bottom record shows the spectrum of direct sunlight with the same instrument and film as used for the study of the spectral output of the flash lamp. Of interest are the absorption lines from the gas in the sun and earth atmosphere. These are the familiar Fraunhofer lines.

The general similarity of the xenon spectra and the sunlight spectrum is evident in this graphical presentation. From a color photographic standpoint and from the above records there is an excess of blue light in the usual xenon lamp. This can be corrected by the use of a filter that absorbs some of the blue light (yellowish filter). The filter should be put on the flash lamp if the flash lamp is to be used in conjunction with daylight illumination.

The xenon spectrum as observed under several different pressure conditions is shown in Fig. 3-7. It is noted that the continuum is strong in the top record (high pressure) and the line spectrum

predominates in the bottom record (low pressure). The spectra from a flash lamp vary during the flash duration. A line spectrum appears first, followed by a strong continuum that masks the lines. Then, at the end of the flash a few strong arc lines are present.

The time-resolved spectrum from a General Electric FT-110 flash lamp, excited from 500 μF of electrolytic capacitors charged to 450 volts, shows many xenon lines for the first 0.25 msec. The very strong continuum of xenon appears in about 0.25 msec. The intensity of the output then decreases during the next 0.25 msec. It is noticed that only a few xenon arc lines are seen during the decay compared to the many spark lines that appear at the first part of the flash. The time-resolved spectrum described above was observed on an instrument designed at the Naval Research Laboratory. I am indebted to them for making the record and giving me the data.

The infrared output of a xenon flash has been measured by Uhl [5]. Absorption of light in the noble gases has been discussed by Harding [6]. The spectrum from a capillary is used as a source by Lee [7]. Many investigations of the spectral output of the xenon lamp were made by LaPorte [8-19] and others.

REFERENCES

1. Glaser, G., Zur Lichtemission stromstarker Funktenentladungen, *Optik*, vol. 7, pp. 33-53, 1950.
2. Früngel, F., "High Speed Pulse Techniques," vol. II, p. 390, Academic Press, Inc., New York, 1965.
3. Goncz, J. C., and P. B. Newell, Spectra of Pulsed and Continuous Xenon Discharges, *J. Opt. Soc. Am.*, vol. 56, no. 1, pp. 87-92, January, 1966.
4. Goncz, J. C., and S. Park, Double Pulsing Boosts Flash Tube Performance, *Microwaves*, April, 1965.
5. Uhl, R. J., Infrared Spectral Output of Xenon Flash Tubes, *M.I.T. Servomechanisms Lab. Rept.* 7668-TM-3, April, 1958.
6. Harding, G. O., Absorption of Light by Electrical Discharges in the Noble Gases, Spring meeting of the Optical Society of America, 1965.
7. Lee, P., Capacitor Discharge through a Capillary Used as a Spectroscopic Source, *J. Opt. Soc. Am.*, vol. 55, no. 7, pp. 783-786, July, 1965.
8. LaPorte, M., Production de lumières blanches ou diversement colorées par luminescence électrique des gaz, Brevet francais No. 800.924 Gr 2. Cl 8, Nov. 21, 1935.
9. LaPorte, M., Durée des éclairs obtenus en déchargeant un condensateur à travers un tube à gaz, *Compt. Rend.*, vol. 201, p. 1108, 1936.

10. LaPorte, M., and R. Pierrejean, Structure des éclairs obtenus en déchargeant un condensateur à travers un tube à gaz, *Compt. Rend.*, vol. 202, p. 645, 1936.

11. Laporte, M., Production de lumière blanche par excitation électrique des gaz, *Compt. Rend.*, vol. 203, p. 321, 1936.

12. LaPorte, M., Production de lumière blanche par excitation électrique du xénon, *Compt. Rend.*, vol. 204, p. 1240, 1937.

13. LaPorte, M., Sur une loi d'émission d'un rayonnement à spectre continu (lumière blanche) par des tubes à xénon, *Compt. Rend.*, vol. 204, p. 1559, 1937.

14. LaPorte, M., and Pierre Corda, Structure fine des éclairs obtenus par décharge d'un condensateur à travers un tube à gaz, *J. Phys.*, vol. 8, p. 232, 1937.

15. LaPorte, M., Production de spectres continus par excitation électrique des gaz rares. Lumière blanche, *J. Phys.*, vol. 9, p. 228, 1938.

16. LaPorte, M., Sur l'auto-absorption du rayonnement continu émis par un tube à xénon excité en lumière blanche, *Compt. Rend.*, vol. 209, p. 95, 1939.

17. LaPorte, M., Etude par spectrophotométrie photographique de la répartition d'énergie dans le spectre continu du xénon, *J. Phys.*, vol. 11, p. 164, 1945.

18. LaPorte, M., R. Legros, and J. Roux, Intensité du rayonnement émis par la décharge d'un condensateur dans des tubes à krypton ou xénon, *Compt. Rend.*, vol. 226, p. 1265, 1948.

19. LaPorte, M., Les lampes à éclairs lumière blanche et leur applications, Gauthier-Villars, Paris, 1949.

4 CIRCUITS FOR ELECTRONIC FLASH EQUIPMENT

Electronic Flash Circuit

The basic circuit of the electronic flash equipment given in Chap. 2 is repeated here, and the electrical details are now discussed. Figure 4-1 shows the elements that must be considered in any design. Besides the all-important flash lamp, the next most important circuit element is the capacitor, shown as C in the circuit diagram. The function of the capacitor is to accumulate electrical energy from the battery, or power source, at a slow rate for a relatively long time and then to discharge the stored energy rapidly as required by the flash lamp. A power flow of megawatts from a charged capacitor into a flash lamp is not uncommon. The electrical capacitor seems to be the only practical device which has this important fast-discharge property.

The electrical energy stored in the capacitor and discharged quickly into the flash lamp is given in *watt-seconds* of energy. Although a flash producing equipment can be rated in watt-seconds,

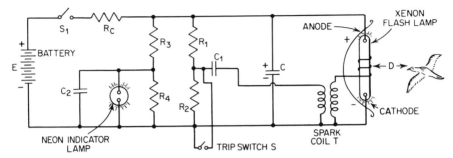

Fig. 4-1 *Elementary circuit of a "direct" triggered flash unit charged from a battery. The synchronizing switch S initiates the flash when closed. A neon lamp is used to indicate when the capacitor has reached a given voltage.*

this is not a true rating of the ability of the equipment for photography or for radiant energy output. The efficiency of the lamp for conversion of electrical energy into radiant energy and the effectiveness of the reflector also influence the output.

In the previous chapter, there was considerable discussion about the discharge of the flash lamp. It will be recalled that the flash lamp, when fully loaded under some conditions, acts somewhat like a resistor. If the flash lamp can be assumed to be a resistor, then the discharge time constant of the current may be calculated as RC seconds, and the discharge time constant of the light (power) as $RC/2$ seconds. For the FX-1 flash lamp at 100 μF and 2,000 volts, the $RC/2$ duration is usually 50 percent too short, probably since the flash lamp requires additional time to develop the full arc and to decay. Furthermore, the one-third peak duration as defined is different from the electrical time constant.

A second time constant of the circuit to consider is the charging time constant $T = R_c C$ which is the product of the capacitance C by the charging resistor R_c. After a brief technical discussion on the capacitor as a circuit element, several types of charging circuits for the capacitor will be considered.

The Capacitor

The electrical capacitor [1] is one of the most important devices in the electric flash photography circuits. The capacitor serves as a storage reservoir for the electrical energy which will subsequently be discharged at a high rate into the lamp for producing a quick flash of light. The weight and cost of some flash units are mainly due to the capacitors. For these and other reasons, the capacitor is a very

important item to consider in the design of flash systems. Figure 4-2 shows typical *paper* and Fig. 4-3 shows *electrolytic* capacitors that are used in electronic flash circuits.

Capacitors consist of metallic plates, or foils, with an insulating material between them called *dielectric*. Paper saturated with oil is commonly used as the dielectric material, while other capacitors use a thin layer of plastic. When a voltage is applied to the capacitor plates, electrical charges flow to the plates; and the dielectric is subjected to an electrostatic field. Electrical energy is required to *charge* the capacitor to a given voltage according to the important relationship below:

Energy stored in a capacitor = $CE^2/2$ watt-sec where

E = voltage across terminals in volts
C = capacitance in farads

The *capacitance* C is a number giving the ability of a capacitor to store electrical charge per volt. A capacitor with a large capacitance will store more energy than one with a smaller capacitance at the same voltage. As will be discussed later, the light output from a flash lamp is a function of the energy from the capacitor and, therefore, can be proportional to the capacitance. By obtaining a suitable capacitor at a given voltage, the amount of light from a flash lamp can be predetermined when the efficiency is known.

The factors [1] that influence the design of a capacitor are briefly discussed below. The capacitance of any capacitor can be calculated from the following equation:

$$C = 0.0884 \times 10^{-6} \frac{KA}{d} \quad \mu F$$

where A = area of the dielectric in square centimeters
d = thickness of the dielectric in centimeters
K = dielectric constant

From this relationship it is observed that a large capacitance requires a large area of a thin dielectric which has a high dielectric constant.

The *thickness* of the dielectric is one of the most important factors to the capacitor manufacturer. If he makes the material thin, he obtains a large capacitance in a given size container. However, the maximum allowable voltage before *electrical breakdown* occurs is reduced. An engineering balance in design must be reached in which the thickness is as small as possible without experiencing an

Fig. 4-2 *Paper capacitors used for electronic flash equipment.*
In general, such capacitors weigh less than capacitors of the same
rating for alternating current applications.

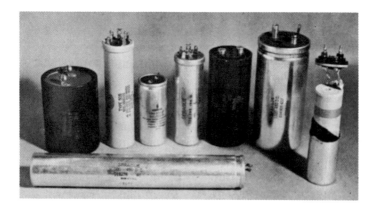

Fig. 4-3 *Typical electrolytic capacitors of the type used in elec-*
tronic flash equipment. Capacitor at right has part of the case
removed to show the internal arrangement.

objectionable number of short-circuited capacitors due to electrical breakdown.

For each capacitor application, the factors that influence the specification are:

1. Voltage stress of the dielectric
2. Capacitance
3. Type of duty cycle
4. Life required
5. Internal series inductance

Capacitors for electronic flash lamp operation are usually highly stressed since the energy per pound is proportional to the square of the voltage. The rating for life may be a function of the time that the capacitor is held at full voltage awaiting a flash. However, if the flash lamp is a *low-resistance* lamp, then the discharge circuit may be oscillatory and the dielectric will be under greater stress than if a *nonoscillatory* discharge is used. Furthermore, the large peak current may cause deformation and even burning at the tabs inside the capacitor at the foil connections.

The Maxwell Company (San Diego, Calif.) gives the following derating data on one of their Mylar plastic film capacitors (No. 5C32MN):

Maximum voltage	5 kV
Capacitance	32 μF
Energy	400 joules
Weight	3.5 lb
Maximum current	40,000 amp
Inductance	10×10^{-9} henry

Dc life data (90 percent reliability) are given below:

Voltage, kV	Life, hr
5.0	2
4.5	6
4.0	20
3.5	70
3.0	200
2.5	1,000
2.0	4,000
1.5	20,000

Capacitors are made of extensive sheets of very thin aluminum foil wound with thin layers of paper or other dielectrics, such as plastic films, and then pressed into a compact form. One important type of capacitor uses very thin metal that is sprayed or evaporated onto the dielectric. Some of these capacitors are self-healing since an electrical breakdown causes the metal to evaporate away from the defect. These are called MP, meaning the metal-paper type. The MP capacitor can be used in flash equipment of 100 μsec flash duration and longer.

Capacitor sections are inserted into metal cans which are exhausted of air and filled with oil or other material before sealing with solder. The dielectric constant of paper, oil, glass, and other materials is from 2 to 10 times greater than that of air. The dielectric constant is a function of temperature in most materials. For example, the capacitance may be greatly reduced when the liquid dielectric freezes.

Comparison of Capacitors

Table 4-1 gives the approximate factors for several types of capacitors. The whole story for selection of a specific capacitor for any duty is not self-evident from the table. One factor not given is the minimum practical voltage of each type of capacitor. Paper capacitors, for example, cannot be made with a very thin dielectric because of the quality control problem of manufacturing the paper without defects. Several layers of paper are used. Electrolytic capacitors are a favorite because of their operation at the relatively low voltage of 450 to 500 volts. The MP type of capacitor is finding many uses because of its ability to store energy and to self-heal some of the breakdowns.

The internal inductance of a capacitor in an electronic flash lamp circuit is a very important factor if ultrashort flashes of light are

Table 4-1 Approximate Comparison of the Specific Cost, Weight, and Density of Three Types of Capacitors

Type of capacitor	Joules per pound	Joules per cubic inch	Temperature range, °C	Cost per joule
Oil paper	25	1.0	−55 to + 85	$0.10
Mylar MP	60	2.5	−55 to + 60	$0.30
Electrolytic	100	5.0	−10 to + 65	$0.10

required. The inductance can be reduced by the use of multiple connecting tabs or by complete edge connections of the metal foils.

The Electrolytic Capacitor

A special type of capacitor called an *electrolytic* uses as a dielectric a very thin oxide layer on aluminum foil. Since this layer is exceedingly thin, the capacitance can be made very large per pound of material. An electrical conducting paste is used for contact to the thin layer. Several limitations are experienced with electrolytic capacitors as listed below:

1. The working voltage cannot exceed about 500 volts (550 for some types) due to excessive leakage current and electrical breakdown.

2. The capacitor has an internal series resistance called the *effective series resistance* (ESR) which must be less than the load resistance, otherwise most of the stored energy will not reach the load.

3. The capacitor becomes ineffective if the temperature is low.
 Below $-15°C$ $\Delta c \simeq -25$ percent of C at $20°C$
 Below $-20°C$ $\Delta c \simeq -40$ percent of C at $20°C$

Regardless of these defects, the electrolytic capacitor is widely used in flash equipment because of the high energy density per unit volume (or weight) and economic advantages (see Fig. 4-3).

Photography equipment in which short-duration flashes of less than 50 or 100 μsec are required cannot use the electrolytic capacitor because of the internal resistance.

Equations of the Capacitor

The charge q in coulombs in a capacitor is proportional to the capacitance C in farads and to the instantaneous voltage e in volts.

$$q = Ce \quad \text{coulombs}$$

and since current is the rate of change of charge with time

$$i = \frac{dq}{dt} \quad \text{amperes}$$

then

$$i = C \frac{de}{dt}$$

or in integral form

$$e = \frac{1}{C} \int i\,dt \quad \text{volts}$$

This equation is useful for estimating the time required to charge a capacitor between flashes.

Example: Consider the time required to charge a 100-μF capacitor to 2,000 volts with a constant charging current of 0.1 amp. Since i is constant, the above equation becomes

$$e = \frac{1}{C} \int_0^t i\,dt = \frac{it}{C}$$

Solving

$$t = \frac{eC}{i} = \frac{(2{,}000)\,(100 \times 10^{-6})}{0.1} = 2 \text{ sec}$$

The charging current for capacitors in flash circuits is *not constant* as stated in the example above, since the current decreases gradually as the capacitor approaches its final value. The simplest type of charging circuit (Fig. 4-1) consisting of a series resistor between the battery and the capacitor is discussed below.

The capacitor is in a discharged condition when the switch is closed in the charging circuit. At the first instant, the entire battery voltage must appear across the resistor since the capacitor cannot accumulate energy in zero time. The initial current is then $i_0 = E/R$. The expression for capacitor voltage must fulfill the conditions of the differential equation below:

$$e = \frac{1}{C} \int i\,dt = E - iR$$

An equation of this type has an exponential solution of the form

$$i = I\epsilon^{-\alpha t}$$

where I and α are constants to be determined and ϵ is the base of the

natural logarithm, ϵ = 2.73. This assumed expression of i is now substituted into the above circuit equation for the evaluation of the constants, I and α. When $t = 0$, the value of $I = E/R$ is determined as before. The exponential factor $\alpha = 1/RC$ is obtained by finding the charge on the capacitor at the end of the charging cycle ($t = \infty$). Thus,

$$q = \int_0^{t\,=\,\infty} i\,dt = EC = \int_0^{t\,=\,\infty} \frac{E}{R}\epsilon^{-\alpha t}\frac{d(\alpha t)}{\alpha} = \frac{E}{R\alpha} \quad \text{and} \quad \alpha = \frac{1}{RC}$$

The complete expression for the instantaneous current then becomes

$$i = \frac{E}{R}\epsilon^{-t/RC} \quad \text{amperes}$$

and the capacitor voltage

$$e = E(1 - \epsilon^{-t/RC})$$

A graph of the two functions $\epsilon^{-t/RC}$ and $(1 - \epsilon^{-t/RC})$ is given in Fig. 4-4. The time scale has been made dimensionless so that the curves can be applied to any problem by multiplying the time scale by the time constant of the particular circuit being studied.

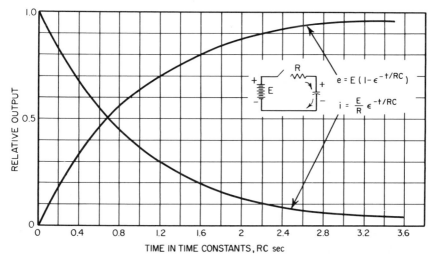

Fig. 4-4 *Dimensionless exponential functions relating to the charge of a capacitor through a resistor from a constant voltage supply.*

Energy Stored in a Capacitor

The instantaneous power at the terminals of the capacitor is

$$p = ei = e\,C\frac{de}{dt}$$

The energy in the capacitor is

$$w = \int_0^t p\,dt = C\int_0^E e\,de = \frac{CE^2}{2}$$

as given before. The energy stored in a capacitor is dependent only upon the value of the capacitance and the terminal voltage, regardless of how fast the capacitor is charged.

The Time Constant

The effective duration of an exponential transient is conveniently expressed as a characteristic number which is the *time* for the transient to reach a given fraction of its final value. This time, by definition, is when the exponent $t/RC = 1$. The time constant τ then is RC seconds. The value of the current and voltage for the capacitor charging example at this instant of time becomes

$$i = \frac{E}{R}\,\epsilon^{-1} = \frac{E}{R}\,\frac{1}{2.73} = 0.365\,\frac{E}{R}$$

$$e = E(1 - \epsilon^{-1}) = 0.635\,E$$

Therefore, it has been shown that any RC charging circuit will reach 63.5 percent of the final voltage in a time of RC seconds (1 time constant).

According to the equation, the capacitor is finally charged after an infinitely long time. From a practical standpoint the capacitor can be considered to be fully charged after its voltage reaches 90 to 95 percent of its final value. The percent of full charge and the stored energy can be given in terms of the time constant τ ($\tau = RC$ seconds) as listed in the following table.

	0.5τ	τ	2τ	3τ	4τ	∞
Percent charge	40.0	63.5	86.5	95	98	100
Percent energy	16.0	40.0	75.0	90	96	100

Therefore, if the time available for charging is equal to $4RC$ sec, the capacitor will have reached 98 percent of its final charge, or 96 percent of its final energy.

Energy Lost in the Charging Resistor

The instantaneous power into the charging resistor is i^2R and the total energy lost during the charging cycle is

$$w = \int_{t=0}^{t=\infty} i^2R\,dt \quad \text{watt-sec}$$

Substituting $i = (E/R)\,\epsilon^{-\alpha t}$ into the above and solving gives

$$w = \frac{E^2C}{2} \quad \text{watt-sec}$$

This is the same energy that is stored in the capacitor. Thus the maximum efficiency of a dc charging system is 50 percent for the conditions of zero initial capacitor voltage, constant supply voltage source, and complete charging to the full battery voltage.

The charging efficiency will be less than 50 percent if the charging time cycle is not complete, as shown in the following table.

Charge time, sec	RC	$2RC$	$3RC$	∞RC
Efficiency, percent	31.5	43.3	47.5	50

Outlet Power

The ordinary electrical power outlet is an economical method for obtaining power for operating electronic flash equipment. However, a power cord to the outlet is required and is often very inconvenient. Furthermore, the several voltages and varying frequencies used in different parts of the world cause problems for those who wish to use electronic flash equipment in several countries. The present

conditions in several countries are given below. Many manufacturers of widely distributed electronic flash equipment use an input transformer that can be reconnected to meet the voltage requirements of most places. A transformer which is satisfactory for 50-cycle operation can be used on a 60-cycle circuit. However, the converse may not be true, depending upon the design of the magnetic core.

Table 4-2 Voltage and Frequency Used in Several Selected Foreign Cities

City	Voltage	Frequency
London, England	240/415	50
Paris, France	120/240	50
Berlin, Germany	220/380	50
Athens, Greece	220/380	50
Jerusalem, Israel	230/400	50
Quito, Ecuador	120/208	60
U.S.A. and Canada	115/230	60
U.S.A. and Canada	120/240	60

Source: U. S. Dept. of Commerce Booklet "Electric Current Abroad," 1963 edition.

Battery Power

Many factors influence the selection of a power supply suitable to charge the capacitors of a flash unit. If the application is in an area remote from civilization or is portable, then some type of battery [4, 5] is required. Batteries are of two general types.

1. Primary batteries, such as the Leclanche type which is expendable after one use
2. Storage batteries, such as the nickel or lead types

The flash lamps on satellites, for example, are operated from nickel cadmium or silver zinc batteries that are recharged by solar cells from radiation from the sun. Nuclear and fuel cell power supplies can be considered for special uses. The nuclear type at the moment is heavy and expensive. Fuel cells are of the compressed gas type or the dissolved fuel type, such as hydrazin (N_2H_4) or methanol (CH_4) in the electrolyte KOH.

The Dry Battery

The Leclanche dry cell consists of a zinc can which holds a

manganese dioxide-carbon electrode and an active paste electrolyte. The open-circuit voltage of a single cell is about 1.5 volts. Battery elements are then connected in series or parallel to obtain a higher voltage or current capability.

The dry battery is notorious for its poor regulation. As soon as current starts to flow, the terminal voltage of the battery drops and continues to drop with time. Polarization partly causes this regulation, but also there is an electrical drop through the electrolyte paste due to internal resistance. The terminal voltage of a dry battery will *recover* if the load is removed since there are depolarizing materials in the paste which absorb the chemical by-products caused by the current.

Batteries are made in many different sizes, depending upon the amount of current required and the time it takes the battery to deliver the current. The capacity of a battery is usually given in ampere-hours for a given ampere drain for a specific load cycle. A large current drain will result in a smaller total output than with a smaller current drain.

At the end of the useful life of a dry battery the voltage across the terminals has dropped to 1 volt (or 0.9 volts) per cell. A voltmeter measurement is sufficient to determine when a battery has reached the end of its usefulness, but this test is best accomplished when an electrical load is connected.

There are several special dry batteries that have been designed to charge electrolytic capacitors directly without the need for conversion equipment, such as vibrators or transistor oscillators. An example of a battery of this type is in common use for portable electronic flash lighting equipment. The many cells (336) are stacked into a rectangular case (dimensions $5\frac{5}{8}$ in. high, 3 in. wide, by $1\frac{19}{32}$ in. thick) with flat contact terminals at the top. The weight is 1 lb, 10 oz. This battery is available from several battery manufacturers, such as Eveready No. 497, Burgess No. U320, Mallory No. PF497, etc. (see Fig. 4-5).

The above 510-volt battery is capable of giving a serious electrical shock to the person handling it. The terminals are covered with Scotch tape so that contact is impossible. Spring-loaded needle points penetrate the tape when the battery is installed in the electronic flash equipment.

Data on the Eveready No. 497 battery (Eveready catalog, p. 236, Jan. 1960) gives the estimated performance for intermittent loads shown in Table 4-3. The regulation of this battery for use in charging

Fig. 4-5 *Photograph of a 510-volt dry battery (left) and a 225-volt dry battery (right) as used for power for electronic flash units. Center battery has the paper cover cut away to show the arrangement of many series cells.*

electronic flash equipment can be seen from the experimental data in Fig. 4-6. This voltage regulation data was made with a load cycle resembling the practical use of a flash equipment that might be expected on the underwater electronic flash unit described later. Eighty flashes from a 600-μF electrolytic were made in four groups of 20 flashes (10-sec rate), with a one-hour rest period between groups. The voltage becomes progressively lower during the 80 flashes ending at the value shown on the lower curve. The voltage recovers to the values shown in the upper curve during the 20-hr rest. There were extra "rest" days during the weekends.

The Lead Storage Battery (Wet)

A widely used rechargeable battery is the lead-sulfuric acid type,

Table 4-3 Eveready No. 497 Dry Battery, 510 volts, Estimated Hours Service at 70°F

Schedule, hr/day	Starting drains, ma	Hours of service for cut-off voltage shown				
		269 volts	302 volts	336 volts	370 volts	403 volts
2	0.1	1,300	1,265	1,210	1,130	1,100
2	0.2	770	730	700	660	610
2	0.3	530	515	490	460	420
2	0.5	320	310	295	275	250
2	1.0	150	144	138	130	115
2	2.0	74	68	64	59	50
2	5.0	24	21	18	15	5

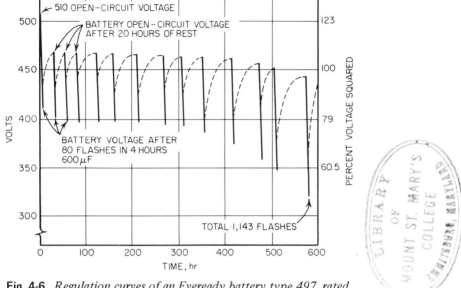

Fig. 4-6 *Regulation curves of an Eveready battery type 497, rated 510 volts for a 60-watt-sec flash lamp load (600 μF at 450 volts). See text for load cycle. A total of 1,143 flashes was obtained from the battery during a 600-hr period.*

such as used for starting automobiles. This battery can be used to supply power to electronic flash equipment, but provision must be taken to prevent spillage of the acid. Some types are sealed and do not require additional water, making spillage impossible. Figure 4-7 is a photograph of several storage batteries. Each cell is contained in a case insulating it from the acid. Closely spaced lead plates are immersed in the liquid with separators of rubber or plastic. Alternate plates are connected together and brought out to terminals. The plates consist of a lattice of lead with inserted volumes of lead oxide.

A wet storage battery of the lead type must be kept in a charged condition, otherwise the chemical action of the sulfuric acid on the plates will ruin the battery by the formation of lead sulfate. The lead sulfate formation during the storage of a battery is a nonreversible one. During discharge $PbSO_4$ is formed on both electrodes, however, the action is reversible and returns on the subsequent charge to PbO_2 and Pb.

The acid is highly corrosive and great care is required to prevent leakage onto other parts of the apparatus or onto the user's clothing. Batteries for portable use are of the invertible spill-proof type.

Fig. 4-7 *Examples of wet batteries as used for electronic flash cir-cuits. Left: a silver-zinc battery of 6-volt output and 20-amp-hr capacity used on deep-sea underwater strobe units. Center: a 4-volt lead acid battery of 3-amp-hr capacity. Right: a 2-volt lead acid battery of 6-amp-hr capacity. Note the floating balls that indicate the charge condition. (Nominal rating.)*

Liquid in a normal wet battery expands when the battery is charged. Therefore, the battery should not be filled to the top with replacement water before the charging cycle, otherwise the acid solution will be forced out through the vent. A small amount of liquid may be splattered out of the battery during charging by the evolved gas. The battery should be carefully cleaned of external acid on the surface and filled with water to the specified level at the end of the charging cycle.

Great care must be used to keep open flames or sparks away from a charging, or recently charged, wet battery since the gas area over the plates consists of a hydrogen-oxygen mixture which can explode and split the battery case. A wet battery will discharge slowly on the shelf without use. It is necessary to recharge a storage battery at frequent intervals, weekly or monthly, depending upon the type.

The voltage per cell of a fully charged lead storage battery is about 2 volts, and the voltage at the end of the useful discharge cycle is about 1.8 volts. One method of measuring the state of the battery is the use of a voltmeter to check the voltage. The reading should be made with the battery supplying load current. Another way to measure the state of charge is to measure the specific gravity of the

acid solution. A fully charged battery will have a specific-gravity of about 1.3 since most of the water is consumed and the acid solution is more concentrated. After discharge, the specific gravity is about 1.15. A hydrometer can be used to measure the specific gravity. It consists of a calibrated float in a glass cylinder into which the battery liquid can be drawn. The float will assume a higher position if the battery liquid is heavier as in the case of a charged battery.

Some batteries are supplied with balls of different specific gravities. These balls are positioned in the battery liquid and can be observed through a window. One battery type has three balls of different color. If all three float, the battery is fully charged; if the green ball sinks, the battery is partly discharged; if the green and orange balls sink, the battery is more than half discharged; if the red ball sinks also, the battery should be charged immediately. Observation of the liquid level in this type of battery is also made through the same window.

Lead storage batteries usually have several plates in parallel in each cell to supply greater current output. Also, many batteries have several cells in series in the same case, thereby producing a greater voltage output. Automobile batteries consist of three cells giving a total of 6.3 volts or 12.6 volts for the six-cell model when fully charged. Aircraft batteries consist of both six- and twelve-cell types with corresponding voltages of slightly more than 12 and 24 volts.

The efficiency of a lead storage battery is about 75 percent; in other words, about three-fourths of the energy put into the battery during the charging cycle is obtained from the battery on the discharge.

Wet Battery Example—Willard No. ER-6-6B

Voltage	6 volts
Capacity	5 amp-hr (at a 5-hr rate)
Energy	30 watt-hr
Weight	3.28 lb
Watthours per pound	9.15
Charging current	0.8 amp
Average discharge cycle before replacement	100 recharges (200 cycles, to 40 percent capacity)
Time between recharging	30 days (120 days to complete discharge) for unused battery
Size	$5\frac{1}{16}$ in. \times $2\frac{3}{8}$ in. $\times 4\frac{1}{4}$ in.

Lead Battery, Sealed Type

The sulfuric acid lead battery can be sealed under specific load conditions and does not need refilling. A life of approximately 50 cycles can be expected when kept within load tolerances. Overcharging above 2.4 volts consumes the water and shortens the life of the battery.

Nickel-Cadmium Battery, Sealed Type

By special design, the nickel-cadmium battery [9] can be hermetically sealed. The hydrogen is suppressed by the choice of electrode area. The oxygen is reduced on the negative electrode. Therefore, the electrolytic is kept nearly constant in the separator, and in the cell open surfaces of electrodes reduce the oxygen. This battery is very popular in the design of portable electronic flash equipment because of the sealed feature. The voltage regulation of the Ni-Cd battery with sintered electrodes is excellent under high load conditions, such as are required to rapidly charge electronic flash equipment.

Silver-Zinc Wet Battery

An excellent battery for storing large energy per pound and for excellent voltage regulation is the silver-zinc battery. It is not used more extensively in portable electronic flash equipment because of the cost and the short life time of about 30 cycles. There are rather strict limitations concerning the charge and discharge cycle.

Zinc-Air Battery

Another expensive battery [10] is the replaceable zinc anode battery which requires oxygen. Claimed advantages are:

1. Produces up to 150 watt-hr per pound, about double that of the silver-zinc battery
2. Mechanically rechargeable by replacing discharged zinc anodes with fresh ones in a matter of 10 min for a 24-volt battery
3. Excellent low-temperature performance

A brief discussion* of the rechargeable battery power supply for submersibles (small submarines) has been given in terms of energy

*See EXIDE battery advertisement in *Undersea Technology*, December, 1966, pp. 13-15. (Cost data estimated.)

density per pound and per cubic inch. The same factors probably apply to batteries which supply electronic flash systems.

Energy conversion is an active technical area, as evidenced by the annual conferences of the American Society of Mechanical Engineers (ASME) [11].

Table 4-4 Comparison of Several Types of Rechargeable Batteries

Battery type	Watt-hours per pound	Watt-hours per cubic inch	Relative dollars per watt-hour
Silver-Zinc	55	3.5	10
Silver-Cadmium	35	2.8	11+
Lead-Acid	20	2.1	1
Nickel-Iron	15	1.0	3
Nickel-Cadmium	12	0.8	6

Power Required for a Flash Unit

The average power required for a flash lamp that operates at a frequency of f flashes per second is $P = CE^2/2 \times f$ watts since this gives the rate at which energy is expended in the lamp. To this power must be added the losses in the charging circuit mentioned above, the standby losses, the rectifier losses, and other circuit losses. Average power for a flash unit is approximately $P = CE^2 f$ watts for a resistance charging circuit with a $4RC$ charging time.

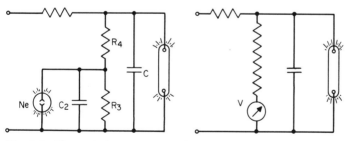

Fig. 4-8 *Charge indicator circuits for capacitors.*

Charge Indicator

Many practical flash equipments use a small neon indicator lamp Ne (Fig. 4-8) to flash when the main capacitor voltage reaches some predetermined voltage, such as 90 percent of the maximum. Resistors R_3 and R_4 are designed so that the starting voltage of the neon bulb will be reached at this selected voltage. A small capacitor

C_2 discharges through the neon lamp and then recharges through R_4 for the next indication. The rate of pulsing of the neon lamp is also useful since the rate will increase as the main capacitor voltage rises to its maximum value.

A voltmeter across the discharge capacitor is a useful indicator of the energy that is ready for discharge into the flash lamp. This

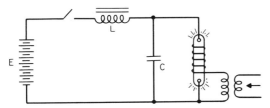

Fig. 4-9 *The inductive charging circuit.*

system is used in many flash equipments. The meter dial can be calibrated to read the light output instead of the voltage since this enables a photographer to adjust his camera aperture for the expected amount of light.

Inductive Charging Circuit

The charging efficiency can be increased if an inductor is added to the charging circuit (Fig. 4-9). Several conditions should be met, such as:

1. The energy storage capability of the inductor must be at least one-fourth that of the capacitor so that saturation of the magnetic core will not occur.

2. The charging circuit should be highly oscillatory, i.e., of low resistance.

3. The frequency of the LC charging circuit should be less than the flashing frequency.

If the frequency of the LC circuit is *greater* than the flashing frequency, a diode should be connected in series with the charging circuit to prevent a back oscillation of charging current through the capacitor. This is treated in the next section.

Engineering design details of inductive charging circuits can be found in the reference given for radar pulse circuits [6]. The electrical problems for the circuit that charges the radar pulse network are identical to the problem of charging the pulse capacitor

of the electronic flash unit. If holdover does occur in the flash lamp with an inductive charging circuit, then the peak current will be very high, limited only by the small resistance in the circuit. A fast-acting circuit breaker is necessary to clear the circuit promptly. This holdover condition, which will be discussed later, is one of the major difficulties associated with all types of high-speed stroboscopic circuits. Failure to deionize prevents the recharging of the capacitor C at very short intervals and thus limits the maximum flash rate of the stroboscope.

It has been found that the weight of the inductor is many times that of the discharge capacitor. Therefore, the advantages of inductive charging are not conveniently utilized on low-frequency, high-energy-per-flash strobe units because of the size and weight and cost of the inductor.

Inductive Charging with a Diode

Consider in detail the electrical conditions that result when a capacitor is charged from a constant potential battery of negligible resistance through an inductor L and a series diode D. Several consequences of this circuit are:

1. The efficiency of the circuit approaches 100 percent when the series resistance becomes small. This is a large improvement compared to the 50 percent efficiency experienced with a charging resistor.

2. The voltage across the capacitor approaches *double* the battery voltage.

3. The circuit is very sensitive to residual voltages across the flash capacitor since the transient initial conditions are very important.

Figure 4-10 shows the circuit just discussed and also the voltage and current relationships.

AC Charging Circuit, Half-wave

A very common capacitor charging circuit consists of an ac half-wave rectification system (Fig. 4-11). The circuit is in wide use since a minimum of components are required. The initial charging current consists of half-wave pulses of current when the capacitor voltage is near zero at the start of the charging period. During each half cycle, the capacitor voltage is increased by the charging current. The end of charging is reached when the capacitor voltage is equal to the open-circuit *peak* voltage of the transformer secondary. The peak

voltage is equal to $\sqrt{2}\,E_2$ where E_2 is the rms value of the secondary voltage. The ratio of the secondary voltage to the primary voltage is the same as the ratio of turns of the secondary windings to the turns of the primary windings.

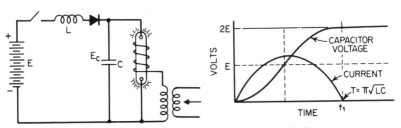

Fig. 4-10 *The inductive charging circuit with a series diode to prevent current reversal.*

Figure 4-11 also shows the secondary current that charges the capacitor. Notice that the conduction time is decreased each half cycle. The pulses become of very short duration at the end of the charging period when the capacitor is almost fully charged. The charging time for the ac half-wave system for a given peak secondary voltage and charging resistor will be longer than the corresponding dc case because of the inactive time of the cycle.

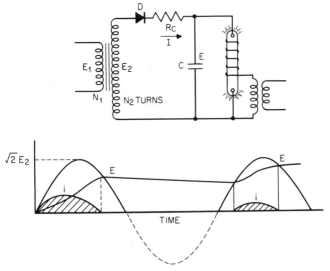

Fig. 4-11 *A commonly used half-wave rectifier charging circuit with final value of $\sqrt{2}\,E_2$ volts across the capacitor.*

The initial rate of increase of the capacitor voltage averaged over a cycle can be compared to the dc case. The average charging current for the ac case is

$$\text{ac case } I' = \frac{1}{2\pi} \int_0^\pi \frac{\sqrt{2}\, E_2}{R} \sin \omega t \; d(\omega t)$$

$$= \frac{\sqrt{2}\, E_2}{\pi R} \quad \text{amperes}$$

if the transformer has negligible inductance and resistance. Also, the diode must be of low voltage drop and of negligible back current. The corresponding current for the dc case is $I = E/R$, $E = \sqrt{2}\, E_2$

$$I = \frac{\sqrt{2}\, E_2}{R}$$

Then the ratio of charging currents is

$$\frac{I'}{I} = \frac{\sqrt{2}\, E_2 / \pi R}{\sqrt{2}\, E_2 / R} = \frac{1}{\pi}$$

The voltage rise rate will be proportional to the current. Therefore, the initial capacitor charging rate will be more than three times greater with the dc system than with the ac. This is counteracted by reducing the charging resistor of the ac system by a factor of π to obtain a first-order correction. Many half-wave charging systems use a very small value of resistance. However, they keep the current at desired peak values by designing a power transformer with large leakage inductance. Physical separation of the primary and secondary windings on the core is one method of obtaining series inductance in the transformer.

The effectiveness of a transformer to limit the current is characterized by its short-circuit impedance. This can be measured as follows:

A suitable ammeter is connected between the secondary terminals, in effect short-circuiting the secondary. Starting at zero, the primary voltage is increased until approximate rated secondary current flows.

With the same primary voltage applied, the secondary open-circuit voltage is measured. The open-circuit voltage divided by the short-circuit current gives the value of the transformer impedance at the secondary terminals.

A complete solution of the transformer-impedance–limited-charging circuit is beyond the scope of this book. Refer to textbooks [6] on power supplies for a more thorough treatment.

It is well to mention that the heating effects in the windings of a half-wave transformer are appreciable due to the peaked wave form of the current. As a result, a transformer designed for sinusoidal current operation will overheat badly even if the average current is below the rated value. Transformers for half-wave rapid recharging should be designed with extra-large-cross-section copper conductors.

AC Full-wave Rectifier and Voltage Doubler

The charging current can be doubled by the use of full-wave rectification since current flows during both halves of the ac cycle. Figure 4-12 shows the full-wave charging circuit. A second circuit (full-wave circuit) called the voltage doubler is shown in Fig. 4-13. The charging current is partially controlled by the size of the capacitor C_1. This capacitor has an ac current through it and, therefore, needs to be of a much more conservative design than the flash producing capacitor C.

Fig. 4-12 *Full-wave rectifier circuit for charging a capacitor from an ac line.*

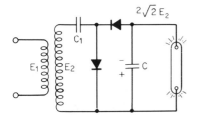

Fig. 4-13 *A voltage doubling circuit that requires a series capacitor and two diodes.*

The Trip Circuit

Some method is needed to produce a pulse voltage of many thousands of volts to trigger the discharge in a flash lamp. By far the most common is the so-called *direct* triggering system (Fig. 4-14).

Fig. 4-14 *External pulse trip circuit (left). Series injection pulse (right). Note that the* main discharge *current of the flash lamp is in the secondary coil of the series system. A special transformer is required.*

The step-up transformer T, commonly called a spark coil, is pulsed when the switch S is closed since the energy stored in the small capacitor C_1 is discharged through the primary coil. The intensity of the pulse depends upon:

1. The size of the capacitor.
2. The voltage to which the capacitor is charged. In this case $ER_2/(R_1 + R_2)$ volts.
3. The turns ratio of the spark coil.
4. The distributed capacitance across the secondary coil of the transformer and the capacitance of the trigger wire system.
5. The switch resistance or contact-bounce effects.

A voltage measurement should be made on any system to determine what voltage is being produced and if the spark is more than adequate for reliable starting. This is discussed further in the section on xenon flash lamps (Chap. 2).

One simple spark test is to use an insulated-handle screwdriver, as one uses it to test the voltage across the spark coil of an automobile. The *distance* that the spark jumps is a direct indication of the voltage. The breakdown voltage of a spark gap can be calculated at 30,000 volts per centimeter, subject to a list of restrictions [7].

Direct measurement of the secondary voltage is possible with a cathode-ray oscilloscope if a suitable voltage divider with a very high

input impedance is used. Such a test not only shows the maximum voltage but also shows the frequency of the oscillations and other interesting facts, such as the loading effect of the main discharge on the spark circuit.

The performance of several types of spark coils excited from a switched capacitor into the primary is shown in the following table.

Table 4-5 Spark Coil (EG&G, Inc.) Performance Data under Pulsed Condition from a Capacitor Discharged into the Primary

Type	Peak output range, kV	Primary discharge capacitor, μF	Input range dc source, volts	PRI current peak amp
TR-36A	3–6	1.0	130–250	25
TR-60	12–30	0.5	200–500	45
TR-69	15–40	0.5	200–500	40
TR-76A	2.5–6.0	10	14–25	100
TR-90A	2.5–5.5	10	10–20	23
TR-130	0.38–1.4	10	10–30	46
TR-131	0.38–1.4	10	10–30	30
TR-132A	8–20	0.5	150–350	80
TR-148A	5–12	0.5	200–400	120
TR-149	0.38–0.70	1.0	15–30	12
TR-153	12–35	0.2	250–600	200
TR-157	0.3–1.2	1.0	10–30	12.5
TR-164A	3–6	10	12–25	32
TR-165	0.35–0.7	10	7–14	17
TR-180	10–20	0.5	100–200	40

Thyratrons, Glowtubes, Krytrons, and SCR Trigger Devices

Many kinds of electrical switching devices can be used in place of the switch S to close the trip circuit. Advantages of using these devices are:

1. The trip current, which can be many amperes, is not required to flow in the delicate switch synchronization contacts, such as used in camera shutters.

2. Electrical pulses from phototubes, microphones, and oscillators can be used to initiate the flashes of light.

The thyratron was the first trigger device used. This is a gas-filled three-element control tube which becomes a low-resistance circuit

FAST TRIGGER CIRCUIT FOR MULTIFLASH

Fig. 4-15 *A sensitive trigger circuit using a thyratron type 5727 to produce a pulse or spark when activated by a contact closure or a pulse of voltage or a pulse of light.*

element when the grid voltage reaches a critical triggering value. Details of a practical trigger circuit using an RCA 5727 thyratron are shown in Fig. 4-15. Also shown is the phototube trip which activates the thyratron whenever a pulse of light strikes its cathode. This device has been very useful for triggering circuits at the moment an explosion occurs. One example to be shown later is the synchronization of photographs at the moment of explosion of dynamite caps.

There is a *sensitivity* control on the grid bias of the thyratron. As the bias is made more and more positive, triggering requires a smaller and smaller voltage pulse. If the sensitivity adjustment is turned too far, then self-triggering will occur at a rate set by the charging circuit for the capacitors. This feature is most convenient in the laboratory. The equipment can be set to operate at a one-flash-per-second rate so that observations can be made of many parts of the circuit with a cathode-ray oscilloscope.

Glow trigger tubes have been used extensively for triggering since they do not require a cathode heater as does the thyratron; and therefore, no standby power is required. The disadvantage of the glow tube, compared to the thyratron, is the requirement for a greater trigger voltage for initiation. A thyratron can be set to trigger when a 0.1-volt pulse arrives. Most glow tubes require 100 volts or

more. There is also a time delay inherent with the starting of a glow tube which may be 100 μsec or more. The starting of the thyratron is much shorter, usually less than a few microseconds.

Several practical trigger circuits that have been and are extensively used are shown in Fig. 4-16. These trigger circuits use the 631-Pl arc tube (as used for a light source in the General Radio Strobotac, model 631-B). Two circuits are shown, the upper for a negatively grounded circuit and the lower for a positively grounded one. The lower circuit also shows a phototube trigger with a gas glow tube (OA4-G) as a relay to aid in synchronization of the flash lamp from the flash of another flash lamp.

Figure 4-17 shows two trigger circuits that use glow trigger tubes Nos. OA5 and No. 6483 (both by Sylvania). These circuits have a very weak continuous glow from the closest grid to the cathode. The glow enables the trigger tube to start more easily and consistently, especially in the dark.

Fig. 4-16 *Trigger circuits for electronic flash lamps utilizing the strobotron 631-P1 glow tube which is also numbered the SN4 and the ID21. Top circuit is negatively grounded, the bottom has a positive ground. A phototube trip is shown for the lower circuit, as used in the 1941 Kodatron unit.*

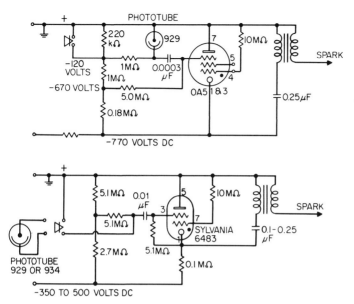

Fig. 4-17 *Glow tube trigger circuits using the OA5 and the 6483 tubes. Note that a continuous glow is maintained through a 10-megohm resistor to the cathode to aid in the starting process.*

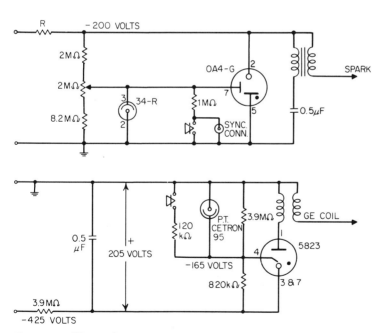

Fig. 4-18 *Glow tube trigger circuits using three element trigger tubes. Note that the phototube trip is shown. These are used in flash equipment made by Graflex.*

Figure 4-18 shows circuits with three electrode glow tubes as trigger switches to start the spark circuit. The phototube, as well as the contactor actuators, is shown. It should be pointed out that the glow tube trigger does not require any heater current. However, a slight time delay may be required to achieve starting. A large voltage pulse is required for reliable starting and minimum delay. A glow tube may not start in the dark! It is important to test this feature if the equipment is to be left inactivated for a long time in complete darkness.

A series of trigger tubes are available from EG&G, Inc. bearing the name Krytron. These can be used in the trigger circuits shown in Fig. 4-19. The Krytron is a four-element (grid, anode, cathode and keep-alive) cold-cathode, gas-filled switch tube designed to operate in an arc discharge mode conducting moderately high-peak currents for short durations. Commutation is normally initiated by a positive pulse applied to a high-impedance control grid; this grid structure encloses the anode except for a small opening at the top. It is through this small opening in the grid that conduction current must pass. This unique design allows the Krytron to hold off high voltages and still have a low tube drop during conduction. A column of ionized gas, appearing in a glow mode and maintained by a keep-alive current, provides an initial source of plasma which produces short delay time. Krytrons are constructed with a rugged glass structure and pigtail leads for mounting into potted or fabricated assemblies which require minimum package size. The environmental ratings substantitate the mechanical and electrical capabilities of the Krytrons.

The grid of the Krytron is a high-impedance element requiring very little trigger energy to cause commutation. The amount of the current required to cause grid-to-cathode breakdown is negligible. At

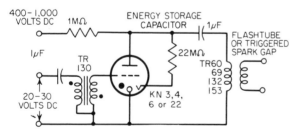

Fig. 4-19 *Typical krytron trigger circuit with EG&G, Inc. transformers.*

the point of firing, the grid potential rises to approximately 80 percent of the applied anode voltage. If the tube is operated with capacitance coupling, grid leak resistance must be provided. (A typical value is 150 kilohms.) If the tube is transformer coupled, the dc path is of adequate resistance.

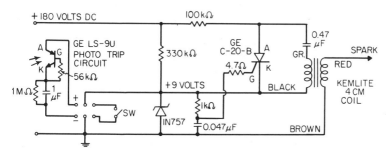

Fig. 4-20 *Trigger circuit with an SCR solid-state device (C-20–B) to control the spark circuit of an electronic flash unit.*

Trigger pulse rise time has a decided effect on the commutation time of the tube; fast rising pulses of high peak amplitudes cause the Krytron to break down in a time shorter than normal because of the over-voltage function. For example, when operating a Krytron at rated anode voltage, the delay time can be reduced 20 to 50 percent by increasing the peak trigger voltage from 300 to 1,000 volts.

The silicon-controlled rectifier (SCR) is an important trigger circuit switch and will probably be the most popular in the future. An example is the circuit shown in Fig. 4-20 which was used on underwater xenon flash equipment complete with provision for photoelectric triggering from another flash lamp.

Circuit Troubleshooting

The term *troubleshooting* has long been a semislang term used by those who keep electrical equipment in operation. In this section a few common sense rules are given for finding trouble in electronic flash equipment.

IMPORTANT: Before investigating the inside of a flash unit, one should (1) discharge the main capacitor by connecting a discharge resistor (such as a 100-ohm, 25-watt wire-wound type) across the capacitor terminals and (2) make sure that the equipment is in an OFF condition.

A small spark can be seen when the capacitor is discharged (Fig. 4-21). It is advisable to check the 100-ohm resistance occasionally to be sure that the wires have not become open-circuited!

An inexperienced person can cause considerable *damage* to faulty electronic flash equipment by over-zealous attack. A person attempting to fix equipment should start on the assumption that the trouble is something very simple. The hard part of the task is to isolate the simple defect and correct it. Successful troubleshooting consists of a series of simple tests or experiments to isolate the faulty part of the circuit or equipment. It is advisable to read over any service manuals that are published by the manufacturer of the equipment before starting.

The "Radio Amateur's Handbook" [8] contains much information about circuit components and their operation and is strongly recommended to those who wish to master the art of servicing any kind of electrical equipment. The following discussion provides a checklist to aid the user in finding the difficulty in his equipment.

First, the batteries must be satisfactory. This can be partly determined by a voltmeter across the terminal of a battery. Then, a load must be applied to find if the battery has the ability to deliver power.

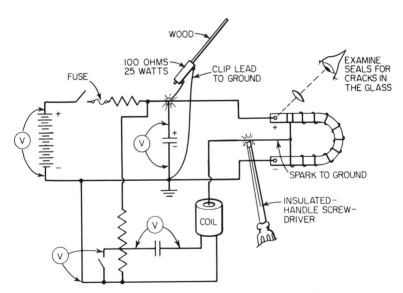

Fig. 4-21 *A circuit diagram showing suggested voltage and spark measurements to discover faulty operation.*

Next, the battery connections must be clean. Often the battery liquid leaks and causes corrosion at the terminals, giving them a high resistance. Scraping or sandpapering the corroded contacts will eliminate this problem.

The switch could be bad. It can be tested with a voltmeter or ohmmeter. There should be negligible voltage across the switch when it is *closed.*

Fuse: Is there a fuse, if so, is it blown? This is often the trouble with equipment. A blown fuse usually means there is some kind of trouble, such as a faulty capacitor or a short circuit. A few tests with an ohmmeter can often locate the difficulty without the necessity of blowing another fuse.

Electron flash equipment with *electrolytic* capacitors requires special care if the equipment has not been used recently. Apparently, an electrolytic capacitor *deteriorates with time* and must be *reformed* before it is ready to operate efficiently with a small leakage current. The reforming process requires a larger amount of charge than just that needed to charge the capacitor. The battery in the equipment may not have sufficient current capacity to do the reforming job, and therefore, the battery voltage will collapse before the flash unit is up to voltage. The cure for an unformed capacitor is an ample current input until the terminal voltage is at rated value and the leakage current has dropped to some minimum value. A flash unit with an ac charger will quickly reform the capacitor in situations in which a small battery cannot.

Returning to the circuit, if the battery switch and fuse are found to be OK and operating, there could be a broken wire to the transformer. This can be detected since an excited transformer makes a "singing" noise. Next, the transformer output goes to rectifiers of several types and then into the capacitors, usually through a resistor. The older type of thermionic rectifiers could be checked by observation of the filaments. A cold rectifier or one not showing a dim glow needed replacement. The modern solid-state rectifier can be checked with an ohmmeter by measuring the resistance in both directions. If there is no difference, the rectifier is probably short-circuited. If the resistance is infinite in both directions, the rectifier is open-circuited. It may be necessary to disconnect one terminal of the rectifier for the ohmmeter test.

We have now checked the circuit up to the main flash capacitor. The voltmeter shows full-rated voltage across it, but the lamp still fails to flash. Is the lamp faulty or is it the trigger circuit or the

connections? A voltmeter reading across the terminals of the lamp should show the same voltage as the capacitor. If it does not, one must look for the reason why.

The spark circuit can be tested with a screwdriver between the lamp circuit (ground) and the spark terminal (Fig. 4-21). There should be a spark that will jump about 3 mm. This is the same test made on the spark plug of an automobile. If there is no spark a car will not operate, and likewise, a flash lamp will not flash.

If no flash is obtained from the lamp, then there must be something wrong with the lamp, such as a cracked seal allowing air to contaminate the xenon gas and, thus, preventing starting. A magnifying glass can be used to look closely at the ends of the seals where they enter the glass. A small crack can usually be seen if the lamp is rotated slowly so that light can be reflected from the inner edges of the crack. A lamp with a cracked seal will not glow when it is excited electrically by a spark coil. Remember that the main flash capacitor is usually connected directly across the terminals of the lamp. There is enough energy and voltage to give you a really powerful shock if you touch both terminals!

The energy in the capacitor can be discharged by a short circuit across the lamp or capacitor terminals. It is better to discharge the capacitor with a resistor to prevent possible damage to the capacitor from the heavy currents that flow with a short circuit.

If the screwdriver test revealed no spark whatsoever, then you must find the trouble in the spark circuit. Is the trip capacitor charged? A voltmeter check will tell this. Is the switch for triggering NG? It can be tested with a voltmeter also. Is the spark coil primary circuit complete? Is the secondary connected and in good condition? When you get a "yes" answer to all of these questions, the flash lamp should be ready to go.

Never stop or give up until the trouble is isolated and mastered. Be persistent! This is the secret to successful troubleshooting.

REFERENCES

1. Früngel, F., "High Speed Pulse Technology," vols. I and II, pp. 7-26, Academic Press, New York, 1965.
2. Drummer, G. W. S., Fixed Capacitors, in "Radio and Electronic Components," vol III, Pitman & Sons, London, 1956.
3. Burger, F. J., and L. Young, in J. B. Birks and J. Hart (eds.), "Progress in Dielectrics," vol. 5, pp. 1-36, Academic Press, New York, 1963.
4. Intersociety Energy Conversion Engineering Conference, Los Angeles,

California, September, 1966. (See also *Design News*, November, 1966.)

5. Collins, D. H., et al., Batteries, *4th Intern. Symp. Batteries*, The Macmillan Company, New York, 1964.
6. Glasoe and Lebacqz, "Pulse Generators," M.I.T. Radiation Laboratory Series, vol. 5, chap. 9, p. 355, McGraw-Hill Book Company, New York, 1948.
7. Cobine, J. D., "Gaseous Conductors, Theory and Engineering Applications," McGraw-Hill Book Company, New York, 1941 (paperback edition, Dover Publications, Inc., New York, 1941.)
8. Collins, A. F., in R. Hertzberg (ed.), "Radio Amateur's Handbook," 11th rev. ed., Thomas Y. Crowell Company, New York, 1960.
9. Dehmelt, K., Hermetically Sealed Nickel-Cadmium Accumulators, *Elektrotech. Z.*, Jan. 11, 1960 (also Varta, 6 Frankfurt/Main, Germany).
10. Chodosh, S. M., E. G. Katsoulis, and M. G. Rosansky, Primary Zinc-Air Battery Systems, *20th Ann. Proc. Power Sources Conf.*, May 24-26, 1966 (reprint Leesona Moos Laboratory, Great Neck, N.Y.).
11. "Advances in Energy Conversion Engineering," ASME, New York, August, 1967.
12. Sutton, G. W. (ed.), "Direct Energy Conversion," McGraw-Hill Book Company, New York, 1966.

5 ELECTRONIC FLASH LIGHTING REQUIREMENTS FOR PHOTOGRAPHY

The *guide factor* and *exposure time* concepts are now presented to help those who wish to use the strobe system for photography. The guide factor, as most photographers know, is the product of the camera lens aperture A and the distance D from the *lamp* to the *subject* that will produce a properly exposed photograph. The guide factor can be either calculated from the speed of the film and the light output of the electronic flash lamp or determined experimentally by taking photographs. Photographers have long used the guide factor for evaluating the use of the expendable flashbulb with cameras.

The user of an electronic flash apparatus usually needs to know the answers to several questions based on the nature of his subjects and what he wishes to accomplish. If possible, he should find the answers to the following questions either before selecting from the many currently available flash equipments or as an aid in the design of a special flash unit:

1. How much light energy is required on the subject or event to obtain a suitable photograph or optical result?

2. What is the maximum allowable exposure time for any particular subject to prevent a blurred image?

To answer these two questions it is necessary to know for any specific high-speed photographic equipment (1) the light output of the flash lamp and (2) the flash duration of the light. Once these are known, then he can decide if the photographic conditions are appropriate for taking a first try at a successful picture.

The instantaneous light output of a flash unit can be measured by a photosensitive detector and displayed on a cathode-ray oscilloscope. The details of such a measurement, together with limitations, will be discussed in a later chapter. Equipment to make transient light measurements is rapidly becoming commonplace in technical laboratories.

The duration of the flash is conventionally obtained by measuring the time between the one-third peak values of light on the rising and the falling portions of the light-time curve on the oscillogram. Once the light-time output has been determined, the light curve can be integrated to obtain the output in candela-seconds or beam-candela-seconds (BCPS).

A special light meter, called an *integrating light meter*, is available which performs the integration of the light directly by an electrical integrating circuit and thus permits a measurement of the beam-candela-second (BCPS) output. Details of this important light meter and its uses will be treated exhaustively later.

When a reflector is used to concentrate the light in a preferred direction, the output of a flash unit is measured in beam-candela-seconds (BCPS) or in effective candela-seconds (CPS). The *reflector factor* is the ratio BCPS/CPS, where CPS is the output in candela-seconds of the bare flash lamp.

Guide Factor

The most significant number describing the photographic ability of a flash unit is the *guide factor* which can now be defined as a function of the output of a particular flash system.

The guide factor is the product of the lamp-to-subject distance D by the camera lens aperture A for satisfactory photography. In terms of the light output (BCPS) and the film sensitivity ASA speed s, the guide factor becomes

$$DA = \sqrt{(BCPS) \frac{s}{c}} \qquad (1)*$$

in which c is a constant equals 15 to 25 if D is in feet and equals 160 to 270 if D is in meters. The smaller value of c gives an optimistic guide factor and the larger gives a pessimistic one.

Thus, for the simple type of single-lamp photography with the lamp near the camera and the subject at a distance several times the reflector diameter, the photographer can approximate his exposure conditions by a straightforward calculation.

For example, consider the photography of a .30-caliber bullet with a velocity of 2,800 ft per sec (850 m per sec). First, to limit the motion of a rapidly moving bullet to 0.01 in. (0.25 mm), the photographer will need an exposure of less than

$$\text{Required exposure time } (t) = \frac{d}{v} \quad \text{seconds}$$

where d = blur distance due to motion

v = velocity (d and v must be in the same units!)

hence t, calculated for the above example, is 0.3 μsec. Next, to get an exposure with an aperture A of $f/4$ and with film that has an ASA speed of s = 100 at a distance D of 3 ft, the required effective BCPS is now calculated from Eq. (1).

$$\text{BCPS} = \frac{D^2 A^2 c}{s} = 22 \text{ BCPS (optimistic)}$$

Assume that a reflector factor of 6 is applicable, then the CPS output of the flash lamp should be 22/6 = 3.6 CPS.

Figure 5-1 shows a .30-caliber bullet in flight immediately after passing through a bar of soap. The photograph was taken with a 0.5-μsec flash source of light in the M.I.T. Strobe Lab using and EG&G, Inc. microflash lamp (type 549) for illumination (Fig. 5-2). The photographic parameters of the scene were computed by the above procedures.

Xenon gas for high-energy pulses in a concentrated lamp has an afterglow that may last for many microseconds (Fig. 5-3). It is seldom used for very-short-exposure high-energy photography as will be discussed in a later chapter. The microflash equipment uses an

*Equation (1) is derived in Chap. 10 on exposure calculations.

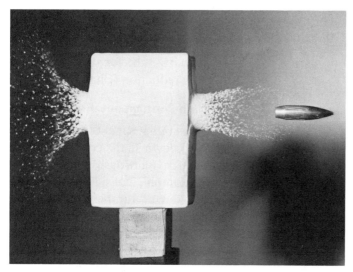

Fig. 5-1 *A .30-caliber bullet (2,800 ft/sec) as it crashes through a bar of soap. Exposure is ~0.5 μsec with Plus X film at f/11. EG&G, Inc. microflash lamp (type 549) was used for illumination with a microphone control for timing.*

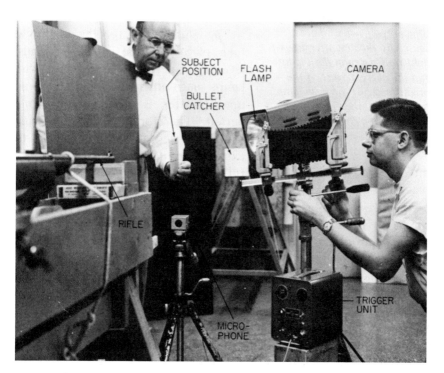

Fig. 5-2 *Strobe lab at M.I.T. showing rifle (left), microphone, camera, microflash lamp, and sand-filled backstop to catch the bullet.*

Fig. 5-3 *A golf swing illustrating "blur" due to a specular subject (golf swing) that is caused by the dim afterglow of light from a xenon flash lamp and the overexposure of the bright image of the flash lamp from the polished metallic handle of the golf club. (*Photograph by Edward Farber.*)*

extended open spark in air over a special quartz tube for starting and for afterglow reduction (Chap. 6).

Multiflash Photography Requirements

The charging time of a flash unit must be known if the equipment is to be used for multiflash photography. As an example, consider the photographs taken of tumblers at the Russian circus in Boston (Figs. 5-4 and 5-5). Several photographs were needed to show their trajectories in space. The pictures had to be taken several times a second because of the high velocity of the acrobat. Quite often it was advantageous to vary the flash rate so the pictures would display the action.

The entire time for the action to take place may be several seconds. Overexposure will result from the arc lamps and other illumination if an open shutter is used for this time period. Therefore, a fast operating shutter is needed on the camera to exclude regular light. For Fig. 5-4 an Alphax Wollensak shutter, set for $\frac{1}{200}$ sec was used. This shutter was hand-operated about three times per second.

Multiflash photographs are always complicated by backgrounds. If the lamp is near the camera, then the background will receive as many exposures as are made. However the image of the subject is exposed only once! The obvious way to cut down exposure of the background is to cross light the subject from the sides (30 to 60°). Two lights are required. Furthermore, the lamps should be spotlights to concentrate the light on the subject and to reduce the light on the background from the flashes. Since each of the two lamps supplies light to separate sides of the subject, the guide factor equation is used for *one* lamp only. For the tumblers (Figs. 5-4 and 5-5) the lamp (FT-524) was used in a specular 18-in. spotlight reflector and driven by 25 μF at 4,000 volts. The light output of the flash unit was

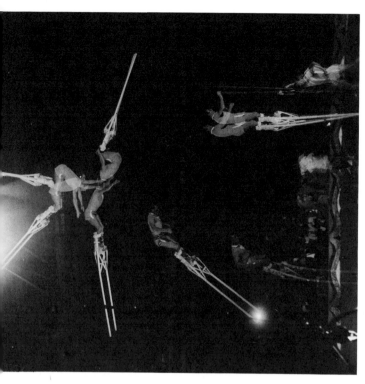

Fig. 5-5 *Alexander Sezhenev of the Russian Circus on 7-ft stilts photographed as he makes a spectacular back flip in air.*

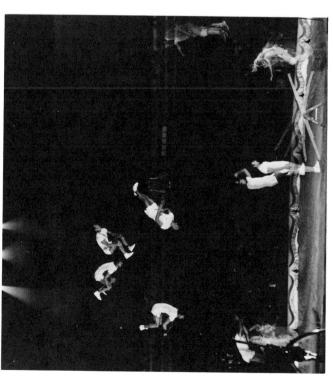

Fig. 5-4 *An acrobat (Vladimir Doveiko) of the Russian circus group performing in Boston. Lighting from two spotlight strobes was arranged from both sides at 60° to the camera-subject axis. An Alfax (1/200 sec) shutter was used to reduce the exposure of the ambient light from the arc lamps.*

measured to be 12,500 BCPS with a 0.2-sec recharge time. The calculated guide factor was $DA = 200$ to 260 for Plus X ($s = 80$) or Ektachrome type S ($s = 80$). Thus at $A = f/9$, a lamp-subject distance of 25 ft was used with success both for black and white and color. Considerable compromise in lamp positioning was needed at the circus because of the heavy traffic on the floor during the performance.

It must be remembered that the guide factor expression requires modification for closeup photography or other special situations. The serious worker with electronic flash can use an integrating light meter for regular as well as unusual situations, preferably a meter having a phototube pickup capable of measuring the light arriving at the ground glass at the image of the subject. The details of exposure calculations for unusual lighting arrangements, such as silhouette and schlieren photography, are given in a special section. The specifications of several flash units will be described in the following chapter.

6 ELECTRONIC FLASH EQUIPMENT (SINGLE FLASH)

This chapter illustrates some of the many types of electronic flash equipments that have been found useful in illumination, photography, and energy conversion. I had hoped to find a tabulation of all currently available flash units, similar to the excellent one published by *Photo Methods for Industry*, July, 1959. The current Smith's Photographics Store catalog gives a list and specifications of amateur photo equipment of the electronic flash type. I do not know of any complete listing of studio and scientific electronic flash equipment. A list of manufacturers and dealers of electronic flash equipment will be given in Appendix I. I am sure that this list is not complete.

Development of the Xenon Flash Lamp

I will describe chronologically the development of the modern flash unit somewhat in the manner in which it was accomplished within my own experiences. The open spark photography method

mentioned in the foreword of this book, although used for the photography of small objects, such as bullets (Talbot, Mach, Cranz, and Boys) and splashes of drops (Worthington), was not in common use because of the complexity of the equipment and the meagerness of the light output.

I recall a powerful spark source [1, 2] (3 μF at 16 kV) which was designed for high-speed photography. The exposure time was about 10 μsec and the noise output was tremendous! Even with a glass cover over the reflector, the device sounded like a gunshot and in addition weighed 120 lb. The comparison of today's efficient small xenon source to this early unit is very impressive. Regardless of its lack of light and its large size, the spark source was used on many important research projects, such as the study of the formation of glass wool from hot slag by strong air and steam jets, the accomplishments of which accelerated the acceptance of flash photography.

An improvement in the art over the open spark was the mercury-vapor lamp [1-10] as a light source. Lower voltage circuits made practical designs of equipment possible. Photography of larger subjects was now possible and portability was improved. The mercury-vapor devices, being subjected to temperature (and of course gas pressure) variations in use, exhibited large variations in light output. The substitution of the noble gases (neon, argon [1, 2], krypton, and xenon [11]) overcame the above-mentioned temperature defect of the mercury-vapor strobe lamp and has made possible the modern equipment designs.

In 1936 a U-shaped argon-filled flash lamp was developed which had the output needed for photography and lacked the temperature problems of the mercury lamp. The equipment could be made with several lights, was portable, and used 115 volts 60-cycle line power; the exposure time was about 30 μsec. One such unit was loaned to Henry B. Kane in 1936. He used the equipment principally for photography to illustrate his series of nature books [12].

Gjon Mili was furnished a two or three lamp argon flash unit in 1937 for trial use in a New York studio. Mili, at that time, was working in New York as a Westinghouse lighting research engineer. Although we both were students at M.I.T. in the electrical engineering department in 1927, we did not get together on photographic problems until we both gave technical talks at an Illumination Society Meeting in Cambridge, Massachusetts. I recall

that Mili's demonstration of an overloaded mercury-arc flash lamp operating directly from the ac line succeeded in blowing out the fuses in the building so that the meeting of the Illumination Society was in the dark when my turn to speak arrived! Soon the fuses were fixed, and I had a good opportunity to demonstrate a two-lamp strobe system which had ample output for regular studio photography. Mili and I, at that meeting, set a date for a trial of the flash unit in a New York studio.

Figure 6-1 shows a high-speed photo of a dancer that was made as soon as I arrived in New York from Boston, hand carrying the flash unit. On the basis of our tests, a new flash unit with five lamp outlets was designed. My notes at the time (July 22, 1937) show five lamps with 48 μF at 3,500 volts on each. As I recall, provision was made later to reduce the capacity when a fast recharge was desired. The flash lamps were argon-filled, U-shaped, and mounted around a small tungsten lamp which could be used for modeling and reflector

Fig. 6-1 *Dance action photo taken in New York in 1937 during trial of multiple argon flash lamps.* (Photograph by Mili and the author.)

alignment. Figure 6-2 shows one of the lamp arrangements together with a "speedlite" single lamp driver that was to eventually become the Eastman Kodak Kodatron flash unit. Herbert Grier designed and built the five-outlet equipment for Mili as well as the equipment of Fig. 6-2. Germeshausen made the lamps.

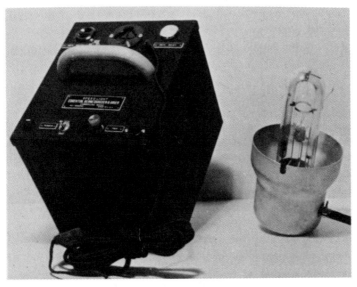

Fig. 6-2 *Right: a U-shaped argon-filled flash lamp mounted around a tungsten modeling lamp. Left: the driver circuit 112 μF at 2 kV (about 1937 or 1938).*

I personally like to unitize each piece of my equipment into a single lamp device. Each flash lamp is then complete with its own charging and triggering circuits. When two or more lights are required, photocells can easily provide positive synchronization!

All of us were busy with high-speed photography of various subjects in the early days. Not only were engineering and scientific problems studied, but also subjects of everyday interest. The photographs were distributed widely in newspapers and magazines. As an example, I give a partial list of subjects that were published in *Life* magazine [13], most of which were obtained by Mili with his five-lamp strobe system from 1939 to 1942.

A sequence of many high-speed photographs has been published in M.I.T.'s alumni magazine, *Technology Review* [14], from 1935 to 1940 with titles and comments by James R. Killian, Jr. Killian and I

decided to organize this material with other examples into a book of photographs. The main object of the book [15] was to cause an awareness of and to spread the use of the electronic flash system of photography. At the time the book was published (1939) there were no commercially available flash units. We put a "build-it-yourself" section at the back of the book, listing the circuit components that were needed and succeeded in generating a great deal of interest.

The book [16] was revised in 1954, with the addition of numerous high-speed photographs and a short technical section. The photographs in these two books, such as the one of the bat [16, p. 37], have been sources that artists have studied and used widely.

In the spring of 1939, we worked with the Eastman Kodak Co. on their display of high-speed photography at the World's Fair in New York. The company liked our suggestion of a baseball crashing into a glass window. Herb Grier designed a spring-operated baseball-shooting cannon, which upon command would throw the ball at a window pane in a darkened room which had camera ports (Fig. 6-3).

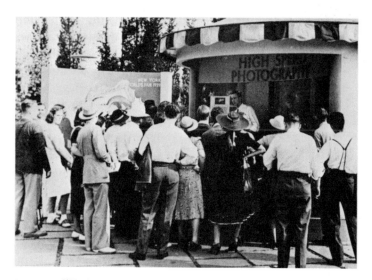

Fig. 6-3 *"High-speed Photography" pavilion of the Eastman Kodak Co., New York World's Fair, 1939.*

Enough time was allowed for all the shutter bugs to open their shutters on "time," or "bulb" so the flash-illuminated subject when it occurred would be recorded on their film. Many glass panes were broken by the end of the summer! Also, many photos were exposed

for souvenirs. After an outdoor lecture on electronic flash, the participants would point their cameras into the darkened room and open their camera shutters at command to photograph the crashing glass.

The Kodatron

The first electronic flash photography studio equipment to be widely accepted was the Eastman Kodak Kodatron flash unit which was made available to photographers in 1940. There are many of these units still in use today. The Kodatron unit (Fig. 6-4) consisted of an adjustable-height stand on a base with casters. The power supply rested upon a pedestal placed at a distance above the floor to permit the operator ready access to the switches and controls. The flash lamp was mounted in a satin finish 18-in. diameter reflector and adjusted to give a wide beam of light. The output was about 8,000 BCPS. A 112-μF paper capacitor charged to 2,000 volts was used in

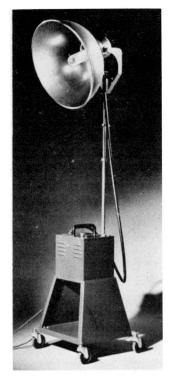

the Kodatron unit to discharge about 200 watt-sec into the flash lamp. The equipment, including the flash lamp, was designed in Cambridge, Massachusetts, by Kenneth Germeshausen, Herbert Grier, and the author. Production was by the Raytheon Company at Waltham, Massachusetts, under the control of our group.

The first flash lamp for the Kodatron equipment was made by the General Electric Co., according to the specification set by Germeshausen in 1940. The outer bulb was frosted to break up the light patterns caused by the lamp when used in a specular reflector.

A 50-watt tungsten lamp was used in the center of a 4½-turn spiral for alignment of the lamp and reflector. The continuous light enabled the photographer to adjust his reflectors and to evaluate the lighting on the subject. The life of the tungsten lamp was

Fig. 6-4 *The 1940 Kodatron flash unit.*

found to be much shorter than the flash lamp, and the cost of the tungsten lamp very much less than the flash lamp. The design was therefore soon converted to a double lamp (GE FT-403) so that the tungsten lamp could be changed without changing the flash lamp. This lamp is in widespread use today in studio units, and Fig. 6-5 shows the double socket and arrangement for changing the tungsten lamp.

The Eastman Kodak Co. became the exclusive sales agency for these units in 1940, but before this some 30 to 40 units had been sold directly to photographers. For example, Tirey Ford in San Francisco obtained three 200-watt-sec flash lamps for photographing dancers.

The Hearst papers were enthusiastic about the strobe and called their photographs "speed ray." George Woodruff, the local Hearst International News Service manager, and the author worked together on many assignments to explore the possible uses of the new electronic flash for news coverage. I recall one busy week in February, 1940 when we covered a track meet, a skating show, a swimming meet, a hockey game, a boxing exhibition, and a musical show. We used three 200-watt-sec units on most of these projects so that we had ample light for effective photography. The pictures were

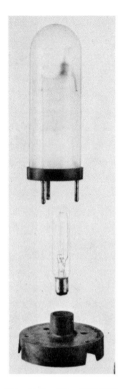

Fig. 6-5 *The FT-403 (glass spiral) and FT-503 (quartz spiral) are built to nest over a 100-watt tungsten lamp. Replacement of the tungsten lamp is accomplished by removing the flash lamp first.*

sent by wire to the various Hearst papers and were given large-size display. One picture of track runners on a curve was run full page in the *St. Louis Post-Dispatch*, February 18, 1940 (Fig. 6-6). The widespread appearance of the photographs and their quality and motion-stopping ability certainly had an influence on the entire industry and helped Eastman Kodak Co. make the decision to take over the sales distribution.

The Kodatron studio equipment was introduced to the photographic fraternity at a convention of the Professional Photographers

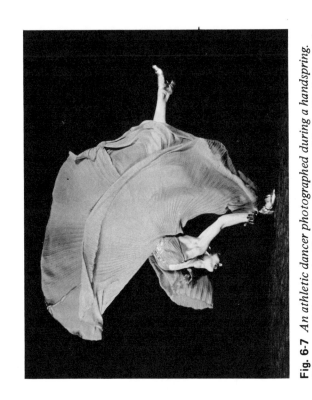

Fig. 6-7 *An athletic dancer photographed during a handspring.* [Photograph by Charles Kaufmann (from a 35-mm Kodachrome), 1940.]

Fig. 6-6 *Photograph of William Fritz, Charles Beetham, and Charles Quigley taken at the BAA track meet in the Boston Garden.* (Photograph by Bill Jones of the *Boston American.*)

Association (Stevens Hotel, Chicago, Ill.) in August, 1940. Charles Kaufmann of the Kaufmann-Fabry studio gave a demonstration of the equipment on the stage, including dancers in action. Figure 6-7 is from a Kodachrome 35-mm slide of one of the dancers taken during this demonstration. I used the open flash system to catch the action when Kaufmann operated his camera. The photographers at the meeting showed great interest in the new electronic flash system of photography. The production of the original Kodatron stopped at the beginning of World War II (1941 to 1942) after some 400 units had been distributed.

Figure 6-4 shows the original Kodatron flash unit that was introduced in 1940; many studio flash units today follow the same design trend. Its features include (1) the use of the equipment weight at the bottom of the lamp post for stability, (2) the use of a combination incandescent and xenon flash lamp to aid the photographer in lining up his light and evaluating shadows, and (3) the use of photocell triggering devices to flash several lights in synchronism without the need for interconnecting wires. The circuit of the Kodatron flash equipment is given in Fig. 6-8, as drawn by Herb Grier.

The full page spread in *Life* magazine of Joe Costa's famous strobe photo of Joe Louis (Fig. 6-9) was significant to me in that nothing was said in the caption about the high-speed photography aspects. This demonstrated that the electronic flash system was now an accepted fact in our technology, like radio, television, and air transport. In fact, almost all boxing photographs are now made with strobe lighting because of the excellence of the photographs.

Portable Kodatron

A portable battery-operated flash unit was designed by our same group and distributed in sample lots by the Eastman Kodak Co. in 1941. However, wartime restrictions stopped all production. A lead-acid four-volt storage battery of a nonspillable type was used for power. Conversion to high voltage was accomplished by a conventional vibrator, transformer, and rectifier; and the energy storage capacitor was rated 28 μF at 2,000 volts. Light was produced by the GE FT-220 sealed-beam lamp (Fig. 6-10) or by a GE FT-214 flash lamp electrically identical to the FT-220. The portable had the same type of trigger circuit as used in the Kodatron equipment and could be photocell or wire synchronized with other units.

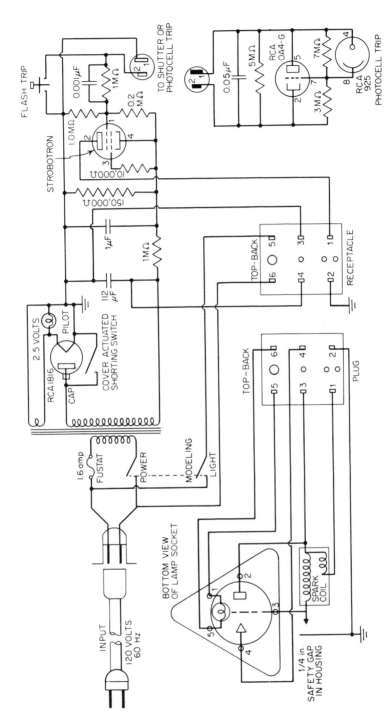

Fig. 6-8 *Electrical circuit of the 1941 Eastman Kodak Kodatron flash unit.*

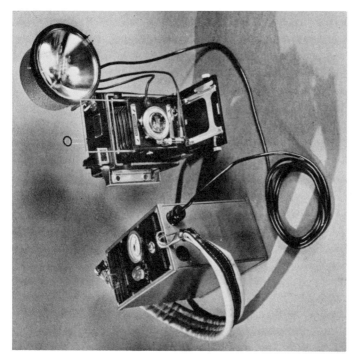

Fig. 6-10 *The 1941 Kodatron portable flash unit.*

Fig. 6-9 *Joe Costa's famous action photo of Joe Louis (1940).*

A battery voltmeter on the panel was found to be a very useful indicator of the condition of the battery. Charge of the battery was through an ac connection; and furthermore, the flash equipment could be operated from an ac line since the transformer was supplied with the proper voltage taps.

The use of low-voltage xenon flash lamps, electrolytic capacitors, high-voltage dry batteries, nickel-cadmium batteries, transistor voltage convertors, improved reflectors, etc. have had a vast influence upon the design of today's portable electronic flash equipment. Some of these units are mentioned later in this chapter.

The full efforts of Germeshausen, Grier, and the author were directed to aerial night photography and other military projects during the 1941 to 1945 period. An account of some of the equipment developed for aerial reconnaisance will be given in Sec. 12-B.

After the Second World War our group in Cambridge and the Eastman Kodak Co. mutually decided to discontinue the prior exclusive arrangement. As a consequence many organizations designed and built flash units with our full cooperation. Soon the electronic flash system became of common use, and its designs and applications are still growing.

High-power Professional Flash Equipment

A 3,200-watt-sec flash unit, with three large flash lamps (GE FT-503) was designed at the end of the war by our group for color photography and manufactured by the Raytheon Co. Some twenty-five of these were sold by the Eastman Kodak Co. under the name Color Kodatron. Figure 6-11 shows this unit at work in an Eastman Kodak studio, Rochester, N.Y. Notice that the equipment is in four boxes for portability and adaptability. The light output was the following:

1. Power unit on one lamp, 14 μF at 4 kV: 5,200 BCPS
2. Power unit plus 1 condenser bank on 1 lamp, 123 μF at 4 kV: 67,200 BCPS
3. Power unit plus 2 condenser banks, 232 μF at 4 kV: 128,000 BCPS
4. Power unit plus 3 condenser banks, 341 μF at 4 kV: 205,000 BCPS
5. Power unit plus 4 condenser banks and 2 lamps, 450 μF at 4 kV: 275,000 BCPS

The total light output could be split by using one, two, or three flash lamps. The charging time for the power unit alone is 1.5 sec

while the total equipment requires 15 sec to charge. Inductors were used in series with the lamps to reduce the noise and the explosive strain on the flash lamps. Multiple lamps were necessary when more than 350 μF were used at one time.

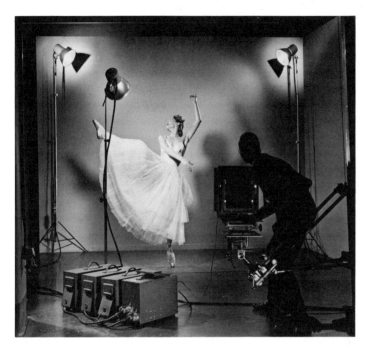

Fig. 6-11 *Robert Phillips using color Kodatron three lamp 3,200-watt-sec flash equipment to photograph a dancer at the Eastman Kodak studio.*

The Sunflash

The next step in size was the EG&G Sunflash which was designed by Fred Barstow for the Commercial Illustrators color studio in New York City. A total energy of 10,000 watt-sec was employed for large subject area coverage in color at small camera aperture.

The goal was to imitate outdoor photography where a small, single source produces a sharp shadow. Reflected light from the walls of the room fills in the shadows in somewhat the same way as sky light does. The Pogano studio in New York mounted the single Sunflash lamp on a semicircular track around the studio so that the angle of the beam could be changed easily (Fig. 6-12). The walls were lined with white venetian blinds which could be adjusted in opening to change the ratio of the fill light to the direct.

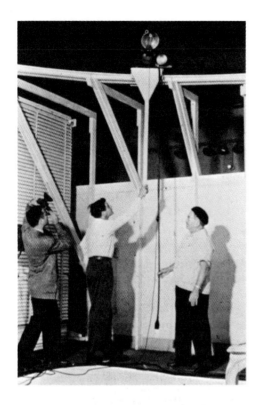

Fig. 6-12 *The Sunlight 10,000-watt-sec strobe lamp on a circular track in the Pogano studio, New York.*

At the time of the Sunflash development, there was an active wintertime outdoor studio activity in Arizona, principally on mail-order fashion photography. The Sunflash made it possible to do the photography in New York at a considerable saving and convenience to the customers. Now there are many studios with large flash units that can accomplish almost any photographic assignment.

Descendents of the early Sunlight equipment are now in active use wherever professional photography of large areas is required. The GE FT-617 flash lamp, which was originally designed for night aerial photography during the war, is used. It is often used with a small reflector for producing a shadow with a sharp edge resembling sunlight. A modern studio also uses large-area sources and a large reflector. The fill-in light is obtained from a large light-colored reflector on the opposite side from the lamp.

The present day large studio flash units of the Ascor Co. and others follow and expand the application of these early experiments with large size flash lamps. Harry Parker at Ascor has long been active in the development and application of flash equipment for photography and other uses.

Electronic Flash Today

As stated before, several times I started to make a complete catalog of all the flash units that are available to the photographer and scientist today. It proved to be too big a job for me so I gave it up. New units are coming out every year to further complicate the picture.

As an example consider Fig. 6-13 which shows some of the current line of flash units that are available from one manufacturer, the Heiland Division of Honeywell, Inc. Seven types of lamps are available for use with cameras. Another lamp is used for copying and is shown in greater detail in Sec. 12-H. Why so many? Well, the power source is one of the main reasons. Some of the devices are operated from the ac line. Others (not shown) use the expendable dry battery, while others use the nickel-cadmium rechargeable battery. The advantages and disadvantages of each were discussed at length in Chap. 4.

The charging time between flashes and the light output are other variations between models. There is also the ring light around the

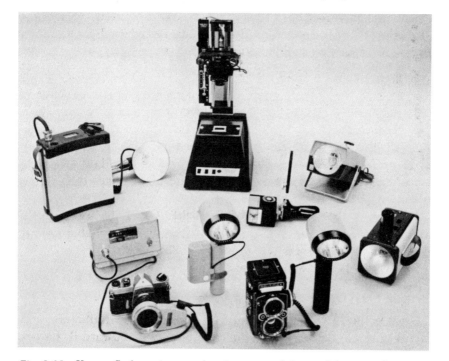

Fig. 6-13 *Xenon flash equipment showing some of the models currently available from one manufacturer.* (Heiland Division of Honeywell, Inc.).

lens which produces flat uniform lighting for closeup photography.

One important decision always arises when one is considering the design or purchase of a portable flash unit. Shall the battery be separate from the lamp house? It seems to be a question of how much the performance can be compromised. Now that films are faster, one can do with less light; and the amateur does not need as many flashes as the professional photographer. Flash units with small batteries in the handle or the flash head are commonplace. Other units have a dry-battery case which is worn on the belt of the photographer. In all cases a sync. cable is required from the flash unit to the camera shutter (X type) to command the light to flash when the shutter is open.

The Auto-Strobonar [20] model 660 has an automatic light integrating circuit to reduce the light from the flash so that the exposure is correct. A weak flash also has a shorter flash duration. It is an interesting lamp for those who like automatic devices.

A visitor to a modern photographic store will find many xenon flash photographic units to interest him. First, he will find some *very small* flash units. He should find the limitations of these since a small design usually means that something has been omitted. Sometimes the limitations are hard to find in the advertising media. Questions such as the following should be asked:

1. Does the BCPS from the 2d, 3d, 4th, . . . , 10th flash vary much compared to the first after the advertised charging time is expended?

2. How many flashes can be obtained from a new battery (or a fully charged one)?

3. What is the guide factor with color film, such as Kodachrome II? (I prefer to know the BCPS output so I can calculate the guide factor myself.) Advertised guide factors are often larger than I care to use.

4. What is the beam angle of the light? Can it be used with a normal 50-mm lens on a 35-mm film without objectionable fall-off of the light in the corners?

5. What is the "flash duration"?

Portable Flash Units

Great effort has been expended on the design, manufacture, and sale of portable flash units of the electronic type. Edward R. Farber has the following to say [17] :

In May of 1940, Harold Edgerton showed me a perfectly practical battery portable while I was visiting M.I.T. In October of 1940 this writer demonstrated his first battery-AC portable. In September of 1941, J. Winton Lemen of EK came through Milwaukee taking orders for Kodatron battery-AC portable and it was used by the *Milwaukee Journal* to photograph the Legion convention. In 1942, Strobo Research delivered 13 battery portables to the *Milwaukee Journal*. In 1945 the Wilcox Battery Portable Stroblite appeared. Very early in 1946 Harry Parker, now president of Ascor, put his first portable on the market. Henry Dormitzer's Synchtron and the Wabash Battery Electroflash came into the market. Later that year Reliance, Seminar, Everflash, King Sol and many others were offering battery portables. Even Raytheon announced a model, and portables flooded the market. The first Heiland-designed Strobonar did not appear till several years later.

Out of 36 companies making electronic flash equipment in 1948, only three do so today, the rest having failed, merged, been absorbed, or discontinued the product.

Ed Farber's monthly column in *Photo Methods for Industry* has been a very helpful source of information on electronic flash. He is always scooping up information about new products and ideas. Farber has given information (*P.M.I.*, November, 1965) on the Heiland Auto-Strobonar flash unit which has an automatic integrator to prevent overexposure, in the range from 2 ft to 20 ft. The automatic feature is a circuit that puts a low-resistance load across the capacitor after the photocell shows that the correct amount of light has been reflected from the subject. The flash duration is shorter for the closeup use.

Paul R. Farber [18] has given a valuable detailed analysis of small portable flash units that were available in the fall of 1966. He first relates in an amusing manner his personal experiences with an early "portable" (60 pounds) after the war at a six-day bicycle race. Thus, as a qualified and experienced strobe user, he points out that there are today on the market a host of small transistorized miniaturized flash units which are advertised appealingly, regarding performance. His theme is to compare these small portable units by the USASI standard (PH3.40, 1962) for guide factors with actual photography and to point out features that he thinks are important. Farber wants a detachable cord for his sync. connection and a pushbutton for operating the flash. Many small units do not have these features. Likewise, he wants a portable with an indicator that shows the

Table 6-1 Rated and Experienced Guide Factors for Portable Flash Units*

Unit	Catalog guide factor for Kodachrome II	Farber's suggested guide factor
Agfatronic	40	28
Braun F-260	40	32
Braun F-40	48	32
Cornet 100	44	38
Cornet 220	60	53
Heliotron I	35	22
Heliotron Supra	40	32
Mecablitz 117	32	28
Mecablitz 118	40	45
Monojet BL	40	36
Monopak	40	32
Spiralite	40	29
Stroboflash I	45	43
Strobonar 400	50	45
Trioblitz X-15	40	29
Ultima 40-B	40	38
Vivitar 40	40	28

*Reported by Paul R. Farber in *U.S. Camera* [18].

amount of light that will occur because of battery condition. He recommends that the shopper for a portable should look for one with a battery monitoring device.

Paul Farber tested 17 flash units. Presumably he put in a new or freshly charged battery and waited until the capacitor was fully up to voltage before he made his exposure. Perhaps he fired the flash unit once and then waited 10 sec before he made his test shot. He did not report this in his article. From my experience with small units it often makes a big difference!

There is a variation of light output from different samples of a type of flash unit due to capacitor, flash lamp, and reflector variations. Perhaps Farber happened to pick a model in the lower output bracket for his tests for some of the units. The manufacturers of flash equipment should have quality control of the light output of their products with limits of rejection.

It is important to note that all except one of the 17 units have a

lower guide factor than rated. Many of my friends who purchase new ultrasmall portables find (like Paul Farber) that their photographs on Kodachrome II are underexposed when the recommended guide factors are followed.

I found Peter Stackpole's comments in *U.S. Camera* [19] most amusing. Apparently Peter is a connoisseur of old flash units both as a collector and as a repair man. The following is a quote from his article:

> I guess this fascination of mine for 'strobes,' which is a common designation for electronic flash, began at the close of the Second World War. Dr. Edgerton, grand-daddy of the high speed flash, had made it possible for Gjon Mili to take those remarkable studio pictures with arrested action. There were artful studies of musicians, dancers, athletes, nudes descending the stairs, etc. which were the envy of us all. Surely, we thought, Mili had a great advantage having a corner on all that equipment.
>
> It wasn't long, however, before strobe equipment began to appear on the market. Soon enough, bad and colorless examples of frozen action photography saturated the market, putting Mili's photography in a class by itself. Mili always argued that seeing and understanding action and lighting enabled him to capture the essence and feeling of action even though it was stopped, sometimes at 1/10,000 of a second.
>
> It wasn't a desire to own heavy studio equipment that started my preoccupation with the strobe, but the vision and possibility of having a portable light source that promised consistent synch with the shutter. (This had always been sort of hit-or-miss with flashbulbs when higher shutter speeds were necessary.) The action-stopping ability of the electronic flash *could* be taken for granted, but what was more important was a consistent and dependable light source, in single and multiples, that *was* portable.
>
> You should have seen some of the Rube Goldberg contraptions that appeared during the mid-forties. Once a man appeared at the office with an electronic vest strobe, easily weighing 50 pounds, which I was to rent in order to cover some ice skaters. Knowing something of the high voltages needed to flash the tube, I shuddered to think of my prospects for survival when I would be slipping around on the ice with it. Fortunately, when the vest-strobe was being demonstrated it began sputtering, making loud pops and smoking. It finally died right there in the office.
>
> Soon the portables became smaller. Some weighed as "little" as 18 pounds, with their heavy oil-filled condensers. G.E. emerged with a seal-beamed flash tube, while Eastman made a few portables, which were later discontinued. Several manufacturers were making portables, mainly

for the professional market, and they threw out quite a bit of light, despite the fact that films of that day were too slow to do them justice. Finally, the big breakthrough came with the light-weight electrolytic condensers, high voltage dry batteries, flash tubes that fired on less voltage, and finally transistorized circuits and nickel cadmium batteries with their unlimited recharging.

Today several of the big strobe manufacturers have dropped the ·portable, making only the studio units. Others have gone after the amateur market with the miniaturized strobes, some of which weigh as little as 10 ounces. There are still enough strobes being made with the features needed by the professional: sufficient light output, reasonably light weight, fast recycling, at least 150 or more flashes per battery charge. Most of these features can't be found in the miniaturized amateur models, because performance and light output have a definite relation to the weight and bulk you must carry.

Stackpole concludes his column by listing the 18 or so flash units of many types (all old or used or both) that he traded for a long focus lens in Brooks store. I hope Peter had a lot of fun with these!

Studio Flash Units

In 1936 and 1937 several people suggested to me that studio photographers could use the electronic flash system for normal portraits. This seemed to me to be an unneeded complication since the electronic flash equipment was much more expensive than a tungsten lamp. The flash lamps were essential in scientific and engineering tasks to stop rapid motions but not in studios.

One day in 1938 or 1939, I received a phone call from the wife of an M.I.T. professor. She had just taken her year-old son John to the M.I.T. portrait studio. John was a jumper, and all the negatives were blurred. She asked if I could move my lights into the studio to photograph her son. Three 200-watt-sec flash units with photocell control were installed. I used the equipment on nights and weekends while Mr. Jackman in the studio kept them busy during the day. He put out a small announcement through M.I.T. channels. Soon there was a growing business. I began to see that the strobe system could be used with success in the studio. Once a photographer starts to use the strobe, he is committed to it from then on for every photographic task. One fringe benefit is the lack of heat from the flash lamps compared to continuous tungsten lamps. It makes a difference in the amount of air conditioning equipment that is needed.

These lamps at the M.I.T. studio were left in operation for many years. I took them out recently to donate them to the Smithsonian Institution in Washington, D.C. in response to a request for early electronic flash equipment. The lamps were still going strong when removed.

The commerical studios needed considerably more light than the portrait studio. For them larger and more flexible systems were put into production. I remember when phone calls came in from several manufacturers of tungsten lighting fixtures. Would I help them design a strobe system? I said I would but recommended other persons who had some very good designs and not much production. At the present time there are many sources of studio equipment with variations in output, types of reflectors, and other conveniences. I expect the future to bring new models and improvements.

Short Duration Xenon Flash Lamps

There are often examples where a short flash of light is required to prevent blur of a photograph of a subject. Listed below are several specific subjects and the required flash duration to prevent blurred pictures of them:

Subjects	Approximate flash duration to prevent blur		
Dynamite caps	1/10,000,000	sec	(0.1 μ sec)
Bullets	1/1,000,000	sec	(1 μ sec)
Golf balls (closeup)	1/100,000	sec	(10 μ sec)
Birds' wings	1/10,000	sec	(100 μ sec)
People and other slow subjects	1/1,000	sec	(1,000 μ sec)

The design of a powerful flash unit with a short flash duration brings up several inherent limitations. To be specific, look at the flash duration data on the efficient FX-1 flash lamp (Chap. 2). Flash durations below 10 μsec are not listed.

Xenon flash lamps apparently cannot be made to produce flashes of light shorter than about a microsecond unless the quantity of light is reduced. One factor influencing duration is the *afterglow* in the gas following the excitation caused by the discharge. This glow usually exists for ten or more microseconds under pulsed conditions. Other gases, although less efficient, do have less afterglow in the gas. In this

class are oxygen, nitrogen, hydrogen, chlorine, and various gas mixtures. Practical designs of short flash equipment using an extended air spark discharge will be given later.

The flash duration can be reduced by using a flash lamp with a shorter length and a larger tube diameter. In addition to a short flash, the lamp may have a higher efficiency and a much higher concentration of candela per unit area. It is common practice to increase the pressure to at least an atmosphere in small lamps so that there will be a larger number of xenon molecules in the gap.

Once the tube resistance is less than a fraction of an ohm the external circuit conditions such as the inductance and resistance in the capacitor and circuit may play the deciding role in limiting the current, peak light, and flash duration. One finds experimentally a tremendous difference in capacitors due to the way in which the conductors are internally connected. Naturally when a short flash is desired, the internal series inductance of the capacitor must be held to a minimum. The capacitor manufacturer gives a hint regarding the conditions when he specifies the natural frequency of the capacitor since the flash duration cannot be less than one-half cycle. For example, a capacitor with a frequency of 30,000 cycles per second will not be capable of producing a flash of less than 1/60,000 sec (16.7 μsec), and the flash may be longer if the current oscillates for more than a half cycle.

Electrolytic capacitors are not suited for short flashes for several reasons: (1) the current in the conventional electrolytic capacitor should not be permitted to oscillate and (2) the electrolytic capacitor has an internal resistance* which dissipates some of the stored energy. For equipment with a flash duration of more than 100 μsec, the electrolytic capacitor is preferred to paper capacitors for the important reasons of reduced weight, volume, and cost.

Chapters 7 and 8 give details of flash equipment with exposures of less than 200 μsec. Such equipment is required for nature photography of birds in flight, bullets, and other rapidly moving subjects.

REFERENCES

1. Edgerton, H. E., K. J. Germeshausen, and H. E. Grier, High-Speed Photography, *Phot. J. Royal Photographic Society of Great Britain,* vol. 76. pp. 198-204, 1936.
2. Edgerton, H. E., K. J. Germeshausen, and H. E. Grier, High Speed Photographic Methods of Measurement, *J. Appl. Phys.,* vol. 8, pp. 2-9, 1937.

*This internal resistance is called ESR for Effective Series Resistance.

3. Edgerton, H. E., Stroboscopic Moving Pictures, *Elec. Eng.*, vol. 50, pp. 327-329, 1931.
4. Edgerton, H. E., The Mercury Arc as a Source of Intermittent Light, *J. SMPE*, vol. 16, pp. 735-741, 1931.
5. Edgerton, H. E., and K. J. Germeshausen, Stroboscopic Photography, *Electronics*, vol. 45, pp. 220-221, July, 1932.
6. Edgerton, H. E., Stroboscopic and Slow-Motion Pictures by means of Intermittent Light, *J. SMPE,* vol. 18, pp. 356-364, 1932.
7. Edgerton, H. E., and K. J. Germeshausen, The Stroboscope and High-speed Motion-picture Camera as Research Instruments, *Trans. Am. Inst. Chem. Engrs.*, vol. 30, pp. 420-437, 1933-1934.
8. Edgerton, H. E., and K. J. Germeshausen, Stroboscopic-light High-speed Motion Pictures, *J. SMPE*, vol. 23, pp. 284-298, 1934.
9. Edgerton, H. E., High Speed Motion Pictures, *Trans. Am. Inst. Elec. Engrs.*, vol. 54, pp. 149-153, 1935.
10. Edgerton, H. E., K. J. Germeshausen, and H. E. Grier, Multiflash Photography, *Phototechnique*, vol. 1, no. 5, pp. 14-16, October, 1939.
11. LaPorte, M., "Les lampes à éclairs lumière blanche," Gauthier-Villars, Paris, 1949. (Other LaPorte references in Chap. 3.)
12. Kane, H. B., Series of nature books, Alfred A. Knopf, Inc., New York.
13. Mili, G., see list of *Life* magazine photos following these references.
14. Edgerton, H. E., see list of *Technology Review* photos.
15. Edgerton, H. E., and J. R. Killian, Jr., "Flash, Seeing the Unseen," 1st ed., Hale, Cushman & Flint, Boston, 1939.
16. Edgerton, H. E., and J. R. Killian, Jr., "Flash, Seeing the Unseen," 2d ed., Charles T. Branford Co., Newton Centre, Mass., 1954.
17. Farber, E. R., Electronic Flash, *Photo Methods for Industry*, vol. 8, no. 1, November, 1965.
18. Farber, P. R., Electronic Flash, a Comparative Study, *U.S. Camera*, October, 1966, p. 52.
19. Stackpole, P., 35 mm Techniques, Strobes as a Sideline, *U.S. Camera*, September, 1966, pp. 28-30.
20. Forney, J., Honeywell's Auto-Strobonar Electronic Flash, *Popular Photography*, October, 1965.

EXAMPLES OF STROBE PHOTOGRAPHY

Examples of strobe photography by Gjon Mili which appeared in *Life*

Fencing 1-2-39	Drums 6-9-41
Roosters 4-17-39	Ted Williams 9-1-41
Javelin 6-19-39	Baseball curve 9-15-41
Hurdles, high jump 6-19-39	(Comments on baseball curve 10-6-41)
Tennis, Alice Marble 8-28-39	Production 10-13-41
Acrobats 11-4-40	Harmonica 10-20-41
Dancers 11-11-40	Dancer 1-12-42
Horses 11-25-40	Ballet 1-19-42
Basketball 1-9-41	Table tennis 3-9-42
Siamese fish 1-20-41	Gym 5-18-42

Dancers 3-10-41
Billiards 4-21-41
Baton twirler 4-28-41
Baseball 5-12-41
Poker 6-9-41

Soap bubbles 7-14-42
Comic dancers 7-14-42
Tango dance 10-30-42
Knitting 11-24-42
Dancer 12-10-42

Other subjects: Bullets in airplane gas tank, Color photos of dancers, Paddle tennis, Diving, Track, Color of Cardinal Spellman, Color of "Keep off the Grass," Baseball, Badminton, Style show, Dogs, People in action, Circus, Rain, Wrestlers, Football, Track Borican

Examples of strobe photography by Harold Edgerton which appeared in *Life*

Milk splash 11-20-39
Other photos from "Flash" 11-20-39
Physics experiments 7-28-41
Circus 6-22-42
Martel and Mignon (dance team) 10-27-42

Examples of strobe photography by Harold Edgerton which appeared in *National Geographic Magazine*

Hummingbirds in Action, August, 1947
Circus Action in Color, March, 1948
Freezing the Flight of Hummingbirds, August, 1951
Photographing the Sea's Dark Underworld, April, 1955
Stonehenge, June, 1960

Examples of strobe photography which appeared in *National Geographic Magazine*

Allen, A. A., A New Light Dawns on Bird Photography, June, 1948
 Split Seconds in the Lives of Birds, May, 1954
 Stalking Birds with Color Camera, 1951 (also in a book)
Davidson, T., Freezing the Trout's Leap, April, 1958
Greenewalt, C. H., Hummingbirds, November, 1960, January, 1963, July, 1966
 Hummingbirds (a book published for the American Museum of Natural History, Doubleday & Company, Inc., New York, 1960)
Griffin, D., Mystery Mammals of the Twilight (Bats), July, 1946
McCue, J. J. G., Bats Hunt With Sound, April, 1961

Photographs made by Harold Edgerton in *Technology Review* (some with Kenneth Germeshausen and Herbert Grier)

Vol. 34, April, 1932, p. 278 A falling drop of milk at 480 exposures per second
Vol. 34, July, 1932, pp. 376-377 Splash of a milk drop
Vol. 35, November, 1932, p. 58 Golf ball impact
Vol. 35, November, 1932, p. 59 Water from a faucet
Vol. 35, January, 1933, p. 142 Fracture of a lamp

Vol. 36, December, 1933, p. 86 Flight of a fly
Vol. 36, December, 1933, p. 104 Cup fracture
Vol. 36, December, 1933, p. 105 Flowing liquid
Vol. 36, January, 1934, p. 138 Pane of glass
Vol. 36, January, 1934, p. 144 Soap bubbles
Vol. 36, April, 1934, p. 268 Fan with smoke
Vol. 36, July, 1934, p. 344 Mosquito, tennis ball
Vol. 36, July, 1934, p. 345, Glass of milk
Vol. 37, October, 1934, p. 24 Sandpipers
Vol. 37, October, 1934, cover Birds in flight
Vol. 37, December, 1934, p. 100 Steel quenching
Vol. 37, January, 1935, p. 144 Football
Vol. 37, February, 1935, p. 180 Clam cilium
Vol. 38, October, 1935, p. 8 Baseball, boxer
Vol. 38, January, 1936, p. 150 Airplane wing
Vol. 38, February, 1936, p. 187 Surface tension
Vol. 39, November, 1936, p. 23 Pouring liquid, hummingbirds
Vol. 39, January, 1937, p. 104-105 Bubble formation
Vol. 39, April, 1937, p. 222 Milk drop crown splash
Vol. 39, February, 1937, p. 156-157 Rolling steel strip
Vol. 39, May, 1937, p. 278 Vocal folds
Vol. 41, November, 1938, p. 8 Glass fracture
Vol. 41, January, 1939, p. 132 Golf multiflash
Vol. 41, January, 1939, p. 133 Golf multiflash
Vol. 41, March, 1939, p. 194 Discussion of golf photo
Vol. 41, July, 1939, cover and p. 385 Pelton wheel
Vol. 42, January, 1940, p. 107 Announcement of "Flash"

7 ELECTRONIC
FLASH EQUIPMENT
OF SHORT EXPOSURE TIME

The commercial inexpensive, efficient, light-weight electronic flash equipment that is available today usually has an exposure time of more than 200 μsec. Therefore, it is not satisfactory for those who wish to see sharp and blurless photographs of rapidly moving objects, such as the wings of birds or bullets. Flash equipment for 1 μsec or less will be described in this chapter, followed by a description of equipment in the 200- to 1-μsec range in Chap. 8.

Short Flashes of Light (Less Than 1 μsec)

Let us define *short* as flash durations of less than 1 μsec. This type of flash source is required for the photography of bullets and other high-speed objects without appreciable blur on the negative image. Flashing lights of short duration are also required for small objects that are enlarged by the camera since the effective velocity of the object is thereby enlarged by the optical magnification.

There are three requirements of the capacitor discharge circuit and flash lamp that must be met for a short flash of light.

1. *The capacitor discharge circuit must have a small inductance.* In other words, the frequency of discharge must be high. A charged capacitor of C farads when switched into an inductive discharge circuit of negligible series resistance will cause a current to flow that oscillates according to the following equation:

$$i = E \sqrt{\frac{C}{L}} \sin \frac{t}{\sqrt{LC}}$$

where E = initial voltage across the capacitor in volts
 L = inductance of discharge circuit in henries
 t = time in seconds
 i = current in amperes

In the limiting condition, the inductance mentioned above is the inductance of the connecting wires between the capacitor and the flash lamp. To this inductance must be added the series *internal* inductance of the capacitor.

There can be a great variation of this internal inductance depending upon the manner in which the capacitor is made. For many applications, such as power factor correction, there is no need to reduce the internal inductance. However, for high-peak-current circuits, the internal inductance of the capacitor is usually the circuit component that limits the current. Capacitors for large-current pulses of high frequency are constructed with many internal connections or edge-connected foils.

The inductance of capacitors for pulse use are given as part of the rating. If one has a capacitor in the laboratory of unknown history, he should measure the internal inductance. One convenient way is to short-circuit* the capacitor at low voltage and to use a cathode-ray oscilloscope to measure the time period of a cycle of the discharge current. Then $T = 2\pi\sqrt{LC}$ seconds per cycle from which the inductance L can be calculated since C is known.

It follows that capacitors that are to be used for creating fast, short flashes of light *must* have a high frequency of discharge, or stated another way, they must have a very small internal inductance. The short-circuit frequency will then be high.

*This short-circuit test requires a special "no-bounce" switch, such as a mercury-wetted relay or a mercury switch.

2. *The circuit oscillations must be damped.* A slightly damped circuit will have a sinusoidally varying current that is damped by a factor $e^{-tR/2L}$ The critical resistance is $R_c = 2\sqrt{L/C}$ ohms; and since $T = 2\pi\sqrt{LC}$, the critical resistance will be $R_c = T/\pi C$ ohms. As an example, let $C = 0.05~\mu$F and $T = 1~\mu$sec, then

$$R_c = \frac{10^{-6}}{(\pi)(0.05 \times 10^{-6})} = 6.5 \text{ ohms}$$

The spark light source or the flash lamp that is excited by the capacitor can be used as the damping resistor. However, the *resistance* of a spark or a flash lamp is *not* an ohmic linear device. The volt-ampere characteristic of a spark gap is a very nonlinear one. Most sparks are much less than 1 ohm during discharge. Thus, a capacitor discharge into an open air spark is almost always oscillatory and several (or many) cycles of current will flow. The effective duration is then much longer than the half-cycle period of the discharge circuit as calculated from the capacitance and inductance.

It has long been known that a spark on an insulating surface [1], such as glass, has several unusual characteristics that can be used to advantage in high-speed photography. An extended spark on an insulating surface has two advantages: (1) the "resistance" can be greater than for an open spark due to the longer arc length that can be used and (2) the light-producing efficiency is improved since more of the energy from the capacitor is converted into light. Also, the afterglow is less since the energy per unit volume is reduced, and the insulating surface tends to cool the arc. A flash unit based on this principle will be discussed shortly.

3. *The afterglow in the gas discharge must be quenched.* The rare gases neon, argon, krypton, and xenon when energetically excited by capacitor discharges have a strong afterglow of light after the current has ceased. The intensity and the decay time of the afterglow becomes greater when the energy per unit volume is increased. Xenon, for example, in the General Radio Strobotac (type 1531A) shows very little afterglow on the low-intensity position but plenty (10 μsec or more) in the high-intensity position.

As pointed out in the previous section, afterglow seems to be less if the arc is extended so that the energy per unit volume is small. This requirement is diametrically opposite of the need for a small intense point source of light as required for silhouette photography.

The Microflash Equipment

A complete flash unit (EG&G, Inc. type 549) with ample light output for reflected light photography and with appropriate triggering circuits based on the ideas of the preceding discussion will now be described.

After considerable experimentation, a "guided" air spark [2], was selected as a practical source for reflected light photography. Xenon and argon, as active gases, were rejected since the afterglow of light lasted too long.

Details of a "guided" arc source [2] in air are shown in Fig. 7-1. The gap is about an inch long on the outside of a 7-mm-OD Pyrex or quartz tube. Starting is facilitated if the electrodes are adjacent to and in contact with the tube walls adjacent to the starter electrode since starting is definitely a surface phenomenon on the quartz insulator. The 16 kV applied to the electrodes is insufficient to cause an arc to start; however, if a high voltage (2-cm spark) is suddenly impressed on the *inside* of the quartz tube, conduction starts very quickly. The inside diameter of the quartz rod is about 2 mm in the tube illustrated. Air at atmospheric pressure is used as a gas since the afterglow of light following the flash is of short time duration and is of a red color. Figure 7-2 shows an oscillogram of the light output of the bare lamp, whose one-third peak duration is about 0.4 μsec and whose peak light is about 5 million horizontal candela.

The above lamp is excited by two series capacitors of 0.1 μF totaling 0.05 μF and charged to 16 kV, which store about 6.5 watt-sec of electrical energy. The efficiency is about 0.3 HCP per watt. Every effort must be made to keep the inductive wire loops in

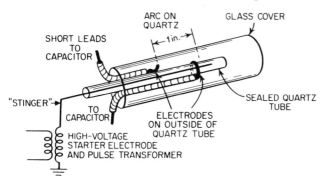

Fig. 7-1 *Guided air spark (16kV, 0.05 μF) for producing a flash of light having a duration of about 0.5 μsec.*

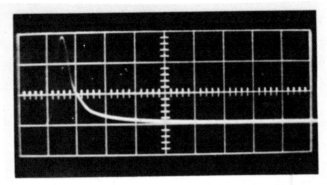

Fig. 7-2 *Light output as a function of time from the microflash equipment. One division = 0.5 μsec. Peak light = 5 × 10⁶ CP.*

the discharge circuit to a minimum if the flash is to be of short duration.

A ⅞-in.-OD glass tube is used on the outside of the guided spark to insulate the high voltage from the reflector and also to reduce the noise from the spark. A rubber cork is used to close the open end of the outside tube to further reduce the noise of the spark.

For bullet photography, the light output should be concentrated into a narrow beam so that an intense spot can be aimed at the event. The assembly can be mounted into a box for practical use (Fig. 5-2). Here a specular reflector produces a spot of about 10 in. diameter at a distance of 3 ft from the lamp. An aperture of $f/8$ is suitable with Plus X film, especially if a light background can be used to outline the dark portions of the bullet and if prolonged development is employed. The photograph of the .30-caliber bullet (Fig. 5-1) as it emerges from a cake of soap was taken with the above strobe.

Triggering of the light at the desired instant to catch the action is often the most difficult task in high-speed photography. Various methods involving electrical contacts, microphones, or phototubes are employed depending upon the problem at hand. Figure 7-3 shows a trigger unit circuit employing all the above methods for the microflash lamp. An adjustable time-delay circuit is also incorporated in the circuit so that different phases of a repeatable action may be studied as desired.

Two microflash equipments can be used to obtain two photographs on a single film at a small time-interval separation. Control of the first flash is from the bullet sound wave which contacts a microphone in the usual manner. A voltage is produced which triggers the first light. The phototube control on the second lamp can

be triggered by the light when the first lamp flashes. A suitable time delay is set into the control element of the second lamp so that the desired delay between the flashes is obtained.

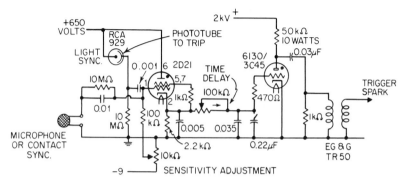

Fig. 7-3 *Trigger circuit as used with the microflash equipment. Contact sync., microphone sync., or phototube sync. can be used to control the flash. A time-delay circuit is also incorporated.*

Shadow Source

The microflash unit can be converted into a point light source by removing the flash lamp and substituting a special spark gap (Fig. 7-4) across the capacitor. There is ample light output to directly expose many types of films without a lens at a distance of about 1 to 2 meters. The subject is placed close to the film so that a silhouette image is created on the film. Refraction through the air permits the photography of the shock waves. Figure 7-5 shows a silhouette photograph of a .30-caliber bullet after it has penetrated a Plexiglas strip.

Very Short Flashes (10^{-7} to 10^{-8} Sec)

As indicated by the theory of the circuits and the gas used for the spark, the production of very short flashes of light dictates the use of very small capacitors with a minimum of self- and circuit inductance. Also, air or some other gas with a short afterglow is required.

Since the capacitor is very small in size, it can be charged very quickly to the self-breakdown voltage of a spark gap directly across the terminals. Such a circuit is shown in Fig. 7-6. The switch tube or SCR initiates the charging cycle when triggered. Energy from the capacitor C_1 is discharged into the small capacitor C through the step-up transformer. When the voltage reaches self-breakdown, the spark gap fires and a brief flash of light is produced.

A series of four donut-shaped capacitors [2] designed to reduce the self-inductance were built and tested with a traveling wave

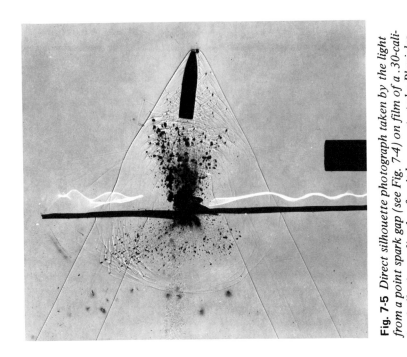

Fig. 7-5 *Direct silhouette photograph taken by the light from a point spark gap (see Fig. 7-4) on film of a .30-caliber bullet immediately after it has penetrated a Plexiglas strip.*

HIGH-VOLTAGE
SPARK WIRE

QUARTZ
TUBE

ELECTRODE

INSULATOR

BRASS ELECTRODE

HOLE FOR LIGHT

TO FILM

"POINT SOURCE OF LIGHT"
ARC PATH

TERMINALS TO
FIT CAPACITORS
IN FLASH UNIT

Fig. 7-4 *Spark gap adapter for the microflash equipment. Light emerges from a small hole in the metal plate.*

arranged behind the display of transparent strobe discs which are gear driven by a motor controlled by an adjustable tuning fork (55 cycles per second). The flashing of the neon strobe lamp is caused by the sound that strikes the microphone. When the frequency of the

Fig. 9-6 *A mercury-arc stroboscope, held by Germeshausen, to observe the action of valve springs of a gasoline engine at high speed in the engine lab at M.I.T., 1934. The author is preparing to take the motion picture. The motion-picture camera must be operated slower than the strobe so that multiple exposures will tend to overcome the flicker caused by the shutter.*

sound and the speed of one of the discs correspond, then a stationary pattern is observed and the frequency is determined.

A pure tone, such as produced by a flute, will cause only one pattern of black lines (spokes) to appear. The tone from a violin which has many overtones of different frequencies will cause several pattern bands to appear.

The instrument has found many applications in music not only in tuning of various musical devices but also in measuring performance.

B. HIGH-SPEED STROBOSCOPES

The inherently short exposure of the electronic flash system and the precise timing of the flashes are great aids in taking clear, distinct

Fig. 9-7 *Photograph of the Stroboconn. Twelve gear-driven transparent discs with radial symmetrical patterns are displayed in front of a neon lamp which has been excited by musical sounds picked up by the microphone. The discs are driven by an adjustable frequency source of power. A standing pattern is observed when the frequency of the note and the disc correspond.*

photographs of rapidly moving objects on both still and moving film for analysis purposes. The strobe circuits in the previous chapter for single-flash and stroboscopic equipment have an upper limit of frequency operation. The circuits of the high-speed stroboscopes discussed in this chapter are distinguished from the circuits of the previous chapter by the addition of circuit modifications which overcome the inherent frequency limitations of the flash lamp. In other words, the driving circuit is able to force the flash lamp to operate at frequencies far beyond its simple capability in the conventional electronic flash circuit.

Details of the conditions in a single-flash circuit at the critical moment of arc holdover are given below, and a rough criterion

derived for the maximum frequency that can be expected. Necessary circuit modifications which overcome the basic lamp limitations are also given.

The Arc "Holdover" Limit of Frequency

The upper frequency limit of an efficient xenon flash lamp, such as the EG&G FX-1 operated from a capacitor charged through a resistor (as in the *RC* circuit of Fig. 9-8) is rather low, 100 cycles per second or less, when the energy per flash is small for that lamp (a few watt-seconds). As the energy per flash increases, this upper frequency operation limit decreases since the gas in the tube requires a longer time to deionize.

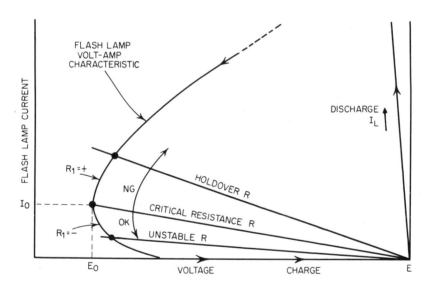

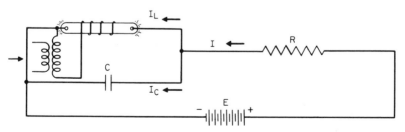

Fig. 9-8 *Upper: volt-amp diagram flash lamp under discharge conditions at the end of the flash cycle. Lower: circuit diagram of resistance charging circuit for a stroboscope.*

Thus the upper limit of high-frequency operation is repeatedly encountered by the designers of stroboscopic lighting equipment for motion-picture and multiflash photography. There are even examples of arc holdover limitations with portable flash equipment where the shortest allowable time between flashes can be as long as 10 sec.

Large continuous currents flow in the flash lamp when it is in the holdover condition. The electrodes and the tube overheat, depending upon the regulation properties of the energy source and the charging circuit. The power supply may be overloaded.

The ability of an electrical-discharge flash lamp to give repetitive flashes of light from a condenser discharge in rapid succession depends upon the characteristics of the ionized gas in the lamp during the deionization period and the characteristics of the charging and discharging circuits. The evaluation of the upper frequency limit of a high-resistance flash lamp and circuit without inductance in either the charge or discharge portion of the circuit is the object of the following discussion and derivation.

At the start of the flash under normal operation, the capacitor voltage is at the rated value E. During discharge the current rises to a high value within a short time and then decreases to 0 as the capacitor voltage decreases to a small value. The charging current from the source begins to flow immediately into the capacitor, but the maximum discharge current in the lamp is usually much larger than the maximum charging current. Under conventional use, the capacitor voltage rises slowly to its initial value during the charging cycle while the charging current decreases slowly to 0.

Should the tube exhibit holdover difficulties, the capacitor voltage will remain at a low value and the charging current will flow continuously through the flash lamp. After the initial flash, the lamp will emit a feeble continuous glow which is very dim in comparison to the flash. No more flashes can be obtained from the lamp until the glow has been extinguished by interrupting the circuit and the storage capacitor is recharged.

Whether or not a given lamp will holdover under specified conditions is an important question. The external factors which influence holdover for a specific flash lamp are (1) the voltage to which the capacitor is charged, (2) the energy per flash, (3) the rate at which the lamp is to be flashed, and (4) the deionization properties of the flash lamp.

Deionization Conditions

The electrical conditions [7] at the terminals of the flash lamp will now be examined at the time of discharge for the simple resistance charging system from a battery or power supply. A high-resistance flash lamp in which the discharge current is not oscillatory will discharge the capacitor to about 50 or 100 volts. At the end of the discharge there is an important division of the charging current into the capacitor and the flash lamp.

As long as the current into the lamp is greater than some limiting value, the light will not extinguish. This current I_0 is the current at the minimum voltage point E_0 of the characteristic curve of the flash lamp. At low currents the incremental resistance $R_1 = \Delta E/\Delta I$ of the lamp goes through zero and then negative (Fig. 9-8). If the power supply load line intersects the V-I curve above the minimum voltage point, a stable condition can occur where the power supply continues to supply current to the flash lamp, i.e., holdover. If the load line intersects the V-I curve below the minimum voltage point, the unstable condition of a negative resistance in parallel with a capacitor occurs, and the lamp will deionize.

Therefore, holdover will not occur if the residual flash lamp current at the end of the discharge is less than I_0, the lamp current at the minimum voltage point on the lamp transient V-I characteristic. Referring to Fig. 9-8, the maximum charging current must be less than I_0 to ensure deionization.

The V-I characteristic of the lamp depends upon the transient condition due to heating and the residual ionization left by the large discharge conditions and thus may vary for different conditions of excitation. An inductance in the lamp discharge circuit will enable the experimental procurement of the entire V-I curve, since the current through the lamp is then forced to go to small values in the negative resistance region of the characteristic curve. Figure 9-9 shows experimental steady-state and transient curves for the GE FT-506 flash lamp. The minimum voltage point for this lamp is about 80 volts and occurs at a current of $I_0 = 0.6$ amp. The steady-state curves are often difficult to obtain experimentally because the cathode may heat to a temperature at which thermionic emission is important. This usually lowers the overall voltage across the lamp.

Minimum Resistance in the Charging Circuit

The minimum charging resistance can now be calculated for the FT-506 flash lamp from the data in Fig. 9-9. At the deionization point the voltage across the resistor is $E - E_0$ and the maximum allowable charging current is $I_0 = 0.6$ amp. Thus, the critical limiting charging resistor R is

$$R = \frac{E - E_0}{I_0} = 1,400 \text{ ohms for a 900-volt power supply}$$

where R = minimum charging resistance

E = supply voltage = 900 volts

E_0 = minimum voltage on the V-I curve of the flash lamp = 80 volts

I_0 = current in the flash lamp following the capacitor discharge at the minimum voltage point = 0.6 amp

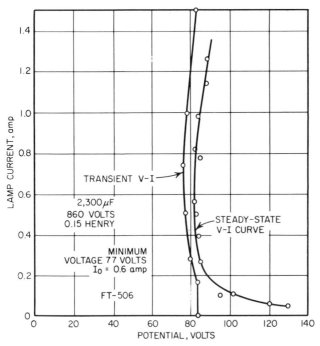

Fig. 9-9 *Volt-amp characteristics of the GE FT-506 flash lamp in steady-state condition following a transient pulse from a capacitor.*

That is, the FT-506 flash lamp will tend to exhibit holdover if the charging resistance is less than about 1,400 ohms for a 900-volt power supply.

Maximum Flashing Frequency and Minimum Time between Flashes

The charging time constant for the flash-capacitor charging circuit is RC seconds, where C is the discharge capacitance in farads and R is the charging resistance in ohms. If we consider three time constants to be ample for charging the capacitor (about 90 percent of full energy), then the minimum time between flashes T is given by $T = 3RC$ (seconds). Substituting for R

$$T = 3 \left(\frac{E - E_0}{I_0} \right) C$$

or approximately

$$T = \frac{3CE}{I_0} \quad \text{if } E_0 \ll E$$

In terms of stored energy $W = CE^2/2$, the minimum time between flashes is

$$T = \frac{6W}{I_0 E} \quad \text{sec}$$

Likewise, the maximum flashing frequency is $f = 1/T = I_0 E/6W$ fps.

Example: Consider the FT-506 flash lamp with 1,000 watt-sec stored energy on a 900-volt circuit. Then calculate the shortest charging time given.

$$I_0 = 0.6 \text{ amp} \quad E = 900 \text{ volt} \quad \text{and} \quad W = 1,000 \text{ watt-sec}$$

the time

$$T = \frac{(6) \ (1,000)}{(0.6) \ (900)} = 11 \text{ sec between flashes (minimum)}$$

The fastest frequency that can be obtained without holdover is then

$$f = \frac{1}{T} = 0.09 \text{ fps (maximum)}$$

With reduced energy per flash the charging time becomes shorter. Consider a 10-watt-sec condition. Then

$$I_0 = 0.6 \text{ amp} \quad E = 900 \text{ volt} \quad \text{and} \quad W = 10 \text{ watt-sec}$$

$$f = 9 \text{ fps (maximum)}$$

Table 9-2 Holdover Currents for Several Flash Lamps in Common Use

Flash lamp types	Arc length, cm	Tube ID, cm	E_0, volts	I_0, amps
FT-506	15	0.5	80	0.6
FT-118	7	0.4	45	1.5
FT-503	35	0.7	200	1.0
FX-1	15	0.4	80	1.1
FX-29	10	0.9	75	2.0

This flashing frequency is 100 times that calculated for the 1,000-watt-sec condition, since the maximum flashing rate is inversely proportional to the energy. It can be seen that the design of a high-power, high-energy stroboscope (for example, 100 cycles) is difficult with large output because of the holdover limitation. Many experimenters have found this out!

Table 9-2 shows the holdover current I_0 for several flash lamps of common interest.

High-frequency Strobe Circuits

Stroboscopes operating at frequencies above those imposed by the arc holdover condition require some method of reducing the charging current at the beginning of the charge cycle. The different methods can be classified into the following groups:

1. Switching in the charging circuit to decrease the current by the interruption of the circuit or the introduction of impedance or a time delay in starting the charging cycle (example, 1538 Strobotac).

2. The use of a constant-current charging circuit (of less than I_0) with a voltage-limiting regulation circuit to limit the final voltage.

3. The use of a series switching tube or element which has a short deionization time; examples are

 a. Mercury-arc control tube

 b. Hydrogen thyratron (EG&G, Inc. 501 high-speed strobe)

 c. Hydrogen multigap switch (Früngel equipment)

4. Inductive charging which usually produces a small current at the beginning of the charging cycle.

The above circuit modifications enable the flash lamp to deionize or control the circuit to overcome the lack of deionization of the flash lamp. The ability of the mercury-arc control tube, the hydrogen thyratron, and the hydrogen gap to control large, short-duration discharge currents and to extinguish very quickly permits flashing rates up to many thousands of flashes per second in a flash lamp. A brief description of these devices will be given below, especially a device that uses the hydrogen thyratron as a switch.

The mercury lamp with a liquid mercury pool as the cathode has a long history since it has been used extensively as a lamp and as a rectifier or switch. Early experimenters, particularly Cooper-Hewitt [9], found that the lamp would start easily if a high potential was applied on the outside of the glass at a point opposite the liquid mercury meniscus. Some interesting details of this starting process were reported by Townsend [10].

Mercury vapor at room temperature has too low a pressure for efficient light production. On the other hand, the mercury lamps at $20°C$ are very effective for deionization. Therefore, they can be operated at a high frequency even if not efficient for light production at high frequency. Lamps of this type [11-14] were used for high-speed photography some years ago but are now superseded by more efficient xenon types.

The temperature and gas pressure in a mercury lamp increase as the device is used. The pressure increases dramatically since the vapor pressure doubles about every $10°C$. Thus, it was found that a mercury-arc stroboscope at room temperature, when first started, was dim with a very short flash duration. It also had a great ability to operate at high frequency. Then as operation time progressed, the lamp became very bright as it warmed. Eventually the pressure became so high that the lamp either failed to start or heldover into a continuous glow. Early use of such mercury lamps involved skillful

preheating so that a series of flashes for photography could be made when desired.

At one time in the lamp development an attempt was made to hold the temperature of a mercury-arc lamp with a thermostatically

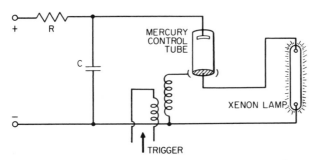

Fig. 9-10 *Use of low-pressure mercury vapor control tube with excellent deionization properties to switch an efficient xenon flash lamp at high frequency.*

controlled oven. This work was abandoned when experiments with the rare gases—argon, neon, krypton, and xenon—were started. The rare gases in a flash lamp follow Boyle's law for pressure and temperature in contrast to the vapor pressure-vs.-temperature relationship of the mercury-pool lamp. The average gas concentration, molecules per cubic centimeter, of a rare gas flash lamp remains constant regardless of temperature. There may be violent non-uniformities due to expansion caused by local heating and electrical effects, but the number of molecules of gas in the lamp are independent of temperature.

The next logical step was to use the low-pressure mercury-pool tube as a switch in series with the high-pressure efficient rare gas lamp. In this way the efficient lamp is forced to operate at high frequency by using the short deionization feature of the low-pressure mercury-arc tube. Such a circuit is shown in Fig. 9-10. The I_0 value for a mercury-control tube is estimated to be about 10 amp.

A second favorable feature of the circuit, shown in Fig. 9-10, is the *series starting* effect of the high voltage that is applied to the external concentration of the mercury tube. It will be noticed that the flash lamp is in the circuit from the cathode to the spark coil. A dim discharge can be seen between the two main lamp electrodes even when the main power is off. Thus, the flash lamp is first pulsed directly by the trigger circuit, and then the main capacitor discharge takes over.

A second switching device which is now in common use for high-frequency stroboscopes and radar circuits is the hydrogen thyratron [15, 16], as developed by Germeshausen (see [15, p. 335]). This thyratron has a heated cathode with large peak-current capability. The hydrogen gas has two useful features for pulse applications. First, the hydrogen gas molecules (ions) are small and light so that they do not damage the cathode surface as much as the heavier mercury ions would. Second, the high mobility of the hydrogen ions results in very rapid deionization. This last effect is most useful in obtaining a device that will operate at high frequency.

A third type of switching device is described by Früngel [17] as a multiple-electrode spark gap. Air, hydrogen, or alcohol can be used at atmospheric pressure with a series of closely spaced gaps which have a short deionization such that the gap can be used as a self-oscillator switch or as a driven switch. The pulse to start this hydrogen or air multigap switch must be vigorous and positive, as discussed by Früngel (see [17, pp. 116-171]).

Hydrogen Thyratron Modulator

Details are now given of the hydrogen thyratron modulator circuit as devised by Germeshausen [16] for operating radar transmitters

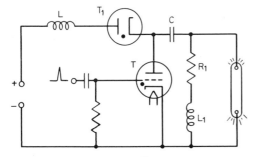

Fig. 9-11 *Basic circuit of hydrogen thyratron modulator type stroboscope for operating a flash lamp at high frequency. L and L_1 are charging inductances, R_1 is a charging resistor, and T is a hydrogen thyraton.*

and high-speed stroboscopes. An example of high-speed stroboscopic equipment using this method is described below.

The typical pulse circuit for a radar or high-speed stroboscope is shown in Fig. 9-11 with a hydrogen thyratron as a control element. Switching of the stored energy in the capacitor C into the flash lamp

is accomplished when the thyratron T is started. Recharging is accomplished through a resonant circuit involving L, L_1, and R_1 with a diode T_1 to prevent the current from reversing. This circuit is preferred since one terminal of the lamp and the cathode of the thyratron are grounded. Note that neither terminal of the capacitor is grounded.

Radar pulse drivers generally use a network consisting of inductors and capacitors in place of the simple capacitor used in most strobe circuits since a square wave form output is desired for the radar pulse oscillator. Numerous experimenters have attempted to use similar pulse networks to obtain a square pulse of light from an electronic flash lamp.

The circuit of Fig. 9-11, illustrating the use of a hydrogen thyratron, is similar to the basic circuit of the EG&G type 501 high-speed stroboscope. The equipment is operated from a 220-volt 60-cycle single-phase source of power that is fused for 20 amp. An input voltage of 220 volts was selected because the power drain of the type 501 stroboscope is too great for conventional 115-volt, 20-amp lines. Other more powerful stroboscopic devices are supplied with power from three-phase power circuits.

Housed in the lower part of the type 501 assembly (Fig. 9-12) is the dc power supply. A conventional full-wave bridge rectifier circuit is used with a charging choke and filter capacitor. A relay in the primary of the power transformer permits remote-control operation of the stroboscope. On this same relay is a set of contacts which may be used to control camera motors simultaneously with the operation of the stroboscopic light. An overload relay in the transformer primary removes power instantaneously if excessive direct current is drawn from the power supply. The central panel contains the hydrogen thyratron, the charging portion of the circuit, and a trigger amplifier which fires the thyratron. On the top panel are mounted three adjustable time-operated switches. From left to right they are:

1. A delay switch which allows the camera to reach operating speed before the flash lamp is started.

2. A light running time switch which establishes the length of time through which the stroboscopic light will operate. (It is important that this time be controlled to prevent damage to the lamp by overheating. Data relative to maximum permissible running times are presented in Table 9-3.)

3. An event delay switch used to open or close an auxiliary circuit

Fig. 9-12 *Front view of the EG&G type 501 high-speed stroboscope. Power supply, modulator, and timer unit are contained within the cabinet.*

at a desired time to initiate a transient for filming. (For example, the switch may be used to fire a dynamite cap at the moment that the camera is up to speed and the flash lamp is on.)

These three switches and a relay-operated switch for the camera motor simplify operation of the type 501 stroboscope. One push button operates the entire device and associated equipment. Human errors in timing are avoided by the use of the automatic features.

Light Output and Flash Duration

Light measurements of the output of bare flashtubes when operated at 1,000 Hz through 7 ft of RG54/U concentric cable are given in Table 9-3. The dimensions of the flashtubes, EG&G type FX-2 helical source and type FX-3 straight source, are given in Fig. 9-13.

The reflector factor for the FX-2 is adjustable since the position of the lamp can be varied in the reflector. Reflector factors for several conditions are listed.

FX-2: M = 75 Max adjustment for narrow angle.

FX-2: M = 32 Broad-beam adjustment for wide-angle use.

FX-3: M = 1.5 Cylindrical reflector around the linear lamp. This is convenient for small subjects since the reflector can be close to the subject.

Table 9-3 Horizontal Lamp Output Measured Perpendicular to the Bare Lamp Axis without a Reflector and Operated at 1,000 fps*

| Flash lamp type | Source size | | Light output, HCPS | | |
	Arc length, cm	Arc diameter, cm	0.01 μF	0.02 μF	0.04 μF
FX-2† and FX-3	9.2	0.1	0.12	0.28	0.57

*A type 935 phototube (S-5 surface) with 1.27-mm glass cover, 1.5 kV voltage into a 400-ohm load resistor was used

†The FX-2 is coiled into a helix 1.3 cm × 1.3 cm. The flash duration (one-third peak) is 1.2, 1.4, and 1.9 μsec for the three conditions shown. The FX-2 light may be 20 percent lower than from a similar FX-3 due to self-absorption. Light output of both depends also upon life and lamp dimensions, especially the tube bore.

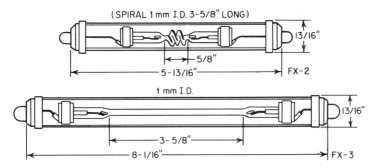

Fig. 9-13 *Dimensions and outlines of two types of quartz flash-tubes. Both FX-2 and FX-3 are filled with xenon gas at 4.5 cm plus 1.5 cm of hydrogen.*

Guide Factor of the High-speed Stroboscope Type 501

The guide factor of the 501 high-speed stroboscope can be calculated for the special case where the flash lamp is located at or

near the camera lens from the following equation, which has been given previously.

$$DA = \sqrt{CPS\ M\ \frac{s}{c}}$$

where D = lamp-subject distance in feet
 A = camera lens aperture
 s = exposure index (ASA) of film
 c = a constant (15 to 25 if D is in feet)
 M = reflector factor
CPS = lamp output in candela-seconds
BCPS = CPS M

For example, consider a film with a speed of 200 ASA, a constant

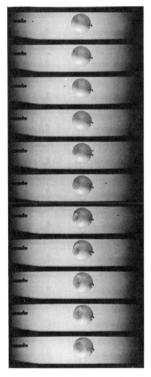

of c = 15, and a reflector with an M factor of 32. Then from Table 9-3, for a capacitor of 0.1 μF, lamp output is 0.12 CPS and BCPS = 4. Using these parameters, DA = 7. At a 1-ft distance, try aperture f = 6.3 for a first test exposure. In actual practice this guide factor value can be increased if the subject is painted white or if a light background is used or if the film is given special processing to increase its effective ASA speed.

The sequence in Fig. 9-14 of a .22-caliber bullet passing through a balloon was filmed against a white cardboard background at 4,000 frames per second. The camera was a 35-mm General Radio type 631 AG with the lens set at $f/1.5$. There was no synchronization between the film speed and the picture-taking rate. The lamp-subject distance D was about 3 ft. Thus, DA = 1.5 × 3 = 4.5. The velocity of the film was adjusted so that the photos would not overlap.

Fig. 9-14 *Sequence of pictures of a .22-caliber bullet penetrating a balloon. Taken on moving film by the light from a type 501 high-speed stroboscope operated at 4,000 fps.*

Maximum Operating Time

The light source in the type 501 stroboscope is designed for high-intensity, short-duration operation. Extended operation

Table 9-4 Maximum Allowable Total Operating Time of the FX-2 and FX-3 Flash Lamps on the EG&G 501 High-speed Strobe

Flash rate per second f	6,000	4,000	800
Capacitance, μF	0.01	0.02	0.04
Watt-seconds per flash	0.32	0.64	1.28
Allowable running time T, sec	0.8	0.6	1.5

will overheat the flash lamp. A safe limit has been found to be about 1,500 watt-sec per burst of flashes. Thus

$$1,500 = \frac{CE^2}{2} f T \quad \text{watt-seconds}$$

where C = capacitance (farads)
E = voltage (8,000)
f = flashing frequency (Hz)
T = running time (seconds)

A number of examples have been calculated and are presented in Table 9-4.

At the end of these runs, the flash lamp will be red hot. Longer periods of operation will cause the tube to become overheated and perhaps permanently damaged. Between operating periods, the lamps should be allowed to cool for several minutes. Shorter running times are recommended.

The xenon flash lamps can be flashed in synchronism with a motion-picture camera by the use of a small reluctance generator which creates a small synchronizing voltage pulse when the camera sprocket teeth pass a permanent magnet. The pulse can be obtained also from other pickups, such as the phototube type. Exposure on each frame of a movie sequence will be constant, regardless of the speed, if the energy per flash and lamp efficiency are constant. This permits a rapid change of speed during a sequence of pictures.

Special Small Lamps

There are several small-size xenon flash lamps which can be operated from the type 501 high-speed strobe when an impedance matching transformer is used. Two of these lamps, the EG&G FX-11 and FX-12, are shown in Fig. 9-15. Small lamps of these types are especially useful for schlieren, microscope, and silhouette photog-

raphy where an intense small-sized source of light is needed.

The matching transformer has a 5 to 1 step-down ratio which effectively couples the low-resistance lamps to the thyratron driver circuit and prevents excessive thyratron currents. A transformer is not necessary with the FX-2 and FX-3 lamps since these appear as high-resistance (80 ohms) loads and can therefore limit the peak current of the hydrogen thyratron to a safe value, in this case 100 amp.

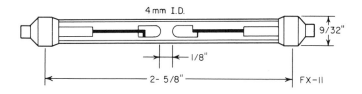

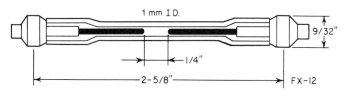

Fig. 9-15 *Dimensions and outlines of two small-sized quartz, xenon-filled flashtubes.*

A special circuit (Fig. 9-16), including a coupling transformer is required to couple the FX-11 flash lamp to the EG&G type 501

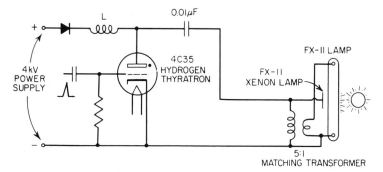

Fig. 9-16 *High-speed stroboscope type 501 adapted to drive an FX-11 small-source xenon lamp through a matching transformer.*

high-speed strobe. This transformer has a 5 to 1 step-down ratio with the lamp on the *low-voltage* side as mentioned before. The normal output of the type 501 unit is 8 kV which produces about 1,800 volts on the FX-11. Since this is insufficient to start the lamp, a

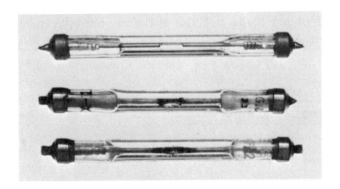

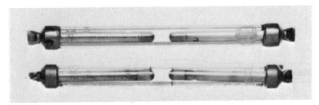

Fig. 9-17 *Small-size xenon-filled flash lamps. Upper: three FX-12 lamps (1.3-mm ID ×6 mm), the top one before use. The lower two show a melted and discolored arc column with condensed quartz in the end chambers. Bottom: two FX-11 lamps (4-mm ID ×4 mm), the top one before use. Note quartz discoloration from use on the lower lamp.*

starting pulse is obtained from the 8 kV terminal as shown in Fig. 9-16. The transformer also serves to reduce the peak load current in the hydrogen thyratron.

The FX-11 has a practical limit of operation at 500 cycles per second of about 1.0 sec of operation time when a 0.01-μF capacitor is used. With greater energy than above, due to larger energy per flash or a longer operation time, the lamp will be overheated and the electrodes and lamp may partially melt.

Other flash lamps, for example the FX-12, can be driven by the type 501 using the circuit shown. The FX-12 has a 0.13-mm bore of 6.3 mm length which restrains the arc into a line shape that is particularly useful for optical systems involving a knife edge, such as

schlieren. However, the FX-12 is *limited in operation by the intense heat from the arc*, which melts the small tungsten electrodes and vaporizes the quartz capillary walls if the operation is too long. It has been found that operation at 1,000 fps with a capacitance of 0.01 μF is limited to a burst of about 0.1 sec. The lamp life will be shorter as the loading is increased due to wall damage and electrode melting.

A photograph (Fig. 9-17) shows a new FX-12 and several that have been operated vigorously in the EG&G 501 flash unit.

Table 9-5 Horizontal Light Output of Lamps as Measured with a 935 Phototube (S-5 Surface) with 1.5 kV into 400 Ohms*

Flash lamp type	Arc length, cm	Arc diameter, cm	Light output, HCPS, at 8 kV		
			0.01 μF	0.02 μF	0.04 μF
FX-11	0.3	0.4	0.22	0.48	1.4
FX-12	0.6	0.13	0.48	0.78	2.25
FX-21	1.3	0.4	0.14	0.4	1.1
FX-2	9.2	0.1	0.12	0.28	0.57

*A glass filter 1.27 mm thick was used. The lamps other than the FX-2 require a 5 to 1 step-down low impedance matching transformer. A half-silvered reflector was used as a trigger electrode.

Xenon-filled gas lamps, with effective lengths of 13 mm, 25 mm, and 38 mm in Vycor or quartz of 4 mm ID (otherwise the same as the FX-11), can be operated from the EG&G type 501 driver and transformer described above. Table 9-5 shows the average observed output for several lamps when operated with 1,000-cycle bursts of 0.1 sec duration. The larger lamps can be loaded with more energy than the FX-11 or FX-12.

Cameras

There is a need for a continuously moving film when many photographs are exposed in a short time by a high-speed strobe. This can be accomplished by several systems.

1. The camera, such as any still one, can be moved or rotated while the exposures are being made so that a fresh unexposed film will appear at the image spot. This can be conveniently accomplished on a tripod by a rotary motion of the camera.

2. Often a rotating mirror can be used to swing the image to a different place on the film for each flash.

3. The drum camera with a strip of film on a wheel makes a most satisfactory method of moving film at a high speed. The drum can be brought up to speed slowly in anticipation of the event. It is important to prevent exposures from lasting longer than one revolution since confusing double exposures may be difficult to understand. Either a capping shutter or control of the flash sequence can accomplish this single-revolution operation.

4. A continuously moving strip of film, such as the Mico Instrument Co. camera (80 Trowbridge St., Cambridge, Mass.) formerly the General Radio type 651 AG, is an excellent method of moving the film. This camera uses 35-mm film of one of the standard types available (Fig. 9-18). A 140-ft length will fit the special reels which have a large core diameter to reduce the rotational velocity when ultrahigh film speeds are required. The film-moving capabilities of this camera are illustrated in Fig. 9-19. It is observed that the acceleration varies with the applied voltage and that there is an adjustable centrifugal governor switch which tends to hold the speed

Fig. 9-18 *Internal view of a Mico type 631 AG high-speed camera with continuously moving film. Slide cover removed to show sprocket and reels.*

constant. With 1,200 full frames of 35 mm per sec, the film must move at 75 ft per sec. The acceleration time is 0.7 sec when 220 volts, 60 cycles is applied. Film of 100 ft length is finished in 1.45 sec, giving about 0.7 sec of active time at the 1,200-frames-per-sec speed.

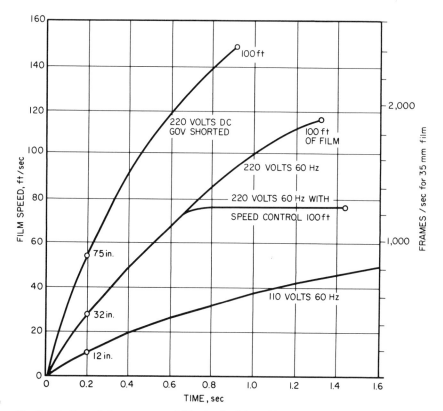

Fig. 9-19 *Speed-time curves of film in the Mico 631 AG camera for several conditions of input voltage and governor settings.*

5. Continuously moving film cameras with a rotating prism (or without) can be used with a short-pulse strobe lamp to obtain motion pictures. The Red Lake Lab camera has a phototube trigger attachment which fires the EG&G, Inc. 501 strobe in sync. with the film position. Likewise, a reluctance pickup has been used many times for the synchronism of the Fastax, the Eastman type III, and other high-speed rotating prism cameras. This reluctance device consists of a small permanent magnet which is held near the steel teeth of the main sprocket. A voltage pulse is produced in a coil when each tooth passes the permanent magnet.

6. A unique camera with very quick starting and stopping ability has been designed by L. C. Eichner Instruments [18] (19 Sebago Street, Clifton, N. J.) based on an earlier design of L. J. Hooper of Worcester Polytechnic Institute. The film can be accelerated to a thousand frames per second in a millisecond or two

by the use of rollers that engage the film directly to pull the film from a light-tight "festoon" storage box. The film had previously been deposited in the box in a loose form so that acceleration of the entire strip of film does not occur at the same time. Likewise, the film is discharged into another festoon box from which it is cranked after the run onto a conventional take-up reel. A light-controlled console designed by R. J. Kerr starts the electronic trip circuits which start the film motion when a bird comes within the field of view of the camera.

W. O. Johnson [19], at the Du Pont Company, has written the following concerning the photoelectric pickoff to synchronize an EG&G 501 strobe to the film speed:

> The sync system of Mr. Greenewalt's camera was quite simple. It consisted of a TI-800 photo diode with a one transistor, transformer coupled amplifier, all mounted on the hinged half of the film gate of the camera. I used a 3-volt grain-of-wheat lamp, the kind that is mounted in a screw-in prefocus base. I used the focussing lens assembly from a Bell & Howell projector sound system. This projected the image of the lamp filament as a line about 0.0005 in. high focussed in the plane of the film. This image falls on the perforation area of the film and is interrupted by the passage of each perforation to produce the sync signal. The photo cell is mounted in a sliding block so that the maximum light from the exciter lamp can be made to fall on the photo cell window. This system has worked satisfactorily without any attention other than cleaning since it was installed.
>
> I had originally used an eight stage miniature photo multiplier tube secured from Dumont Laboratories with a two-stage vacuum tube amplifier but found that the necessary interlocks to protect the P.M. tube when opening the camera caused some difficulty.
>
> The 35-mm rapid starting camera which I built later for use at the Mechanical Development Laboratory was somewhat more complicated. The optical system was identical to the one in the 16-mm camera. The output of the synchronizing circuit was clipped and fed to a wave-shaping amplifier and then to a double scale-of-2 counter so that with 4 synchronizing pulses being produced by the passage of each frame of film it was possible by switching in either none, one, or both of the counters to secure full frame, half frame or quarter frame pictures. The camera was fitted with snap-in gate-shaping masks which controlled the actual frame size. The synchronizing signal was also used to count frames out of an electronic register which was used to keep an exact tally of the film in the festoon supply chamber. A pre-set minimum-frame-count signal from this register prevented the possibility of using up the entire festoon supply, which would have caused damage either to the camera or the film.

The camera relies upon the shortness of the strobe flashes to produce pictures without blur on the fast-moving film.

Crawford Greenewalt was able to make some remarkable motion pictures of the wing action of hummingbirds with this camera at 1,200 frames per sec because of the quick starting ability. Conventional high-speed cameras proved useless since the birds were frightened by the camera noise and were allowed time to escape from view, because of the delay in reaching operating speed.

C. DOUBLE-FLASH EQUIPMENT

Most laboratories have standard *single* flash equipment in common use for investigations of rapid transient mechanical motions. The next step beyond a single picture is a sequence of photographs usually on a moving-picture film. These pictures can be studied individually or as a movie on the screen. The average velocity of a moving subject can be measured by determining from the pictures the distance that the object moves during the interval between two exposures. Electronically controlled flashes of light of short duration are especially useful for velocity determinations since (1) the images are sharp without the blur caused by long exposure and (2) the interval of time between exposures can be accurately determined.

For many purposes only two exposures are needed, and these can be put on a stationary film, using a still camera. The object of this section is to describe two applications, one of which is a flash unit [22] especially designed for double flash work of very rapid subjects where extremely short exposures are required, such as a dynamite cap explosion. The interval of time between flashes must be very short and of a known time duration. The second application [23] concerns the measurement of human blood flow.

The apparatus described below for measuring the velocities of shock waves, as well as other rapidly moving devices, consists of a single light source of the spark-in-air type that is energized by two separate circuits to give two pulses of light from the same position in space. The second flash is arranged to occur at a determined time after the first. The silhouette or shadow method is used to make the shock waves visible in the photographs.

Silhouette Photography

Of the several methods of taking silhouette photographs, the most efficient, as far as light requirements are concerned, is the field lens

type (Chap. 10). Here the light from a small-volume spark source is collected over a large solid angle by a field lens and redirected into the lens of a camera. The main disadvantage is the limitation of the area that can be covered by the photography since the picture area cannot exceed the area of the field lens. Glass lenses of large size are not common, especially for experiments where the lens might be expended for each shot. Plastic Fresnel lenses [24] are very useful in this connection, since their cost is relatively small. Scotchlite backgrounds permit shadow photographs to be made over large areas as described in Chap. 10. Glass lenses can have much better quality than the plastic Fresnel type since the line pattern is not present in the glass lens.

Because of the efficient utilization of light by the field lens system, it has been found that a suitable exposure can be made with modern films by using an 0.005-μF capacitor charged to 8,000 volts even when triggered with a series control gap and a 5-ohm damping resistor. The light itself is a $^1/_8$-in. air gap in a quartz tube that fits loosely over 40-mil tungsten wire electrodes. It was found that consistent starting without time jitter was achieved by using the quartz tube to bridge the gap. Eventually the quartz tube becomes darkened from electrode sputtering and should be changed to maintain the light output.

The optical arrangement is shown in Fig. 9-20. The light from the spark is focused by the plastic Fresnel lens into the camera lens. This camera lens can then be stopped down without a loss of light on the film if the image of the spark does not fill the area of the lens. As small an aperture as possible should be used to exclude light from the subject if this light is objectionable in the photograph. When the aperture is made too small, the out-of-focus image of the field lens may have dark areas since the light from some areas may be excluded by the aperture because of imperfections in the lens.

If schlieren-type photographs are desired, the spark image should be deflected so that only a portion of the light goes into the camera lens past the iris edge. Naturally, the result will not be of high optical quality because of uneven illumination of the field when plastic lenses are used. However, the quality of the plastic lenses is entirely adequate for straight silhouette photography, and the shock waves associated with bullets and explosions will record photographically by this system when the shock front is strong. This is shown in the accompanying photographs of dynamite caps and bullets.

Flash Circuit

The electrical circuit of a double-flash source is also shown in Fig. 9-20. Light is emitted by the quartz-tube enclosed spark gap. Two capacitors discharge their energy into the lamp gap as controlled by the triggering circuit pulses into the three electrode gaps.

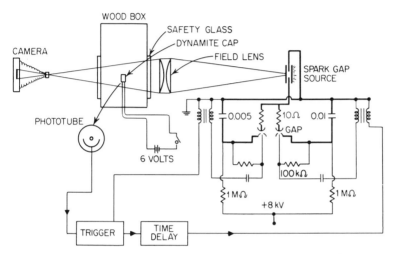

Fig. 9-20 *Arrangement for photographing a dynamite cap explosion twice in order to measure the velocity of the particles.*

It was found experimentally that the light from the second flash is weaker than from the first if the same energy is used in each capacitor. To compensate, the capacity was doubled to a value of 0.01 μF for the second capacitor since this makes the second flash about as bright as the first. Circuit inductance in the capacitor discharge circuits should be reduced to a minimum since the frequency of oscillation determines the maximum rate at which energy can be discharged into the gap. The gaps in the circuit have negligible resistance; and, therefore, damping resistance is needed since the circuit will normally oscillate about 10 cycles before the amplitude of the current is down to one-third of the initial peak value.

The critical damping resistance given in terms of the capacitance C and the frequency of oscillation f is $R = 1/\pi Cf$.

For the example shown, $C = 0.005 \times 10^{-6}$ farad and $f = 3 \times 10^{6}$ cycles (approximate). The critical damping resistance is calculated to be about 20 ohms. Actually a lower resistance than this is used in the

circuit, and some of the oscillations are tolerated in consideration of the resultant increased light output.

Measurements show that the second flash is lower in peak value but longer in duration. However, the integrated light output of the second flash is about the same as the output of the first flash. The following explanation gives a reason for the long second pulse. Due to a failure to deionize, the first gap after firing remains filled with ionized gas. Therefore, it conducts when the second gap is fired; and some of the energy of the second capacitor is diverted from the lamp into the first circuit. To compensate for this loss, the second capacitor is made about double in energy storage to the first.

The duration of the first flash is 0.15 μsec and the second is 0.3 μsec. The peak light of the second flash is half (12,000 CP) that of the first (24,000 CP). Therefore, the exposure on the film from each flash is about the same.

The triggering circuit must be fast and consistent if accuracy is to be obtained. For example, the pulse transformers and thyratrons that are used to produce the triggering voltage pulses must be faster than about 0.5 μsec from the initial signal until the flash of light. A series capacitor is required in the trigger circuit because of the 8 kV. An accurate adjustable time delay circuit is used to start the second flash at a known instant after the first. The maximum time delay for one

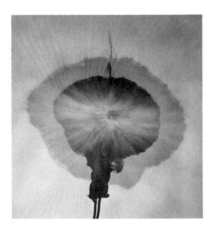

Fig. 9-21 *Double exposure of dynamite cap with 5 μsec between pictures. Note the jet from the upper end of cap.*

special equipment was 100 μsec, and this proved to be satisfactory for most dynamite cap and bullet photography applications.

A phototube trigger is used for studying dynamite caps. As soon as the metal case of the cap breaks open to emit light, the first gap circuit is triggered by the phototube signal. Then an

adjustable time delay circuit is used to trip the second gap circuit causing the second flash of light to occur.

Examples: Figure 9-21 shows two superimposed exposures of a dynamite cap during detonation. The interval of time between

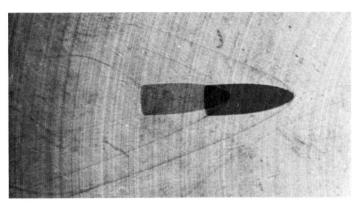

Fig. 9-22 *Double exposure of a .22-caliber Swift bullet made with double-flash unit having a 10-μsec interval between flashes.*

exposures is about 5 μsec. Of special interest is the rapid jet that has emerged from the end of the cap. Note that there is a blurred exposure at the center of the picture made by the light from the explosion itself. This exposure from the subject can be reduced or enhanced by closing or opening the camera aperture. Such adjustment does not materially affect the exposure due to the sparks *if the imaged light from the spark on the lens is not obstructed by the iris.*

The two superimposed photographs of a .22-caliber Swift bullet in Fig. 9-22 were taken 10 μsec apart. It is very easy to measure the yaw of the bullet from these pictures. A different Fresnel lens than that shown in Fig. 9-21 was used. It is noted that the patterns left by the two lenses are entirely different.

Conventional direct silhouette photographs can also be made with the double-flash unit. The open spark source for this purpose is located about one meter from the bare film of 8 × 10 in. size in a darkened room. The bullet is located about 10 cm away from the film. Refraction of the direct light from the small source by the sound waves causes the light to be deflected.

A commercial model [25] (EG&G, Inc. type 2307) of the above double-flash silhouette equipment was developed by EG&G, Inc. and has been distributed for a number of years, particularly to the Aberdeen Proving Ground for the study of dynamite cap explosions.

An improved time-delay circuit which could be calibrated was used in this model.

Reflected Light Double Flash

This section shows electrical details of a double-flash unit for studying blood flow [23]. An electronic xenon flash unit was constructed so as to produce two brief, intense flashes of light with a time delay between them in order to measure the average velocity of capillary blood flow in human conjunctival vessels. A 35-mm camera with a 35.6-cm lens tube and 40-mm Zeiss macrolens was adapted for closeup photography with two flashes of light for a double exposure. The normal eye searching movements give enough displacement during the delay so that the vessels are seen as distinct pairs in the photograph (Fig. 9-23). The distance traveled by red blood cells or

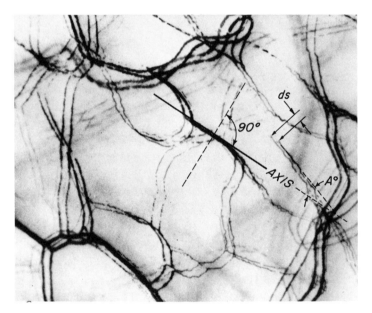

Fig. 9-23 *Example of a double-flash photograph of the conjunctival vessels showing the method of evaluating velocity by double exposure.*

clumps of cells during the delay can be measured, and the average speed calculated. It was found that the velocity measured in this way is highly variable, since the velocity of blood flow in the capillaries is inconstant, but can be averaged from a series of pictures taken over

an interval of 60 sec. Motion pictures taken concurrently support this observation.

The circuit described utilizes silicon-controlled rectifiers in the switching and time-delay networks and is based on a vacuum-tube circuit developed by LaForge [26]. The reasons for use of an electronic flash unit for eye photography have been presented previously [27] and are summarized briefly as follows: (1) the small physical size of the flash lamp permits efficient direction of the light onto a relatively small area, (2) a high peak light intensity which is required for adequate exposure and maximum depth of field, (3) a very brief effective exposure time which is determined by the duration of the flashes (in the present instrument they are of the order of 250 to 400 μsec) so that motion of either subject or camera causes no blurring, and (4) constant light color quality and exposure control. Two of the disadvantages of an electronic flash unit in a medical application are the hazards of high voltage and fracture of the walls of the flash lamp. These hazards are eliminated by careful insulation of the flash lamp and by its enclosure in a heavy-duty Pyrex tube.

Flash Lamp

The flash lamp is a U-shaped modification of the EG&G, Inc. FX-33 lamp contained in a glass tube. The U-shape permits the source of light to be kept as close to the subject as possible while keeping the high-voltage leads as far away as possible. The spark coil which triggers the discharge is also enclosed in the tube to avoid carrying the high trigger voltage through the cable from the power supply; a thin aluminum disc is inserted between the flash lamp and the spark coil to direct heat away from the plastic of the spark coil.

The circuit supplies sufficient power to fire the xenon flash lamp twice with a delay between flashes variable from 2 to 200 msec (Fig. 9-24). Silicon-controlled rectifiers (SCR's) are used to replace mercury-pool control tubes as used by LaForge. Replacement of the mercury tubes by semiconductors permits operation of the unit without special consideration for spatial orientation of the switching devices, increases resistance of the unit to physical shocks, and eliminates the hazard of spilled mercury if a tube is broken.

The main storage capacitors C_1 and C_2 are charged to approximately 450 volts by half-wave rectification of the output of a line-operated transformer. When switch S_1 is closed, a positive

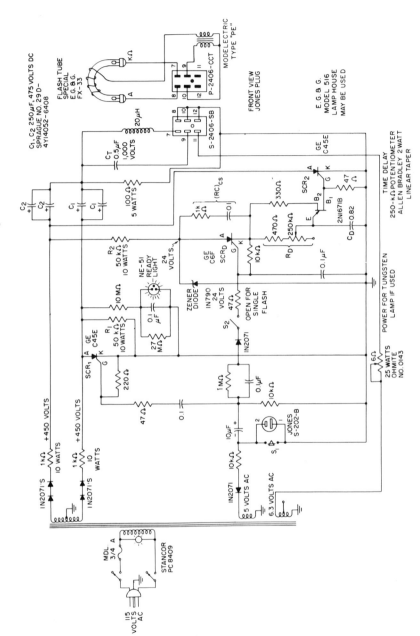

Fig. 9-24 *Circuit for driving a double-flash electronic lamp.*

voltage pulse is applied from gate-to-cathode of SCR_1, causing SCR_1 to conduct and completing the circuit SCR_1, C_1, the flash lamp, and the spark coil and trigger capacitor C_T. The current in the spark coil and C_T triggers the flashtube. The positive pulse caused by closing S_1 is also applied from gate-to-cathode of the time-delay SCR, SCR_D, causing it to conduct. This current flows into the RC network R_D and C_D, increasing the voltage applied to the emitter of the unijunction transistor 2N1671B. At the time the emitter-base junction becomes forward biased, and C_D discharges through the 47-ohm resistor. The resulting voltage pulse raises the gate-to-cathode voltage of SCR_2 until SCR_2 conducts, completing the circuit SCR_2, C_2, the flash lamp, and the spark coil and C_T and thus firing the flash lamp a second time. The time delay is independent of line voltage variations, as the voltage applied to the time-delay circuit through SCR_D is held constant at 24 volts by the Zener diode 1N790. The rate of change of the 2N1671B emitter voltage may be reproducibly controlled by varying R_D, thus changing the time delay between flashes. The range of time delays in this unit is approximately 2 to 200 msec; a different range could be obtained by varying C_D and/or R_D.

R_1 is in parallel with SCR_1 in order to match the current drain of approximately 9 mamp from C_2 caused by the time-delay circuit, thus making the two firing circuits more nearly symmetrical and the flashes more nearly equal. The positive voltage supplied to the SCR's, C_1, and C_2 is unfiltered half-wave rectified ac. The drop in voltage between 60-cycle peaks reduces the current available to the SCR's when the capacitors are discharged to less than the minimum holding currents, so that the SCR's shut off after each flash, permitting recharging of C_1 and C_2. The initial holding current required to hold SCR_D on with the short-gating pulse produced by closing S_1 is approximately three times the steady-state holding current required once the SCR is fully on. The current available through R_2 is greater than the steady-state holding current but less than the initial holding current. The current-supplying network $(RC)_{CS}$ is in parallel with SCR_D and supplies the required additional holding current. The 20-μH inductance in series with the flash lamp limits the switching transients, protecting the SCR's. A switch S_2 in series with the gate signal lead of SCR_D may be opened to permit single-flash operation of the unit by interrupting the time-delay circuit so that SCR_2 is not triggered.

A useful approximation for predicting the behavior of circuits with xenon flash lamps of construction similar to the FX-33 utilizes an effective series resistance of the ionized flash lamp and associated circuit elements of 1 ohm. This is determined from the ratio of peak voltage to peak current. Thus, the time constant of the flash lamp current is roughly RC = (1 ohm)(C) = C sec. The power time constant is roughly $RC/2$ sec. Light and power are linearly related to a first approximation; therefore, the flash duration can be estimated.

Duration of flash = $RC/2 = C/2$ sec. Provided switching transients are limited (in this instrument by the 20-μH series inductance), the value of the peak lamp current is the ratio of the peak voltage applied across the lamp to the effective series resistance (in our case, 450 volts per 1 ohm = 450 amp). Thus, doubling the capacitance hardly changes the peak lamp current since it is determined by the voltage applied. However, the time constant of the light pulse is almost doubled. An evaluation of the approximation was made on the flash unit at 225 and 450 μF per flash.

Eastman type 5302 fine-grain positive film developed in Diafine permits increased film speed and fine grain. The film is blue-sensitive, which aids greatly in obtaining contrast in the details of the small veins and arteries. Studies of normal subjects reveal that mean capillary blood flow velocity (vessel diameter 9 ± 0.5 μm) was 410 ± 36 μm per sec. The vessels which receive blood from the capillaries, i.e., the beginning of the venous system (venules) had a velocity flow of 390 ± 36 μm per sec (vessel diameter 77 ± 2 μm).

These techniques, now being employed in medical laboratories, are providing valuable information regarding studies of blood flow velocity in health and disease [28, 29]. The technique might also be applied to other dynamic but relatively slow-moving systems in which photomicrography is used to estimate velocity of motion.

D. MULTIFLASH PHOTOGRAPHY

One of the most fascinating and creative kinds of photography is the so-called multiflash type by which several photographs are superimposed on the same negative. The French physiologist E. J. Marey [30] was one of the leaders, and probably the originator, in the use of the technique. His book gives the results of his careful studies of the way in which all kinds of animals, including people, move. One of Marey's photographic systems was the use of a black background against which a series of sun-illuminated exposures displayed the

arranged behind the display of transparent strobe discs which are gear driven by a motor controlled by an adjustable tuning fork (55 cycles per second). The flashing of the neon strobe lamp is caused by the sound that strikes the microphone. When the frequency of the

Fig. 9-6 *A mercury-arc stroboscope, held by Germeshausen, to observe the action of valve springs of a gasoline engine at high speed in the engine lab at M.I.T., 1934. The author is preparing to take the motion picture. The motion-picture camera must be operated slower than the strobe so that multiple exposures will tend to overcome the flicker caused by the shutter.*

sound and the speed of one of the discs correspond, then a stationary pattern is observed and the frequency is determined.

A pure tone, such as produced by a flute, will cause only one pattern of black lines (spokes) to appear. The tone from a violin which has many overtones of different frequencies will cause several pattern bands to appear.

The instrument has found many applications in music not only in tuning of various musical devices but also in measuring performance.

B. HIGH-SPEED STROBOSCOPES

The inherently short exposure of the electronic flash system and the precise timing of the flashes are great aids in taking clear, distinct

Fig. 9-7 *Photograph of the Stroboconn. Twelve gear-driven transparent discs with radial symmetrical patterns are displayed in front of a neon lamp which has been excited by musical sounds picked up by the microphone. The discs are driven by an adjustable frequency source of power. A standing pattern is observed when the frequency of the note and the disc correspond.*

photographs of rapidly moving objects on both still and moving film for analysis purposes. The strobe circuits in the previous chapter for single-flash and stroboscopic equipment have an upper limit of frequency operation. The circuits of the high-speed stroboscopes discussed in this chapter are distinguished from the circuits of the previous chapter by the addition of circuit modifications which overcome the inherent frequency limitations of the flash lamp. In other words, the driving circuit is able to force the flash lamp to operate at frequencies far beyond its simple capability in the conventional electronic flash circuit.

Details of the conditions in a single-flash circuit at the critical moment of arc holdover are given below, and a rough criterion

derived for the maximum frequency that can be expected. Necessary circuit modifications which overcome the basic lamp limitations are also given.

The Arc "Holdover" Limit of Frequency

The upper frequency limit of an efficient xenon flash lamp, such as the EG&G FX-1 operated from a capacitor charged through a resistor (as in the *RC* circuit of Fig. 9-8) is rather low, 100 cycles per second or less, when the energy per flash is small for that lamp (a few watt-seconds). As the energy per flash increases, this upper frequency operation limit decreases since the gas in the tube requires a longer time to deionize.

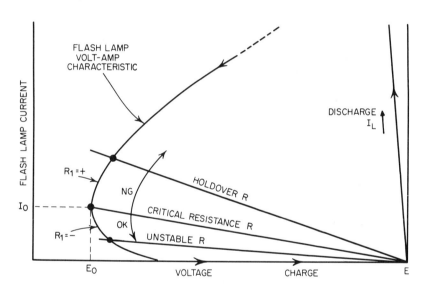

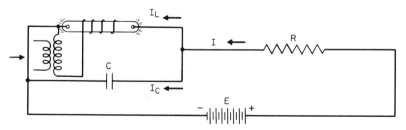

Fig. 9-8 *Upper: volt-amp diagram flash lamp under discharge conditions at the end of the flash cycle. Lower: circuit diagram of resistance charging circuit for a stroboscope.*

Thus the upper limit of high-frequency operation is repeatedly encountered by the designers of stroboscopic lighting equipment for motion-picture and multiflash photography. There are even examples of arc holdover limitations with portable flash equipment where the shortest allowable time between flashes can be as long as 10 sec.

Large continuous currents flow in the flash lamp when it is in the holdover condition. The electrodes and the tube overheat, depending upon the regulation properties of the energy source and the charging circuit. The power supply may be overloaded.

The ability of an electrical-discharge flash lamp to give repetitive flashes of light from a condenser discharge in rapid succession depends upon the characteristics of the ionized gas in the lamp during the deionization period and the characteristics of the charging and discharging circuits. The evaluation of the upper frequency limit of a high-resistance flash lamp and circuit without inductance in either the charge or discharge portion of the circuit is the object of the following discussion and derivation.

At the start of the flash under normal operation, the capacitor voltage is at the rated value E. During discharge the current rises to a high value within a short time and then decreases to 0 as the capacitor voltage decreases to a small value. The charging current from the source begins to flow immediately into the capacitor, but the maximum discharge current in the lamp is usually much larger than the maximum charging current. Under conventional use, the capacitor voltage rises slowly to its initial value during the charging cycle while the charging current decreases slowly to 0.

Should the tube exhibit holdover difficulties, the capacitor voltage will remain at a low value and the charging current will flow continuously through the flash lamp. After the initial flash, the lamp will emit a feeble continuous glow which is very dim in comparison to the flash. No more flashes can be obtained from the lamp until the glow has been extinguished by interrupting the circuit and the storage capacitor is recharged.

Whether or not a given lamp will holdover under specified conditions is an important question. The external factors which influence holdover for a specific flash lamp are (1) the voltage to which the capacitor is charged, (2) the energy per flash, (3) the rate at which the lamp is to be flashed, and (4) the deionization properties of the flash lamp.

Deionization Conditions

The electrical conditions [7] at the terminals of the flash lamp will now be examined at the time of discharge for the simple resistance charging system from a battery or power supply. A high-resistance flash lamp in which the discharge current is not oscillatory will discharge the capacitor to about 50 or 100 volts. At the end of the discharge there is an important division of the charging current into the capacitor and the flash lamp.

As long as the current into the lamp is greater than some limiting value, the light will not extinguish. This current I_0 is the current at the minimum voltage point E_0 of the characteristic curve of the flash lamp. At low currents the incremental resistance $R_1 = \Delta E/\Delta I$ of the lamp goes through zero and then negative (Fig. 9-8). If the power supply load line intersects the V-I curve above the minimum voltage point, a stable condition can occur where the power supply continues to supply current to the flash lamp, i.e., holdover. If the load line intersects the V-I curve below the minimum voltage point, the unstable condition of a negative resistance in parallel with a capacitor occurs, and the lamp will deionize.

Therefore, holdover will not occur if the residual flash lamp current at the end of the discharge is less than I_0, the lamp current at the minimum voltage point on the lamp transient V-I characteristic. Referring to Fig. 9-8, the maximum charging current must be less than I_0 to ensure deionization.

The V-I characteristic of the lamp depends upon the transient condition due to heating and the residual ionization left by the large discharge conditions and thus may vary for different conditions of excitation. An inductance in the lamp discharge circuit will enable the experimental procurement of the entire V-I curve, since the current through the lamp is then forced to go to small values in the negative resistance region of the characteristic curve. Figure 9-9 shows experimental steady-state and transient curves for the GE FT-506 flash lamp. The minimum voltage point for this lamp is about 80 volts and occurs at a current of $I_0 = 0.6$ amp. The steady-state curves are often difficult to obtain experimentally because the cathode may heat to a temperature at which thermionic emission is important. This usually lowers the overall voltage across the lamp.

Minimum Resistance in the Charging Circuit

The minimum charging resistance can now be calculated for the FT-506 flash lamp from the data in Fig. 9-9. At the deionization point the voltage across the resistor is $E - E_0$ and the maximum allowable charging current is I_0 = 0.6 amp. Thus, the critical limiting charging resistor R is

$$R = \frac{E - E_0}{I_0} = 1{,}400 \text{ ohms for a 900-volt power supply}$$

where R = minimum charging resistance

E = supply voltage = 900 volts

E_0 = minimum voltage on the V-I curve of the flash lamp = 80 volts

I_0 = current in the flash lamp following the capacitor discharge at the minimum voltage point = 0.6 amp

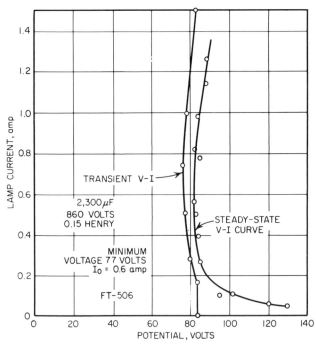

Fig. 9-9 *Volt-amp characteristics of the GE FT-506 flash lamp in steady-state condition following a transient pulse from a capacitor.*

That is, the FT-506 flash lamp will tend to exhibit holdover if the charging resistance is less than about 1,400 ohms for a 900-volt power supply.

Maximum Flashing Frequency and Minimum Time between Flashes

The charging time constant for the flash-capacitor charging circuit is RC seconds, where C is the discharge capacitance in farads and R is the charging resistance in ohms. If we consider three time constants to be ample for charging the capacitor (about 90 percent of full energy), then the minimum time between flashes T is given by $T = 3RC$ (seconds). Substituting for R

$$T = 3 \left(\frac{E - E_0}{I_0} \right) C$$

or approximately

$$T = \frac{3CE}{I_0} \quad \text{if } E_0 \ll E$$

In terms of stored energy $W = CE^2/2$, the minimum time between flashes is

$$T = \frac{6W}{I_0 E} \quad \text{sec}$$

Likewise, the maximum flashing frequency is $f = 1/T = I_0 E/6W$ fps.

Example: Consider the FT-506 flash lamp with 1,000 watt-sec stored energy on a 900-volt circuit. Then calculate the shortest charging time given.

$$I_0 = 0.6 \text{ amp} \quad E = 900 \text{ volt} \quad \text{and} \quad W = 1,000 \text{ watt-sec}$$

the time

$$T = \frac{(6) \ (1,000)}{(0.6) \ (900)} = 11 \text{ sec between flashes (minimum)}$$

The fastest frequency that can be obtained without holdover is then

$$f = \frac{1}{T} = 0.09 \text{ fps (maximum)}$$

With reduced energy per flash the charging time becomes shorter. Consider a 10-watt-sec condition. Then

$$I_0 = 0.6 \text{ amp} \quad E = 900 \text{ volt} \quad \text{and} \quad W = 10 \text{ watt-sec}$$

$$f = 9 \text{ fps (maximum)}$$

Table 9-2 Holdover Currents for Several Flash Lamps in Common Use

Flash lamp types	Arc length, cm	Tube ID, cm	E_0, volts	I_0, amps
FT-506	15	0.5	80	0.6
FT-118	7	0.4	45	1.5
FT-503	35	0.7	200	1.0
FX-1	15	0.4	80	1.1
FX-29	10	0.9	75	2.0

This flashing frequency is 100 times that calculated for the 1,000-watt-sec condition, since the maximum flashing rate is inversely proportional to the energy. It can be seen that the design of a high-power, high-energy stroboscope (for example, 100 cycles) is difficult with large output because of the holdover limitation. Many experimenters have found this out!

Table 9-2 shows the holdover current I_0 for several flash lamps of common interest.

High-frequency Strobe Circuits

Stroboscopes operating at frequencies above those imposed by the arc holdover condition require some method of reducing the charging current at the beginning of the charge cycle. The different methods can be classified into the following groups:

1. Switching in the charging circuit to decrease the current by the interruption of the circuit or the introduction of impedance or a time delay in starting the charging cycle (example, 1538 Strobotac).

2. The use of a constant-current charging circuit (of less than I_0) with a voltage-limiting regulation circuit to limit the final voltage.

3. The use of a series switching tube or element which has a short deionization time; examples are

a. Mercury-arc control tube

b. Hydrogen thyratron (EG&G, Inc. 501 high-speed strobe)

c. Hydrogen multigap switch (Früngel equipment)

4. Inductive charging which usually produces a small current at the beginning of the charging cycle.

The above circuit modifications enable the flash lamp to deionize or control the circuit to overcome the lack of deionization of the flash lamp. The ability of the mercury-arc control tube, the hydrogen thyratron, and the hydrogen gap to control large, short-duration discharge currents and to extinguish very quickly permits flashing rates up to many thousands of flashes per second in a flash lamp. A brief description of these devices will be given below, especially a device that uses the hydrogen thyratron as a switch.

The mercury lamp with a liquid mercury pool as the cathode has a long history since it has been used extensively as a lamp and as a rectifier or switch. Early experimenters, particularly Cooper-Hewitt [9], found that the lamp would start easily if a high potential was applied on the outside of the glass at a point opposite the liquid mercury meniscus. Some interesting details of this starting process were reported by Townsend [10].

Mercury vapor at room temperature has too low a pressure for efficient light production. On the other hand, the mercury lamps at $20°C$ are very effective for deionization. Therefore, they can be operated at a high frequency even if not efficient for light production at high frequency. Lamps of this type [11-14] were used for high-speed photography some years ago but are now superseded by more efficient xenon types.

The temperature and gas pressure in a mercury lamp increase as the device is used. The pressure increases dramatically since the vapor pressure doubles about every $10°C$. Thus, it was found that a mercury-arc stroboscope at room temperature, when first started, was dim with a very short flash duration. It also had a great ability to operate at high frequency. Then as operation time progressed, the lamp became very bright as it warmed. Eventually the pressure became so high that the lamp either failed to start or heldover into a continuous glow. Early use of such mercury lamps involved skillful

preheating so that a series of flashes for photography could be made when desired.

At one time in the lamp development an attempt was made to hold the temperature of a mercury-arc lamp with a thermostatically

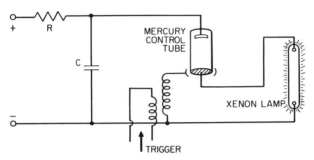

Fig. 9-10 *Use of low-pressure mercury vapor control tube with excellent deionization properties to switch an efficient xenon flash lamp at high frequency.*

controlled oven. This work was abandoned when experiments with the rare gases—argon, neon, krypton, and xenon—were started. The rare gases in a flash lamp follow Boyle's law for pressure and temperature in contrast to the vapor pressure-vs.-temperature relationship of the mercury-pool lamp. The average gas concentration, molecules per cubic centimeter, of a rare gas flash lamp remains constant regardless of temperature. There may be violent non-uniformities due to expansion caused by local heating and electrical effects, but the number of molecules of gas in the lamp are independent of temperature.

The next logical step was to use the low-pressure mercury-pool tube as a switch in series with the high-pressure efficient rare gas lamp. In this way the efficient lamp is forced to operate at high frequency by using the short deionization feature of the low-pressure mercury-arc tube. Such a circuit is shown in Fig. 9-10. The I_0 value for a mercury-control tube is estimated to be about 10 amp.

A second favorable feature of the circuit, shown in Fig. 9-10, is the *series starting* effect of the high voltage that is applied to the external concentration of the mercury tube. It will be noticed that the flash lamp is in the circuit from the cathode to the spark coil. A dim discharge can be seen between the two main lamp electrodes even when the main power is off. Thus, the flash lamp is first pulsed directly by the trigger circuit, and then the main capacitor discharge takes over.

A second switching device which is now in common use for high-frequency stroboscopes and radar circuits is the hydrogen thyratron [15, 16], as developed by Germeshausen (see [15, p. 335]). This thyratron has a heated cathode with large peak-current capability. The hydrogen gas has two useful features for pulse applications. First, the hydrogen gas molecules (ions) are small and light so that they do not damage the cathode surface as much as the heavier mercury ions would. Second, the high mobility of the hydrogen ions results in very rapid deionization. This last effect is most useful in obtaining a device that will operate at high frequency.

A third type of switching device is described by Früngel [17] as a multiple-electrode spark gap. Air, hydrogen, or alcohol can be used at atmospheric pressure with a series of closely spaced gaps which have a short deionization such that the gap can be used as a self-oscillator switch or as a driven switch. The pulse to start this hydrogen or air multigap switch must be vigorous and positive, as discussed by Früngel (see [17, pp. 116-171]).

Hydrogen Thyratron Modulator

Details are now given of the hydrogen thyratron modulator circuit as devised by Germeshausen [16] for operating radar transmitters

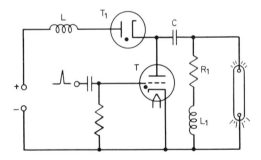

Fig. 9-11 *Basic circuit of hydrogen thyratron modulator type stroboscope for operating a flash lamp at high frequency. L and L_1 are charging inductances, R_1 is a charging resistor, and T is a hydrogen thyraton.*

and high-speed stroboscopes. An example of high-speed stroboscopic equipment using this method is described below.

The typical pulse circuit for a radar or high-speed stroboscope is shown in Fig. 9-11 with a hydrogen thyratron as a control element. Switching of the stored energy in the capacitor C into the flash lamp

is accomplished when the thyratron T is started. Recharging is accomplished through a resonant circuit involving L, L_1, and R_1 with a diode T_1 to prevent the current from reversing. This circuit is preferred since one terminal of the lamp and the cathode of the thyratron are grounded. Note that neither terminal of the capacitor is grounded.

Radar pulse drivers generally use a network consisting of inductors and capacitors in place of the simple capacitor used in most strobe circuits since a square wave form output is desired for the radar pulse oscillator. Numerous experimenters have attempted to use similar pulse networks to obtain a square pulse of light from an electronic flash lamp.

The circuit of Fig. 9-11, illustrating the use of a hydrogen thyratron, is similar to the basic circuit of the EG&G type 501 high-speed stroboscope. The equipment is operated from a 220-volt 60-cycle single-phase source of power that is fused for 20 amp. An input voltage of 220 volts was selected because the power drain of the type 501 stroboscope is too great for conventional 115-volt, 20-amp lines. Other more powerful stroboscopic devices are supplied with power from three-phase power circuits.

Housed in the lower part of the type 501 assembly (Fig. 9-12) is the dc power supply. A conventional full-wave bridge rectifier circuit is used with a charging choke and filter capacitor. A relay in the primary of the power transformer permits remote-control operation of the stroboscope. On this same relay is a set of contacts which may be used to control camera motors simultaneously with the operation of the stroboscopic light. An overload relay in the transformer primary removes power instantaneously if excessive direct current is drawn from the power supply. The central panel contains the hydrogen thyratron, the charging portion of the circuit, and a trigger amplifier which fires the thyratron. On the top panel are mounted three adjustable time-operated switches. From left to right they are:

1. A delay switch which allows the camera to reach operating speed before the flash lamp is started.

2. A light running time switch which establishes the length of time through which the stroboscopic light will operate. (It is important that this time be controlled to prevent damage to the lamp by overheating. Data relative to maximum permissible running times are presented in Table 9-3.)

3. An event delay switch used to open or close an auxiliary circuit

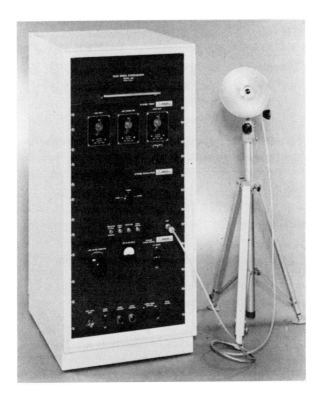

Fig. 9-12 *Front view of the EG&G type 501 high-speed stroboscope. Power supply, modulator, and timer unit are contained within the cabinet.*

at a desired time to initiate a transient for filming. (For example, the switch may be used to fire a dynamite cap at the moment that the camera is up to speed and the flash lamp is on.)

These three switches and a relay-operated switch for the camera motor simplify operation of the type 501 stroboscope. One push button operates the entire device and associated equipment. Human errors in timing are avoided by the use of the automatic features.

Light Output and Flash Duration

Light measurements of the output of bare flashtubes when operated at 1,000 Hz through 7 ft of RG54/U concentric cable are given in Table 9-3. The dimensions of the flashtubes, EG&G type FX-2 helical source and type FX-3 straight source, are given in Fig. 9-13.

The reflector factor for the FX-2 is adjustable since the position of the lamp can be varied in the reflector. Reflector factors for several conditions are listed.

FX-2: $M = 75$ Max adjustment for narrow angle.

FX-2: $M = 32$ Broad-beam adjustment for wide-angle use.

FX-3: $M = 1.5$ Cylindrical reflector around the linear lamp. This is convenient for small subjects since the reflector can be close to the subject.

Table 9-3 Horizontal Lamp Output Measured Perpendicular to the Bare Lamp Axis without a Reflector and Operated at 1,000 fps*

Flash lamp type	Source size		Light output, HCPS		
	Arc length, cm	Arc diameter, cm	0.01 μF	0.02 μF	0.04 μF
FX-2† and FX-3	9.2	0.1	0.12	0.28	0.57

*A type 935 phototube (S-5 surface) with 1.27-mm glass cover, 1.5 kV voltage into a 400-ohm load resistor was used

†The FX-2 is coiled into a helix 1.3 cm × 1.3 cm. The flash duration (one-third peak) is 1.2, 1.4, and 1.9 μsec for the three conditions shown. The FX-2 light may be 20 percent lower than from a similar FX-3 due to self-absorption. Light output of both depends also upon life and lamp dimensions, especially the tube bore.

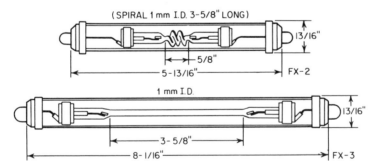

Fig. 9-13 *Dimensions and outlines of two types of quartz flash-tubes. Both FX-2 and FX-3 are filled with xenon gas at 4.5 cm plus 1.5 cm of hydrogen.*

Guide Factor of the High-speed Stroboscope Type 501

The guide factor of the 501 high-speed stroboscope can be calculated for the special case where the flash lamp is located at or

near the camera lens from the following equation, which has been given previously.

$$DA = \sqrt{CPS\ M\ \frac{s}{c}}$$

where D = lamp-subject distance in feet
 A = camera lens aperture
 s =exposure index (ASA) of film
 c = a constant (15 to 25 if D is in feet)
 M = reflector factor
CPS = lamp output in candela-seconds
BCPS = CPS M

For example, consider a film with a speed of 200 ASA, a constant

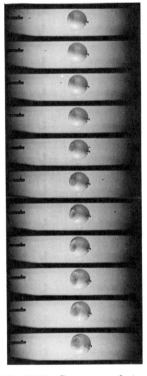

of c = 15, and a reflector with an M factor of 32. Then from Table 9-3, for a capacitor of 0.1 μF, lamp output is 0.12 CPS and BCPS = 4. Using these parameters, DA = 7. At a 1-ft distance, try aperture f = 6.3 for a first test exposure. In actual practice this guide factor value can be increased if the subject is painted white or if a light background is used or if the film is given special processing to increase its effective ASA speed.

The sequence in Fig. 9-14 of a .22-caliber bullet passing through a balloon was filmed against a white cardboard background at 4,000 frames per second. The camera was a 35-mm General Radio type 631 AG with the lens set at $f/1.5$. There was no synchronization between the film speed and the picture-taking rate. The lamp-subject distance D was about 3 ft. Thus, DA = 1.5 × 3 = 4.5. The velocity of the film was adjusted so that the photos would not overlap.

Fig. 9-14 *Sequence of pictures of a .22-caliber bullet penetrating a balloon. Taken on moving film by the light from a type 501 high-speed stroboscope operated at 4,000 fps.*

Maximum Operating Time

The light source in the type 501 stroboscope is designed for high-intensity, short-duration operation. Extended operation

Table 9-4 Maximum Allowable Total Operating Time of the FX-2 and FX-3 Flash Lamps on the EG&G 501 High-speed Strobe

Flash rate per second f	6,000	4,000	800
Capacitance, μF	0.01	0.02	0.04
Watt-seconds per flash	0.32	0.64	1.28
Allowable running time T, sec	0.8	0.6	1.5

will overheat the flash lamp. A safe limit has been found to be about 1,500 watt-sec per burst of flashes. Thus

$$1,500 = \frac{CE^2}{2} f T \quad \text{watt-seconds}$$

where C = capacitance (farads)
 E = voltage (8,000)
 f = flashing frequency (Hz)
 T = running time (seconds)

A number of examples have been calculated and are presented in Table 9-4.

At the end of these runs, the flash lamp will be red hot. Longer periods of operation will cause the tube to become overheated and perhaps permanently damaged. Between operating periods, the lamps should be allowed to cool for several minutes. Shorter running times are recommended.

The xenon flash lamps can be flashed in synchronism with a motion-picture camera by the use of a small reluctance generator which creates a small synchronizing voltage pulse when the camera sprocket teeth pass a permanent magnet. The pulse can be obtained also from other pickups, such as the phototube type. Exposure on each frame of a movie sequence will be constant, regardless of the speed, if the energy per flash and lamp efficiency are constant. This permits a rapid change of speed during a sequence of pictures.

Special Small Lamps

There are several small-size xenon flash lamps which can be operated from the type 501 high-speed strobe when an impedance matching transformer is used. Two of these lamps, the EG&G FX-11 and FX-12, are shown in Fig. 9-15. Small lamps of these types are especially useful for schlieren, microscope, and silhouette photog-

raphy where an intense small-sized source of light is needed.
The matching transformer has a 5 to 1 step-down ratio which
effectively couples the low-resistance lamps to the thyratron driver
circuit and prevents excessive thyratron currents. A transformer is
not necessary with the FX-2 and FX-3 lamps since these appear as
high-resistance (80 ohms) loads and can therefore limit the peak
current of the hydrogen thyratron to a safe value, in this case 100
amp.

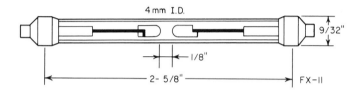

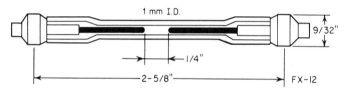

Fig. 9-15 *Dimensions and outlines of two small-sized quartz,*
xenon-filled flashtubes.

A special circuit (Fig. 9-16), including a coupling transformer is
required to couple the FX-11 flash lamp to the EG&G type 501

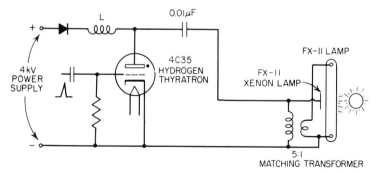

Fig. 9-16 *High-speed stroboscope type 501 adapted to drive an*
FX-11 small-source xenon lamp through a matching transformer.

high-speed strobe. This transformer has a 5 to 1 step-down ratio with the lamp on the *low-voltage* side as mentioned before. The normal output of the type 501 unit is 8 kV which produces about 1,800 volts on the FX-11. Since this is insufficient to start the lamp, a

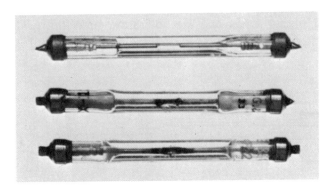

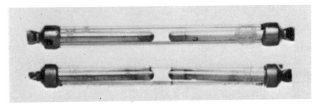

Fig. 9-17 *Small-size xenon-filled flash lamps. Upper: three FX-12 lamps (1.3-mm ID X6 mm), the top one before use. The lower two show a melted and discolored arc column with condensed quartz in the end chambers. Bottom: two FX-11 lamps (4-mm ID X4 mm), the top one before use. Note quartz discoloration from use on the lower lamp.*

starting pulse is obtained from the 8 kV terminal as shown in Fig. 9-16. The transformer also serves to reduce the peak load current in the hydrogen thyratron.

The FX-11 has a practical limit of operation at 500 cycles per second of about 1.0 sec of operation time when a 0.01-μF capacitor is used. With greater energy than above, due to larger energy per flash or a longer operation time, the lamp will be overheated and the electrodes and lamp may partially melt.

Other flash lamps, for example the FX-12, can be driven by the type 501 using the circuit shown. The FX-12 has a 0.13-mm bore of 6.3 mm length which restrains the arc into a line shape that is particularly useful for optical systems involving a knife edge, such as

schlieren. However, the FX-12 is *limited in operation by the intense heat from the arc*, which melts the small tungsten electrodes and vaporizes the quartz capillary walls if the operation is too long. It has been found that operation at 1,000 fps with a capacitance of 0.01 μF is limited to a burst of about 0.1 sec. The lamp life will be shorter as the loading is increased due to wall damage and electrode melting.

A photograph (Fig. 9-17) shows a new FX-12 and several that have been operated vigorously in the EG&G 501 flash unit.

Table 9-5 Horizontal Light Output of Lamps as Measured with a 935 Phototube (S-5 Surface) with 1.5 kV into 400 Ohms*

Flash lamp type	Arc length, cm	Arc diameter, cm	Light output, HCPS, at 8 kV		
			0.01 μF	0.02 μF	0.04 μF
FX-11	0.3	0.4	0.22	0.48	1.4
FX-12	0.6	0.13	0.48	0.78	2.25
FX-21	1.3	0.4	0.14	0.4	1.1
FX-2	9.2	0.1	0.12	0.28	0.57

*A glass filter 1.27 mm thick was used. The lamps other than the FX-2 require a 5 to 1 step-down low impedance matching transformer. A half-silvered reflector was used as a trigger electrode.

Xenon-filled gas lamps, with effective lengths of 13 mm, 25 mm, and 38 mm in Vycor or quartz of 4 mm ID (otherwise the same as the FX-11), can be operated from the EG&G type 501 driver and transformer described above. Table 9-5 shows the average observed output for several lamps when operated with 1,000-cycle bursts of 0.1 sec duration. The larger lamps can be loaded with more energy than the FX-11 or FX-12.

Cameras

There is a need for a continuously moving film when many photographs are exposed in a short time by a high-speed strobe. This can be accomplished by several systems.

1. The camera, such as any still one, can be moved or rotated while the exposures are being made so that a fresh unexposed film will appear at the image spot. This can be conveniently accomplished on a tripod by a rotary motion of the camera.

2. Often a rotating mirror can be used to swing the image to a different place on the film for each flash.

3. The drum camera with a strip of film on a wheel makes a most satisfactory method of moving film at a high speed. The drum can be brought up to speed slowly in anticipation of the event. It is important to prevent exposures from lasting longer than one revolution since confusing double exposures may be difficult to understand. Either a capping shutter or control of the flash sequence can accomplish this single-revolution operation.

4. A continuously moving strip of film, such as the Mico Instrument Co. camera (80 Trowbridge St., Cambridge, Mass.) formerly the General Radio type 651 AG, is an excellent method of moving the film. This camera uses 35-mm film of one of the standard types available (Fig. 9-18). A 140-ft length will fit the special reels which have a large core diameter to reduce the rotational velocity when ultrahigh film speeds are required. The film-moving capabilities of this camera are illustrated in Fig. 9-19. It is observed that the acceleration varies with the applied voltage and that there is an adjustable centrifugal governor switch which tends to hold the speed

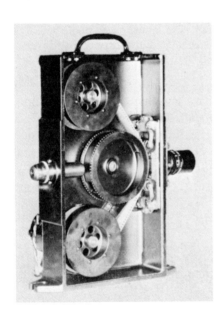

Fig. 9-18 *Internal view of a Mico type 631 AG high-speed camera with continuously moving film. Slide cover removed to show sprocket and reels.*

constant. With 1,200 full frames of 35 mm per sec, the film must move at 75 ft per sec. The acceleration time is 0.7 sec when 220 volts, 60 cycles is applied. Film of 100 ft length is finished in 1.45 sec, giving about 0.7 sec of active time at the 1,200-frames-per-sec speed.

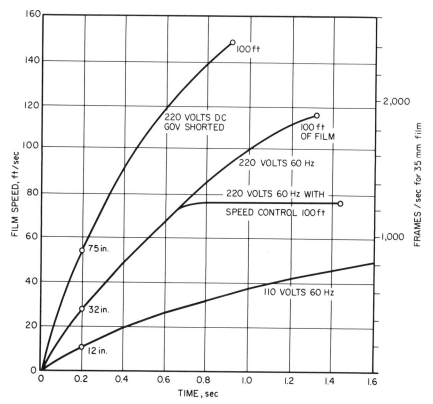

Fig. 9-19 *Speed-time curves of film in the Mico 631 AG camera for several conditions of input voltage and governor settings.*

5. Continuously moving film cameras with a rotating prism (or without) can be used with a short-pulse strobe lamp to obtain motion pictures. The Red Lake Lab camera has a phototube trigger attachment which fires the EG&G, Inc. 501 strobe in sync. with the film position. Likewise, a reluctance pickup has been used many times for the synchronism of the Fastax, the Eastman type III, and other high-speed rotating prism cameras. This reluctance device consists of a small permanent magnet which is held near the steel teeth of the main sprocket. A voltage pulse is produced in a coil when each tooth passes the permanent magnet.

6. A unique camera with very quick starting and stopping ability has been designed by L. C. Eichner Instruments [18] (19 Sebago Street, Clifton, N. J.) based on an earlier design of L. J. Hooper of Worcester Polytechnic Institute. The film can be accelerated to a thousand frames per second in a millisecond or two

by the use of rollers that engage the film directly to pull the film from a light-tight "festoon" storage box. The film had previously been deposited in the box in a loose form so that acceleration of the entire strip of film does not occur at the same time. Likewise, the film is discharged into another festoon box from which it is cranked after the run onto a conventional take-up reel. A light-controlled console designed by R. J. Kerr starts the electronic trip circuits which start the film motion when a bird comes within the field of view of the camera.

W. O. Johnson [19], at the Du Pont Company, has written the following concerning the photoelectric pickoff to synchronize an EG&G 501 strobe to the film speed:

> The sync system of Mr. Greenewalt's camera was quite simple. It consisted of a TI-800 photo diode with a one transistor, transformer coupled amplifier, all mounted on the hinged half of the film gate of the camera. I used a 3-volt grain-of-wheat lamp, the kind that is mounted in a screw-in prefocus base. I used the focussing lens assembly from a Bell & Howell projector sound system. This projected the image of the lamp filament as a line about 0.0005 in. high focussed in the plane of the film. This image falls on the perforation area of the film and is interrupted by the passage of each perforation to produce the sync signal. The photo cell is mounted in a sliding block so that the maximum light from the exciter lamp can be made to fall on the photo cell window. This system has worked satisfactorily without any attention other than cleaning since it was installed.
>
> I had originally used an eight stage miniature photo multiplier tube secured from Dumont Laboratories with a two-stage vacuum tube amplifier but found that the necessary interlocks to protect the P.M. tube when opening the camera caused some difficulty.
>
> The 35-mm rapid starting camera which I built later for use at the Mechanical Development Laboratory was somewhat more complicated. The optical system was identical to the one in the 16-mm camera. The output of the synchronizing circuit was clipped and fed to a wave-shaping amplifier and then to a double scale-of-2 counter so that with 4 synchronizing pulses being produced by the passage of each frame of film it was possible by switching in either none, one, or both of the counters to secure full frame, half frame or quarter frame pictures. The camera was fitted with snap-in gate-shaping masks which controlled the actual frame size. The synchronizing signal was also used to count frames out of an electronic register which was used to keep an exact tally of the film in the festoon supply chamber. A pre-set minimum-frame-count signal from this register prevented the possibility of using up the entire festoon supply, which would have caused damage either to the camera or the film.

The camera relies upon the shortness of the strobe flashes to produce pictures without blur on the fast-moving film.

Crawford Greenewalt was able to make some remarkable motion pictures of the wing action of hummingbirds with this camera at 1,200 frames per sec because of the quick starting ability. Conventional high-speed cameras proved useless since the birds were frightened by the camera noise and were allowed time to escape from view, because of the delay in reaching operating speed.

C. DOUBLE-FLASH EQUIPMENT

Most laboratories have standard *single* flash equipment in common use for investigations of rapid transient mechanical motions. The next step beyond a single picture is a sequence of photographs usually on a moving-picture film. These pictures can be studied individually or as a movie on the screen. The average velocity of a moving subject can be measured by determining from the pictures the distance that the object moves during the interval between two exposures. Electronically controlled flashes of light of short duration are especially useful for velocity determinations since (1) the images are sharp without the blur caused by long exposure and (2) the interval of time between exposures can be accurately determined.

For many purposes only two exposures are needed, and these can be put on a stationary film, using a still camera. The object of this section is to describe two applications, one of which is a flash unit [22] especially designed for double flash work of very rapid subjects where extremely short exposures are required, such as a dynamite cap explosion. The interval of time between flashes must be very short and of a known time duration. The second application [23] concerns the measurement of human blood flow.

The apparatus described below for measuring the velocities of shock waves, as well as other rapidly moving devices, consists of a single light source of the spark-in-air type that is energized by two separate circuits to give two pulses of light from the same position in space. The second flash is arranged to occur at a determined time after the first. The silhouette or shadow method is used to make the shock waves visible in the photographs.

Silhouette Photography

Of the several methods of taking silhouette photographs, the most efficient, as far as light requirements are concerned, is the field lens

type (Chap. 10). Here the light from a small-volume spark source is collected over a large solid angle by a field lens and redirected into the lens of a camera. The main disadvantage is the limitation of the area that can be covered by the photography since the picture area cannot exceed the area of the field lens. Glass lenses of large size are not common, especially for experiments where the lens might be expended for each shot. Plastic Fresnel lenses [24] are very useful in this connection, since their cost is relatively small. Scotchlite backgrounds permit shadow photographs to be made over large areas as described in Chap. 10. Glass lenses can have much better quality than the plastic Fresnel type since the line pattern is not present in the glass lens.

Because of the efficient utilization of light by the field lens system, it has been found that a suitable exposure can be made with modern films by using an 0.005-μF capacitor charged to 8,000 volts even when triggered with a series control gap and a 5-ohm damping resistor. The light itself is a $1/8$-in. air gap in a quartz tube that fits loosely over 40-mil tungsten wire electrodes. It was found that consistent starting without time jitter was achieved by using the quartz tube to bridge the gap. Eventually the quartz tube becomes darkened from electrode sputtering and should be changed to maintain the light output.

The optical arrangement is shown in Fig. 9-20. The light from the spark is focused by the plastic Fresnel lens into the camera lens. This camera lens can then be stopped down without a loss of light on the film if the image of the spark does not fill the area of the lens. As small an aperture as possible should be used to exclude light from the subject if this light is objectionable in the photograph. When the aperture is made too small, the out-of-focus image of the field lens may have dark areas since the light from some areas may be excluded by the aperture because of imperfections in the lens.

If schlieren-type photographs are desired, the spark image should be deflected so that only a portion of the light goes into the camera lens past the iris edge. Naturally, the result will not be of high optical quality because of uneven illumination of the field when plastic lenses are used. However, the quality of the plastic lenses is entirely adequate for straight silhouette photography, and the shock waves associated with bullets and explosions will record photographically by this system when the shock front is strong. This is shown in the accompanying photographs of dynamite caps and bullets.

Flash Circuit

The electrical circuit of a double-flash source is also shown in Fig.
9-20. Light is emitted by the quartz-tube enclosed spark gap. Two
capacitors discharge their energy into the lamp gap as controlled by
the triggering circuit pulses into the three electrode gaps.

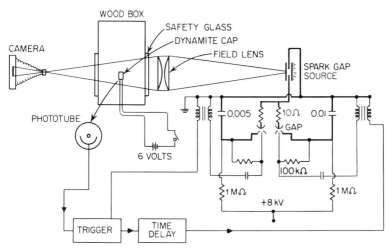

Fig. 9-20 *Arrangement for photographing a dynamite cap explosion
twice in order to measure the velocity of the particles.*

It was found experimentally that the light from the second flash is
weaker than from the first if the same energy is used in each
capacitor. To compensate, the capacity was doubled to a value of
0.01 μF for the second capacitor since this makes the second flash
about as bright as the first. Circuit inductance in the capacitor
discharge circuits should be reduced to a minimum since the
frequency of oscillation determines the maximum rate at which
energy can be discharged into the gap. The gaps in the circuit have
negligible resistance; and, therefore, damping resistance is needed
since the circuit will normally oscillate about 10 cycles before the
amplitude of the current is down to one-third of the initial peak
value.

The critical damping resistance given in terms of the capacitance C
and the frequency of oscillation f is $R = 1/\pi C f$.

For the example shown, $C = 0.005 \times 10^{-6}$ farad and $f = 3 \times 10^6$
cycles (approximate). The critical damping resistance is calculated to
be about 20 ohms. Actually a lower resistance than this is used in the

circuit, and some of the oscillations are tolerated in consideration of the resultant increased light output.

Measurements show that the second flash is lower in peak value but longer in duration. However, the integrated light output of the second flash is about the same as the output of the first flash. The following explanation gives a reason for the long second pulse. Due to a failure to deionize, the first gap after firing remains filled with ionized gas. Therefore, it conducts when the second gap is fired; and some of the energy of the second capacitor is diverted from the lamp into the first circuit. To compensate for this loss, the second capacitor is made about double in energy storage to the first.

The duration of the first flash is 0.15 μsec and the second is 0.3 μsec. The peak light of the second flash is half (12,000 CP) that of the first (24,000 CP). Therefore, the exposure on the film from each flash is about the same.

The triggering circuit must be fast and consistent if accuracy is to be obtained. For example, the pulse transformers and thyratrons that are used to produce the triggering voltage pulses must be faster than about 0.5 μsec from the initial signal until the flash of light. A series capacitor is required in the trigger circuit because of the 8 kV. An accurate adjustable time delay circuit is used to start the second flash at a known instant after the first. The maximum time delay for one

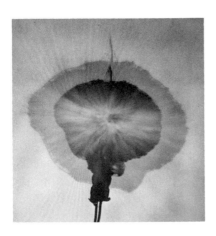

Fig. 9-21 *Double exposure of dynamite cap with 5 μsec between pictures. Note the jet from the upper end of cap.*

special equipment was 100 μsec, and this proved to be satisfactory for most dynamite cap and bullet photography applications.

A phototube trigger is used for studying dynamite caps. As soon as the metal case of the cap breaks open to emit light, the first gap circuit is triggered by the phototube signal. Then an

adjustable time delay circuit is used to trip the second gap circuit causing the second flash of light to occur.

Examples: Figure 9-21 shows two superimposed exposures of a dynamite cap during detonation. The interval of time between

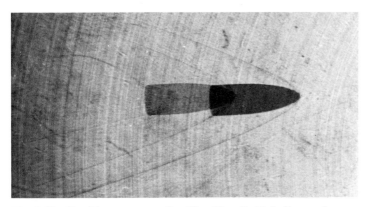

Fig. 9-22 *Double exposure of a .22-caliber Swift bullet made with double-flash unit having a 10-μsec interval between flashes.*

exposures is about 5 μsec. Of special interest is the rapid jet that has emerged from the end of the cap. Note that there is a blurred exposure at the center of the picture made by the light from the explosion itself. This exposure from the subject can be reduced or enhanced by closing or opening the camera aperture. Such adjustment does not materially affect the exposure due to the sparks *if the imaged light from the spark on the lens is not obstructed by the iris.*

The two superimposed photographs of a .22-caliber Swift bullet in Fig. 9-22 were taken 10 μsec apart. It is very easy to measure the yaw of the bullet from these pictures. A different Fresnel lens than that shown in Fig. 9-21 was used. It is noted that the patterns left by the two lenses are entirely different.

Conventional direct silhouette photographs can also be made with the double-flash unit. The open spark source for this purpose is located about one meter from the bare film of 8 × 10 in. size in a darkened room. The bullet is located about 10 cm away from the film. Refraction of the direct light from the small source by the sound waves causes the light to be deflected.

A commercial model [25] (EG&G, Inc. type 2307) of the above double-flash silhouette equipment was developed by EG&G, Inc. and has been distributed for a number of years, particularly to the Aberdeen Proving Ground for the study of dynamite cap explosions.

An improved time-delay circuit which could be calibrated was used in this model.

Reflected Light Double Flash

This section shows electrical details of a double-flash unit for studying blood flow [23]. An electronic xenon flash unit was constructed so as to produce two brief, intense flashes of light with a time delay between them in order to measure the average velocity of capillary blood flow in human conjunctival vessels. A 35-mm camera with a 35.6-cm lens tube and 40-mm Zeiss macrolens was adapted for closeup photography with two flashes of light for a double exposure. The normal eye searching movements give enough displacement during the delay so that the vessels are seen as distinct pairs in the photograph (Fig. 9-23). The distance traveled by red blood cells or

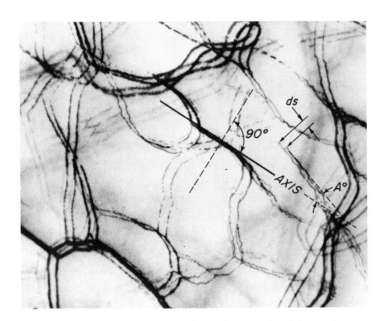

Fig. 9-23 *Example of a double-flash photograph of the conjunctival vessels showing the method of evaluating velocity by double exposure.*

clumps of cells during the delay can be measured, and the average speed calculated. It was found that the velocity measured in this way is highly variable, since the velocity of blood flow in the capillaries is inconstant, but can be averaged from a series of pictures taken over

an interval of 60 sec. Motion pictures taken concurrently support this observation.

The circuit described utilizes silicon-controlled rectifiers in the switching and time-delay networks and is based on a vacuum-tube circuit developed by LaForge [26]. The reasons for use of an electronic flash unit for eye photography have been presented previously [27] and are summarized briefly as follows: (1) the small physical size of the flash lamp permits efficient direction of the light onto a relatively small area, (2) a high peak light intensity which is required for adequate exposure and maximum depth of field, (3) a very brief effective exposure time which is determined by the duration of the flashes (in the present instrument they are of the order of 250 to 400 μsec) so that motion of either subject or camera causes no blurring, and (4) constant light color quality and exposure control. Two of the disadvantages of an electronic flash unit in a medical application are the hazards of high voltage and fracture of the walls of the flash lamp. These hazards are eliminated by careful insulation of the flash lamp and by its enclosure in a heavy-duty Pyrex tube.

Flash Lamp

The flash lamp is a U-shaped modification of the EG&G, Inc. FX-33 lamp contained in a glass tube. The U-shape permits the source of light to be kept as close to the subject as possible while keeping the high-voltage leads as far away as possible. The spark coil which triggers the discharge is also enclosed in the tube to avoid carrying the high trigger voltage through the cable from the power supply; a thin aluminum disc is inserted between the flash lamp and the spark coil to direct heat away from the plastic of the spark coil.

The circuit supplies sufficient power to fire the xenon flash lamp twice with a delay between flashes variable from 2 to 200 msec (Fig. 9-24). Silicon-controlled rectifiers (SCR's) are used to replace mercury-pool control tubes as used by LaForge. Replacement of the mercury tubes by semiconductors permits operation of the unit without special consideration for spatial orientation of the switching devices, increases resistance of the unit to physical shocks, and eliminates the hazard of spilled mercury if a tube is broken.

The main storage capacitors C_1 and C_2 are charged to approximately 450 volts by half-wave rectification of the output of a line-operated transformer. When switch S_1 is closed, a positive

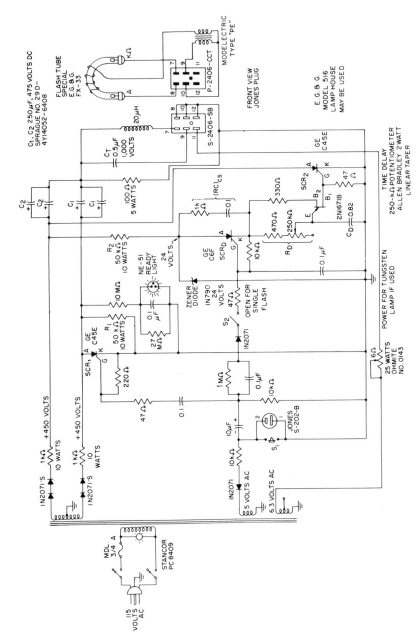

Fig. 9-24 *Circuit for driving a double-flash electronic lamp.*

voltage pulse is applied from gate-to-cathode of SCR_1, causing SCR_1 to conduct and completing the circuit SCR_1, C_1, the flash lamp, and the spark coil and trigger capacitor C_T. The current in the spark coil and C_T triggers the flashtube. The positive pulse caused by closing S_1 is also applied from gate-to-cathode of the time-delay SCR, SCR_D, causing it to conduct. This current flows into the RC network R_D and C_D, increasing the voltage applied to the emitter of the unijunction transistor 2N1671B. At the time the emitter-base junction becomes forward biased, and C_D discharges through the 47-ohm resistor. The resulting voltage pulse raises the gate-to-cathode voltage of SCR_2 until SCR_2 conducts, completing the circuit SCR_2, C_2, the flash lamp, and the spark coil and C_T and thus firing the flash lamp a second time. The time delay is independent of line voltage variations, as the voltage applied to the time-delay circuit through SCR_D is held constant at 24 volts by the Zener diode 1N790. The rate of change of the 2N1671B emitter voltage may be reproducibly controlled by varying R_D, thus changing the time delay between flashes. The range of time delays in this unit is approximately 2 to 200 msec; a different range could be obtained by varying C_D and/or R_D.

R_1 is in parallel with SCR_1 in order to match the current drain of approximately 9 mamp from C_2 caused by the time-delay circuit, thus making the two firing circuits more nearly symmetrical and the flashes more nearly equal. The positive voltage supplied to the SCR's, C_1, and C_2 is unfiltered half-wave rectified ac. The drop in voltage between 60-cycle peaks reduces the current available to the SCR's when the capacitors are discharged to less than the minimum holding currents, so that the SCR's shut off after each flash, permitting recharging of C_1 and C_2. The initial holding current required to hold SCR_D on with the short-gating pulse produced by closing S_1 is approximately three times the steady-state holding current required once the SCR is fully on. The current available through R_2 is greater than the steady-state holding current but less than the initial holding current. The current-supplying network $(RC)_{CS}$ is in parallel with SCR_D and supplies the required additional holding current. The 20-μH inductance in series with the flash lamp limits the switching transients, protecting the SCR's. A switch S_2 in series with the gate signal lead of SCR_D may be opened to permit single-flash operation of the unit by interrupting the time-delay circuit so that SCR_2 is not triggered.

A useful approximation for predicting the behavior of circuits with xenon flash lamps of construction similar to the FX-33 utilizes an effective series resistance of the ionized flash lamp and associated circuit elements of 1 ohm. This is determined from the ratio of peak voltage to peak current. Thus, the time constant of the flash lamp current is roughly $RC = (1 \text{ ohm})(C) = C$ sec. The power time constant is roughly $RC/2$ sec. Light and power are linearly related to a first approximation; therefore, the flash duration can be estimated.

Duration of flash = $RC/2 = C/2$ sec. Provided switching transients are limited (in this instrument by the 20-μH series inductance), the value of the peak lamp current is the ratio of the peak voltage applied across the lamp to the effective series resistance (in our case, 450 volts per 1 ohm = 450 amp). Thus, doubling the capacitance hardly changes the peak lamp current since it is determined by the voltage applied. However, the time constant of the light pulse is almost doubled. An evaluation of the approximation was made on the flash unit at 225 and 450 μF per flash.

Eastman type 5302 fine-grain positive film developed in Diafine permits increased film speed and fine grain. The film is blue-sensitive, which aids greatly in obtaining contrast in the details of the small veins and arteries. Studies of normal subjects reveal that mean capillary blood flow velocity (vessel diameter 9 ± 0.5 μm) was 410 ± 36 μm per sec. The vessels which receive blood from the capillaries, i.e., the beginning of the venous system (venules) had a velocity flow of 390 ± 36 μm per sec (vessel diameter 77 ± 2 μm).

These techniques, now being employed in medical laboratories, are providing valuable information regarding studies of blood flow velocity in health and disease [28, 29]. The technique might also be applied to other dynamic but relatively slow-moving systems in which photomicrography is used to estimate velocity of motion.

D. MULTIFLASH PHOTOGRAPHY

One of the most fascinating and creative kinds of photography is the so-called multiflash type by which several photographs are superimposed on the same negative. The French physiologist E. J. Marey [30] was one of the leaders, and probably the originator, in the use of the technique. His book gives the results of his careful studies of the way in which all kinds of animals, including people, move. One of Marey's photographic systems was the use of a black background against which a series of sun-illuminated exposures displayed the

action on a single photographic film. Muybridge [31] used a sequence of pictures with separate cameras.

Historical mention should be made of the pioneer multiflash photographic applications by Cranz [32], Schardin [33], Bull [34], and many others who have developed the electrical multiple-spark source methods. Most of the subjects of the photography were bullets, and silhouette pictures were made with the flashes of light from sparks, often on a moving film.

This section discusses some of the technical problems that arise when the system is applied to reflected-light ballistic photography where the exposure time per flash must be short and the interval of time between flashes also short. Reflected-light photographs require considerably more light than silhouette photos. Furthermore, it is more difficult to operate a high-power lamp at high frequency than a low-power lamp because of deionization effects of the gas in the flashtube.

Multiflash light sources can be classified into the following three general types:

1. Separate lamps, each controlled by a separate energy storage circuit to flash once at selected intervals of time

2. A single flash lamp operated by a fast rechargeable circuit, including a rapid deionization control tube, such as a hydrogen or a mercury-arc tube

3. A single flash lamp operated by a series of separate energy storage circuits with a series of rapid deionization devices for switching each energy source

The equipments that are described in this section are in the last two classifications. It will be noted that the first system produces a series of photographs with a different type of lighting on each because the lamp used on each is at a different position in space.

Rapid-flashing Sources

Cranz [32] and others who worked with him used a self-oscillating spark source of light for ballistic photography. The interval of time between sparks depended upon the charging time of the capacitor and the voltage at which the spark would occur. Since the sparking voltage is strongly influenced by the residual gases in the gap, the interval of time between flashes can be variable in time. Some improvement of this unsatisfactory condition is obtained by directing a blast of air into the gap.

One high-frequency driving circuit [35] for an electronic flash lamp has been shown before (Fig. 9-11) in which a hydrogen thyratron controls the starting and deionization of the flashtube. The deionization of the thyratron is such that the capacitor C can be charged from the source in time for a fast rate, such as 10,000 fps. Flash lamps themselves are notoriously long in their deionization process, because they are filled with a rare gas at high pressure which remains ionized long after each flash. However, the hydrogen thyratron with its rapid deionization time controls the stopping and restarting instants of the flashes.

A Multiflash (20) Equipment

An attempt was first made to extend the circuits of the double flash, which has been described (Sec. 9-C), to a 20-flash unit with enough light (9 watt-sec per flash) for reflected-light photography at a 50-kilocycle rate. It was found that air gaps could control the starting of the discharges, but the gaps would not deionize after each firing and, thus, caused circuit difficulties in the subsequent discharges due to their electrical conduction. The difficulty was also present in the double-flash equipment but was not serious since only *one* gap was in the circuit when the second gap fired. A slightly larger capacitor on the second flash circuit is used to equalize the light from the light gap for the second flash in the type 2307 (EG&G, Inc.) equipment, as was explained before.

It was found that the mercury-arc control tube (EG&G, Inc. mercury switch) would serve effectively as a switching tube at a 100-kilocycle rate if the energy per flash was about 1.5 watt-sec. Figure 9-25 shows the lineup of the equipment to drive the EG&G type FX-2 flash lamp. Experiments showed that the FX-2 flash lamp was damaged by overheating when it was flashed with 9 watt-sec of energy for twenty times at a 1-kilocycle rate. Operation was satisfactory at 1.5 watt-sec per flash.

Other tubes were tried, such as the FX-1, FT-218, FT-210, etc. with varying success. However, the FX-2 or the FX-3 had the highest efficiency and the flashes were more consistent. The FX-2 gave almost the same light and duration for each flash. In contrast, other tubes appeared to have a much longer flash duration for their subsequent flashes.

The light output per flash with the FX-2, as measured with a type 935 phototube on a cathode-ray oscilloscope, showed 20 distinct flashes of 1 μsec duration. However, the light was not identical. The

second flash was usually about 25 percent higher than the first. Then the subsequent flashes decreased in intensity until the last was about 50 percent of the light of the second flash. On rare occasions a

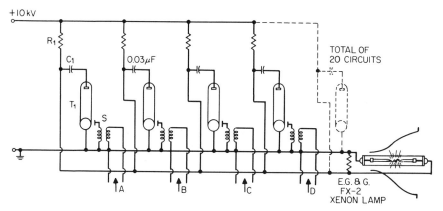

Fig. 9-25 *Circuit for flashing a series of capacitors into a flash lamp at a high rate of speed. Flashes at a 100-kilocycle rate have been switched with 1.5 watt-sec per flash.*

mercury-arc tube would fail to deionize, and then one or more of the flashes would be smaller. It is believed that the variation in light from flash to flash is due to temperature and pressure wave effects in the xenon gas. Consistent operation was experienced with 1.5 watt-sec per flash at a 100-kilocycle rate for 20 flashes. The power input to the tube during this time is 150,000 watts and the total energy is 30 watt-sec. An oscillator with a peaking circuit is used to trigger a thyratron circuit at equal intervals of time. Then a gating circuit, when triggered by some event, would start the sequence of pictures at a rate set into the oscillator. Details of the gate and sync. circuits are shown in Fig. 9-26.

Figure 9-27 shows a multiflash equipment for photographing bullets, and Fig. 9-28 shows an example. Fourteen photographs taken at about a 30,000-fps rate show a .22-caliber bullet in flight as it strikes a string. Figure 9-29 shows a larger projectile striking a parachute line at a 1,000-cycle flash rate. Both Figs. 9-28 and 9-29 were taken by the Fabric Research Laboratories, Inc. (Dedham, Mass.). The multiflash equipment was used by this organization to study the rapid loading of parachute cords for use during reentry from space.

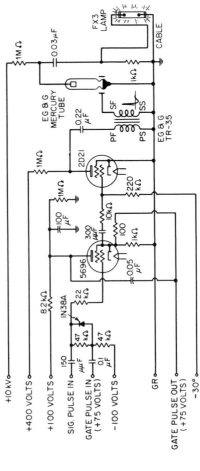

Fig. 9-26 *Gating and triggering circuit as used for each component circuit of the multiflash equipment. The rate-setting oscillator is connected to the "sig. pulse-in" terminal. The trigger signal from the event is connected to the "gate pulse-in" terminal.*

Fig. 9-27 *Photograph of a multiple flash unit showing six photos of a bullet. A separate panel is used for each driving circuit.*

202

Fig. 9-29 *An 8-oz, 2.5-in. diameter projectile traveling approximately 500 ft/sec and rupturing a high-strength parachute suspension line. Time between successive exposures approximately 1 msec.*

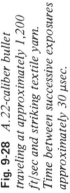

Fig. 9-28 *A .22-caliber bullet traveling at approximately 1,200 ft/sec and striking textile yarn. Time between successive exposures approximately 30 μsec.*

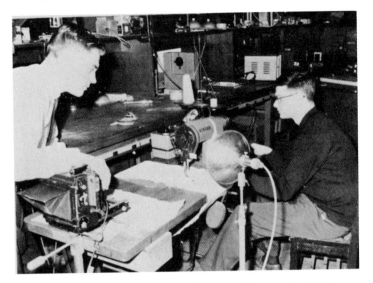

Fig. 9-30 *John Carson opens the shutter while a student in the textile laboratory at M.I.T. operates the sewing machine. A series of 11 photos at a 10,000-cycle-per-second rate was exposed.*

Fig. 9-31 *Multiflash photo of thread in a sewing machine, taken at 100-μsec intervals (10,000 fps). The sewing machine is operating at 4,800 rpm.*

A multiflash study (11 flashes) of a sewing machine is shown in Figs. 9-30 and 9-31. In Fig. 9-30 a Strobotac at the back of the machine enables the operator to hold the speed of the sewing machine at 4,800 rpm. The thread positions at 100-μsec intervals give a clear story of the action of the thread during part of the cycle. Other photographs taken at random show additional phases of the thread action and the irregularities that occur.

The Multiple-spark Light Source

David Kocher [36] developed a 10-exposure Cranz-Schardin camera which operated up to 10^{-7} sec between flashes. The energy per flash was 0.22 joules at 30 kV and the flash duration was about 10^{-7} sec. The following is quoted from Kocher:

> Each of the ten flash light sources used in the camera system is a capillary spark in air. The gap is constructed and oriented so that light radiating from one end of the capillary illuminates the field lens. The capillary gaps are arranged on a circle to illuminate properly the camera lenses. Each capillary gap is triggered independently.
>
> The construction of a single capillary spark gap is as follows. The capillary is ¾-mm-bore Pyrex, bonded at one end by an epoxy fillet to a thin sheet of molybdenum in which a ¾-mm hole has been drilled. The molybdenum sheet serves as one electrode while permitting light to radiate axially from the capillary through an aperture of fixed location and size. Molybdenum was chosen as the electrode material because of its relatively high melting point and good workability. The second electrode for the capillary is a close-fitting tungsten wire inserted in the opposite end of the capillary to within 2.5 cm of the molybdenum electrode.
>
> Energy storage for the spark discharge is provided by a 500-$\mu\mu$F, 30-kV ceramic capacitor of a kind commonly used as high-voltage filter capacitors in television sets. The capacitor is connected directly across the capillary gap with short leads, and charged from a 30-kV supply through three standard 2-watt, 2-megohm molded composition resistors connected in series. The capillary gap is triggered by a 25- to 30-kV trigger voltage applied to a trigger lead consisting of two turns of insulated wire wrapped around the Pyrex capillary at the midpoint of the spark gap.
>
> The peak light is 24,000 candela and the ⅓ peak duration is 0.1 μsec measured on-axis with an *S-4* response phototube calibrated by means of a xenon flash lamp standard. Measurements with an *S-1* response phototube show the flash duration to be longer at the red end of the visible spectrum. Accordingly, a blue (Wratten #47B) filter is used in the camera to reject the red light. When used with the field lenses, filter and camera described above, the capillary gap provides sufficient light to properly expose Plus X film.

When it is desired to flash the light sources consecutively at intervals greater than about 10 μsec, the trigger voltages may be obtained from separate trigger transformers driven by conventional thyratron-capacitor discharge circuits. For inter-picture times in the range from 10 μsec to 0.5 μsec, an alternative method is used, as diagrammed in Fig. [9-32]. An

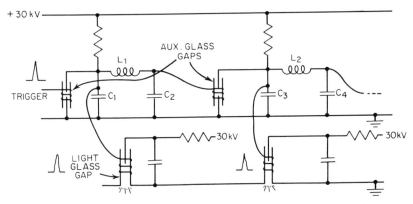

Fig. 9-32 *Circuit for obtaining a rapid sequence of flashes of light.* (From Kocher.)

auxiliary set of ten spark gaps is used to discharge ten auxiliary capacitors (C_1, C_3, etc. in Fig. [9-32]). The trigger lead of each capillary light source is connected to the high voltage electrode of its respective auxiliary spark gap. The rapid 30-kV discharge of the auxiliary capacitors provides an excellent trigger voltage for the capillary gaps.

The timing of the auxiliary spark discharges (and consequently the capillary light sources) is accomplished by the use of L_1 and C_2, L_2 and C_4, etc. in the timing circuit of Fig. [9-32].

An external source is used to trigger auxiliary gap #1, thereby discharging capacitor C_1 and triggering capillary gap #1. In this manner the auxiliary gaps are fired in sequence with the intervals between successive firings determined by separate inductances and capacitances. In practice, the timing intervals are changed by changing both the timing inductors and capacitors (L_1 and C_2, etc.).

In the present equipment C_1, C_3, etc. are fixed at 4,400 $\mu\mu$F and 30 kV. The auxiliary spark gaps are constructed of 2-mm-bore quartz tubing with close-fitting tungsten electrodes inserted from each end, leaving a 2.5-cm gap. The trigger lead consists of two turns of insulated wire around the quartz tube about 1.6 cm from the ground electrode. C_2, C_4, etc. consist of either 500 $\mu\mu$F or 4,400 $\mu\mu$F at 30 kV, selected by connecting a 3,900 $\mu\mu$F capacitor in parallel with a permanently connected 500 $\mu\mu$F capacitor. The charging resistors are identical to those used for the capillary gap assembly.

For ease in picture rate selection, the inductors are made with "plug-in" leads. For each value of inductance, the two available values of C_2, C_4, etc. permit delay times differing by a factor of approximately three. For inter-picture times of several microseconds or less, the duration of the auxiliary spark discharge becomes significant and inductances smaller than the calculated value must be used. For timing intervals in this range the selection of the proper inductance for a given picture interval is aided by a bit of experimentation.

The inductors must withstand momentary peak voltages of 30 kV. For inductances in the milli-henry range, multiple-section wound radio frequency chokes potted in epoxy were satisfactory. For smaller time delays, coils were wound with close-spaced insulated wire or open-spaced insulated wire or open-spaced bare wire.

For inter-picture times of ¼ microsecond, the time delay inductors and capacitors are removed, and the trigger lead of each auxiliary gap is connected directly to the high voltage electrode of the preceding gap. For inter-picture intervals of 0.1 μsec the trigger lead of each capillary light gap is connected directly to the high-voltage terminals of the preceding capillary light gap capacitor, and the series of auxiliary timing spark gaps is not used.

Note that the time intervals between successive light flashes can be adjusted independently. The use of a variable picture rate considerably increases the usefulness of the camera when photographing events where action proceeds at a variable rate.

Experience with this light source indicates that there can be a variation of two-to-one in light output and ± 20% in timing for successive flashes in a single run.

Because of the high voltage used for the spark gaps, small radii of curvature were avoided in the construction of all exposed terminals. Corona from small conductors and connectors can be eliminated by the use of insulating sleeves of sufficient diameter. Dust and moisture can cause random breakdown and erratic operation, particularly for the first few firings when the voltage is applied after a period of disuse.

Photographic Results

Figure [9-33] is a sequence of schlieren photographs showing the initiation of a longitudinal sound wave in glass. The sound wave is generated by the elastic impact of a ⁵⁄₃₂ -in. steel ball mounted in the nose of a .22-caliber long rifle bullet. The impact takes place at the edge of a piece of ¼-in. plate glass. In the first picture the bullet has passed about halfway through a vertical trigger wire and is approaching the edge of the glass. The air shock wave has progressed beyond the edge and is visible along the flat side of the glass. The second picture shows that the ball has just touched the glass as a small dark region of compression is visible in the

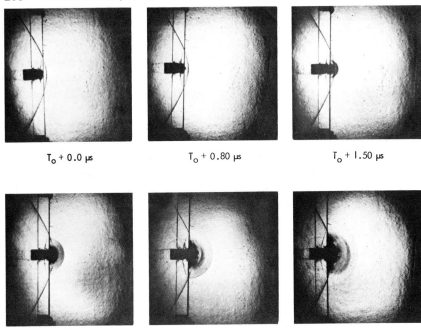

$T_o + 0.0 \; \mu s$ $T_o + 0.80 \; \mu s$ $T_o + 1.50 \; \mu s$

$T_o + 2.15 \; \mu s$ $T_o + 2.85 \; \mu s$ $T_o + 3.45 \; \mu s$

Fig. 9-33 *Schlieren sequence of sound wave in .25-in. plate glass caused by impact of a steel ball mounted in nose of .22-caliber bullet. Total elapsed time is 3.45 μsec.* (Photograph by David Kocher.)

glass at the point of impact. Note the relative movement of the sound in air and in glass in the sequence of photographs. Measurements made on these photographs give the velocity of the sound in glass as 17,700 ft per second, using the bullet diameter as a reference distance.

The schlieren apertures for the photographs of Fig. [9-33] consist of opaque stops in which are placed holes just the size of the light source image. Unrefracted light from each spark light source passes through these small apertures, producing bright field schlieren pictures in which refractive gradients appear dark. The background illumination in these pictures is non-uniform primarily because of refractions introduced by pieces of automobile safety glass placed on both sides of the event to protect the field lenses. The capillary gaps have a directional radiation pattern that produces a small variation in background illumination.

For critical schlieren photography, it is important to recognize that the capillary gap resembles a line source of light behind a small aperture. Since all points within the capillary cannot be simultaneously in sharp focus on the schlieren aperture, the schlieren modulation at the aperture becomes complicated. This difficulty can be avoided by the use of a shorter capillary gap if a decrease in light output is acceptable.

The circular apertures described above can be used to advantage in the photography of slightly self-luminous subjects. Closing the camera aperture down to the size of the spark light source image reduces the brightness of the self-light of the subject, while the backlighting is undiminished.

An AC Multiflash Circuit

A circuit [37] for driving a multiflash strobe lamp at integrally timed pulses (120, 60, 30, etc. per second) in phase with the line frequency (60 cycles per second) is described. Such a circuit does not require (1) the large filter capacitor which is necessary for a continuously variable-frequency stroboscope or (2) a means for suppressing arc holdover since the charging circuit starts at the zero-voltage condition.

Photography of large subjects with multiple-exposure strobe lighting requires considerable light per flash and a rapid recycle rate. A classical example is the photography of a golf swing or a tennis serve. Subjects such as this require a strobe that covers about 3 × 3 meters of space at the subject. This area must also be lighted

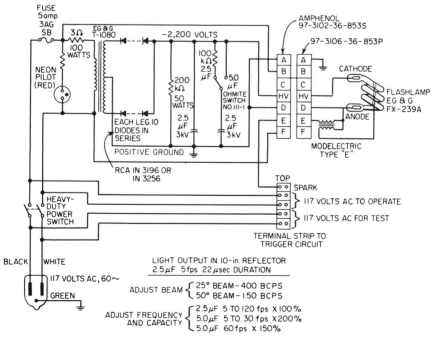

Fig. 9-34 *A 120-cycle strobe power and discharge circuit.*

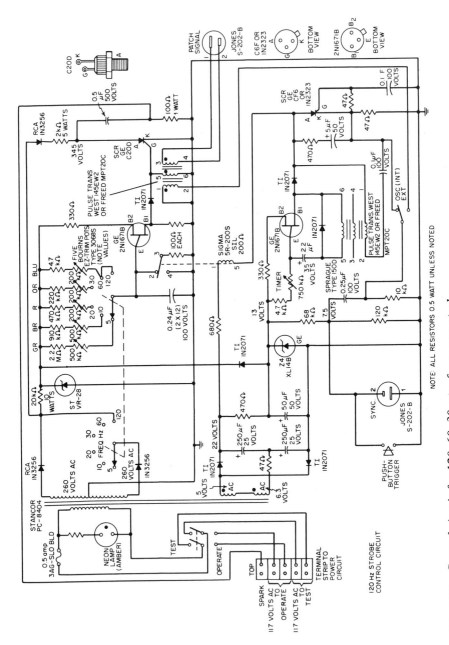

Fig. 9-35 *Control circuit for 120, 60, 30, etc. frequency strobe.*

210

uniformly. The frequency of the strobe should be at least 100 fps in order to obtain enough pictures to portray the action of subjects such as golf strokes.

This section presents a very specialized and limited solution to the holdover problem, consisting of a specially timed discharge circuit to flash the lamp at the part of the cycle when the voltage is approaching or near to zero. For this condition, the initial charging current from the power supply is almost zero giving the lamp time to deionize before the charging pulse of current occurs. The circuit is given in Figs. 9-34 and 9-35. Figure 9-36 shows the EG&G, Inc. model 553 multiflash lamp.

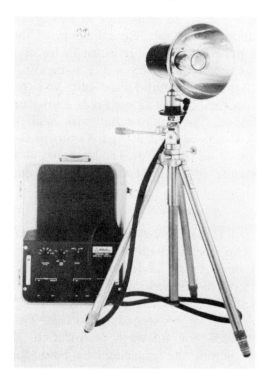

Fig. 9-36 *EG&G, Inc. 553 multiflash photographic light source for making multiple exposure motion studies at 20, 30, 60, and 120 cycles per second with a BCPS of 375. The system includes a heavy-duty quartz xenon light source. The tube mount provides for forced air cooling of the compact helical flashtube. The position of the removable flashtube is adjustable in the reflector to vary the beam width from 25 to 50°.*

Strobe Lamp

The xenon-filled flash lamp for intermittent operation at high power should be made of quartz and have large electrodes if the energy per flash is large, the number of flashes per second is high, and the sequence of flashes is great. Lamps that have been used are the GE FT-503, FT-524, and the EG&G, Inc. FX-239A. The first two lamps consist of a 4½-turn helix of 6-mm-ID quartz. The FT-524 model is open at the end so that a blast of air or a liquid can be used for cooling. The FX-239A is a xenon-filled three-turn helix in a special holder suited for air cooling. The inside diameter of the lamp tubing is 4 mm, and the inside helix diameter is about 2.5 cm.

The normal operation calls for a 2.5-μF capacitor at 120 cycles which at 2,200 volts stores about 6 watt-sec. The efficiency of the FX-239A is about 4 candelas per watt and the reflector factor of a 10-in. specular reflector is such that the BCPS is 375 with a 30° angle. The flash duration is 22 μsec to one-third peak light. An extra capacitor can be switched in to total 5 μF (12 watt-sec), and extra external capacitors can be added. The light output with 5 μF is doubled for flashing rates of 5, 10, 20, and 30 fps. At 60 fps the output is 1.5 times that for the 2.5-μF capacitor. The lamp may skip at 120 cycles with 5 μF because of insufficient charging of the capacitor.

Power and Discharge Circuit

The unit operates from a 115-volt, 60-cycle line capable of supplying about 20 amp. The special high-voltage transformer (EG&G T1080) has a high leakage reactance to limit the capacitor charging current, and a 3-ohm resistor in series with the primary of this transformer further limits the secondary charging current to 1.25 amp (peak) which prevents overshoot of secondary voltage. Two strings of silicon diodes are used for full-wave rectification. A 200,000-ohm bleeder resistor across the capacitor dissipates the stored energy when the unit is switched off. The storage capacitor for flashing the lamp is charged in one half cycle of the 60-cycle line and is discharged into the lamp when the lamp is triggered by the control circuit. Also, charging is accomplished on both half cycles of the ac power circuit to enable the lamp to flash at 120 times per second.

Control Circuit

The principal method of controlling the instant of flashing is by timing the flashes to be synchronous with the ac line voltage and to

occur at or near the voltage zero. A General Electric 2N1671B unijunction (UJ) transistor supplies the gate trigger for the GE C20D silicon-controlled rectifier (SCR) in the flashtube pulse circuit. The UJ transistor power supply is unfiltered resulting in a dip at the end of each half cycle which causes the transistor to fire if the emitter capacitor voltage is near the peak point. The Zener diode VR-28 limits the maximum supply voltage and Zener diode Z4XL14B provides a low-voltage bias. Frequency is determined by a switch and selected resistors to obtain submultiple frequencies of the line frequency.

The SCR GE type C20D discharges a 0.5-μF capacitor at 345 volts into the spark coil which then triggers the flash lamp. The UJ oscillator is kept inactive by a relay which grounds the emitter circuit until a small SCR (GE type IN2323) is turned on by a push button switch or the "X" contacts in a camera shutter. The length of the flash sequence, which may be up to 1.5 sec, is determined by a second UJ transistor timing circuit which turns the IN2323 SCR off, thereby deenergizing the relay.

Two units may operate in synchronism by using a cable between the Jones connectors marked PATCH SIGNAL. Polarity must be observed. The flash rate and sequence may be determined by either control circuit depending on which one is chosen by the operator.

A unit may also be slaved from a master unit by using a light-activated SCR (LASCR) device, such as the L9U, plugged into the Jones connector of the slave unit. The OSC.-EXT. switch on the slave must be in the EXT. position for light control. The light from the master flash must fall on the window of the LASCR to trigger the second flash unit.

Single flashes may be obtained when the OSC.-EXT. switch is in the EXT. position. For each closure of the push button or device plugged into the Jones sync. connector a flash will occur. A contactor may be used to obtain a series of flashes.

Other interesting methods of control can be devised with this flexible circuit for obtaining either single flashes or a multiple series of flashes at integral fractions of the supply frequency.

The background is preferably black velvet since this material has the smallest reflection factor. There is a black paper that has a black felt surface that is fairly satisfactory (Louis Dejonge & Co., 330 Tompkins Avenue, Staten Island, N.Y.). Ordinary black cloth or paper is not satisfactory since the surface is somewhat specular. The two strobe lights are at a large angle to cross light the subject without

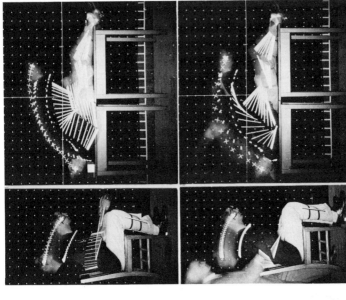

Fig. 9-38 *Stroboscopic multiple-image photographs. Right: lying down to sitting up. Markers on head, neck, chest, upper and lower leg. Flash rate 10 fps. Left: leaning forward to sitting up. (Photographs by Jones.)*

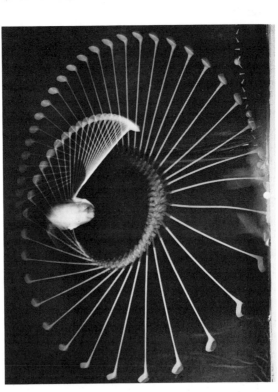

Fig. 9-37 *A golf drive at a 120-sec rate. Note that the club hit the ground before it hit the ball. The camera is on the floor for a low-angle view and the golfer is wrapped with black velvet material so that his picture does not confuse the golf club pattern.*

illuminating the background. It is important to side light since there may be as many as 100 exposures of the background compared to one of the subject.

Figure 9-37 shows a golf ball drive taken at 120 cycles per second. Such a photograph shows in a graphic manner the action of a golfer as he winds up the club and hits the ball. The velocity of the club before and after impact can be measured. Also, the velocity of the ball can be determined. A similar study of the impact of a baseball with a bat has been made. This type of photograph does not give all the facts since the ball may (usually does) leave the bat at a considerable angle which cannot be resolved on a single photograph. Stereo photography permits the measurement of such phenomena. A second camera above the action is very useful for supplementing the information on the first camera.

Multiflash photography for analysis purposes can be accomplished with Scotchlite markers, as used so effectively by Jones et al. [47]. Figure 9-38 from Dr. Jones shows the motion of people by the use of Scotchlite patches which reflect the light of a small strobe placed near the lens of the camera. This will be explained in Chap. 10.

Often there is confusion in the multiflash photograph when too many images are superimposed. Also, it is not known which of the many markers are photographed at a given instant. Jones et al. [48] used a rotating transparent filter disc with several colors in front of the camera to code the various images on the film.

Another technique of avoiding background exposure in a multi-flash photograph is the use of a spotlight that can be aimed at the subject during the action. As an example refer to Fig. 5-5 which shows Alexander Sazhenev of the Russian Circus doing a backflip on 7-ft stilts at the Boston Garden, October 12, 1963. The lighting consisted of two 18-in. specular reflectors with FT-524 flash lamps each excited by 25 μF at 4 kV. The beam-candela is 25,000 BCPS which gives a guide factor of about 250 with Ektachrome type S negative film. A power supply capable of charging the capacitor of each in 0.5 sec was used. Note that the person did not keep the lamp aimed on the subject for the last exposure, which shows an underexposed photo of the performer on the ground.

The camera shutter was a Wollensak "Alphax" type of self-winding shutter that could be hand fired two times per second. The fastest shutter time was 1/200 sec. A fast shutter time is important to exclude ordinary light from the film but to allow the strobe

flashes to be used since the "X" contacts of the shutter control the flashing instant. The focal length of the lens was 6½ in. and the aperture $f/5.6$.

REFERENCES

1. "Handbook of High-speed Photography," General Radio Company, Concord, Mass., 1967; *Strobotactics*, a new journal of General Radio Company starting June, 1967; "Handbook of Stroboscopy," General Radio Company, Concord, Mass., 1966.
2. Rutkowski, J., "Stroboscopes for Industry and Research," Pergamon Press, Inc., New York, 1966.
3. Kivenson, G., "Industrial Stroboscopy," Hayden Book Company, New York, 1965.
4. Harashima, A., et al., "Stroboscope, Examples of Multiflash Photography," Kodansha, Tokyo, 1966.
5. Catalogue of 4910 Stroboscope, Bruel and Kjaer Co., Naerum, Denmark.
6. Dawe Instruments, Ltd., 83 Piccadilly, London.
7. Edgerton, H. E., and D. A. Cahlander, Holdover in Xenon Flashlamps, *J. SMPTE*, vol. 70, pp. 7-9, January, 1961.
8. Buttolph, L. J., Mercury Arcs, *Rev. Sci. Instr.*, vol. 8, p. 487, September, 1930.
9. Bourne, H. K., "Discharge Lamps for Photography and Projection," Chapman & Hall, Ltd., London, 1948 (p. 74, Cooper-Hewitt 1902 lamps described).
10. Townsend, M.A., Cathode Spot Initiation on a Mercury Pool by Means of an External Grid, *J. Appl. Phys.*, vol. 12, no. 3, pp. 209-215, March, 1941.
11. Edgerton, H. E., Stroboscopic and Slow-motion Pictures by means of Intermittent Light, *J. SMPTE*, vol. 18, pp. 356-364, 1932.
12. Edgerton, H. E., K. J. Germeshausen, and H. E. Grier, High-speed Photography, *Phot. J.*, vol. 76, pp. 198-204, April, 1936.
13. Edgerton, H. E., K. J. Germeshausen, and H. E. Grier, High Speed Photographic Methods of Measurement, *J. Appl. Phys.*, vol. 8, pp. 2-9, 1937.
14. Edgerton, H. E., K. J. Germeshausen, and H. E. Grier, Multiflash Photography, *Phototechnique*, vol. 1, no. 5, pp. 14-16, October, 1939.
15. Germeshausen, K. J., The Hydrogen Thyratron, in G. N. Glasoe and J. V. Lebacqz (eds.), "Pulse Generators," M.I.T. Radiation Laboratory Series, vol. 5, 1st ed., Sec. 8.11, pp. 335-354, McGraw-Hill Book Company, New York, 1948.
16. Germeshausen, K. J., New High Speed Stroboscope for High Speed Motion Pictures, *J. SMPTE*, vol. 52, March, 1949.
17. Früngel, F., "High Speed Pulse Technology," vols. I and II, Academic Press, New York, 1965. (Vol. I: pp. 59-97 Thyratron, pp. 97-100 Ignition, pp. 107-113 Mercury Arc Tube Double Ended, pp. 113-163 Spark Gaps, pp. 163-167 Quenching Spark Gaps, pp. 167-171 Quenching Gaps as Triggers.)

18. *Prod. Eng.*, Eichner Instrument Co., Clifton, New Jersey, Mar. 2, 1959, p. 54.
19. Johnson, W. O., Rapid Starting High Speed Camera, *J. SMPTE*, vol. 69, pp. 485-488, 1960.
20. Rutkowski, J., "Stroboscopes for Industry and Research," Pergamon Press, Inc., New York, 1966.
21. Thorwart, W., The Sophisticated Spark, *Perspective*, reprinted by Impulsphysik GMBH, 400 Sulldorfer Landstrasse, 2 Hamburg 56 Rissen, Germany.
22. Edgerton, H. E., Double Flash Microsecond Silhouette Photography, *Rev. Sci. Instr.*, vol. 23, no. 10, pp. 532-533, October, 1952.
23. Gallagher, P. N., et al., Measurement of Capillary Blood Flow Using an Electronic Double Flash Light Source, *Rev. Sci. Instr.*, vol. 36, no. 12, pp. 1760-1763, December, 1965.
24. Sources of plastic Fresnel lenses:
 Eastman Kodak Company, Rochester, N.Y. (Apparatus and Optical Div.)
 As of February 1966 three sizes were available—all have 200 lines to the inch.
 80 mm, 2½ × 2¾
 6 in., 4 × 5
 10 in., 8 × 8
 Bolsey Corporation of America, P.O. Box 248, Hartsdale, N.Y. 10530
 This company lists lenses from 1.5 in. to 17 in. in diameter and also some of rectangular form and of various focal lengths.
 Edmund Scientific Company, Barrington, N.J. 08007
 Cat. 671, p. 30; 2¼ × 2⅛ to 24¾ × 19¼, of several focal lengths.
25. Type 2307 Double Flash Light Source, *Rept.* B1895, EG&G, Inc., Boston, March, 1959.
26. LaForge, D. H., "Photographic Measurement of Conjunctival Blood Circulation in Diabetes," thesis, M.I.T., Cambridge, Mass., 1962.
27. Edgerton, H. E., Concentrated Strobe Lamp, *J. Biol. Phot. Assoc.*, vol. 30, no. 2, pp. 45-51, May, 1962.
28. Cameron, M. P., and M. O'Connor (eds.), The Aetiology of Diabetes Mellitus and Its Complications, *Ciba Foundation Colloquia on Endocrinology*, vol. 15, pp. 315-329, Little, Brown and Company, Boston, 1964.
29. Wells, R. E., Jr., Rheology of Blood in the Microvasculature, *New Engl. J. Med.*, vol. 270, pp. 832, 839, 889, and 893, Apr. 16 and 23, 1964.
30. Marey, E. J., "Movement," translated by Eric Pritchard, Appleton Press, New York, 1895.
31. Muybridge, E., "Animal Movements," 11 vols., 781 plates, Chapman & Hall, Ltd., London, 1887.
32. Cranz, C., and H. Schardin, Kinematographic auf ruhendem Film und mit extrem hoher Bildfrequenz, *Z. Physik*, vol. 56, pp. 147-183, 1929.
33. Schardin, H., The Multiple-spark Camera in Studies Requiring Highly Detailed Photography, *Proc. 5th Intern. Congr. High Speed Phot.*, pp. 329-334, SMPTE, New York, 1962.
34. Bull, L., Marey's Cinematograph, *Visual Medicine*, vol. 2, no. 1, pp. 33-38, March, 1967.

35. Germeshausen, K. J., New High-speed Stroboscope for High-speed Motion Pictures, *J. SMPTE*, vol. 52, pp. 24-34, March, 1949.
36. Kocher, D. G., A Multiple-spark Light Source and Camera for Schlieren and Silhouette Photography, *J. SPIE*, vol. 1, pp. 207-210, August-September, 1963.
37. Edgerton, H. E., and V. E. MacRoberts, Multiflash Strobe, *Proc. 7th Intern. Congr. High Speed Phot.*, pp. 72-76, Dr. Othmar Helwich, Darmstadt, 1967.
38. Edgerton, H. E., and F. E. Barstow, Multiflash Photography, *Phot. Sci. Eng.*, vol. 3, no. 6, pp. 288-291, November-December, 1959.
39. Bull, L., *Compt. Rend.*, vol. 138, pp. 554 and 755, 1904.
40. *Ibid.*, vol. 174, p. 1059, 1922.
41. *Ibid.*, vol. 202, p. 554, 1936.
42. Edgerton, H. E., and J. R. Killian, Jr., "Flash, Seeing the Unseen," 2d ed., Charles T. Branford Co., Newton Centre, Mass., 1954.
43. Miller, C., "Handbook of High-speed Photography," 2d ed., General Radio Company, West Concord, Mass., 1967.
44. Edgerton, H. E., and D. Cahlander, Holdover in Xenon Flash Lamps, *J. SMPTE*, vol. 70, pp. 7-9, January, 1961.
45. Früngel, F., "High Speed Pulse Technology," vols. I and II, Academic Press, New York, 1965.
46. Smith, F., Origins of Photographic Instrumentation, *Phot. Eng.*, vol. 3, no. 3, 1952. (This is an historical review article with 39 references.)
47. Jones, F. P., J. A. Hanson, J. F. Miller, Jr., and J. Bossom, Quantitative Analysis of Abnormal Movement: The Sit-to-stand Pattern, *Am. J. Phys. Med.*, vol. 42, no. 5, pp. 208-218, October, 1963.
48. Jones, F. P., and D. N. O'Connel, Color Coding of Stroboscopic Multiple-image Photographs, *Science*, vol. 127, no. 3306, p. 1119, May 9, 1958.

10 EXPOSURE CALCULATIONS AND SPECIAL PHOTOGRAPHY

Derivation of the Photographic Guide Factor

By means of the guide factor discussed in Chap. 5, for a given single-lamp flash-lighting system and film under limited conditions to be specified later, a photographer is able to estimate the aperture of his lens for his first attempt. The guide factor is the product of the camera lens aperture A and the distance in feet D from the flash lamp to the subject.

As an example, suppose the guide factor is given as 80 for a particular flash lamp and film where distance is measured in feet. Then, if the lamp is placed 10 ft from the subject, the aperture for a first trial exposure should be $f/8$. Naturally if the subject is dark or in an open area where there are no reflections, the aperture should be changed to admit more light, such as $f/5.6$ instead of $f/8$.

The derivation [1,2,3] of the guide factor equation in terms of light-subject distance D in feet and the camera aperture A is given below. Refer to Fig. 10-1 for the lamp-camera-subject arrangement.

Several assumptions are necessary for the derivation to be made, and these should be kept in mind when applying the guide factor equation.

1. The lamp and the camera are fairly close to each other, and both are approximately the same distance to the subject. The camera distance to the subject is not important, but the lamp-subject distance is very important.

2. The subject is at a distance from the camera of at least ten times the focal length of the lens.

3. The subject is at a great distance from the flash lamp reflector, for example at least 10 diameters of the reflector.

The light output of an electronic flash lamp is $(CE^2/2)n$ = output in CPS except for electrolytic capacitors where internal resistance may absorb energy depending upon the effective resistance of the flash lamp and the internal effective resistance of the electrolytic capacitor. In this case

C = capacitance in farads of the energy storage system

E = voltage to which the capacitor is charged in volts

n = efficiency of the flash lamp in CP per watt

$\dfrac{CE^2}{2}$ = joules or watt-seconds of energy stored

This light output energy is then directed onto the subject by a reflector. The light at the center of the beam is increased by a

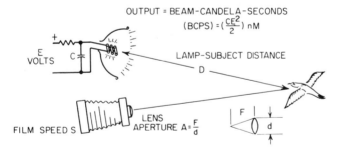

Fig. 10-1 *Camera and flash lamp arrangement used for the guide factor derivation.*

reflector factor M as compared to the beam from a bare lamp. Then the beam-candela-second output is BCPS = $(CE^2/2)nM$. At a distance D to the subject, the light energy per unit area is $IT = \text{BCPS}/D^2$. This is the incident exposure IT at the subject.

For proper exposure of the *film* in a camera, it is known [4] that the incident light power per unit area is I at the subject, where $I = A^2 c / sT$ foot-candelas; A = aperture of lens; s = ASA film speed; c = a constant, 15 to 25 when D is in feet; and T = exposure time. Note that camera-to-subject distance does not appear in this equation! Neither do the light-reflecting properties of the subject that is being photographed!

Equate the value of incident exposure at the subject IT, as obtained from the flash lamp, to that required by the photographic arrangement. Thus

$$\frac{BCPS}{D^2} = \frac{A^2 c}{s}$$

Then solve for the guide factor DA which is

$$DA = \sqrt{BCPS \frac{s}{c}}$$

This is the *guide factor* as used in photography. Note that it depends upon the square root of the beam-candela-second output and square root of the film speed.

Closeup Photography Light Requirements

Those who take closeup photographs or microscope pictures are aware that "more light" is required as the enlargement is increased. The following derivation [5] gives a rule for calculating the light that will be needed, and the necessary modification of the guide factor for a simple lens.

A camera focused on a closeup subject has its lens adjusted to a greater distance from the film than the focal length of the lens F. The relationship between the distance from the subject to the lens f_1 and the distance from the lens to the image plane f_2 from the single-lens theory of optics is $1/f_1 + 1/f_2 = 1/F$. Notice that less light will arrive at the image plane when the camera is focused on a closeup object since the effective aperture f_2/d is a larger number than when focused at infinity F/d. The following derivation will show a decrease of exposure as a function of linear magnification of the image size on the film. The exposure will decrease by the factor $1/(m + 1)^2$ where m is the image magnification. Should the magnification be 1 to 1,

then the exposure is 25 percent of the exposure of a distant subject if the incident illumination is the same on both. In other words, four times the exposure is required. Let us now show that the increased exposure factor is equal to $(m + 1)^2$ to maintain the exposure as the image is magnified.

Suppose the subject, a small area A_1, is photographed from a great distance. Then the area of the image A_2 will be smaller than the subject by a factor $(f_2/f_1)^2$. $A_2/A_1 = f_2^2/f_1^2$

The light from this area A_2 will be proportional to the incident flux density I_1 on the subject, the area A_1, and the effective light-collecting area A_x of the lens which has a diameter d and a focal length F. The light flux density I_2 at area A_2 is then

$$I_2 = \frac{\text{flux through lens area } A_x}{A_2 \text{ (or image of } A_1)} = \frac{(I_1 A_1/f_1^2) A_x}{A_1 (f_2/f_1)^2} = \frac{I_1 A_x}{f_2^2}$$

Note that the light flux density at the image plane I_2 is independent of the distance f_1. If f_1 is large, then $f_2 = F$ and $d/F = 1/A$ where A is the aperture of the lens. Next find the ratio of the exposure at the film plane when the camera is focused at infinity compared to that when exposed at a shorter distance. Let this ratio be called B.

$$B = \frac{I_2 \text{ (light flux density for } f_1 = \infty)}{I_2 \text{ (light flux density for } f_1 \neq \infty)} = \frac{I_1 A_x/F^2}{I_1 A_x/f_2^2} = \left(\frac{f_2}{F}\right)^2$$

and since

$$\frac{1}{F} = \frac{1}{f_1} + \frac{1}{f_2}$$

$$B = \left(\frac{1}{f_1} + \frac{1}{f_2}\right)^2 f_2^2 = \left(\frac{f_2}{f_1} + 1\right)^2 = (m + 1)^2$$

Thus, to obtain the same exposure on the film, regardless of distance from the lens to the subject, the incident radiation on the subject must be increased by the factor $(m + 1)^2$. For example, let $m = 4$;

then 25 times the exposure is required on the subject as compared to distant photography. Note that this factor increases rapidly as the magnification is increased.

Guide Factor for Closeup Photography

The guide factor concept can be used for closeup photography [5] if the lamp and reflector are small compared to the dimensions of the system. For example, the FX-11 has a lighted area of 3 × 4 mm and its reflector can be a wraparound aluminum sheet. With such a combination the square law is effective down to 1 or 2 cm from the lamp.

The light flux density at a distance D from the lamp is

$$IT = \frac{BCPS}{D^2} \quad \text{exposure in foot-candela-seconds}$$

This is also equal to the requirement of light flux density for exposure

$$IT = \frac{A^2 c}{s} (m + 1)^2$$

where A = aperture
s = film speed ASA
c = a constant (15 to 25 if D is in feet)
m = magnification

Then the guide factor is

$$DA = \sqrt{BCPS \frac{s}{c} \frac{1}{(m + 1)}}$$

Thus, the normal guide factor for large distances will be reduced by the factor $1/(m + 1)$ if the image is magnified by the factor m.

Film Exposure Calculations

Initial exposure calculations for most projects are commonly made with the aid of the guide factor which has been discussed. However, there are several important types of high-speed photography which

require a different calculation. A few of these are mentioned in the following discussion.

Information upon the sensitivity* of the film that is to be used is needed for the solution of the problem since the end point of the

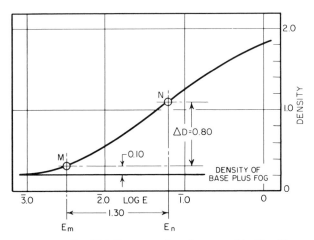

Fig. 10-2 *The H & D curve of a photographic film illustrating the graphical determination of the ASA film speed.*

calculation is to determine the *density* of the exposed film. Density is not only a function of exposure and type of film; it likewise depends upon the development time and temperature procedure that is used and other factors such as the age of the film, the storage time after exposure, etc.

Consider the idealized H & D curve of a film to find the relationship between density and exposure. Figure 10-2 shows such a curve. Notice that both scales are logarithmic. The horizontal scale is the logarithm to the base ten of the exposure *IT* or *E* in meter-candela-seconds. For example, 0 on this scale corresponds to 1 meter-candela-second and 1 on this scale corresponds to 10 meter-candela-seconds; also $\bar{1}$ on this scale corresponds to 1/10 meter-candela-second. The vertical scale is the density of the developed image due to the exposure plus the processing. Density is the logarithm of the opacity (1/transmission) of the processed material.

Density 0 corresponds to a transmission of 1 (completely clear)

Density 1 corresponds to a transmission of 1/10

*A sensitometer using a xenon flash lamp is described in Chap. 11.

Density 2 corresponds to a transmission of 1/100
Density 3 corresponds to a transmission of 1/1,000
The speed of a film is determined from the H & D curve by a standard set of rules [6], as agreed to by the United States of America Standards Institute (formerly the American Standards Association).

Speed of Photographic Negative Materials

The following is quoted from [6]:

> *Sensitometric Derivation of Speed*
> The method for determining speed is illustrated in Fig. [10-2]. In this figure, the density-log exposure curve of a photographic material is plotted for the developing conditions specified in 4.3.3.2. Two points are shown on the curve M and N. Point M is located 0.1 above fog-plus-base density. Point N lies 1.3 log exposure units from point M in the direction of greater exposure. The developing time of the negative material is so chosen that point N lies at a density interval $D = 0.80$ above the density at point M. When this condition is satisfied, the exposure E_m, corresponding to point M, represents the sensitometric parameter from which speed is computed.
> *Determination of American Standard Speed of a Specific Sample*
> Speed (arithmetic) shall be computed by use of the formula:

$$S_x = \frac{0.8}{E_m}$$

> Where S_x is the speed (arithmetic) and E_m is the exposure (expressed in meter-candle-seconds) corresponding to the point M on the density-\log_{10} exposure curve (for the developing conditions specified in 4.3.3.2) at which the density is equal to 0.10 plus base density and fog density.

From this method of speed determination it is known that the film tested will produce a density increase of 0.1 above fog when exposure by $IT = E_m = 0.8/S_x$. As an example, Plus X negative film which has an ASA speed of $S_x = 80$ will require an exposure of $IT = 0.01$ meter-candela-seconds.

The H & D curve presents the entire story of the way in which the film will react under several systems of development. Therefore, the user can decide upon the type of developer, the temperature, and the development time by studying the H & D curve data. *One word of caution*: the H & D curves should be made with the xenon flash lamp* if this type of lamp is to be used for the photography, and the

*See Sec. 12-F on the xenon sensitometer.

flash duration should be the same. Most H & D curves are made with tungsten lamps. A greater density will be obtained with the xenon flash of the same candela-second output because the light from a xenon lamp is more actinic due to the large blue content.

Since a density increase of 0.1 is very marginal and on the underexposed side, a photographer should double or triple the minimum exposure so that his negative will have a greater density. Several examples are now given to show how to calculate the required exposure for specific photographic examples.

Silhouette Photography

By far the simplest type of photography is the silhouette or shadow type where a small source (point source) exposes a film with the subject between the light and the film. The definition of the edge of the shadow of the subject is controlled by the size of the source and the position of the subject. For example, a subject close to the film and the use of a very small source will create the sharpest shadow image.

All the early silhouette photographs of bullets made by Mach, Boys, and others were of the direct shadow type where a spark from a Leyden jar (capacitor) served as a point source. Such shadow photographs are especially interesting since they are very sensitive to refraction of the air. The photographs of bullets, for example, show the shock waves and turbulence in the air that are created by the bullets. The photographic exposure IT on the film is calculated from the square law, $IT = \mathrm{CPS}/D^2$ exposure (meter-candela-seconds), where CPS is the output of the point source of light in candela-seconds and D is the lamp-to-film distance in meters.

Example: Suppose Plus X film is used at 10 ft. What is the minimum output of the lamp for a density of 0.1 above fog? Plus X film ASA speed is equal to 80. Then the incident exposure to produce a density of 0.1 above fog will be $IT = 0.8/80 = 0.01$ meter-candela-seconds at point M.

$$\mathrm{CPS} = (IT)(D^2) = (0.01)(10)^2(0.305)^2 = 0.093$$

since 1.0 ft = 0.305 meters

By increasing the exposure by about twenty times ($\log_{10} 20 = 1.3$), the density increment will be 0.9 units. This is a rather dense negative but usable. For this case CPS = 0.093 × 20 = 1.86. Figure 10-3 shows the direct silhouette system that has just been discussed.

Many important results have been made with the simple shadow system of high-speed photography. Figures 7-4 and 7-5 show equipment for silhouette photography and an example.

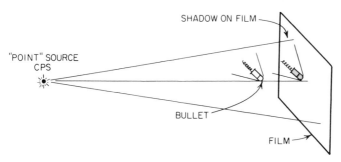

Fig. 10-3 *Silhouette method of photography accomplished in a darkroom on film without use of lens.*

Direct Image of a Source

Consider now the exposure on a film due to the light from an image of a light source (Fig. 10-4). The light entering the lens of diameter d is calculated by first finding the light flux density at the lens which is at a distance D from the source.

$$\text{Light flux density} = \frac{\text{CPS}}{D^2} \text{ lumens per square meter}$$

Then the light flux intercepted by the lens is obtained by multiplying the flux density by the area of the lens.

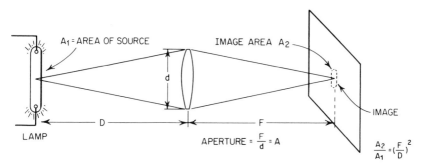

Fig. 10-4 *Direct image method of photography.*

$$\text{Light} = \frac{\text{CPS}}{D^2} \frac{\pi d^2}{4} \quad \text{lumens}$$

This light flux is imaged on an area A_2 which is determined by the optical magnification.

$$(IT)_f = \frac{\text{CPS}}{D^2} \left(\frac{\pi d^2}{4}\right) \frac{1}{A_2}$$

$$\frac{\text{Image area}}{\text{Source area}} = \frac{A_2}{A_1} = \left(\frac{F}{D}\right)^2$$

from the geometry of a simple lens. Notice that F is the distance of the film from the lens and is longer than the focal length of the lens except when D is very large. The exposure at the film is then

$$(IT)_f = \frac{\text{CPS}}{D^2} \frac{\pi d^2}{4} \frac{D^2}{F^2} \frac{1}{A_1} = \frac{\text{CPS}}{A_1} \frac{\pi}{4} \frac{1}{A^2} \quad \text{meter-candela-seconds}$$

Notice that the distance D cancels out when a lens is used if the source is imaged on the film. The exposure depends inversely upon the *actual* aperture squared A^2 where $A = F/d$. The rated aperture of the lens becomes equal to A when D is very large compared to the focal length of the lens.

Exposure of a Point Source

Suppose that the light source is at a very great distance so that the resolution of the optical system is inadequate to form an image of the lamp. An example of this is the photography of a xenon flash lamp on a satellite from two or more locations on the earth for accurate positioning. The geometric image of the bare lamp is much smaller than the minimum image possible by the optical system. Then the exposure is calculated by averaging the light flux over the *circle of confusion* of the image. Suppose the circle of confusion is 0.001 in. in diameter, then the exposure is

$$(IT)_f = \frac{(\text{CPS}/D^2)\,(\pi d^2/4)}{(\pi/4)(0.001)^2/144}$$

$$= \frac{\text{CPS}}{D^2} d^2 \times 10^6 \times 144 \quad \text{foot-candela-seconds}$$

or

$$\frac{CPS}{(D/d)^2} \times \frac{10^{10}}{(2.54)^2} \quad \text{meter-candela-seconds}$$

where D = distance to satellite, d = diameter of lens opening, and D and d are in the same units.

Field Lens Silhouette Photography

A most convenient method of silhouette photography with a field lens to collect the light and redirect it into the camera lens has been discussed in Chap. 7. This system is most efficient since the light is effectively used. However, the field lens must be larger than the subject area, thus, limiting the system to the photography of objects smaller than the lens. (See Fig. 7-8.)

The exposure on the film was shown in Chap. 7 to be

$$IT = \frac{CPS}{f_3^2} \quad \text{meter-candela-seconds}$$

where IT is in meter-candela-seconds if f_3 (camera focal length) is in meters.

Density on the film can be increased in several ways, such as

1. Reduction of image size by the use of a shorter focal length camera lens
2. Use of faster film or processing
3. Increase of the light output of source
4. Increase of the aperture of the field lens

Improved results are obtained if the field lens is a corrected type (achromatic) consisting of at least two different kinds of glass so that the image of the spark source will be at the same spot for several colors of light. However, this is not necessary for routine silhouette photography. The achromatic field lens is important when the schlieren system of photography is used since an opaque stop is inserted at the image point to eclipse some of the light for increased sensitivity.

Scotchlite Background

Two special reflecting surfaces should be mentioned since they are important for specialized uses. One of these is the "Scotchlite" (a trade name of the 3M Company) reflecting surface which is in

common use for road signs at night. The Scotchlite surface is covered by an array of glass spheres which reflect the light *back to the source* regardless of the angle to the plane of the array. The light received near the source can be as much as 100 times that received from a

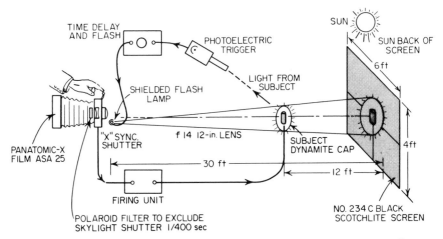

Fig. 10-5 *Diagram of a method of photographing large-scale subjects in silhouette during daylight conditions.*

white diffusing surface. The second type of reflector is the *corner* reflector which consists of three mirror surfaces at 90° with respect to each other. Such a mirror combination has the ability to always reflect light to the source regardless of the angle. Both of the above methods are of use in specialized applications where the camera and light source are close together. An example [7] of the Scotchlite system is given below.

A method of photographing shock waves which makes it possible to work on large-scale experiments outdoors in daylight is described. Formerly, such experiments have been made at night or indoors. Figure 10-5 shows a combination of devices to enable one to photograph the shock wave from an explosion in direct daylight. A short exposure of the shutter is essential to exclude the effect of continuous light both from the ambient daylight and from the subject light, such as a dynamite cap or firecracker.

The camera shutter can be used to initiate the chain of events. As soon as the shutter is opened, an electrical signal from the "X" shutter contact fires the explosion through a firing unit. Then early light from the explosion triggers a phototube device. The outgoing signal,

after being delayed by a desired time, triggers an electronic flash lamp which is located near the camera lens. The camera lens is focused on the Scotchlite screen if photographs of the shock waves are desired.

This screen is a reflective type which has the remarkable ability to reflect the light from a source back to the source. The light received at the film can be several hundred times more than that received from a flat white screen. It is important to keep the lamp and the camera lens as close together as possible. An efficient silver type 244 screen can be used. A dark screen called Black Type 234 is especially useful for daylight operation since it gives a small reflection from diffuse side lighting from the sun or sky.

A Polaroid filter can be used to reject the polarized light from a blue sky in back of the camera. The angle of the filter is changed to minimize the light arriving at the film. The filter also reduces the light from the flash, but by a smaller factor than it reduces the sky light since the light from the sky is polarized. If the sky is cloudy or hazy, there is no advantage in using the Polaroid filter since the sky light is not polarized. However, a dark screen in back of the camera is very effective.

Two flash sources have been used. First, an EG&G, Inc. FX-11 ($\frac{1}{8}$-in. gap in xenon at 2 atm in a 4-mm-ID Vycor tube) was used with a 1-μF capacitor at 1,000 volts. The lamp was mounted in a metal half-cylinder and was located as close as possible to the lens. Excellent photographs of shock waves were made at 20 ft from a silver Scotchlite screen No. 244, especially when a small 1/16-in. aperture was put over the tube.

Daylight operation at greater distances requires more light, and a special tube (FX-21) was designed with a ½-in. arc length in a 4-mm-ID Vycor tube filled with xenon at 2 atm. The output of the FX-21 with 0.25 μF at 3 kV is 1.25 CPS with a one-third peak duration of 1 μsec.

Figure 10-6 shows the shock wave resulting from the explosion of a No. 6 Cyanamid dynamite cap. One can clearly see the trails left by the supersonic particles that precede the shock front. A second weaker shock wave appears to follow the first. Photographs have also been made without any electrical connection to the explosion by tripping a shutter from the flash of a light from the explosion. The "X" contacts on the shutter then trigger the electronic flash. A suitable delay mechanism is used to take the photograph at the time desired. This combination should be especially useful for field work

since no control wires are needed. About 6 msec was required to open the shutter when a capacitor was discharged into the shutter trip solenoid.

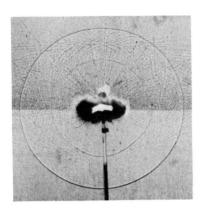

Fig. 10-6 *Silhouette photograph of a No. 6 dynamite cap taken against a 4 × 6 ft Scotchlite in open daylight but with the sun behind the screen.*

The exposure of a Scotchlite system is difficult to calculate because of the following factors:

1. The optical characteristics of the Scotchlite screen. There are many types of materials with different angles and efficiencies. Refer to the 3M Company for details of currently available materials in sheet and roll form.

2. The positioning of the flash lamp and the lens is very important, especially if the Scotchlite is an efficient one with a narrow angle of return. The lamp should be as close as possible to the center of the lens. In one case a small lamp was actually placed across the center of the lens with a metal barrier to prevent the light from the lamp entering the lens.

Schlieren Photography

Schlieren photography [9, 10] is field lens photography except that it uses a "stop" which increases the sensitivity of the system to small changes of the optical index of refraction. The required amount of light for exposure is greater than that for the field lens system.

Basic exposure calculations can be made on a schlieren system assuming that the stop or aperture is not effective. Then the same rules apply as to the single lens system in Chap. 7 and in this chapter. Additional light will be required depending upon the adjustment of the stop.

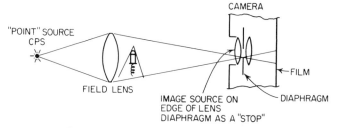

Fig. 10-7 *Conversion of field lens system to a schlieren system by using the camera lens diaphragm as a stop.*

A field lens system can be converted into a simple schlieren system as indicated in Fig. 10-7. The camera lens diaphragm is adjusted to $f/11$ or a smaller hole. Then the optical system is adjusted until the image of the point source of strobe light is located on or near the edge of the diaphragm. This can be done visually by observing the image on the diaphragm leaf.

H & D Curves for Films

Experimentally measured H & D curves from some black-and-white and color films as exposed on the EG&G sensitometer which is

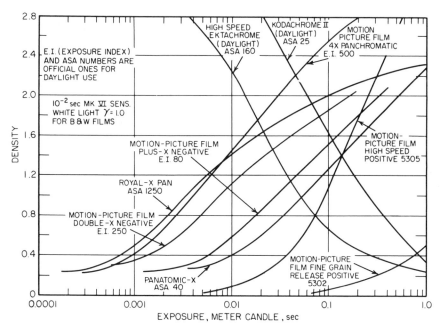

Fig. 10-8 *H & D curves for several black-and-white and color negative films as determined on the EG&G, Inc. xenon flash sensitometer.*

described in Sec. 12-F are shown in Fig. 10-8. An exposure time of 10^{-2} sec was used. The films were developed to a gamma of one. Figure 10-8 contains information to assist in the calculation of the density of the processed film after being exposed by the light as expressed as incident exposure IT on the film.

REFERENCES

1. Edgerton, H. E., and J. Carson, Photographic Guide Factor, *Professional Photographer*, pp. 54-55, July, 1965.
2. Moon, P., and D. E. Spencer, Calculation of Camera Exposure, *J. Franklin Inst.*, vol. 258, p. 113, August, 1954.
3. Moon, P., and D. E. Spencer, On Photographic Exposure and Exposure Meters, *J. SMPTE*, vol. 63, p. 233, 1954.
4. "General Purpose Photographic Exposure Meters," USAS PH 2.12, p. 10, United States of America Standards Institute, 1957.
5. Edgerton, H. E., and J. Carson, Motion Picture Photomicrography with Electronic Flash, *Appl. Opt.*, vol. 3, p. 1211, November, 1964.
6. "Speed of Photographic Negative Materials," USAS PH 2.5, United States of America Standards Institute, 1960.
7. Edgerton, H. E., Shock Wave Photography of Large Subjects in Daylight, *Rev. Sci. Instr.*, vol. 29, no. 2, pp. 171-172, February, 1958.
8. Clark, G. L., Light Economics in High Speed Photography, *J. SPIE*, vol. 1, pp. 111-116, April-May, 1963.
9. Townsend, H. C. H., Improvements in the Schlieren Method of Photography, *J. Sci. Instr.*, vol. 11, no. 6, p. 183, June, 1934.
10. Taylor, H. G., and J. M. Waldram, Improvements in the Schlieren Method, *J. Sci. Instr.*, vol. 10, p. 378, 1933.

11 TECHNIQUES OF LIGHT MEASUREMENT

Phototube Measurements of Light

Of the many different electrical photosensitive devices, the vacuum phototube [1-3] appears to be the best suited for the measurement of visual light since (1) a linear relationship (almost) between light intensity and current output is possible if the voltage across the phototube is more than ample to collect all of the emitted electrons and (2) the spectral sensitivity can be made to resemble that of the eye by the use of a suitable optical filter. Gas-filled phototubes cannot be used for linear measurement of light since the current is a function not only of light, but also of voltage, gas pressure, flash duration, and intensity. Silicon photodiodes can be used if the internal capacitance is considered and if the infrared sensitivity is removed by a filter.

Spectral Sensitivity of a Phototube

When a photon impinges on a metal surface in a vacuum its energy, or some of it, is imparted to the metal surface and may be

gained by a single electron in the metal lattice. If the energy received by the electron from the photon exceeds the work function of the metal, then the electron may be emitted from the surface into the vacuum where it can be attracted to the anode by the electrical field.

The energy in a quanta or photon of light = hf joules, where $h =$ Planck's constant = 6.624×10^{-34} joule-seconds, $f =$ frequency of radiation in cycles per second, $\phi =$ voltage equivalent of work function in volts (this is numerically expressed in volts, one electron volt = 1.6×10^{-19} joules), and $e =$ electronic charge of electron, 1.6×10^{-19} coulombs. Any excess energy in the electron will appear as stored kinetic energy ($\frac{1}{2} mv^2$) joules where v is the velocity and m is the mass of the electron.

There is a limiting wavelength λ for electron emission which is defined by the relation $hf = \phi e$. Since $f = c/\lambda$, the critical wavelength $\lambda_c = ch/\phi e = (1.24/\phi)\mu$m, where h and e are as above and $c = 3 \times 10^{10}$ cm/sec (velocity of light). At a wavelength greater than this, there is not sufficient energy in a photon to cause emission of an electron. The work function of a surface is therefore the critical factor in a phototube since it affects the limit of the spectral sensitivity. The laws of photoemission are (1) the critical photoemission wavelength of metal surface is $\lambda_c = (1.24/\phi)\mu$m; (2) the number of electrons is directly proportional to the total incident radiant flux if the spectral distribution remains the same and if ample voltage is used on the anode to collect all the electrons to the anode; and (3) the maximum initial energy of emitted electrons is independent of the amount of flux but is a linear function of the *frequency* of the radiant energy above the cutoff frequency.

The limiting wavelength as a function of color and work function is given in the following table:

Color	Wavelength (cutoff), μm	Work function (cutoff), volts
Blue (far)	0.3	4.12
Blue	0.4	3.1
Green	0.555	2.24
Red	0.7	1.77

Photocathode Surface of Pure Metals

Cathode metal	Work function, volts	Cutoff wavelength, μm
Cesium	1.36	0.91 infrared
Potassium	1.55	0.8
Lithium	2.36	0.525
Tungsten	4.1	0.32 ultraviolet

Practical Phototube Surfaces

Nearly all phototubes in use today have cathodes of complex combinations of cesium with other metals and elements. The most widely used are the S-1 cathode of silver-oxygen–cesium-oxygen surface which has red sensitivity as well as blue and the S-4 cathode of a cesium-antimony alloy which has a very high efficiency in the blue but very little red sensitivity.

The survey article by R. W. Engstrom [1] lists the above and several other phototube surfaces and their characteristics.

Spectral Sensitivity of a Phototube

The emission of current as a function of wavelength for a photoelectric surface must be measured experimentally. At each wa.elength the current will be proportional to the incident power per square centimeter H_λ and a factor depending upon the phototube surface which is called the spectral sensitivity R_λ

$$i_a = R_\lambda H_\lambda \quad \text{amp/(cm}^2)/(\mu\text{m}),$$

and the total current

$$i = A_c \int_{\lambda=0}^{\lambda=\infty} R_\lambda H_\lambda \, d\lambda \quad \text{amp,}$$

where A_c is the area of the cathode. The corresponding light arriving at the cathode is

$$L = (A_c)(685) \int_{\lambda=0}^{\lambda=\infty} V_\lambda H_\lambda \, d\lambda \quad \text{lumens,}$$

where V_λ is the visibility function. Information on practical surfaces

that are in use today is given in (1) spectral sensitivity curves (relative values). The spectral sensitivity R in microamperes per

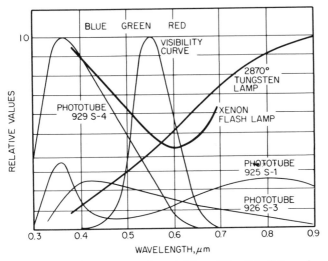

Fig. 11-1 *Relative spectral sensitivity of the S-1, S-3, and S-4 phototubes with the visibility curve and spectral output of a 2870°K tungsten filament and of a typical xenon flash lamp.*

microwatt is usually given at the peak of the sensitivity. See Fig. 11-1 for the curves of spectral sensitivity of several phototube surfaces. (2) The luminous sensitivity is the ratio of i/I amperes per lumen (or microamperes per lumen) if the phototube is used with a tungsten lamp of 2870°K. Absolute spectral characteristics of the responses of several phototube surfaces are presented in Table 11-1 from Engstrom's references.

The sensitivity of the S-4 surface to daylight or xenon flash light is about double that of the sensitivity to tungsten light (2870°K). The xenon source has a larger percentage of its energy in the blue portion of the spectrum where the S-4 surface is sensitive.

Electrical Design of a Practical Light Measuring Device

Consider now the requirements for a combination phototube and circuit [3, 4] for measuring the light output from a flash lamp. Figure 11-2 shows a resistor R_L through which the phototube current flows. The voltage drop is then proportional to the light received by the phototube if there is a linear light-vs.-current

Table 11-1 Practical Phototube Cathodes (Vacuum Type)*

Type	Surface	Peak sensitivity		Cutoff wave-length, μm	Remarks
		μm	μamp/μwatt		
S-1	Ag + O$_2$ + Cs	0.75	0.0015	1.0	Red-sensitive
S-2	Ag + O$_2$ + Cs	0.8	0.002	1.1	Similar to S-1
S-3	Ag + Rb + O$_2$	0.44	0.002	0.8	Closest to visibility function but seldom used
S-4	Antimony Cesium	0.375	0.04	0.6	Excellent surface, lacks red sensitivity
S-5	Antimony Cesium in ultraviolet transmitting envelope	0.375	0.04	0.6	Receives ultraviolet radiation through a special glass envelope
S-8	Antimony Bismuth + Cesium	0.42	0.004	0.8	Sensitivity loss of 10 compared to S-4 surface, but has greater red sensitivity

*Sensitivity values vary by a factor of 2 or 3 for individual phototubes. Eye sensitivity peaks at 0.55 μm and tungsten spectral distribution of energy peaks at 0.9 μm when the temperature of the filament is 2870°K. (From [1] and RCA data book.)

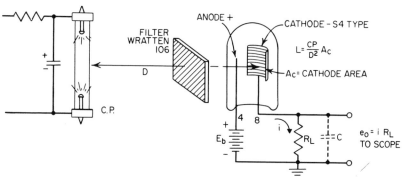

Fig. 11-2 *Elementary circuit of a phototube with optical filter and output resistance to produce a voltage proportional to instantaneous light output in candelas.*

relationship in the phototube. Linearity requires that the anode voltage e_b of the phototube must be greater than some minimum

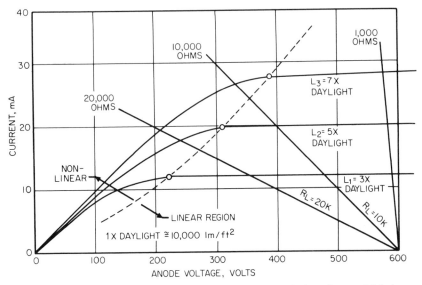

Fig. 11-3 *Response of the RCA 929 phototube with S-4 surface to high-intensity pulse light from a xenon flash lamp. "Daylight" is approximately 10,000 lm/ft².*

value depending upon the peak light and for a particular resistor. This will now be discussed in terms of the volt-ampere relationship of the phototube.

With a given amount of light L_1 on the cathode, the current output i_p is a function of the anode voltage up to the saturation value as shown in Fig. 11-3. The phototube current does not change appreciably as the supply voltage is increased above the saturation value. The phototube must be used only where this saturation current condition exists if the current is to be a measure of light, that is, if proportionality is to exist between light flux on the cathode and current output.

With a more intense light, L_2 or L_3, a higher voltage is required to reach the saturation value (Fig. 11-3). A curve of the saturation current vs. the anode voltage can be determined experimentally by using a series of different intensities of light. The small circles show the approximate boundary condition between the linear and non-linear operation.

The anode voltage requirement must be held even *including the influence of the electrical load*. Refer to the diagram and circuit (Fig. 11-2), which shows a phototube with a load resistor across a battery supply. Light received by the phototube causes a current to flow,

resulting in a resistive drop of output voltage e_0 across the resistor. The voltage across the tube is decreased by this output voltage. As the resistance is increased to obtain more output, it is done at the expense of the anode voltage. One must be certain that the anode voltage e_b never decreases below that required for the saturation current since the linear current-light relationship of the phototube is then destroyed. As an example, look at the curve marked $R_L = 20$ kilohms. The output voltage will be about the same value with L_2 and L_3 light. However, if the resistance is decreased to 1 kilohm, then the useful *linear* relationship is reestablished but with a reduction of output voltage e_0.

The desired linear relationship can be obtained with the larger resistance by increasing the battery E_b until the intersection of the load line with the L_3 curve falls on the saturation current corresponding to L_3. A voltage exceeding 600 volts is not recommended since the phototube may arc over (or glow) if there is residual gas. A gassy phototube will not produce a linear light-vs.-current relationship.

If there is any question about the linearity of any specific phototube system, one should test by (1) increasing the supply voltage or (2) increasing the light. In the first case, the output should remain essentially constant while in the second, the output should be proportional to the light if linearity is inherent in the system.

Transient Response

Consider next the phototube and circuit requirements for measuring the rapidly changing light output of a flash lamp as a function of time. The voltage across the load resistor that is in series with the phototube will be proportional to the light incident upon the cathode if the restrictions regarding the anode voltage supply are fulfilled. A cathode-ray oscilloscope is used to display the signal with a time sweep across the screen so that the light-time curve can be observed and photographed if desired.

Another limitation, in addition to the linearity restriction, on the maximum possible load resistor R_L is encountered with transient light. This factor is the *time constant* of the light-measuring circuit including the load resistor R_L in parallel with all the capacitance C due to the cathode-ray oscilloscope, its input leads, the phototube, and the circuit wiring. The time constant is the RC product of the above in seconds.

As an example, consider a 1-megohm load resistor connected to an oscilloscope which has an input of 20 pF (1 pF = 10^{-12} farads = 10^{-6}

μF) and a circuit capacitance of 10 pF. The time constant will be 30 μsec.

If the above circuit is used to record the light from a 1-μsec pulse of light, an erroneous result will be obtained! Actually the circuit will act as a capacitor integrator during the light flash, followed by an *RC* exponential discharge of the various capacitances through the load resistor. The oscilloscope will display the time constant (30 μsec) of the measuring circuit if the flash of light is short compared to the time constant.

From the above, the circuit time constant must be smaller than the flash lamp light decay time if the light measurements are to be meaningful. For the example above, the time constant should be less than 0.1 μsec. This calls for a load resistance of 3,000 ohms with a correspondingly lower output voltage.

The phototube is required to produce abnormally large currents if the output voltage is to be increased. When this is done, the knee of the curve extends further into the linear portion requiring a high value of E_b to ensure linearity. A phototube such as the RCA 929

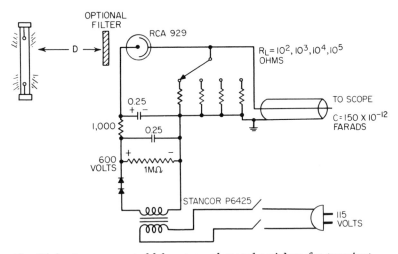

Fig. 11-4 *An ac-operated laboratory phototube pickup for transient light measurement.*

type can be used with 600 volts on the anode, and with peak currents of 10 to 20 mamp.

An example of the use of the RCA 929 with a complete circuit for this purpose is shown in Fig. 11-4. The minimum time constant is 15 nsec (1 nsec = 10^{-9} sec = 10^{-3} μsec) with R_L = 100 ohms.

For still higher voltages, tubes such as the RCA 935 type should be used since the anode is brought out of the end opposite the cathode, thus giving less opportunity for voltage spark-over in the stem or base.

One specific phototube circuit used at M.I.T. for measuring fast flashing lights has 2,000 volts on the anode of a 935 tube and a 100-ohm load resistor. The time constant is estimated to be about 15 nsec which is about the limit of time measurement of many cathode-ray oscilloscopes.

Phototubes with a planar transparent anode and cathode are available from the ITT Industrial Laboratories (Ft. Wayne, Ind.). The FW114 Biplanar diode has a 0.25-in. spacing between cathode and anode. Such a geometrical arrangement is superior to the conventional phototube arrangement of a curved cathode and a single-wire anode.

Spectral Response

When using phototubes for light measurement, it must be kept in mind that the sensitivity is a function of the spectral characteristics of the phototube surface. Various spectral response curves for the S-1, S-3, and S-4 surfaces were shown before in Fig. 11-1. The S-4 photoelectric surface seems to be the most stable, and most sensitive of the several types of photosensitive surfaces that are commercially available. The principal objection to the S-4 surface is its very low sensitivity in the red portion of the spectrum. When a sensitivity match to the *human eye visibility curve* is desired this lack of red sensitivity can be serious.

A fairly good match of the eye visibility curve can be achieved by using a Wratten 106 filter with an S-4 or S-5 surface. However, the sensitivity to daylight color of light is reduced about 6 to 1. If the phototube sensitivity curve is desired to match the photographic spectral sensitivity of films, especially blue-sensitive emulsions, then the phototube with the unfiltered S-4 phototube surface can be used.

Other more complicated filters with the S-3 surface can give a more accurate fit to the visibility function. One such combination was perfected by Gage [5] who used two glass filters of variable thickness and different absorption characteristics. A good fit was accomplished, but it is seldom used because of expense.

It should be emphasized that *any* type of phototube surface can be used if comparison is being made between two light sources that have the *same* spectral distribution. For this reason and because of

added sensitivity for the xenon flash lamp, many instruments use the S-4 surface without a filter when comparing xenon flash lamps.

Calibration

Direct calibration with a known continuous light source of a phototube with high voltage on the anode and a low value of load resistance is difficult and may be inaccurate due to destructive thermal effects. It seems advisable to use a standard flash lamp whose output is known. Then the readings can be put on a comparison basis.

Xenon flash lamps are especially useful for calibration since their output is consistent in value and in spectral distribution if the voltage and capacity are controlled. One such flashtube is the EG&G, Inc. standard flash lamp FX-1, whose characteristics have been measured over wide input conditions (Chaps. 2 and 3). For example, a flash from a 100-μF capacitor charged to 1,000 volts has a peak output of 1 million horizontal candela in a direction at right angles to the axis of the lamp.

The light energy incident on the cathode, if the lamp and phototube are spaced more than 6 ft apart, is

$$ L = \frac{HCP}{D^2} \times A \quad \text{lumens} $$

where L = incident lumens entering phototube
 HCP = horizontal candela output of flash lamp
 D = lamp-to-phototube distance
 A = effective area of phototube cathode expressed in the same units as D (cathode area = 3.52×10^{-3} ft^2 for RCA 929)

Suppose the sensitivity S of the phototube (RCA 929, Fig. 11-2) is 116 μamp per lm with light from a xenon flash lamp. Then the peak output current corresponding to 10^6 CP of light of a xenon flash lamp will be

$$ \text{Peak } i_p = \frac{HCP}{D^2} \times A \times S = \frac{(10^6)\,(3.52 \times 10^{-3})\,(116 \times 10^{-6})}{D^2} $$

or

$$ \text{Peak } i_p = \frac{0.407}{D^2} $$

from a 1 million peak candela lamp. Where i_p is in amperes and D is in feet the peak output voltage will be

$$\text{Peak } e_0 = R_L \times \text{peak } i_p \quad \text{volts}$$

for a 1 million CP lamp. Therefore

$$\text{Peak } e_0 = \frac{0.407 \, R_L}{D^2} \quad \text{volts}$$

for a 1 million CP lamp, where e_0 is in volts, R_L in ohms, and D in feet.

When many tests are to be made, it is very convenient to arrange D, R_L, and an optical filter so that the deflection on the oscilloscope is an integral number of light units. Then the light readings can be made directly from the voltage scale on the oscilloscope. For the above example, the phototube is moved until D is the correct value to make a peak deflection of 1.0 division of the cathode-ray screen. For an unknown flash lamp at the *same* distance, the peak light can then be read directly from the oscilloscope screen in millions of candela per division.

Example: Consider the design of a phototube light pickup with a *visibility response* using an RCA 929 phototube *plus* a Wratten 106 filter. The sensitivity will be reduced by a factor of about 6 for a daylight spectral distribution of light from the sensitivity of an unfiltered S-4 phototube surface. The sensitivity should be measured with a standard xenon flash lamp. Assume $S = 25$ μamp per lm, then the voltage across the load resistor will be

$$e_0 = R_L \frac{\text{HCP}}{D^2} \, AS \quad \text{volts}$$

Solve for the light output,

$$\text{HCP} = e_0 \frac{D^2}{R_L} \, (12 \times 10^6)$$

For direct reading on the oscilloscope of 10^6 CP per cm adjust as follows: sensitivity of cathode-ray oscilloscope = 1.0 volt per cm, R_L = 1 kilohm. Solve for D = 9.1 ft or 2.77 meters.

The phototube should be located at this distance from the flash lamp, and care should be taken to reject reflected light from walls and surfaces. A chart can now be made for attachment to the phototube measuring device. *Calibration information*: RCA 929 plus Wratten 106 filter, distance to flash lamp 2.77 meters, for 10^6 CP = 1 scale division (545 scope), for sensitivity 1 volt per division, for R_L = 1 kilohm.

R_L	0.1	1	10	kilohms	Load resistor
V_{max}	6.0	50	200	volts	Limited by phototube
RC	0.015	0.15	1.5	μsec	Time constant

V_{max} is the maximum output voltage before saturation effects in the phototube destroy the linear effects. If the output exceeds the value indicated by V_{max}, then the above calibration is void and the light-time curve is inaccurate.

The Output of a Flash Lamp

In most uses of flash lamps the important quantity to measure is not the instantaneous candela as a function of time but the *candela-second* output which is the integrated value of the candela curve over the entire flash duration. The candela-second output is responsible for the *exposure* of the film in a camera. Exposure is the integral of the incident illumination as a function of time.

The output of a flash unit can be obtained by integrating the instantaneous candela curve as read on a cathode-ray oscilloscope.

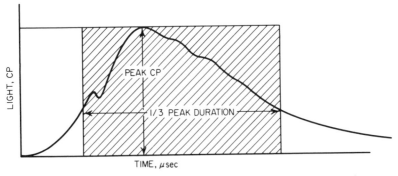

Fig. 11-5 *Approximate method of determining the candela-second output (CPS) of a flash lamp by taking the product of the peak CP by the one-third peak flash duration.*

Figure 11-5 shows such a curve and the way in which the integral can be obtained by a very approximate method. The output (CPS) is shown to be the product of the peak light by the flash duration. Actually this method gives a rather optimistic value compared to the integral value, but the error is not usually significant for photographic purposes.

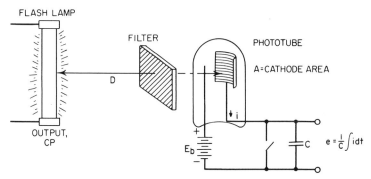

Fig. 11-6 *The basic circuit of the* integrating *meter for the measurement of the transient output of a flash source of light. Note that the phototube current is integrated in the capacitor C.*

Integrating Meter for Light Measurement

An electrical circuit can be arranged to integrate the light and present a meter reading of the integral, i.e., the output in candela-seconds (CPS). Figure 11-6 shows such an arrangement. It is exactly the same as Fig. 11-2 except for the substitution of a capacitor for a resistor in the output circuit of the phototube. The voltage output of the capacitor is given as $e = (1/C)\int i\, dt$. The limits of integration are of great importance. The lower limit is controlled by the switch, which short-circuits any residual charge in the capacitor from previous currents just before use. Thus, the capacitor voltage immediately after the switch is opened will be zero.

Now the flash occurs and there will be a pulse of current which follows accurately the instantaneous output of the flash lamp. The capacitor in the phototube circuit will charge as follows

$$e = \frac{1}{C} \int_0^\infty i\, dt = \frac{1}{C} \int_0^\infty \frac{SA\,(CP)}{D^2}\, dt = \frac{SA}{CD^2} \quad \text{CPS}$$

since

$$CPS = \int_0^\infty CP\, dt \quad \text{and} \quad \frac{(A)(CP)}{D^2} = \text{lumens at cathode}$$

S = phototube sensitivity in amperes per lumen

The output voltage e can be recorded on an oscilloscope or measured by a high-input impedance voltmeter at the end (infinity time!) of the flash. The latter method is a very convenient one since the entire instrument can be made portable including the batteries. One such circuit will be described subsequently.

The integrating light meter measures the continuous light as it measures the flash. An error may occur if this regular light is too strong or if there is a delay in the observation which allows the error to accumulate. The practical instruments used to measure flash lamps have either a camera shutter to exclude ordinary light, except for a brief exposure at the instant of flash, or a switch which opens the battery circuit at the end of the flash period. This last feature is shown in the meter example that follows.

Practical Integrating Meters

Figure 11-7 gives the circuit of a meter [6, 7] that has been used for many years at M.I.T. This was the basic circuit of the General Radio Co. type 1501 light meter. Figure 11-8 shows a light meter being used to measure the BCPS output of a flash lamp in order to evaluate the photographic effectiveness. A small meter (Fig. 11-9) especially designed for photographic use is distributed by the American Speed Light Corp. (63-01 Metropolitan Avenue, Middle-village, N. Y.). William Maris (Fig. 11-10) uses the Ascor light meter in his studio to adjust the lighting on a typewriter. A white card at the typewriter is imaged on the ground glass. The probe is then attached to the ground glass over the image of the white card. Other competing meters are distributed by the Thomas Instrument Co. (Rt. 1, Phoenix, N. Y.), the Mornick Co. (4115 Weslow, Houston, Tex.), the Calumet Manufacturing Co. (6550 North Clark Street, Chicago, Ill.). The Bowens flash meter (English) is distributed by the Bogen Photo Corp. (232 S. Van Brunt Street, Englewood, N. J.). The probe light measurement has been found to be excellent for professional studios for checking and controlling the electronic flash lamps and photographic arrangements.

A light measuring device, named "Lite-Mike," is manufactured by EG&G, Inc. and uses a silicon photodiode (Fig. 11-11). A five-position switch is provided which gives three settings for continuous light sensitivity and two for the integration of pulses. The photohead can be detached from the power unit for convenience in detecting

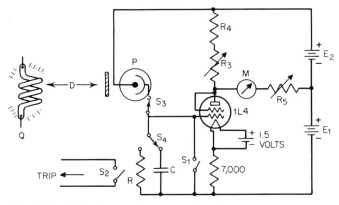

Fig. 11-7 *Light-integrating meter circuit.*
P = *phototube RCA 929*
k = *80 μamp/lm with xenon flash light (k = phototube sensitivity)*
M = *meter, 100 μamp full scale (R_M = 1 kilohm)*
R_3 = *zero adjusting resistor 0.15 megohm, 1 watt*
R_4 = *plate load resistor 0.11 megohm, 1 watt*
R_5 = *sensitivity control resistor 65 kilohms, 1 watt*
R = *input resistor (optional for continuous light measurement)*
C = *input integrating capacitor 0.1 μF mica (minimum), must have very high internal resistance*
E_1 = *45 volts, W30 Burgess battery or equivalent*
E_2 = *45 volts, W30 Burgess battery or equivalent*
S_1 = *switch to discharge integrating capacitor to initial short-circuited condition for circuit balance; switch is initially closed*
S_2 = *switch to flash the electric flash lamp after S_1 is opened so that the integration of current in C can be accomplished*
S_3 = *switch to open the phototube circuit after flash is over so that average continuous light will not cause meter drift while the reading is taken*
S_4 = *selector switch, left: R instantaneous light flux reading, right: C integrated light flux reading*
Q = *standard flash lamp for calibration*
1L4 = *triode-connected amplifier tube of small input grid current*
 Switches are arranged to operate in the sequence described above with either a rotary or push button.

Fig. 11-8 *A light meter (General Radio type 1501) used to measure the incident light from a round-the-lens xenon flash lamp. The beam-candela-second (BCPS) output of the lamp is determined from the meter reading multiplied by the square of the distance from the lamp to the meter.*

Fig. 11-9 *Ascor model M801 light meter for measuring integrated incident light.*

Fig. 11-11 "Lite-Mike" silicon diode light-measuring equipment for both continuous and integrated light.

Fig. 11-10 The probe receives the light reflected from the white card from the flash when the photographer pushes the switch on the meter. (The camera lens must be open.) The meter indicates the ASA speed of film for proper exposure. Adjustment of aperture or light-subject distance is made to give desired conditions.

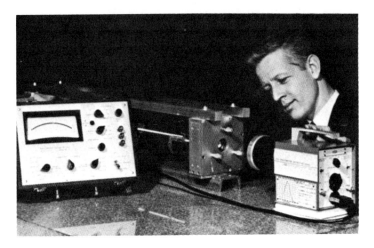

Fig. 11-12 *Val Gates observes the input of a type 580 radiometer detector head for measuring a laser beam. Output is read on the meter at left.*

radiation. Peak sensitivity occurs at 0.85 μm with cutoff at 1.2 μm. An optical filter is required to measure luminous quantities.

A radiation measuring system with extended capability is also available from EG&G, Inc. (series 580/585). One family of detector heads uses biplanar vacuum photodiodes with S-1, S-5, and S-20 surfaces. A detector is connected to an indicator unit which measures the continuous current or the integrated current from the phototube. The head in Fig. 11-12 is arranged to measure the output beam power of a gas laser. Interconnecting provisions allow the use of various types of input optics (narrow beam adapters, telescopes, beam splitters, filters) as well as the inclusion of a grating monochromator. A wide variety of photometric and radiometric (spectral) measurements may be made on any source of continuous or flash radiation.

A new series of detector heads (Fig. 11-13) employing photomultiplier tubes increases the sensitivity of the vacuum diode type by about four decades. Model 585-66 detector head (200- to 750-nm spectral range) can measure radiant power as low as 9×10^{-13} watts/$(cm^2)(nm)$ and irradiant energy as low as 9×10^{-13} joules/$(cm^2)(nm)$ at 450 nm. Another photomultiplier covering the 700- to 1,200-nm range can measure radiant power to 7.5×10^{-10} watts/$(cm^2)(nm)$ and radiant energy to 7.5×10^{-10} joules/$(cm^2)(nm)$ at 800 nm. A regulated high-voltage power supply is included and also an internal standardization source to ensure system calibration.

Utilizing standards traceable to the U. S. National Bureau of Standards, a complete spectroradiometer system is calibrated in sensitivity vs. wavelength thus permitting absolute irradiation measurements of both continuous and pulsed (as fast as 1 nsec) light sources.

A multidecade meter produces energy and power measurements directly on an indicating meter scale. Provision is also available for the usual cathode-ray oscilloscope presentation of the output of pulsed light sources.

The additional sensitivity of the photomultiplier over the phototube will permit additional applications into the studies of low power and energy with phosphors, chemical reaction, electroluminescence, emissivity and reflectivity of surfaces, biochemical analyses, etc.

Measuring the Output of a Flashtube

One of the most important uses of the integrating light meter is the measurement of the output of flashtubes and associated equipment. Likewise, the performance of the flashtubes in various reflectors can be determined.

The total light output of a flashtube under specified operating conditions requires a measuring system that integrates in space all the

Fig. 11-13 *Spectroradiometer system with photomultiplier detectors.*

light that is emitted. Such a measurement can be made by placing the tube in an integrating sphere of large size compared to the tube and arranging a light-sensitive device that receives the integrated light. This integrating-sphere technique is widely used by lamp manufacturing companies. However, it is an inconvenient method to use when only a few spot checks are necessary because of the amount and size of equipment required.

If the output is equal in all directions as with a spherical source, the total light flux can be calculated by measuring the incident light flux per unit area at a measured distance from the source in one direction and then multiplying this flux density value by the area of a sphere having that radius. In this way, the total light flux from a spherical source can be evaluated over the entire solid angle, for example,

$$Q = 4\pi D^2 W \quad \text{lumen-seconds}$$

where Q = flashtube output in lumen-seconds

D = distance from the source to the light meter in feet

W = reading of the light meter in lumen-seconds per square foot (foot-candela-seconds) incident light

Practical sources are *not* spherically symmetrical due to irregularities of the emitting element and to the tube base. It has been found experimentally that with practical tubes of helical types, such as the General Electric Company FT-214, the factor 4π should be replaced by 10 when the incident light is measured in a horizontal direction perpendicular to a vertical line through the tube base. Thus, $Q = 10D^2 W_h$ lm-secs, where W_h is the reading of the meter in lumen-seconds per square foot in a horizontal direction perpendicular to the vertical axis of the flashtube.

The candela-seconds (CPS) output of a symmetrical spherical source is CPS $= Q/4\pi = WD^2$ CPS (by definition).

Correspondingly, for the unsymmetrical practical tube, the horizontal-candela-second (HCPS) output is HCPS $= Q/10 = W_h D^2$. The word "horizontal" signifies that the measured direction is horizontal and perpendicular to a vertical axis through the tube base. This concept of horizontal-candela-second output is very useful since this portion of the light is usually directed by the reflector toward the subject which is to be illuminated.

So far in this discussion, the tube has been considered to be placed in a large open space so that no reflections will influence the incident

light W received by the meter. From a practical consideration, some care is necessary to keep the tube at a distance from lightly colored surfaces or from specular surfaces that might increase the received incident light at the meter. If it is impossible to isolate the tube from such surfaces, then absorbing materials, such as black velvet cloth, should be used to cover the surfaces. It is easy to find the error caused by various surfaces by comparing the meter readings when the surface in question is covered and uncovered by a black velvet cloth.

Measuring the Output of a Flash Lamp in a Reflector

When a reflector is used with a flash lamp, the meter can be used to read the combined effect of the lamp and the reflected output from the reflector. The purpose of a reflector is to gather the light and to direct it upon the subject that is to be illuminated. In some cases the subject is small and at a great distance, thus calling for a reflector that concentrates the light in a small angle to cover the subject. Again, the reflector may be close to a large object requiring a wide angle for desired coverage.

Measurements of the output of lamp-reflector combinations are usually made at a distance of at least ten times the diameter of the reflector in order to avoid crossover effects in the beam. From an experimental standpoint, the light meter can measure the reflector performance at any distance.

The output of a lamp-reflector combination can be given in beam-candela-seconds (BCPS) on the center axis of the reflector where the light output is usually greatest. As before with a bare lamp, the BCPS = $W_b D^2$, where W_b is the reading of the meter on the beam axis in lumen-seconds per square foot and where D is the distance from the lamp to the meter in feet.

The ability of the reflector to increase the output in the axial direction can be stated as the ratio of light with the reflector to that received without the reflector. This ratio can be called the *reflector factor*

$$M = \frac{\text{BCPS}}{\text{HCPS}} = \frac{W_b D_b{}^2}{W_h D_h{}^2} \quad \text{reflector factor}$$

$$M = \frac{W_b}{W_h} \quad \text{if } D_b = D_h$$

Two meter readings are thus required to obtain the reflector factor experimentally.

A highly specular reflector may produce a distorted image of the light source in space, and for this reason the meter may show large variations with slight changes in position. This nonuniformity of lighting will show up in a striking manner if a photograph is taken of a bare wall. Many reflectors require diffusion to break up the patterns which result. A diffuse surface either on the reflector or on the lamp or in front of the reflector can be used. The meter enables the designer of the reflector to measure quickly the light variation in space and the loss of light resulting from the use of a diffusing means.

A large value of M on the central axis is not usually desired since a large factor always means a narrow beam, usually with hot spots. More information is required to describe the complete reflector performance over the entire field of use. For this the integrating light meter can be used to measure the beam-candela-second output for all angles for any given example, and thus the entire performance can be determined.

One arbitrary method of describing "beam spread" or "reflector angle" of a particular reflector is to determine the angle between light rays that have a value that is half of the light ray strength at the center of the beam. The reflector angle of the average reflectors as used for light-on-the-camera photography varies from 30 to 70°.

Flashtube Efficiency

Flashtube equipment designers and users are very much interested in the efficiency of existing and experimental flash lamps for the obvious reason that a more efficient lamp means either additional useful output for a given equipment or a smaller equipment for the same overall result.

As given in Chap. 2, the electrical energy input into a flash lamp from a capacitor can be calculated from the expression of the energy stored in the capacitor

$$\text{Capacitor stored energy} = \frac{CE^2}{2} \quad \text{watt-seconds}$$

where C = capacitance of the capacitor in farads
E = initial voltage to which the capacitor is charged

Most of this energy is received by the flash lamp during the discharge; and, therefore, efficiency calculations are usually made by using the above equation for calculating the energy input to the flash lamp.

The capacitance values, as marked on commercial capacitors, are only nominal values. The actual values should be measured if accurate efficiency factors are to be obtained. Commercial tolerance of capacitance is often -0 to +15 percent. Therefore, most of the capacitors will be larger than rated. The importance of this is realized when the difference between the efficiency of various flash lamps may be only a few percent.

Likewise, the voltage must be accurately known especially since it enters the stored-energy expression as the square. Comparison of two flash lamps of similar characteristics should be made with the same capacitor and the same voltage measuring equipment to cancel out as many variables as possible.

The light can be read much more accurately with the meter than is required for photography, especially black and white. It is well known that the effective speed of photographic emulsions varies depending upon age, past history of storage, processing, etc.

One flash lamp that can be used as a standard is the EG&G, Inc. type FX-1 which is rated at 2,000 volts with 100 μF. Curves of peak light, efficiency, peak current, and flash duration are given in Chap. 2.

Almost any flash lamp can be used as a standard light source especially if it is calibrated with respect to some other standard lamp. General Electric Co. (Nela Park, Cleveland, Ohio), the U. S. Bureau of Standards, and EG&G, Inc. (Bedford, Mass.) have made calibrations of xenon lamps as standard flash lamps.

The output from the flash lamp can be determined with the light meter, either with an integrating sphere or by reading the horizontal-candela-seconds at a given distance and then multiplying this reading by the tube-meter distance squared and an appropriate factor, for example, ten, which depends upon the lamp's geometry. Efficiency is then the ratio of output to input.

$$\text{Efficiency} = \frac{\text{output}}{\text{input}} = \frac{10\ WD^2}{CE^2/2} \quad \text{lumens per watt}$$

or

$$\frac{WD^2}{CE^2/2} \quad \text{candelas per watt}$$

The efficiency for each type of flash lamp is a function of the capacitance, the series inductance if used, and the voltage to which the capacitor is charged. A complete chart can be presented of the efficiency as a function of these factors for any given flash lamp as has been given for the FX-1 (Chap. 2).

There will be efficiency differences between individual flash lamps due to inherent differences in manufacturing. Likewise, each flashtube will lose efficiency with use as the electrode material sputters on the sides of the bulb. All these variations are easily measured with the light meter.

The decrease in overall efficiency due to long interconnecting cables between the capacitors and flash lamps can be measured. The effect of electrolytic capacitors and other circuit elements can also be measured.

A study of the efficiency curves of a flash lamp indicates that the voltage and capacity should be high for high-efficiency operation. In other words, a flash lamp should be loaded to its limit for the most efficient operation.

Low-voltage operation of a flash lamp is demanded if electrolytic capacitors are used. Likewise, dry batteries have a cost that is almost directly proportional to voltage. Due to these factors, portable flash equipments do not use flash lamps at their maximum efficiency.

REFERENCES

1. Engstrom, R. W., Absolute Spectral Characteristics of Photosensitive Devices, *RCA Review*, pp. 184-190, June, 1960.
2. Zworykin, V. K., and E. G. Ramberg, "Photoelectricity and Its Applications," John Wiley & Sons, Inc., New York, 1949.
3. Edgerton, H. E., and R. O. Shaffner, Measuring Transient Light with Vacuum Phototubes, *Electronics*, pp. 56-57, Aug. 25, 1961.
4. Edgerton, H. E., and P. W. Jameson, Phototube Used for Short Flash Observation, *Electronics*, pp. 72-74, Sept. 14, 1962.
5. Gage, H. P., Glass Color Filters for Special Applications, *J. Opt. Soc. Am.*, vol. 27, p. 159, April, 1937.
6. Edgerton, H. E., Light Meter for Electric Flash Lamps, *Electronics*, p. 78, June, 1948.
7. Edgerton, H. E., Photographic Use of Electrical Discharge Flash Tubes, *J. Opt. Soc. Am.*, vol. 36, no. 7, pp. 390-399, July, 1946.
8. Wyckoff, C. W., and H. E. Edgerton, Xenon Electronic Flash Sensitometer, *J. SMPTE*, August, 1957.
9. Biplanar Diode Phototubes, *Application Note* E7, ITT Industrial Laboratories, Fort Wayne, Indiana, November, 1966.
10. Introduction to Model 580 Radiometer System, *Application Notes,* No. 5801A, EG&G, Inc., 160 Brookline Ave., Boston, August, 1966.

12 SPECIALIZED APPLICATIONS

A. UNDERWATER PHOTOGRAPHY WITH STROBE LIGHTING

It is unfortunate that photography cannot be used over large areas of the sea bottom as it is so effectively used over land areas. Aerial photography, for example, has revolutionized map making, surveying, and exploration of all types. An aerial camera can make precision records of large areas from great heights except when the atmosphere is foggy.

The water is always "foggy"! Even with extremely clear conditions, an underwater camera can seldom be used even at 30 meters from the bottom or from a subject. The light scattering and absorption effects [1-3, 10] of the water act as fog does in the air to limit the range and performance. Attempts to extend the photographic range with polarized light, favorable wavelengths, or pulsed light with gated reception may show a doubling of the range. The complications of some of these proposed systems are so great that they are not practical today.

Sonar techniques (underwater sound) offer greater range than optics but the presentation of the echo data is usually given on a *time basis* in contrast to the *angle* information produced in a photograph.

Although photography under the sea can only be used at relatively short distances, because of the scattering and absorption problems, it does have the ability to gather a tremendous amount of detail. Therefore, underwater photography would best be utilized for closeup details of biological, geological, and other subjects in the sea.

We seldom stop to appreciate the tremendous amount of information contained in a single photograph. Even the simplest camera has the ability to store more than a million bits of information. There is no simple system comparable to photography for recording a scene and for imparting that scene to another person. Moreover, the information is stored for future use. Photography plays a most important role in instrumentation and research efforts.

The electronic flash system of lighting for photography has become important in oceanographic research. The energy in a small

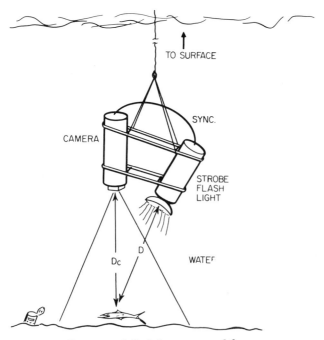

Fig. 12-1 *Camera and flash lamp encased for sea pressure with electrical connections for synchronization of the flash with the shutter.*

battery can be used efficiently and effectively to take many photographs without any electrical connections to the surface. A strobe lamp on or near a camera is essential once the subject is appreciably below the surface where daylight is ineffective.

Consider the underwater camera and lamp system of Fig. 12-1. Three important design details must be solved. These are (1) a pressure-resisting waterproof case [4-9], (2) optical windows [4-8, 11] for the lamp and camera which are also pressure-resistant, and (3) electrical [4-9] connections to synchronize the flash of light with the camera shutter. It is important that the salt water does not reach the electricity!

Although a hollow sphere is the "best" shape for an underwater camera pressure case, it is seldom used because of the mechanical problems of mounting the parts on the inside. Instead, the cylinder has been the preferred shape. Every effort is made to reduce the cylinder size by repackaging the camera parts or the strobe so that a minimum cylinder diameter will be needed. The largest part of a camera system is usually the reel of film. Thus, the conventional 100-ft (30.48-meter) metal spool of 35-mm film requires a cylinder with an inside diameter of 4 in. (10+ cm). For convenience the same size of cylinder can be used for the strobe.

A cylinder with a wall of $\frac{3}{8}$ in. (0.95 cm) thickness made of 17-4PH centrifugally cast and tempered stainless steel has the capability of withstanding the deepest ocean pressure, at a depth of 11,000 meters where the pressure is 17,000 psi (1,200 kg per cm^2). The cylinders should be tested for defects before starting on an expedition. It is better to have the case break at home than at sea. Figure 12-2 shows a collapsed deep-sea case for a camera or strobe.

For shallow depths (200 ft or 60 meters) the case wall can be much thinner. Such a case will exhibit distortion instead of the violent collapse usually experienced with deep-sea cases. Shallow cases can be made with buoyancy even with the interior camera because of the thin walls.

Design considerations for the cylindrical case, the end enclosures, the glass covers for the strobe, and the optical windows for the camera are discussed in [6-8].

Underwater Light Requirements

The light output of a strobe lamp is equal to the energy stored in the capacitor ($C_1V^2/2$) in joules, multiplied by the efficiency n of the lamp in candelas per watt. The *beam* output of the lamp with a

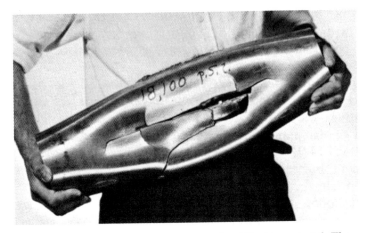

Fig. 12-2 *Underwater camera case made of faulty material. The case collapsed at an external pressure of 18,100 psi (1,273 kg/cm².). The case might have operated at the ocean's deepest point, but the safety factor would have been small.*

reflector is increased by a factor M so that the total output in beam-candela-seconds is

$$\text{BCPS} = Mn \frac{C_1 V^2}{2} \quad \text{beam-candela-seconds}$$

as given before.

In air the familiar equation of the guide factor is used:

$$DA = \sqrt{\frac{(\text{BCPS})\, s}{c}}$$

where D = lamp-to-subject distance in feet
 A = camera lens aperture
 s = ASA film speed
 c = constant in the range of 15 to 25 for distance in *feet*, 160 to 270 for distance in *meters*

The guide factor enables the photographer to quickly and easily estimate the proper conditions for a suitably exposed photograph. The required integrated light output of a flash unit for a specific photographic problem can be solved from the above. (See Chap. 5.)

$$\text{BCPS} = D^2 A^2 \frac{c}{s} \quad \text{beam-candela-seconds}$$

In water, the guide factor equation cannot be used since the optical effect of the water is not included. The light is absorbed and scattered by the water and suspended material in the lamp-subject path as well as the subject-camera path. A similar effect is experienced in the air but at vastly greater distances.

Anyone who has tried to take underwater photos in a harbor or silty river knows of the problem. In Boston Harbor one can seldom see more than a meter or so through the water because of organic and suspended material. Often a person cannot see his hands in front of his face! Naturally the camera and lamp have difficulty in obtaining a picture under such conditions. If the camera operator cannot see anything, then the camera will have exactly the same limitation.

There has been a large amount of serious experimental and theoretical research on the absorption and scattering of light in water, for example, the work of Duntley [1], Tyler [2], Preisendorfer [3], Johnson [10], Clark [12], and many others.

E. R. Fenimore Johnson, who has accomplished much with turbid underwater photography, describes in the following the use of his device to aid in turbid water photography.

> I have used an aluminum box having the form of a truncated pyramid, the lower end being closed with a plastic window, the upper end with a clear glass cylinder which projected into the water inside the box. The water in the box was not just clean water; it was triple filtered water. In this way I have been able to obtain photographs of the surfaces of piers and bay bottoms where water had the equivalent of a Secchi disc reading of one foot by placing the larger surface four to eight inches from the object to be photographed.

A large plastic window is used at the bottom of the clear water section. Illumination is provided by electronic flash lamps on the edge. Very turbid water requires a front plate very close to the subject with lamps also in the clear water.

Johnson also has written that he has extended the range of underwater photography by a factor of two by the use of infrared film with tungsten lamps covered with a Wratten No. 25A red filter. The lamps are placed at the corners of a square and about halfway to the subject. He attributes the penetration to the red light.

Inclusion of Light Absorption in the Light Calculation

The reduction of light in water with distance is usually given mathematically as an exponential function of the distance traversed,

as well as a function of the color. The inverse square law of reduction is also in effect. We can then say that the incident exposure on the subject is

$$IT = \frac{BCPS}{D^2} \epsilon^{-\alpha D}$$

where α is the attenuation coefficient.

The color of the incident light will depend upon the distance since α is a function of wavelength of the light.

In exceptionally clear clean water this coefficient can be as small as $1/20$ meters^{-1} ($\epsilon = 2.73$). A table of attenuation lengths for *distilled* water as a function of wavelength has been presented by Duntley [1, p. 216].

Wavelength, nm	400	440	480	520	560	600	650	700
meters/ln = $1/\alpha$	13	22	28	25	19	5.1	3.3	1.7

Note that the red light (600 nm) is attenuated much more than the blue (400) and green (500) light! This means that the color balance is changed as a function of water path. The red light from sunlight, for example, is effectively gone at 10 meters below the surface. A filter on the camera to correct the color balance will greatly reduce the total light that enters the camera. Each depth requires a different filter!

The absorption of light from the subject to the camera likewise will involve a similar factor. Assume that the camera and flash lamp are at the same distance $D = D_c$ from the subject. Then the required exposure IT at subject will be

$$IT = \frac{A^2 c}{s} \frac{1}{\epsilon^{-\alpha D}}$$

(See Chap. 5.)

The *light* required for underwater photography can be found by equating the two equations for exposure and solving for

$$BCPS = A^2 D^2 \frac{c}{s} \epsilon^{\alpha 2D}$$

The "water factor" can be stated as $\epsilon^{\alpha 2D}$. This is the amount by which the exposure must be increased to overcome the effects of the

absorption and scattering of the water in the lamp-subject-camera path compared to the similar "in-air" case. Figure 12-3 shows the water factor $\epsilon^{\alpha 2D}$ as a function of αD. Note that when $\alpha D = 2$ (two attenuation lengths) the water factor is 55 times that for the air case!

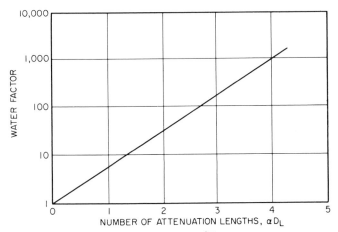

Fig. 12-3 *Plot of the water factor $\epsilon^{\alpha 2D}$ as a function of the number of attenuation lengths.*

The water factor for one attenuation length is equal to 7.5 (ϵ^2). Beyond three attenuation lengths the factor becomes exceedingly large, and, furthermore, the image is lost because of the back-scattered light (fog). Considerable improvement is possible by side lighting and by placing the lamps close to the subject since the light on the image is increased and the scattered light reduced.

The light calculations are approximate since the attenuation factor is a function of wavelength. Also the optics of the lens are influenced by the water-glass interface which changes the sizes of the images on the film as compared to air operation. Table 12-1 shows several

Table 12-1 Calculated Water Factor for Distilled Water for Distances of 1, 2, 3, and 4 Meters for Three Wavelengths

Color	Attenuation length, meters*	$\epsilon^{\alpha 2D}$ for distance shown			
		$D = 1$ meter	$D = 2$ meters	$D = 3$ meters	$D = 4$ meters
Blue (480 nm)	28	1.07	1.15	1.23	1.33
Green (560 nm)	19	1.11	1.23	1.36	1.52
Red (650 nm)	3.3	1.95	3.35	6.05	11.25

*S. Q. Duntley (see [1]).

calculated water factors as a function of wavelength (color) as well as of attenuation lengths.

As a general rule, a round number is taken, such as *ten*, for the amount by which the light should be increased over that required for air conditions *when the attenuation length is approximately equal to the lamp-subject distance and the camera-subject distance.*

The next problem for the underwater photographer to solve is *how to measure the attenuation length* at the place where he wishes to take a photo. Duntley [1] gives a hint in his paper (p. 216) where he states that "Many experiments by swimmers show that any large, dark object (such as a dark suited swimming companion) is just visible at a horizontal distance of about 4 attenuation lengths when there is sufficient daylight." A meter [2, 15] for measuring $1/\alpha$ should be useful for determining exposure conditions.

The attenuation length of actual ocean water varies greatly with local conditions. Fortunately, the attenuation length is long at great depths in the sea near the bottom. Coastal waters, however, are very turbid especially where streams discharge sediment-laden water into the sea after a heavy rain.

Duntley gives typical attenuation lengths $(1/\alpha)$ in meters/ln as found by Jerlov.

Caribbean	8 meters/ln
Pacific N. Equatorial Current	12 meters/ln
Pacific Counter Current	12 meters/ln
Pacific Equatorial Divergence	10 meters/ln
Pacific S. Equatorial Current	9 meters/ln
Gulf of Panama	6 meters/ln
Galapagos Islands	4 meters/ln

Closeup photography at, for example, 1 meter from the lamp and camera requires very little color filtering in clear clean water. The light from the strobe is of "daylight" quality so "daylight" types of color films can be used.

For greater distances, such as beyond 2 meters, color-correcting filters are needed. Table 12-1 shows the selective color absorption in distilled water for several distances. In general, the filter will pass the red light and attenuate the green and blue.

The light from the sun and the strobe can be mixed with great success in clear shallow water up to 2 meters deep. Daylight will flood all the subjects in depth whereas the strobe will give strong

front lighting on the subject. The daylight produces a mottled effect from the waves which may be wanted or not depending upon the project.

Cousteau and others used indoor lamps, such as 3200°K tungsten lamps or chemical flash lamps, with daylight color film with great success. At one distance the absorption of the red light will be correct. Thus, the water acts as a filter to reduce the excess red light to the proper value. For closer distances the photos will be yellowish-red. For greater distances the photos will be blue-green. Cousteau's award winning motion pictures "The Silent World" and "The World without Sun" (both available in 16-mm sound from Columbia) are examples that those studying underwater photography should not fail to see.

A short article about color in underwater photography by Bates Littlehales [35] of the National Geographic Society has many practical suggestions. He mentions Phinizy's work with filters to help obtain on film a picture similar to that which the diver sees. Littlehales discusses the use of color negative films which can be modified in the printing process to produce the desired color rendition. In conclusion he states, "I would like to see the twilight world of underwater penetrated but not overpowered."

Those interested in pursuing this underwater color photography subject further will find articles by Mertens [17] and Brooks [23] to be of great interest. Books by Greenberg [18], Hersey [19], Rebikoff [21], Schenck and Kendall [22], etc., are listed in the bibliography.

The exposure due to back-scattering of the light from particles in the water can be partially eliminated by several means such as color filters, pulsed or gated light, or circular polarizing filters [93]. The gated system requires a light that pulses for a very short time, less than a microsecond, and a shutter that opens after the light reaches the target, thus eliminating the exposure due to the back-scattered light.

Three *general rules* for underwater photography are:

1. Use as wide an angle (short focal length lens) as possible so that the camera-subject and lamp-subject distances will be minimized.

2. Arrange the lights on the side of and close to the subject to overcome the back-scatter fog that is experienced with a lamp-on-the-camera system.

3. Move the lamp or lamps as close as possible to the subject so that the lamp-subject distance is a minimum.

The last item to consider is the required *flash duration* to stop the motion of the subject. In ocean photography, a millisecond exposure time is sufficient since there are few subjects with high velocity. The important factor about ocean photography is not the exposure time, but the efficient use of the light since the lamp is only "on" when the exposure is made. The conversion of electrical energy to light is very efficient with xenon flash lamps, and a small battery can provide sufficient energy to expose many thousands of photographs. Several practical systems of underwater photography with electronic flash will now be described.

A Handheld Underwater Flash Lamp

The equipment described here is a camera-lamp combination of minimum performance for routine underwater still photography of closeup subjects by divers. Below is a list of specifications which the author considers to be important and minimum for average requirements.

1. The photographic equipment should be *as small as possible* for convenience in the boat before the dive and to give minimum resistance when the diver is swimming.

2. *Auxiliary light* in addition to daylight is essential for most projects since sunlight is not effective, especially at depth. A lamp near the camera is important for lighting subjects in the shadows. A common example is the portrait of a diver. Without flash, the face is not usually exposed because of the shadowing of the diving mask. Color photography requires a lamp close to the subject and a small camera-subject distance.

3. *Fast charging time.* The lamp should be ready to flash again in a few seconds since time is precious underwater. The diver has no time to spare waiting for a slow-charging unit to get ready for the next photo.

4. *Many photos from a battery.* There are not many opportunities during an expedition aboard a rocking boat or in camp to charge or change batteries in a flash unit. The battery should have ample capacity to cover all requirements for an expedition.

5. The *color* of the lamp should emphasize the red end since water absorbs red more than any other color. However, the daylight

quality of the xenon flash lamp is adequate if the lamp-subject distance is less than about six feet.

6. The equipment should be *quiet*. Many electronic flash devices create sound which is effectively transmitted by water and may disturb underwater subjects.

7. The battery current drain for a "stand-by" condition should be negligible so that the equipment may be left in a "ready" condition for an entire dive.

8. An indication of the *battery condition* is required so that the battery can be changed or recharged before flash failures are experienced.

9. Weight and balance in water must be such that a diver can handle and use the equipment without effort.

The Flash Unit

An electronic flash lamp which attempts to fulfill these requirements has been made (Fig. 12-4). Figure 12-5 shows the details of the circuit.

Fig. 12-4 *Underwater flash of 50-watt-sec capacity attached to a Nikonos underwater camera.*

The high-voltage, dry-battery type of electronic flash equipment was selected since it is quiet, has a fast charging time, and has the capability of many flashes.

The batteries (510 volts) are rather expensive (about $15) and are not commonly available in remote areas. Therefore, the user must be

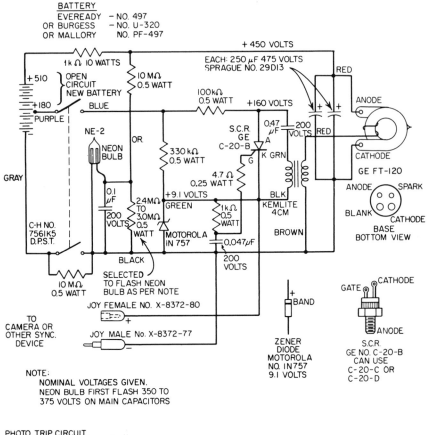

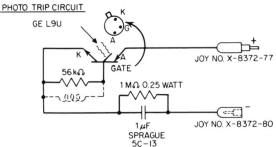

Fig. 12-5 *Circuit diagram of an electronic flash unit with an SCR trigger and a phototrip circuit.*

sure to take an ample supply of fresh batteries which must be protected from moisture and heat. For example, heat caused by long exposure to direct sunlight can cause the batteries to self-discharge. Plastic bags are a convenient method for excluding moisture.

A flash capacitor of 50-watt-sec of energy storage was selected, together with a flash-lamp-reflector combination, to produce a rather broad beam of light to match approximately the field of a 35-mm (air) lens. The beam output is about 1,500 BCPS. In air, the guide factor with Kodachrome II film is about 40 to 45. In water, at a 3-ft distance, the aperture should be $f/11$, or perhaps $f/8$, depending upon the condition of the water.

The assembly of the parts was put into a plastic tube some 4 in. in diameter and about 1 ft long, with a metal arm for attachment to the camera. The window is made of Plexiglas and is sealed with an "O" ring.

Controls are (1) an on-and-off switch and (2) a pilot lamp which informs the user that his equipment is ready to flash. The condition of the battery is indicated partly by the flashing rate and by the time to recharge. When this charging time exceeds 5 sec, the user knows that his battery is getting tired and should be changed. However, there are many flashes left in the battery, and the user can continue shooting, but at a reduced rate of flashing.

Two wires are brought out for synchronization and are used to connect to the "X" type camera shutter contacts. There is no appreciable time delay of the flash after the contacts close.

The xenon flash lamp can be used with any underwater camera that is equipped with "X" synchronization contacts on the shutter which close an electrical circuit when the shutter is wide open. The Nikonos camera has a place to bring out both "X" and "M" contacts in a watertight plug at the base of the camera. The plug can be set to give either connection. It should be emphasized here that the "M" contacts will flash a strobe lamp *before* the shutter is open, and no exposure will be made by the flash. The "M" contacts are for expendable flash lamps which require about 20 msec of lead time.

Care must be exercised when the Nikonos special watertight plug is inserted: (1) The keyway must engage at the bottom of the plug, (2) the "O" ring must be clean and must be located in the cylindrical wall of the camera, and (3) the retaining screw must be pulled in tight against the camera body.

It is important to check a new camera and flash to see if the *flash occurs* when the *shutter is open*. This can be accomplished by placing

a piece of white paper in the camera gate. Then with the lens out, flash the lamp and look into the camera to observe the paper. If the paper is not seen with the flash, there is something wrong!

Other ways to "miss" a photo are (1) the lens cover is left on the lens, (2) the film is "over" and not under the backup plate, (3) the shutter time is faster than 1/60 of a second which does not expose the entire picture because of the focal plane shutter, and (4) the contacts in the sync. plug are accidentally connected to the wrong contacts in the camera. The "X" contacts must be used.

The flash unit can be upgraded from 50 to 150 watt-sec by the addition of more capacitors. The charging time will be increased by three and the number of flashes from the battery will be less by a factor of about four. A longer waterproof case is required to hold the additional capacitors. (The above is adapted from an article that appeared in *Skin Diver* [26], and the following is adapted from another article which also appeared in *Skin Diver* [27].)

There have been two kinds of reactions by divers to this strobe unit for underwater use: (1) The unit is too big and heavy and (2) the unit does not have enough light. Thus, it seems that an average device has been reached, but there do not seem to be many average divers! They all want something different, either smaller or brighter. Those divers who want a smaller unit will first need to compromise on the amount of light in each flash, the number of flashes from a battery, or on the other factors mentioned in the specification list given on pages 268 and 269.

Phototrigger

In the following, a method is shown for obtaining *more light* [26] by using two, three, or more underwater lamps synchronized by a phototrigger device which enables as many units as desired to be flashed as slaves under command of a master light on the camera without interconnecting wires. The diver who wants "more light" can be accommodated easily.

There are a few technical problems with the phototrip which must be recognized and understood. For example, (1) the photosensitive trigger device must "see" the master light or enough reflected light from the subject to cause the slave lamp to trigger reliably. The camera operator must know the limitations of his master light and his slave light as well as the phototrigger. (2) The slave lamp can also be triggered by any flash lamp; therefore, if there are other photographers in the area (or a lightning storm!) their flash lamps can

cause the slave to operate. The slave lamp may not be recharged if the command comes too soon after the slave lamp has been triggered by another photographer. (3) Sunlight may cause the slave to operate when the flash equipment is taken out of the water or when a shadow comes across or leaves the phototrigger unit.

Photographic Arrangement

Any kind of photography, either above or underwater, is improved by the use of two lamps instead of one. The most commonly used combination of two lamps consists of a master light close to the camera and a slave lamp on the opposite side. The slave lamp can be at an angle of about 45°, at a closer distance than the master lamp, and higher than the camera.

Photographers often call such a slave lamp the "key" light since the light from it gives the basic exposure of the subject. Since it is at an angle, the key light also gives shadows that help tremendously to give modeling and character to the photographs. Light from the master lamp, which should always be close to the camera, will give an overall flat exposure which fills in the shadows from the key slave light.

The photosensitive trip device is mounted in a heavy-walled glass test tube and clamped to the handle of the strobe unit. The light-sensitive area of the photo pickup (GE Co. L9U) is directed toward the master light by turning the clamps or the glass tube so that the sensitive area will be exposed by light from the key lamp but shielded from light from the sun and other sources. (See Fig. 12-6.)

With a bit of imagination one can visualize a light-shielding tube able to exclude all light except from the master light. Also a lens can be used to collect more light from the master lamp and focus it on the light-sensitive trigger. Normally these refinements are not required because the peak of the pulse light is very high (usually a million candelas) and the light sensor is sensitive to a short flash of light.

There must be cooperation between two divers when they use the double light system. The diver with the camera is the one who selects the moment that the photograph will be made. His buddy must keep an eye on the photographer-diver and at the same time point his lamp and phototrip at the subject and at the master lamp. Also, he must keep the lamp at the correct distance from the subject, otherwise the photos will be over- or underexposed.

A tripod can be used for underwater fixed-subject photography in exactly the same manner as side lighting is used above water. Doubtlessly, many unusual lighting schemes will be evolved when diver-photographers become proficient with the multiple light

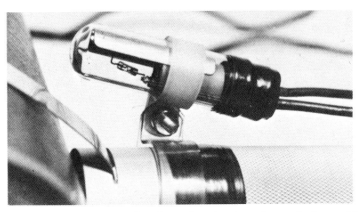

Fig. 12-6 *Photograph of a photoelectric trip unit attached to a 50-watt-sec underwater electronic flash unit.*

system. With the rapid recycling strobe, many photos with several different arrangements can be made in hope that one of the photographs will be an extraordinary one.

Three 50-watt-sec flash units can be assembled with two clamps and two handles. In this way a single diver can handle all three as a single flash lamp with three times more light than a single unit. The three phototrips are nested at the front of the assembly, and there is no reason why more lamps cannot be assembled either together or separately as desired. Such a combination, however, may be difficult to handle underwater because of waves and currents!

Electrical Circuit

The complete wiring diagram of a 50-watt-sec strobe unit, with an SCR circuit (GE Co. No. C-20-B) for triggering so that an external phototrip (GE Co. No. L9U) can be used, is shown in Fig. 12-5. Simpler circuits are possible without the SCR (silicon-controlled rectifier). For example, the photodiode itself is sometimes used to trigger the coil directly. The circuit shown, however, is also insensitive to electrical leakage between the trip terminals. The voltage across the trip circuit is only 9 volts, whereas it can be as high as 150 volts in some circuits. Items which are known to be

satisfactory are shown, but others can be substituted. For example, the flash lamp is a GE Co. FT-120, which was selected because of the glass cover on the bulb and rugged four-pin base. Equally well, the FT-118, the FT-151, or even the FT-106, FT-218, or FT-110 can be used if enough spark is present.

The electrolytic capacitors used for storing the energy for the flash are available from a number of sources. Practically all radio component or electronic device stores have a variety of capacitors that will serve. These stores also have a stock of many kinds of the other components that are needed for the assembly.

The battery is one of the most important items in the design. The cost of the battery and its useful life, even when not taking photographs, is a cause for concern. Such a dry battery will run down because of its internal chemical effects regardless of how many photographs are made. Actual performance curves for the 50-watt-sec underwater lamp are shown in Fig. 4-6.

The user is advised to have fresh spare batteries that are kept cool and dry so that they will function when it is time for them to operate.

The light output of the 50-watt-sec strobe unit described, as measured at a distance of 6 ft in air, is 1.5 million peak beam-candelas at the center of the reflector. The flash duration is about 1,000 μsec; therefore, the output is 1,500 beam-candela-seconds (BCPS). The output is the product of the peak beam-candelas multiplied by the flash duration (see Chap. 2).

Exposure Calculations

A flash unit with an output of 1,500 BCPS will have a guide factor *in air* of

50 to 39 for Kodachrome II, $s = 25$
80 to 62 for Ektachrome X, $s = 64$

as calculated by the equation given at the beginning of this chapter and in Chap. 5. I personally use the lower, more conservative value.

In water this *air* guide factor equation will be too large and inaccurate because of the absorption and scattering of light in the water. The diver-photographer must be an expert in guessing, measuring, or calculating, or all three, the amount of correction (the water factor) for a satisfactory photograph. Naturally color photography causes the most trouble. Not only is the absorption of the water with distance a problem, but also the selective color

absorption. Distant photographs will always be red-deficient because of the greater absorption of red. No filter can correct this situation for simultaneous close and far subjects.

Deep-sea Underwater Photography Equipment

A few practical systems of deep-sea underwater photographic equipment will now be described and some examples shown. Figure 12-7 shows a typical arrangement for two cameras (stereo pair), an electronic flash unit, and a sonar pinger on a metal rack (Unistrut system). Dr. Hersey [19] of W.H.O.I. says, "A single camera is only one-half of a stereo camera system!" His experience with stereo has impressed him with the added information which a stereo presentation can produce.

Another underwater camera arrangement used by Dr. Hersey is shown in Fig. 12-8. Note that the strobe is closer to the bottom and off the axis of the camera since this positioning tends to reduce the back-scatter from the strobe. A similar arrangement with as many as three cameras and two 200-watt-sec strobes has been used to obtain

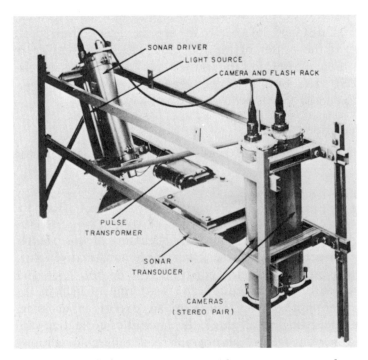

Fig. 12-7 *Simple frame arrangement with stereo camera, strobe (100 watt-sec), and pinger sonar system for camera positioning.*

photographs with the cameras at 40 ft above the bottom in clear ocean water. A pair of 35-mm cameras with a wide spacing to permit accurate measurement of depth over a small area of the ocean bottom has been used by the U.S. Coast and Geodetic Survey. Other ocean camera-lamp systems are discussed in Hersey's book [19] on underwater photography.

The "Unistrut" material (Figs. 12-7 and 12-8) is very convenient for construction of special racks and clamps for oceanographic instruments. The experimenter in the field can change the arrangement easily to suit his special requirements.

The chassis of a typical underwater camera is shown in Fig. 12-9. The case has a 4-in. ID with a ⅜-in. wall of 17-4PH stainless steel and can be used at the greatest known depth of the sea. A tempered glass window 1 in. thick is placed over a 1-in.-diameter hole in a 1-in. steel end plate through which the special Hopkins lens [11] is inserted. Film is supplied on standard 100-ft rolls. The aperture plate has been cut

Fig. 12-8 *Underwater camera rack placed at an angle to put the strobe off axis and closer to the subject. Combined compass and direction indicator is on a string in the photographic field.*

away on the sides to permit the use of some of the film between the sprocket holes. All of the electrical connections of the shutter, the data lamp, the film winding motor, etc. are easily available on a back panel so that the camera can be set up for automatic or push-button modes of operation.

A data chamber is photographed with each exposure at 9 frames ahead. Information consists of pressure (depth), time (24-hr clock), and a data card. Data on the film prevents accidental errors due to film identification.

An example of a deep-sea photograph is given in Fig. 12-10. Since the camera can produce a tremendous quantity of photographs on each lowering and since there may be a dozen lowerings on an expedition, the number of photos soon becomes a data reduction problem. The

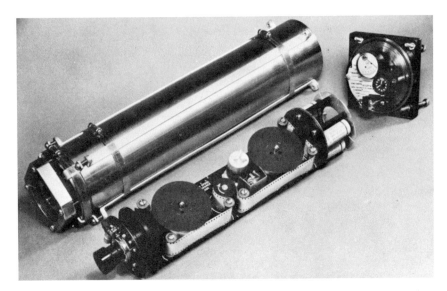

Fig. 12-9 *An in-line deep-sea camera housed in a pressure case for ultimate depth in the sea. The lens at the left is optically corrected to look into the water through a 1-in. glass window. The right-hand lens photographs a data chamber containing pressure, time, and other information between each frame.*

Fig. 12-10 *Underwater bottom photograph taken from the* Atlantis II *(W.H.O.I. research ship) at 07:12 hr at 2,500 meters depth on lowering No. 3.* (Photograph by Johnston, May 25, 1963.)

photographs have different importance depending upon whether an oceanographer, a biologist, or a geologist is looking at them. In order that everyone may be aware of the information contained on the photographs, the best pictures from each roll may be posted on some conspicuous wall. If someone notices some feature of special interest to him he can then look at the other 500 photos on the roll. There should be a library of films to preserve the information. Catalog information on the location, depth, time of day, date, subjects shown in the photos, etc., would need to be listed. One could then easily look up the photos of interest. As the expedition progressed, more areas would be covered in the library collection.

The recent discovery of very large sharks [31] at great depths (1,100 fathoms) off San Clemente Island, California, was made with a camera system conceived by Prof. John D. Isaacs of Scripps. A camera system with a bait box on the bottom was thrown overboard and allowed to stay on the bottom until a release mechanism would permit the camera to float to the surface for retrieval many hours

Fig. 12-11 *Rare bottom fish around a bait box photographed by the deep-sea camera in 1,800 fathoms of water.*

later. Photos of rare bottom fish are shown in Fig. 12-11. The sharks are so large (18 to 20 ft) that only a part of their bodies can be photographed on one frame. Richard Rosenblatt has identified the "Monster" as a sleeper shark named *Somniosus pacificus.*

A very practical problem of sea photography is measurement and control of the height of the camera over the bottom. A camera, for example, must be held accurately at some selected height, such as 10 meters from the bottom. There are at least four ways to do this.

1. The "trigger" [4, 5] method in which a shutter operating device, usually a switch, hangs below the camera. This bottom activated electrical switch causes operation of the camera when it is at the desired height. The camera is then raised in preparation for the next operation after the exposure is made.

2. The use of a "pinger" [32, 33] sound source on the camera which enables the operator on the ship to know at all times where his camera is located above the bottom. A pinger sends out a short powerful pulse of underwater sound at regular 1-sec intervals. One sound wave goes directly to the surface from the pinger; and another goes down to the bottom of the sea, is reflected, and then arrives at a later time at the surface. The operator on the ship measures the time delay between the two signals and knows where his camera is positioned since the velocity of sound in water is known to be about 5,000 ft per sec.

3. The "sled" system of Captain Jacques Y. Cousteau [19, 34, p. 246]. His device, a special sled which carries the camera and strobe, has the ability to right itself regardless of how it is dragged across the bottom by a strong cable from the ship.

The sled, or "troika" as Cousteau calls it, is an ideal platform for a deep-sea camera. The lamps and cameras are carefully placed behind the heavy metal parts of the sled to reduce the probability of damage as the sled goes through rough areas on the bottom of the sea. Cousteau is always careful to make a detailed sonar study of the area over which he plans to drag the sled and also to observe winds and tides. Then he lowers the device to the bottom and traverses over the area of interest.

What if the sled becomes wedged into a tough spot and becomes an anchor? Cousteau partially solves this problem with a double-cable attachment method. The main cable is firmly attached to the stern of the sled. A weaker cable ties the main cable to the bow. If the sled is stuck, a powerful vertical pull will break the weak connection and the sled will upend, hopefully releasing itself from the bottom attachment.

Cousteau once dragged his sleds over the mid-Atlantic rift mountains and obtained some remarkable photographs. One of these

appears as an illustration in his book "The Living Sea" [34, p. 239], and resembles a moonlike scene. It seems incredible that the sled could travel over such a rough place without difficulty. Incidentally, one of the sleds is still on the bottom about halfway to Europe. If you want this sled with its movie camera and strobe for a souvenir, I am sure that Cousteau will give it to you if you find it. The location of the sled is halfway between Monaco and New York, possibly north of the direct line by some 500 to 1,000 miles.

There are many other cameras at the bottom of the sea. I personally know of one stereo pair that is full of exposed pictures—probably the best that I have ever made. This loss was experienced at a spot on the north wall of the Puerto Rico Trench, at $20°07'N$, $66°30'W$. We were pulling the gear up with the winch after the photo run when suddenly the cable parted and the camera went down with thousands of feet of cable on top of it.

I thought it would be worth looking for; and so the following year, I returned to the same spot with an improvised hook. I had the use of the ship for an all-night dragging search but had no luck. Perhaps we snagged the cable, but it slipped free. Better fishing next time! If any of my readers finds the camera system, please remember that the film must be developed. One camera has Plus X film, the other has super Ektachrome color film.

4. The "captive vehicle" method. One system uses a television camera on a tethered submersible with a cable to the master ship. A monitor screen permits the operator on the ship to control the submersible in the desired pattern. Then when the subject is in view, the photographic equipment is turned on to obtain high-quality photographs for measurement or record purposes.

An ambitious project of photographing telegraph cables was undertaken in 1961 off Newfoundland's continental shelf. As stated by Mr. G. R. Leopold, in *Bell Telephone Lab. Rept.* (file No. 34912-16), "The purpose of the investigation was to examine the cables and the ocean bottom at first-hand and to seek out possible physical explanations for our apparent vulnerability to trawler breaks in the area."

The "vehicle," as it was called, was a Vare Industries controlled-buoyancy device operated from electrical propulsion supplied by a cable to the controlling ship, the Polar Star. A television camera on the vehicle transmitted a picture to a television screen on the ship to record the action below. An operator on the ship then could use the

Fig. 12-12 *Transatlantic cable on the bottom of the ocean.* (Photograph by Leopold, Bell Telephone Lab.)

Fig. 12-13 *Codfish near the transatlantic cable.*

necessary controls to guide the vehicle in following the cable once it was found.

A deep-sea 35-mm camera and a 100-watt-sec xenon flash lamp were mounted near the television camera tube on the vehicle. An operator watching the screen could take photographs whenever he desired by pressing a push button. Examples of this effort are seen in Figs. 12-12 and 12-13.

A very difficult but successful deep-sea photographic effort was the photography of the *Thresher* wreck site some 200 miles east of Boston in 8,500 ft of water. The ill-fated *Thresher* was a nuclear-powered submarine which sunk during her deep-diving tests in April, 1963. Many groups worked on the recovery and photography efforts. Worzel of the Lamont Geological Observatory, Columbia University, while aboard the *Robert D. Conrad* made many photographs with a Thorndike camera [5] of the "bottom contact" type. Figure 12-14 shows an air tank on the bottom. The strobe lamp is on the structure

Fig. 12-14 *Underwater photograph of compressed air tank on the sea bottom near the site of the* Thresher *sinking.* (Photograph by Worzel.)

at the center of the photo. A cable passes through the rings to a release weight that triggers the camera.

While aboard the W.H.O.I. research ship *Atlantis II*, Dr. Hersey used the "pinger" system on several EG&G, Inc. cameras, similar to

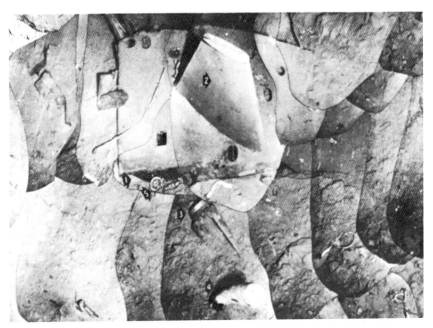

Fig. 12-15 *Photomosaic of the sail area of the* Thresher *at 8,500 ft. The conning station at arrow (1) is upside down with the leading edge to the left in this photograph. The sail planes (2) are completely reversed. Below the sail is a torpedo shutter door (3); an air bottle (4) is near the camera sled compass; the actuating gear for torpedo shutter door is at (5).* (Official U.S. Navy Photograph.)

the gear shown in Fig. 12-8 together with four widely spaced hydrophones for camera location information. The U. S. Naval Research Laboratory [20] used an EG&G, Inc. camera with remote surface control. The cameras were started when a magnetometer showed the presence of iron. Some 40,000 photos were made within 1,000 ft of the wreck and from these a photomosaic was made. Figure 12-15 shows part of the *Thresher* wreck on a section of this photomosaic.

A battery of 200-watt-sec underwater strobe lamps was attached to the hull of the *Trieste* bathyscaphe which made dives during the summer of 1963 and 1964 to search for the remains of the *Thresher*. The strobes were on tracks so that they could be pulled to the deck

for servicing and adjustment. The *Trieste* brought a small piece of the wreckage to the surface with its articulated arm, as well as photographs.

A very successful photographic expedition was accomplished by the Naval Research Laboratory ship *Mizar* to find and photograph the *USS Scorpion* which was lost in May, 1968 in 10,000 ft of water some 400 miles northwest of the Azores. The *New York Times* carried stories on Oct. 31, 1968 and Jan. 2, 1969.

Positioning of the Photograph

Bottom photography is usually uneventful, showing many miles of desertlike sediment. Therefore, it is not too important to know *exact* positions. If one expected to photograph the *identical* area for a second time, it would be very difficult for two reasons: (1) The exact ship position is not known, and (2) tides and currents displace the camera in an unknown manner, even if the ship is held directly above the target. Some method of "bottom" navigation is required if the camera is to be brought back to an identical bottom area.

One way to locate a spot on the bottom is to anchor a buoy. The position of the buoy with respect to the anchor position will depend upon the water currents and their effects on the float. Tight cables from large buoys to large anchors tend to minimize the positional error.

A second and more involved method is a sonar transponder on the bottom which sends a ping when commanded. Let us call this a "soundhouse" as contrasted to the "lighthouse" used in surface navigation. Whenever one sends a sound signal from the surface or from a pinger on a camera, he will receive an echo response at a delay corresponding to the distances involved. Thus, he can measure two distances, one to the bottom and a second to the soundhouse. A transponder soundhouse receives sound pulses from the sonar on the ship and returns a reinforced echo which is also recorded on the sonar receiver. A series of signals will appear on the chart from the soundhouse. The ship and soundhouse are at their closest position when the signal is received at the earliest time on the recorder chart. A second pass can then be made from another direction to obtain further information.

If a person has two soundhouses, he can put two positions on the chart where he might be located. With three soundhouses, there is no ambiguity in the ship's position. The problem is the same as the surface navigational "fix" where information from three known

lighthouses is used. A lighthouse gives an angle; in contrast, a soundhouse gives an echo delay time which is proportional to distance since the velocity of sound in water is almost a constant. The bottom navigation problem is more difficult than the surface navigation problem because of the added complication of water depth. A submerged water craft and an aircraft have exactly the same problem of navigation in a three-dimensional medium. There may be several problems in the initial installation of the soundhouses, but once they are in place, an accurate survey can be made and the ship should be able to go repeatedly to the same pinpointed spot.

Now a camera or other device can also be accurately located by the use of an attached pinger. The pulses from the pinger will give the operator on the ship the usual camera-to-bottom distance. At the same time, the pulses from the camera will stimulate the transponder soundhouses; and they in turn will send additional signals to the ship. These signals enable the operator to know where his camera is located with respect to the target, if the position of the target is known with respect to the soundhouses. The remaining job, which requires skill, is the manipulation of the ship so that the camera photographs the desired subject. The same sonar procedure can be used with the bathyscaphe, with the additional feature that a human observer can take over the controls when the subject comes into view. Also, once the bathyscaphe has been put into the desired area, the use of a side-looking sonar can be very helpful if the target projects from the bottom.

The soundhouse transponder can be used as a marker. For example, a submarine could take one along on dives with the provision for dropping it at the main center of interest. In this way the sub can go back to the identical spot for another try.

In conclusion, it appears that sound will be the principal medium by which men and instruments can navigate precisely in the sea. Both light and radio are not effective for large distances underwater because of absorption. Sound is effective to several miles, whereas photography is only effective to 30 meters under ideal conditions. However, the two methods used together can obtain much information about the bottom of the sea.

B. NIGHT AERIAL PHOTOGRAPHY

Interest in night aerial photography [37] with an electronic flash light source began at M.I.T. quite unexpectedly during the summer

of 1939. Major George W. Goddard of the Air Force Photographic Laboratory at Wright Field came to the Stroboscopic Laboratory and inquired whether the new type of electronic flashtube, then in the developmental stage, could be used as a light source to take photographs at night from reconnaissance airplanes.

From personal experiences as a pilot and an aerial photographic interpreter in World War I, Goddard was impressed with the need for night photographic cover. During his first visit to our laboratories, he expressed his sincere conviction of the imperative need for night aerial photography. Then, as in World War II, which was to occur two years later, the enemy often moved at night; and the high command repeatedly had to know what happened at a particular place at night behind the enemy lines. The only satisfactory solution to such a problem is night aerial photography, the origin of which dates back more than a half a century when a few preliminary photographic experiments were made in 1917 and 1918 with improvised flash bombs.

Two Systems of Night Photography

From World War I to 1939, progress in night photography was confined to refinements and improvements of flash-bomb techniques. Originally, the aerial camera shutter was opened when the bomb was dropped and was closed manually after the flash had occurred. In his experiments Goddard used bombs in small gliders and parachute-suspended flash bombs of about 40 lb weight. He made a photograph of the Eastman Kodak Tower, Rochester, New York in November, 1925 with a bomb that exploded over the lake. An important advance was made in the middle of 1926 when Goddard invented an automatic light-actuated camera shutter. He used a photoelectric system to actuate the shutter from the light of the flash bomb.

In spite of apparent success, the flash-bomb method of night photography had several disadvantages. The flash bomb is dangerous because the powder is easily ignited. The number of reconnaissance photographs that can be taken per flight is restricted by the limited number of bombs that can be carried. The plane can operate only at a given altitude because the time-delay fuses are adjusted before takeoff to be dropped from a predetermined altitude. If there is a cloud layer between the plane and the target, the pilot cannot complete his assignment by flying lower because of limitations imposed by the preset fuses. The flash bomb, with its noise and light,

may create the impression of a bombing attack on the target. This is objectionable in cases in which civilian tension may be high.

The electronic-flash system overcomes some of these difficulties since the equipment is not explosive, the number of photographs that can be taken is almost limitless, and the plane carries its own light source which is quiet and can operate at any altitude. However, these desirable features are not achieved without some disadvantages. For example, since the camera and flashtube are closely spaced, photographs made with the electronic-flash system do not have shadows which are helpful for identifying and indicating the heights of objects. Furthermore, the back-scattered light from the source causes fog on the film which reduces the contrast. This is especially true when the camera and flashtubes are close together as most installations tend to be because of aircraft construction. Another factor is the weight of the flash equipment which increases as the square of the altitude at which photographs are to be made. This must necessarily establish an ultimate altitude limit for the electronic-flash system. Finally, the electrical power requirements for electronic-flash photography equipment impose a substantial load on the electrical system of the plane when continuous photo cover of a strip is required from a fast-moving aircraft.

At first thought, the two systems of night photography might be regarded as competitive. It is more accurate to say that they complement each other. Under tactical conditions it was found that one or the other was better suited to photograph a given mission. A totally effective night squadron needs both systems and must be able to switch from one to the other at a moment's notice. The need for both systems was dramatically demonstrated during the invasion of Normandy, June 6, 1944.

On the night of D-Day there was a cloud layer at an elevation of 3,000 ft over all the German-controlled French area to be photographed. Therefore, airplanes equipped with flash bombs were not able to accomplish their missions. A plane with an electronic-flash unit was able to go below the clouds and photograph target objectives even though the area photographed was not as wide as that which would have been obtained by the flash-bomb method. Lt. Edward Lentcher, a pilot of the 155th Night Photo Squadron, found clouds as low as 800 ft. He banked his plane opposite the targets to get additional oblique coverage and returned with photographs which were of considerable tactical importance and which could not have been made by flash-bomb technique.

Early Development Work

When Major Goddard approached M.I.T., he wished to take photographs from an altitude of a mile or more and asked what help we might be able to provide. A few rough calculations with the inverse square law of light distribution, using the known exposure and weight data for equipment that was modern in 1939, quickly showed that apparatus required to make night photographs at the height of one mile would weigh several tons. Furthermore, the flashtube would need to be many hundredfold more powerful than any tube whose construction or design had then been attempted. Our knowledge then indicated that the required kind of flashtube could probably be built, but there was also a good probability that the tube would explode during its first and only operation from the intense heat and high pressure that would develop when the flash occurred. Even an optimist couldn't feel too encouraged about the prospect of success.

For one concerned with flying, Goddard was completely unimpressed by the very considerable weight of the proposed nocturnal photoflash equipment. He knew that the new airplanes, then on the drawing board, would have no difficulty in carrying such heavy equipment; and he offered encouragement and inspiration in the face of other obstacles. Before he left Cambridge, he had committed us to work on the problem and promised that an official request would come through from the Air Force at Dayton, Ohio. Thus started a chain of developmental work which continued until the end of hostilities in August, 1945. By the end of the war, six distinct types of flash photographic units had been perfected for the U. S. Army and Navy and had seen service on nearly all fronts. Figure 12-16 shows an A-26 airplane (1945) with a xenon flash unit in the tail. The intense beam is visible because of the scatter from dust particles in the air.

Early Tests of Electronic-flash Equipment

The first experimental electronic-flash unit for night aerial photography was given its initial trial in the A-18 Army Air Force bomber in April, 1941, over Boston with a camera in a companion airplane. A phototube was used for synchronization. This early equipment was normally operated at an altitude of about 2,000 ft, and with a camera covering a 40° cone, a region of land 1,500 feet square could be photographed. With such photographs, buildings, roads, automobiles, and other objects could be easily distinguished and identified in night photographs.

The experimental equipment then was sent to Wright Field to undergo further exhaustive tests to demonstrate its practical utility. On the basis of this preliminary work, a larger and more comprehensive flash unit was designed to fit the B-24 and B-25 airplanes

Fig. 12-16 *A-26 aircraft with the xenon flash at the tail. Camera was in the nose, providing the greatest possible separation of the two in order to minimize back scatter of light. The object on the bottom is a precision X-band radar which enables pilots to find their targets in the dark.*

which represented the latest available type of craft. As soon as the equipment was finished, it was flown to Dayton and in flight tests exceeded expectations of its performance.

It was during these tests that a first opportunity was provided for recognizing the rather unusual requirements of aerial night photography for military operations. Ordinarily, the military services depend on daylight aerial photographs to determine details of the terrain of enemy territory, the location of enemy troops, guns, and supply depots, and so on. Night aerial photography is employed primarily to provide intelligence reports of the enemy's operations under cover of darkness. Daylight photography is used to learn what force the enemy has; the role of night photography is to reveal how and where the enemy's force is being applied. For this purpose the primary target of night photography is motion, i.e., the movement of troops and equipment along highways, railroads, and waterways over as large an area as possible. So long as road traffic can be revealed in night photographs, excellence of photographic quality is much less

important than increased area of coverage. There is a tendency, therefore, to accept photographs which give the necessary intelligence, even though they may be of poor photographic quality if judged by more customary standards.

Today, night photography [38] has been improved tremendously by advances in flashtube design and in electrical circuits. Corresponding improvements in aircraft and in navigation methods have added to the usability of night photography. Several of the modern systems use "pods" that can be quickly attached to an aircraft to convert it to a night photographic aircraft. One such system is shown in Fig. 12-17. It would seem from this installation photo that the system of Fig. 12-17 would have a ceiling limited by back-scattering of light rather than basic exposure because of the proximity of the flash lamps and the camera. Every effort must be made to increase the camera-lamp spacing [41] if maximum quality is required. A two-aircraft system is best with the camera in one plane and the lamp in the other, but this is not considered because of night operational problems.

Fig. 12-17 *A three-lamp removable "pod" containing xenon flash lamps on the wing of a Navy Vigilante aircraft.*

Photographing the Desired Objective

Once the early experimental equipment for the B-24 and B-25 planes was perfected, the Army requested models for use in maneuvers. The results of army tests showed the photographic equipment to be satisfactory and capable of producing pictures well

suited to military needs. For a while, it seemed that the problem of aerial night photography had been solved. Soon, however, another problem arose. The photographs taken at night were seldom of the assigned subjects. Night navigation, rather than night photography, had become the important systems problem.

Even in familiar territory where towns were lighted, night pilots had great difficulty finding isolated crossroads and other important assigned locations of suspected troop activity. Over enemy territory, with towns blacked out, the probability of photographing a particular road intersection appeared to be virtually zero. For this reason the Army, which would be the primary user of the system for tactical reconnaissance, showed a lack of interest in further development.

It is now clear, of course, that several of the radar systems then being developed could have been extremely useful in solving the

Fig. 12-18 *Xenon flash system photograph of night traffic in a European town in 1944. The direction and quantity of travel can be determined.*

problem of night aerial navigation. In 1943, however, even those who were frantically busy with the development of radar techniques and systems did not appreciate the full usefulness and capabilities of radar. Also, the secrecy which surrounded the subject at that time

Fig. 12-19 *Night photograph of a river crossing taken in Burma during World War II. The bridge is gone and two trucks are visible on the left bank waiting for an improvised ferry to take them across the river.*

Fig. 12-20 *Night photo of M.I.T. taken in 1945 from a B-17 at an altitude of one mile. Note exhibition tents in the main court.*

made it practically impossible for those not included in the "inner circle" to learn what was going on or to take advantage of radar techniques.

Ultimately some of the developments of radio navigation and radar provided the means for precise night navigation which enabled night photographic reconnaissance to play its full part in tactical operations toward the close of the war. This was particularly true of the Gee system of radio navigation which was developed in England between 1936 and 1939, was in operation by 1941, and was a standard method of navigation for British and American air forces from the autumn of 1943 until the end of the war in Europe.

Close support night aerial photography at the end of World War II was successfully accomplished by a tracking radar system (SCR 584) that indicated on a chart the exact position of the aircraft. The radar dish was mounted on the top of a truck so that it could be quickly moved to any desired location, preferably on a hill. The truck contained a plotting board with a mechanism to show the location of the aircraft. A radio link was used to instruct the pilot where to fly in order to find the target. He was also informed when to start the camera so that a photograph of the target would be produced.

X-band-type radar on the aircraft can be used to find some targets, such as lakes, shore lines, or bridges.

Figure 12-18 is a night photograph of a convoy of trucks and cars in a European town in 1944. One of the most important uses of night photography was to detect traffic at night (Fig. 12-19).

A night photo of M.I.T. taken from a B-17 aircraft is shown in Fig. 12-20 (November, 1945). Two FT-617 flash lamps each operated from 40,000 watt-sec were used for illumination.

C. BEACONS, LIGHTHOUSES, BUOYS, AND SIGNALS

A flash lamp has the remarkable ability of attracting the attention [42-49] of an observer. The intense short flashes of blue-white light from the xenon lamp are especially effective at an angle to the eye axis. Thus, one of the most important uses of the xenon flash lamp is as a beacon or a signal lamp. In addition the lamp is very efficient and can be designed with a very long life.

The electroencephalograph method of observing the voltages appearing in the brain has long used strobe lamps to shine onto the eyes of patients. Frequency and intensity variations are then used, and the response is observed.

Satellite Strobes

The first electronic flash system to operate from a satellite upon command from earth is on the ANNA [50, 51] satellite. The purpose of this optical beacon is to provide a reference point in both time and space for geodetic observations from widely spaced earth-based cameras. By comparing photographs of a flash sequence taken from various points on the earth's surface, the earth's form and intercontinental distances may be more accurately determined. The five-flash sequence from the ANNA beacon is photographed in orbit at an altitude of about 600 miles. The camera-satellite slant range is 850 miles.

The first attempt to orbit such a satellite was unsuccessful. ANNA 1A splashed into the ocean off Florida, a victim of a malfunction in one of the rocket stages. The successful ANNA 1B was put into orbit October, 1962 and is still orbiting (1969) ready to give forth a five-flash sequence upon command from an earth radio signal. Officially, however, she is "space junk" since the specific program for which she was designed has been completed.

The basic ANNA design consisted of two parallel flashtubes operating at about 900 volts from an electrolytic capacitor bank capable of storing 1,100 watt-sec of energy. The dual flashtube system provided the necessary redundancy which guarded against the failure of one of the tubes. Each linear flashtube was backed up by a flat plate reflector. The power supply was battery operated, and solar cells recharged the nickel-cadmium batteries between operations while the satellite was illuminated by the sun. The interval between flashes was 5.6 sec.

GEOS is the improved "next generation" geodesy satellite, carrying an electronic flash system based on the ANNA design concept. GEOS has a more sophisticated optical system than ANNA: instead of putting out light more or less evenly in the direction of the earth, it puts four times as much light towards the earth's horizon as it does straight down. The vertical output is 2,000 CPS per flash assembly, and the output at 45° off-axis is 8,000 CPS per assembly. This beam pattern is provided by a helical flashtube in a modified parabola reflector, and the result is that viewing and photography of the satellite is permissible at larger angles where the slant and range atmospheric extinction is greater than it is vertically.

Four flash assemblies are used on each GEOS satellite, each one providing 450 watt-sec of energy per flash every 4 sec. A sequencer coordinates the flash assemblies with each other to provide the

desired total optical output. Power input to each flash assembly during operation is 160 watts, and five consecutive flash sequences of five flashes each may be programmed before a cooling period is required. GEOS was put into orbit in September, 1966.

Fig. 12-21 *Photograph taken in space of a Gemini satellite during docking experiments in 1966. Two strobe beacons are visible from the sides of the light-colored section. Sightings at 20 to 40 miles were experienced.*

Another space use of a xenon flash unit is the Agena Acquisition Beacon from which bright blue-white flashes enable astronauts to locate the particular satellite vehicle being sought. The Agena unit operates from a 24-volt battery and uses 15 watt-sec of stored energy at 55 flashes per min. The optical output is 60 BCPS minimum which appears brighter than a third-magnitude star at a 20-mile distance. The oral reports of astronauts as they maneuver to a target in space contain many comments about the strobe Agena lights. The blue-white flashes must be a welcome sight when a target vehicle is sought in the blackness of space. Similar units are being placed on the Apollo capsules. Figure 12-21 shows the two strobe lamps on the Gemini capsule.

Aircraft Anticollision Beacons

A xenon flashtube, when flashed two times per second, is a very effective anticollision beacon when mounted on the nose, wings, and tail of a rapidly flying aircraft. Now (in 1969) many of the airplanes coming into Boston have strobe beacons on their wings in addition to the conventional tungsten lamp with a rotating mirror. There is a good possibility that the xenon system will be used to a greater extent in the future as an eye-catcher type of flash since it does attract attention and is easily distinguished from other lights [53].

Runway Approach Lights

Most airports in the United States are equipped with chains of xenon flashtubes in specular reflectors along the approaches to runways. In bad weather these units are flashed in sequence, starting from the furthest to the nearest. A pilot sees a wave of light that goes toward the runway. It is a very effective system of indicating direction to a pilot who must feel his way to the runway in a haze.

The first of these wave light installations was made by the Sylvania Company and installed at the Newark, New Jersey airport in 1947

Fig. 12-22 *First strobe runway approach lighting system at the Newark, New Jersey airport. The lamps are flashed in sequence starting with the one furthest from the runway.*

(Fig. 12-22). For many years this was the only set in operation. Aircraft pilots often would request permission to land at Newark in bad weather since they knew the xenon wave beacon would help them find the beginning of the runway. These systems are now

commonly called "wave beacons" or "zip lights," and they are popular with pilots in bad weather.

Aids to Navigation, Airport Beacons, Lighthouses

Xenon flash beacons for airports were used by the U. S. Air Force during World War II. The characteristic blue flash of the xenon lamp was utilized to distinguish it from the myriad of other lights in a community. One of these strobe beacons was in service at the Bedford, Mass. airport near Boston. I used it many nights to return to Bedford airport after making experiments with aerial night photographic equipment during World War II. Single strobe lamps are often used at the front of an approach to help the pilot identify which runway is in use.

A conventional lighthouse optical system, using a tungsten light source is designed around a large optical system that makes a beam of small angle. The optics are then rotated to produce a revolving beam. A xenon flash lamp substituted in such an optical arrangement is not practical at the present time since xenon flash lamps of small size have short life under high-power conditions. The rotational feature of the mechanism is a needless requirement with a pulsed light source.

The long-life linear xenon flash lamp permits a new lighthouse design which involves no rotational features. Instead, trough reflectors which produce narrow vertical beams and wide-spread horizontal beams are used. Three such reflector-lamp assemblies are mounted at $120°$ angles to give a circular coverage of $360°$ for each flash. The xenon gas that produces the light from the electrical discharge from the capacitor is not changed during the life of the lamp. Secondary effects at the electrodes and the walls of the lamp cause the lamp to darken, affecting its efficiency, or cause the lamp to become a hard starter or a self-starter. A lamp of large size for a given amount of energy will have a very long life. In fact, the lamps will be changed periodically during service and cleaning rather than for sudden failure. In contrast, the tungsten lamp reaches the burnout point and stops abruptly when the filament opens.

Xenon flash systems with large flash lamps of long life were considered for use in lighthouses as early as 1960 when the first experiments were run. The first extended test operation of such a lamp by the U. S. Coast Guard in an operational lighthouse was made in 1964 at Graves Light, which marks one of the entrances to Boston

Harbor. The lamp was used without the aid of optics. The FX-80 xenon lamp has a 1.5-cm ID and is about 120 cm in length. This installation demonstrated the feasibility of using xenon flash systems as the source of illumination in such locations. Lt. Comdr. C.J. Glass [52] (U. S. Coast Guard) in a report about the tests of the xenon flash lamp at Graves Light says in part, "It appears that the use of existent xenon flash tubes permits higher effective intensities and longer lamp life than can be obtained using incandescent lamps."

As a result of this report, the U. S. Coast Guard installed the first giant xenon flash lighthouse system in 1966 on a tower at Cape Henry at the mouth of Chesapeake Bay. The light was designed to utilize the inherent advantages of xenon flash and, as such, was a radical departure from the conventional rotating beacon lighthouse. The strobe beam illuminates the full 360° horizon with each flash and concentrates the light vertically in a 2° beam. The maximum optical output is over 1 million CPS which, with its flashing characteristic, is as effective visually as a continuous 5-million-CP source [44]. The accompanying photography (Fig. 12-23) shows the beam with its two duplicate lamp systems as it was being tested in

Fig. 12-23 *Cape Henry Lighthouse lamp during shakedown tests before installation.*

Fig. 12-24 *Ambrose Light Tower put into service August 23, 1967. There are six FX-80 xenon flash lamps (2,000 watt-sec each) mounted in 2° reflectors.*

Boston prior to installation. Each individual lamp may be operated at any of four energies ranging from 500 to 2,000 joules, depending upon the weather conditions prevailing at the time. The lower energies are used on clear nights because the lamps are actually too bright under these conditions. A second strobe lighthouse system was put into operation at Ambrose Light Tower at the entrance to New York Harbor on August 23, 1967 (Fig. 12-24). The equipment replaced the well-known Ambrose Light Ship which had guided ships for many years into New York Harbor.

Xenon systems are also being considered for use in the smaller flashing buoys used as channel markers. The U. S. Coast Guard is presently evaluating several units in Ambrose Channel and collecting data from visual observations by shipping interests.

Balloon-borne Beacon

A xenon flash system has been designed for use on experimental high-altitude balloons to be used for tracking, mapping, surveying,

and other optical experiments. The resulting system is completely self-contained in a 9½-lb package and provides 500 or more flashes of 125 watt-sec each on its self-contained battery. Operating at altitudes of up to 85,000 ft, the beacon may be tracked visually at slant ranges of up to 30 nautical miles and photographically at slant ranges up to 100 nautical miles.

D. LASER STIMULATORS

A xenon flash lamp used by Maiman [54] at the Hughes Research Laboratory in 1960 started a surge of research in stimulated radiation of crystals. As this is being written eight years later, the field is still very active and still full of promise, as stated in the recent review paper by Kiss and Pressley [55].

A recently published book by Elion [56] not only reviews the many types of lasers but also discusses at length their applications. The book also contains an extensive bibliography.

Maiman used quartz spiral lamps to surround the ruby crystals for his first experiments. Several xenon flash lamps of the spiral type were available in 1960. One of these was the FT-506 (GE Co.) rated 1,000 watt-sec at 900 volts. Maiman reports the threshold was 700 watt-sec, but the lamp was often flashed with 1,500 watt-sec to obtain greater output. The life of the lamp was short because of this

Fig. 12-25 *Ruby rod surrounded by a quartz spiral from an FT-506 flash lamp.*

overload. Figure 12-25 shows an FT-506 flash lamp with ruby and container.

Another spiral flash lamp used for optical stimulation (FT-524, GE Co.) was originally designed at M.I.T. during 1940–1943 and used

as a light source for low-level aerial photography. The flash lamp permitted evaluation photos to be made during night bombing attacks on submarines which had surfaced to charge their storage batteries. The normal method of operation involved a series of approximately ten photographs taken at a flash rate of about two per second from an altitude of 200 ft above the water with 100 watt-sec per flash.

Maiman used the quartz spiral from the FT-524 lamp after it was removed from its regular base so that a ruby rod could be mounted in the center of the spiral in a manner similar to the use of the FT-506.

In his early experiments Maiman [54] pulsed the FT-524 flash lamp with 200 watt-sec of energy. The intense radiation from the xenon gas was absorbed by the ruby crystal at the center. A cylindrical reflector was used as a cover for the entire unit, as shown in the exploded view of Fig. 12-26. The ends of the ruby rod were parallel, polished, and coated as a mirror. In this way radiation could be internally reflected from the ends, making possible the buildup of energy in an internal wave once the absorbed energy of the impurity centers in the crystals had reached the condition for inversion. One of the mirrors was semitransparent so that about 10 percent of the incident radiation would escape. A series of short pulses of coherent

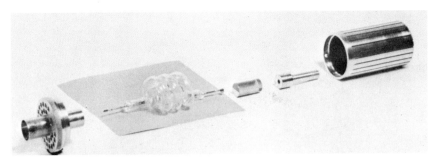

Fig. 12-26 *An expanded view of the 1960 Maiman-type laser. The case at the right serves as mirror and cover.*

red light of about 6944Å was created when the xenon lamp was flashed.

Many of the laser systems today use a linear flash lamp or lamps [57, 58]. Figure 12-27 shows sketches of the cross sections of six systems. The approximate threshold energy before stimulated radia-

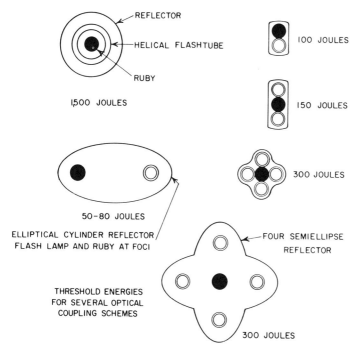

REFLECTOR

HELICAL FLASHTUBE

RUBY

1,500 JOULES

100 JOULES

150 JOULES

300 JOULES

50-80 JOULES

ELLIPTICAL CYLINDER REFLECTOR
FLASH LAMP AND RUBY AT FOCI

FOUR SEMIELLIPSE
REFLECTOR

THRESHOLD ENERGIES
FOR SEVERAL OPTICAL
COUPLING SCHEMES

300 JOULES

Fig. 12-27 *Six types of optical stimulators using linear flash lamps to excite ruby crystals.*

tion is created is indicated for each type of excitation. Note that the elliptical system seems to be the most efficient of those shown.

Another lamp-reflector laser system utilizes a short flash lamp at the axial center of a parabolic reflector that images all of the light output onto a ruby rod at the focus of an opposing parabolic reflector. Provision for the output is made through a hole in the center of the second reflector.

A special xenon flash lamp with electrodes in right-angle arms is shown in Fig. 12-28. Such a configuration is a convenience for the electrical leads since the connections are removed from the optical path of the ruby crystal. Two lamps and a ruby crystal (cross-hatched) are shown in Fig. 12-29 together with the capacitor and the charging circuit. Degreased aluminum foil is wrapped around the lamps and the crystal to act as a reflector of light. Carbon will be formed by radiation from any oil or grease on the aluminum foil, and this carbon will reduce the radiation received at the crystal. The threshold energy to cause stimulated energy will thereby be raised.

Figures 12-30 and 12-31 show some of the xenon flash lamps (EG&G, Inc.) that are used in laser stimulators. Most of these lamps

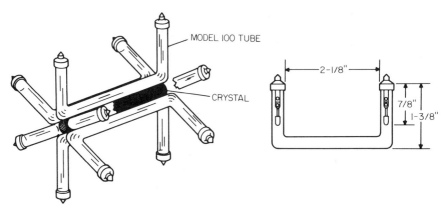

Fig. 12-28 *Xenon flash lamp designed as a laser stimulator. Four lamps are shown in contact with a ruby crystal.*

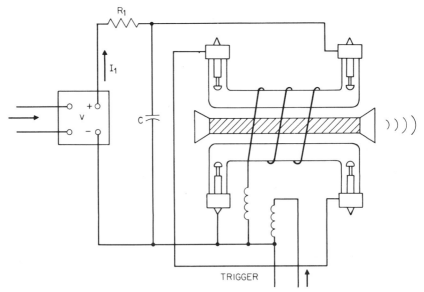

Fig. 12-29 *Two xenon flash lamps in contact with a ruby crystal to produce coherent radiation. Aluminum foil around the assembly reflects radiation toward the ruby.*

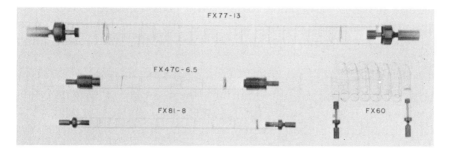

Fig. 12-30 *Xenon-filled quartz flash lamps (EG&G, Inc.) used for laser stimulation:*
FX77-13 rated 2,500 watt-sec at 3.5-msec flash duration
FX47C-6.5 rated 4,000 watt-sec at 1.4-msec flash duration
FX81-8 rated 6,000 watt-sec at 3.8-msec flash duration
FX-60 rated 9,000 watt-sec at 2.0-msec flash duration

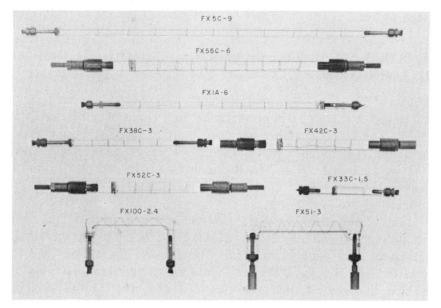

Fig. 12-31 *Typical linear xenon quartz flash lamps (EG&G, Inc.):*
FX5C-9 rated 600 watt-sec at 0.3-msec flash duration
FX55C-6 rated 2,000 watt-sec at 1.0-msec flash duration
FX1A-6 rated 400 watt-sec at 0.25-msec flash duration
FX38C-3 rated 400 watt-sec at 1.0-msec flash duration
FX42C-3 rated 600 watt-sec at 1.0-msec flash duration
FX52C-3 rated 600 watt-sec at 1.0-msec flash duration
FX33C-1.5 rated 100 watt-sec at 0.35-msec flash duration
FX100-2.4 rated 100 watt-sec at 0.08-msec flash duration
FX51-3 rated 600 watt-sec at 1.0-msec flash duration

require a series inductance to limit the peak current. If this is not done, the lamp may explode because of the thermal and mechanical stresses set up by the high currents. Data on life and blowup limits are given in [59].

The review paper by Kiss and Pressley [55] lists the many laser host materials and dopants that have been studied. Pulsed pumping systems, such as the xenon flash system, are discussed on page 1482. Of great interest is the Q switching system which releases the stored energy in a crystal suddenly to create a giant pulse of great intensity. The 94 references in [55] and the predictions of the last paragraph point to future developments.

DeMaria et al. [60] discuss the subject of ultrashort pulses of light from a laser source. They say in their summary, "Experimental techniques are now available for the generation of repetitive and single coherent optical pulses of extremely short duration and high peak power." A list of 38 references is given at the end of this paper.

E. CLOUD AND BUBBLE CHAMBER ILLUMINATION

Wilson [63] used a heated mercury vapor lamp, excited by a capacitor discharge, to photograph his first cloud chamber tracks in 1911. The cloud chamber has been built in many sizes and types since the first model. One of the largest was made by Bridge [64] and used extensively on Mt. Evans in Colorado and also in South America. Special long linear xenon lamps mounted in cylindrical reflectors were used.

Many cloud chambers have used the xenon electronic flash lamp to photograph [66-69] the tracks. Likewise, liquid hydrogen bubble chambers and those with similar liquids use the xenon flash as described by Bradner [70]. It should be emphasized that a liquid bubble chamber requires a shorter flash of light [71] than a cloud chamber since the bubbles grow much faster than the droplets. Pless and Plano [71] state that a 2-μsec exposure is required, indicating that a longer exposure will result in a loss of detail due to motion.

FX-26 flash lamps (EG&G, Inc.) were used to illuminate the 72-in. single-window-type hydrogen bubble chamber at the University of California, Berkeley. The flash lamp was imaged through a lens into the liquid hydrogen against a special curved reflector area composed of linear prisms called "coat hangers." Actually, three lamps were

used (Fig. 12-32). A bank of capacitors (512 μF) was used on each lamp and charged to 500 volts although some photographs have been taken on Plus X film with 1,000 volts. The ozone created by the ultraviolet light and the spark voltage was found to be objectionable in the hydrogen chamber. The use of a pressurized nitrogen atmosphere around the lamp overcame this problem. A sample photograph of ionization tracks in liquid hydrogen is shown in Fig. 12-34. The 72-in. chamber described above has been moved from Berkeley to Stanford and is in use there.

An alternative design for the single-window cloud chamber has been developed by Sukiennicki and Barney [72] at Stanford for the SLAC system that is to be used with the large linear accelerator. A Scotchlite screen is glued on a curved surface that is emersed in the liquid hydrogen. A previous design is given by Powell, et al. [73].

Fig. 12-32 *Three powerful flash lamps (EG&G type FX-26) flashed in synchronization to illuminate bubbles in a 72-in. chamber at the Lawrence Radiation Laboratory, Berkeley, California.*

Fig. 12-34 *Example of a hydrogen bubble chamber photograph of tracks left by moving particles in a magnetic field. (Stanford University.)*

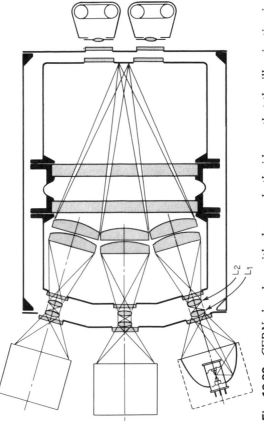

Fig. 12-33 *CERN chamber with glass on both sides so that the illumination is a straight-through system. Scattered light from the bubbles is imaged by the two cameras.*

Früngel, Kohler, and Reinhard [74] have described the electronic flash illumination system for the CERN (Geneva, Switzerland) 2-meter hydrogen bubble chamber. An argon high-pressure gap (1 to 3 atm) of a demountable type is used with 140 μF, at 3.5 to 5 kV. A series triggering system is used which eliminates the third electrode. Three of these argon gap lamps are used in an optical system (Fig. 12-33).

The repetition rate is 1 to 3 sec between flashes. Life is given as 40,000 flashes (to 60 percent light). Then the lamp is demounted for cleaning and adjustment. New electrodes can be installed although the rated life of the electrodes is 10^5 flashes. The electrode diameter is 14 mm and the gap is 14 mm.

The bubble chamber has proven to be a most valuable instrument for probing into nuclear reactions. New and larger chambers are currently being designed. As an example, the Argonne National Laboratory is working on a 12-ft chamber design.

F. SENSITOMETER WITH XENON LAMP

Xenon Flash Lamp Sensitometer

The xenon flash lamp is excellent as a light source for the sensitometer [78], an instrument which measures the exposure characteristics of photographic materials. Such an instrument with several flash conditions of intensity and flash duration is of great help in testing films for high-speed photography. As is well known, the darkening of a film is not only a function of the incident exposure on the film but also of the duration of the light. "Reciprocity failure" is the term for this effect.

The sensitometer is also widely used to expose strips of film through a stepped grey scale so that the film can be checked. For example, if one goes to a distant tropical island to do research, he can check to see if the film has been affected by the humidity, by the heat, or by radiation. There are examples where film has been shipped and stored near radioactive materials, resulting in badly fogged films of no value.

Those who handle continuously operating processing machines for developing films find that a standard exposed sample made in a sensitometer gives them a check on the overall processing system.

A photograph of a flash sensitometer is shown in Fig. 12-35. A hinged cover is placed over the strip of film that is to be exposed. Figure 12-36 shows a cutaway view of the xenon flash lamp at the

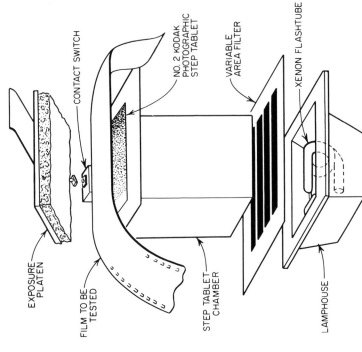

Fig. 12-36 *Xenon sensitometer for testing paper and film for photographic ability.*

EXPOSURE PLATEN

CONTACT SWITCH

FILM TO BE TESTED

NO. 2 KODAK PHOTOGRAPHIC STEP TABLET

VARIABLE AREA FILTER

STEP TABLET CHAMBER

XENON FLASHTUBE

LAMPHOUSE

Fig. 12-35 *Photograph of sensitometer which exposes film with xenon flash lamplight and has either a 10^{-2}, 10^{-3}, or 10^{-4} sec exposure time.*

bottom. A variable-area filter is located near the flash lamp and a graded strip is required to make a series of exposures at one time. The xenon lamp flashes when the hinged cover pushes the film against the graded strip. There is an audible "click" when the microswitch closes.

The electrical conditions for the three flashes are shown below. Push-button switching changes the capacitance and a series resistance to produce the desired duration.

Scale	C	Series R
1/10,000 sec	10 μF paper	0 ohms
1/1,000 sec	250 μF electrolytic	2 ohms
1/100 sec	500 μF electrolytic	25 ohms

A 155-μH inductor is used in series with the lamp on the 1/10,000-sec scale.

G. ELAPSED-TIME MOTION PICTURES

The electronic flash lamp offers economy of lighting and often great convenience for elapsed-time equipment. Also the heat on the subject is considerably less, especially on small subjects where closeup photographs are made. The electronic flash lighting can be made to exceed the exposure due to normal lighting. Also, bothersome moving shadows from daylight exposure can be eliminated or made so dim that they are not noticed.

The light per flash must be constant, otherwise the exposure of the frames will flicker or fade. Dry-battery operation is influenced by this voltage regulation effect if the batteries are marginal in capacity. One solution for the regulation problem is to use a regulating circuit to stop the charging of the capacitor at the desired voltage, such as 450 volts, from a higher-voltage battery. In a typical circuit a 625-volt battery is used to charge a 450-volt electrolytic capacitor with a relay that opens the charging circuit at 450 volts and holds it near that voltage by intermittent action.

An elapsed-time camera for studying biology and geology subjects underwater has been used for observing the motions of starfish, sea urchins, sand dollars, the tidal flow of water, and the tidal effects on sand and sediments. The camera is in the 6-in. plastic tube at the bottom of Fig. 12-37. It is a Flight Research No. 3B, pulsed 16-mm

camera of the 50-ft-magazine type. A 24-volt dry battery is used for power to operate the clutch, the shutter, and the wind-up motor. The exposure time is about 1/50 sec with the "full shutter" essential for the strobe light. The film must be completely uncovered when

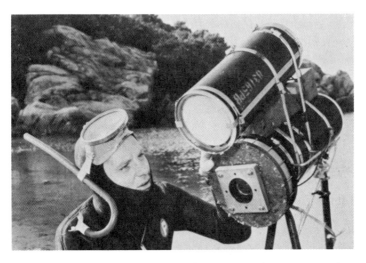

Fig. 12-37 *Dr. Kenneth Read with a motion-picture camera in a water tight case (lower) for elapsed time operation. Flash lamp is in upper case.*

the flash occurs. A narrow shutter slit cannot be used since only a part of the frame would be exposed when the flash occurs. The elapsed-time camera and strobe unit have been used by Dr. Kenneth Read (Boston University) to photograph sand dollars on the sea bottom. He has also taken elapsed-time motion pictures at two per minute of starfish and sea urchins. Single frames often reveal crabs, lobsters, flounders, skates, and other animals. The photographs show the ebb and tide of the sea water with the cycle of flow. The clarity of the water varies depending upon the tide and wind cycle. Complete details of the circuits will be published in the Transactions of the Seventh International Congress on High-Speed Photography, Stockholm, Sweden, 1968.

Microscope

Elapsed-time motion pictures taken through a microscope are known to be a very powerful research tool for studying the growth and development of all sorts of slowly changing biological subjects.

Electronic flash has not been extensively used in this application since visual checking by the operator is not possible when the flash is off. An auxiliary lamp can be used as shown in Sec. 12-I. A tungsten lamp, either close or optically coupled, can be used to supply a beam of light of about the same character as the flash lamp beam. Because of the technical advantages that are offered, further applications of electronic flash are expected in all sorts of elapsed-time photography, especially those taken through the microscope.

H. COPY TECHNIQUES

The short exposure and color temperature of the electronic flash lamp have been useful for many photographic tasks in copying and in enlarging. One of the first uses was the exposure of newspaper microfilm copy. It seems that a large newspaper page after turning traps some air. As this air gradually escapes under the paper, the paper moves ever so slowly. A blurred negative of the printing will certainly result if the camera shutter is operated too quickly after the page is turned. Electronic flash illumination overcomes the small slow-motion problem in the copy since the exposure is very short. The contrast of microfilm negative is very high, and therefore the output of the flash unit for each flash must be constant. A voltage regulation system is desirable to obtain this constant output per flash. The copy must also be illuminated uniformly.

One useful copy device produces a black-and-white print from a 35-mm color slide by the use of a small xenon flash lamp and a Polaroid camera. The enlargement is set by the sizes of the slide and the Polaroid print. A photograph of one such copy unit is shown in Fig. 12-38. Provision is made to adjust the output of the flash lamp by the use of a variable series resistor. Thus compensation can be made for dark or light slides. Extra-dark slides can be given several flashes of light if required. The black-and-white copier has proven to be most useful in an editorial office since the copies can be made immediately from color slides.

The first slide copier was made for my wife so that she could make black-and-white copies of slides of our grandchildren to be sent to relatives. The second was sent to the National Geographic Society's photographic department so that editorial copies could be made quickly. Although they are not commercially available at the present time, the Polaroid Company has distributed a thousand slide copiers

Fig. 12-38 *Slide copier for producing a Polaroid black-and-white print from a 35-mm color slide.*

Fig. 12-39 *Honeywell Repronar copying equipment with xenon flash as light source. A 35-mm reflex camera is used.*

around the country. Many of these are still being used as sensitom-
eters by the Polaroid Company for the testing of their photographic
materials.

A slide copier for making 35-mm color slides into color prints on
Polaroid material may someday be made available. I feel that such an
item should find many uses.

A combined slide and transparency copier onto 35-mm color or
black-and-white negative materials is made by Honeywell, Inc. under
the name Repronar. Figure 12-39 shows this equipment in use. A
xenon flash lamp with two intensity settings is used for illumination
of daylight-type color film. A tungsten lamp is operated by a switch
on the panel when previewing and composition of the picture is
required. The camera can be adjusted for different enlargements. This
permits the cropping of a color slide so that only a portion is copied.
The camera is a reflex type which permits the operator to compose
and focus the picture. An exposure calculator is included to show the
operator the proper camera aperture for the magnification that is
selected.

I. SMALL SUBJECT PHOTOGRAPHY
(MICROSCOPE)

Photography of Small Subjects

Photography of small subjects is not usually convenient or
successful with conventional lighting equipment. This is because the
flash lamp and reflector are so large that they cannot be placed close
to the subject and still leave space for the camera.

Two optical solutions are possible. (1) The use of a concentrated
beam reflector or lens to project the image of the lamp onto the
subject from a distance. A conventional microscope illuminator is a
lamp of this type. Thus, a small concentrated spot of light can be
imaged on the subject from a distance. (2) The use of a small lamp
close to the subject. If the lamp itself can be made small in size with
a small reflector and placed close to the subject, there may be both
ample light on the subject and physical space for the camera.

An electronic flash driver power supply (EG&G, Inc. type LS-15)
with two optional lamp heads to provide the two above-mentioned
methods of illumination will now be described.

The power unit charges two 525-μF capacitors in series to 900
volts. When the capacitors are discharged into the flash lamp, 100
watt-sec of energy is converted into light in a short time. Two series

resistors are optional in the lamp discharge circuit to reduce the integrated light output to 50 and 25 percent of the amount without resistance. The series resistors also increase the flash duration. The flash lamp (EG&G FX-33) is of small size, 4-cm arc length with a 0.4-cm inside diameter. The lamp tubing is of quartz which is required to withstand the energy density.

The trigger tube in the power supply is a 2D21 thyratron with a heated cathode. This tube can be triggered easily from a positive pulse of less than a volt; therefore, the equipment is useful for photography where synchronization of the flash from microphones, electromagnetic pickups, or other small electrical signals is desired.

The main power output and the trigger circuit are available electrically at a six-prong, high-voltage plug so that almost any electronic flash lamp, such as a ring type, can be arranged for flashing by the use of suitable connections. Also, a 6-volt, 60-cycle source is available on two of the above terminals so that a focus lamp of the tungsten variety can be used for optical alignment and for illumination for camera lens adjustment.

Microscope Lamphouse

A standard microscope lamphouse has been adapted to the strobe lamp, retaining the tungsten lamp for alignment purposes. Since the two sources are not in exactly the same place, there is a difference in the distribution of the light output from the two sources. This is serious when high magnification with dark field and phase types of lighting are used. However, as one studies the setup problem, one can learn to use the system with success. Often a trial and error system shows one quickly what can and what cannot be achieved. For large subjects or for straight, bright field microscopy, the double light system described here is ample for the majority of the lighting problems that arise.

The tungsten lamp is a GE Co. No. 210 (6-volt type). It is placed as close as possible to the quartz flash lamp and behind it. Adjustment of the focus knob changes the displays of the spot on a piece of white paper. At one adjustment the image of the tungsten filament can be seen clearly. At another adjustment, the reflection of the tungsten lamp on the two walls of the flash lamp can be seen. From these tests, the experimenter knows where and how the image of the flash lamp will appear on the subject. The lamp image is a long spot depending upon the orientation of the lamp. The lamp is then flashed so that the operator can check the area and position of the spot of light that is to make the exposure.

Considerable variations are possible by defocusing the condenser lens. A circular spot of uniform intensity can be produced; however, the intensity will be reduced.

Examples: Bright field photographs of live paramecium were made by Dr. Charles Walcott [79] using the flash lamp that has just

Fig. 12-40 *Dr. Walcott exposing with flash and focusing with tungsten through a microscope.*

been described. The short-flash 100-watt-sec unit was of help in stopping the motion of the subject. Figure 12-40 shows Dr. Walcott taking the photographs, and Fig. 12-41 shows a sample of the paramecium pictures. The cilia are shown as though motionless.

Dr. Searle Rees [80] at the Diabetes Foundation, Clinical Research Laboratory, Brookline, Mass. and the author have used the above lighting system very successfully to photograph the blood circulation system in the conjunctiva. In the white of the eye, the arteries and veins are displayed below transparent layers so that photography is possible. A flash of short duration and high intensity is necessary in order to reveal details in the circulation.

Figure 12-42 shows a diagram of how the photographs are made. Note that Eastman type 5302 fine-grain positive film is used. This film is blue-sensitive which aids greatly in obtaining contrast in the details of the small veins and arteries (Figs. 12-43 and 12-44). Also

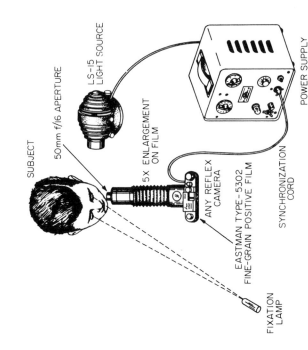

Fig. 12-41 *Live paramecium photographed using the arrangement in Fig. 12-40. The motion of the cilia are stopped by the flash.*

Fig. 12-42 *Arrangement for photographing blood circulation in the white of the eye.*

SUBJECT

50mm f/16 APERTURE

LS-15 LIGHT SOURCE

5× ENLARGEMENT ON FILM

ANY REFLEX CAMERA

EASTMAN TYPE-5302 FINE-GRAIN POSITIVE FILM

SYNCHRONIZATION CORD

POWER SUPPLY

FIXATION LAMP

Fig. 12-43 *Closeup photograph of blood circulation in the white of the eye of a healthy person.*

Fig. 12-44 *Closeup photograph of the blood flow system of an un-healthy person.*

observe that the strobe flash is brought up to the eye from the side so that the blood cells are actually transilluminated from the light-colored tissues behind the capillaries.

Bare Lamp Illumination

The FX-33 flash lamp has also been mounted in a heavy-wall test tube so that it can be used very close to a subject. The assembly is shown in Fig. 12-45. Note that the lamp has an aluminum reflector attached to its surface to direct the light forward. Also, the lamp is placed very close to the wall of the test tube so that the lamp can be placed very close to the subject to be photographed. This combination of lamp and circuit is waterproof and has been used for photographing underwater subjects in small aquariums.

Combination Lamp for Flash and Continuous Use

The microscope illuminator described in the previous section has an obvious defect which was mentioned. The tungsten lamp for visual viewing and the xenon flash lamp are at *different places* so the lighting of the subject will be different for each. The effect becomes more and more serious as the magnification is increased.

With special circuits, a xenon lamp can be operated continuously at 60 fps at low energy and then flashed by a large capacitor

Fig. 12-45 *The bare lamp, FX-33, in a heavy-walled glass tube for closeup photography.*

discharge at the desired moment. An air blower is necessary to keep the lamp cool. There are switches in the capacitor circuit which permit three conditions of excitation: 100, 200, and 300 watt-sec of electrolytic capacitors charged to 900 volts.

The key circuit element is the switching tube (mercury type or relay) which is triggered at the proper moment to switch the energy from the large capacitors into the flash lamp which is simultaneously being continuously pulsed by a small capacitor (either 0.5 or 1 μF at 900 volts) at 60 fps. Synchronization with a camera shutter results when the relay is closed. The flash lamp is an "end-on" type made by EG&G, Inc. (FX-19 or FX-24). The design is similar to the lamp designed by Warmholtz, et al. [81]. Donaldson [82] accomplishes the same result with a simple relay that parallels the large charged capacitor directly across the flash lamp.

Some optical difficulty is experienced with the 60-cycle operation since the xenon arc at low energy does not fill the flash lamp. Furthermore, the arc occurs at various places in the lamp. Thus, the image position is *not* the same as for each flash, and hence there may be considerable visual jitter due to the wandering of the arc position in the lamp.

Small Lamp with High Energy at a High Flash Rate

A light source of small size (about 5 cm long and 3 mm in diameter) has been developed by Dyonics, Inc. (71 Pine Street, Woburn, Mass.) especially for the photography of the fundus (inner back surface of the eye) at motion-picture rates. The lamp can be flashed with 100 watt-sec of energy at 30 cycles per second for a run of 1 min or less. The lamp can be operated continuously at 16 fps according to T. J. Van Iderstine, the designer of the equipment. He uses a resonant charging circuit and a series inductance in the lamp circuit to aid in the deionizing process.

A liquid cooling system involving a refrigeration system and a circulated liquid is required to remove the heat from the quartz flash lamp.

For fundus photography of the inner surface of the eye approximately 5 percent of the available light energy is collected in the optical system and directed through the pupil onto the fundus of the eye. The flashes produced are synchronized with a camera shutter to produce single or motion pictures of the eye. At a reduced output and a 60-fps rate the unit may be utilized to produce television images directly on a monitor or for video-tape recording. Figure 12-46 shows the above equipment being used to take photographs of the fundus of a pig.

The Chadwick-Helmuth Company (111 E. Railroad Avenue, Monrovia, California) has a small-source flash lamp (1 mm) which is

used for a narrow-beam stroboscope or for a microscope illuminator. The unit is called the "Point-Source Strobex."

Fig. 12-46 *A 100-watt-sec xenon lamp (Cineflash) arranged for taking photographs of the fundus of a pig.*

J. THE PHOTON PHOTOTYPESETTING MACHINE

The xenon flash lamp with its ultrashort pulse of intense radiation plus the precise timing control feature has made possible a line of phototypesetting and photocomposition machines by Photon, Inc., Wilmington, Mass. and Lumitype of Paris, France. Both organizations have recently joined forces under the name Photon. The inventors of the process are Louis Moyroud and René Higonnet, telephone engineers from France who came to the United States in 1948.

The heart of the Photon machine is a rapidly moving disc with a sequence of characters to be photographed (Fig. 12-47). A series of accurately placed slots are located on the edge so that precise firing of the xenon flash lamps will put an image of the desired character at the desired spot on the film. A photoelectric cell fires the flash lamp at the correct time when the proper slot is in line. The size of the resulting character on the copy is determined by the optical magnification.

Details of the instructions for a line of type are put into the machine, including the length of the line and the justification

information. The following is quoted from an article by Sidney J. Paine [92]:

The Photographic Unit

Now let us look at the photographic unit and see what happens after one line has been typed and the carriage return key pressed.

Inside the photographic unit to the rear of the operator is the glass matrix disc containing 16 fonts of type. This disc is revolving 8 times per second. To put type on film, a stroboscopic light flashes once per revolution each time projecting through a chosen character on the disc. The image of the character then goes through a chosen one of the 12 lenses in the lens turret which is in front of the disc. After the image has passed through the lens turret, it is reflected at 90° by a prism and is placed on film. This prism moves after each character is photographed the exact space required for the width of the character and justifying space, if any. Although the disc is revolving 8 times per second, the speed of the strobe flash is so great (about 4 millionths of a second) that it prevents any blur of the character on film.

The matrix disc of the Photon 200 machine rotates at 8 revolutions per second and carries all the characters in front of the window at that 8-per-second rate. The electronic flash lamp will

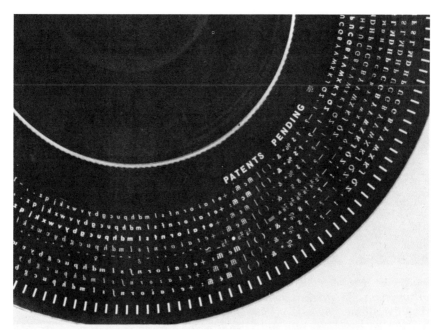

Fig. 12-47 *Portion of a disc containing 1,440 characters and timing slits.*

Fig. 12-48 *ZIP's 264-character typographic memory contained in three stationary 88-character matrix plates. Each character has its own high-powered xenon flashtube and is constantly ready to fire, which is the key to ZIP's great speed.*

Fig. 12-49 *Higonnet holds the flash module of the ZIP machine; Moyroud is above. Two hundred and sixty-four of these modules are assembled in a matrix behind characters for very rapid photosetting. The xenon flash lamp (FX-6A) is at the top of the module.*

operate when both the commutator and the photocell signal are in a "go" state. The position of the lens turret determines the size of the character of the film. Note the radial marks at the outer edge of the disc. These slots are used to obtain a precise timing pulse to start the xenon flash lamp.

The Photon ZIP is capable of much greater speed of action than the Photon 200 model. Note that 264 small xenon flash lamps are mounted in a matrix behind 264 characters (Fig. 12-48). All of these lamps are constantly ready to fire. A pair of parallel but opposing reflecting mirrors bring the flashed character to the right spot on the film.

The monthly bibliographical medical reference magazine, *Index Medicus* which is published by the National Library of Medicine (Department of Health, Education, and Welfare) was the first user of the ZIP machine. Since then, they have been used on numerous tasks where fast composition is necessary, such as telephone books, spare parts lists for automotive companies, etc.

Messrs. Moyroud and Higonnet are shown in Fig. 12-49 with one of the FX-6A special flash lamps and the electrical circuit that operates it. The ZIP machine is capable of 600 characters a second.

K. PHOTOCHROMIC GOGGLE SYSTEM

An optical filter which can be activated by ultraviolet light from a quartz flash lamp in less than 100 μsec is shown in Fig. 12-50. This device was developed to protect the eyes of a person who might be exposed to the light from a nuclear detonation. It is known that the exposure of the eye to an intense light source of this type can cause flash blindness and even retinal burns before the normal reflex of the eye can protect itself by blinking or by closing the iris.

The active material in the filter is a liquid containing a photochromic chemical, 2% solution of 5'-bromo-8'-methoxy-6'-nitro-1-phenyl-3,3-dimethylindolino benzopyrylospiran in toluene. Normally the liquid is clear but becomes dark when exposed to ultraviolet light. The liquid again becomes clear after a time delay determined by the chemicals and other conditions such as temperature.

The photochromic solution is confined in a layer only 0.0010 in. thick between two optically ground and polished quartz wedges. Xenon flashtubes positioned above and below the quartz wedge

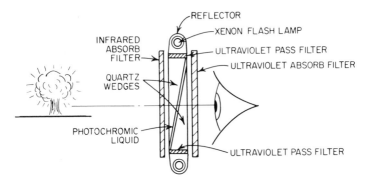

Fig. 12-50 *Protective eye filter with quartz xenon flash lamps and photochromic liquid.*

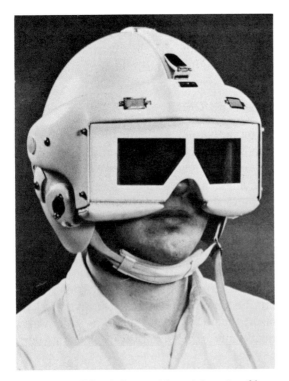

Fig. 12-51 *Pilot helmet with quick-acting filter for protection against flash blindness from nuclear explosions.*

system provide the ultraviolet activating energy. Special filters protect the eye from the visible light emitted by the flashtubes but transmit the ultraviolet energy to the photochromic material. The wedges distribute the ultraviolet light to the photochromic solution in a uniform manner so that the entire goggle area is colored to the same density.

The xenon flash lamps are flashed from a 600-joule capacitor at 3,500 volts with series gaps to control the starting moment as activated by a phototube or an electromagnetic signal or both.

In the open or clear state, the filter transmits 35 percent of the incident visible light. There is no optical distortion present. The transmission is 1 part in 3,000 after the photochromic material is activated. An automatic opening time of 2 sec can be arranged without any attention by the user of the filter.

Figure 12-51 shows the flash goggle in an aviator's helmet. A cable in the back attaches the equipment to a power pack which contains the capacitor and power supply. A pullout plug separates when the helmet is removed.

REFERENCES

1. Duntley, S. Q., Light in the sea, *J. Opt. Soc. Am.*, vol. 53, no. 2, pp. 214-233, February, 1963. (This is a review article with many references.)
2. Tyler, J. E., W. H. Richardson, and R. W. Holmes, Method for Obtaining the Optical Properties of Large Bodies of Water, *J. Geophys. Res.*, vol. 64, no. 6, pp. 667-673, June, 1959.
3. Preisendorfer, R. W., "Divergence of the Light Field in Optical Media," Ref. 58-41, p. 16, Scripps Institute of Oceanography, University of California, San Diego, 1957.
4. Ewing, M., A. Vine, and J. L. Worzel, Photography of the Ocean Bottom, *J. Opt. Soc. Am.*, vol. 36, no. 6, pp. 307-321, June, 1946.
5. Thorndike, E. N., Deep-Sea Cameras of the Lamont Observatory, *Deep-Sea Res.*, vol. 5, pp. 234-237, 1958.
6. Edgerton, H. E., and L. D. Hoadley, Cameras and Lights for Underwater Use, *J. SMPTE*, vol. 64, pp. 345-350, July, 1955.
7. Edgerton, H. E., and L. D. Hoadley, Protection for Underwater Instruments, *AIEE Trans.*, vol. 79, pt. 1, no. 52, pp. 689-694, January, 1961.
8. Edgerton, H. E., and L. D. Hoadley, Pressure Testing Facility, *Underwater Eng.*, vol. 2, no. 2, pp. 29-30, Mar.-Apr. 1, 1961.
9. Edgerton, H. E., Photographing the Sea's Dark Underworld, *National Geographic Magazine*, vol. 107, pp. 523-537, April, 1955.
10. Williams, J., E. R. F. Johnson, and A. C. Dyer, Water Transparency Observations along the East Coast of No. America, *Smithsonian Misc. Collection*, vol. 139, no. 10, pp. 1-181, Oct. 26, 1960.

11. Hopkins, R., and H. E. Edgerton, Lenses for Underwater Photography, *Deep-Sea Res.*, vol. 8, nos. 3 and 4, pp. 312-319, December, 1961.

12. Clark, G. L., and R. H. Backus, Light Penetration and Migration, *Deep-Sea Res.*, vol. 4, pp. 1-14, 1956.

13. "General Purpose Photographic Exposure Meters," USAS PH 2.12, United States of America Standards Institute, 1957.

14. "Speed of Photographic Negative Material," USAS PH 2.5, United States of America Standards Institute, 1960.

15. Sasaki, T., S. Watanabe, G. Oshibs, N. Okami, and M. Kajihara, On the Instrument for Measuring Angular Distribution of Underwater Radiance, *Bull. Japan. Soc. Sci. Fisheries,* vol. 28, no. 5, pp. 489-496, May, 1962.

16. Replogle, F. S., and I. B. Steiner, Resolution Measurements in Natural Walter, *J. Opt. Soc. Am.,* vol. 55, no. 9, pp. 1149-1151, September, 1965.

17. Mertens, L. E., Underwater Photography, *J. SMPTE*, vol. 75, pp. 983-988, October, 1966.

18. Greenberg, J., "Underwater Photography Simplified," Seahawk Press, Coral Gables, Fla., 1963.

19. Underwater Photography of the Deep Sea, in J. B. Hersey (ed.), "Deep-Sea Photography," (Oceanographic Studies No. 3), Johns Hopkins Press, Baltimore, 1968.

20. Brundage, W. L., and R. B. Patterson, Ocean Bottom Photography from a Deep Towed Camera System, *J. SPIE*, vol. 4, pp. 156-160, April-May, 1966.

21. Rebikoff, D. I., "Exploration Sous-Marine," B. Arthaud, Paris, 1952.

22. Schenck, H. V., and H. Kendall, "Underwater Photography," Cornell Maritime Press, Inc., Cambridge, Md., 1954.

23. Brooks, E. H., The World Under Water, *J. Phot. Soc. Am.*, vol. 23, no. 7, pp. 11-13, July, 1966.

24. Brooks, E. H., Underwater Photography, *The Prof. Photogr.*, vol. 93, no. 1954, pp. 48-51, 85, November, 1966.

25. Brooks, E. H., On Underwater Optics, SPIE Conference, Santa Barbara, California, October, 1966 (to be published).

26. Edgerton, H. E., A Handheld Underwater Camera, *Skin Diver*, December, 1963, pp. 54-55.

27. Edgerton, H. E., Underwater Slave, *Skin Diver*, August, 1964, pp. 40-42.

28. Harvey, E. N., and E. R. Baylor, Deep Sea Photography, *J. Marine Res. (Sears Found. Marine Res.),* vol. 7, no. 1, pp. 10-16, Apr. 15, 1948.

29. Moncrief, H. S., Historical Development in Underwater Photography, *J. Phot. Soc. Am.*, vol. 17, November, 1951.

30. Emery, K. O., Submarine Photography with the Benthography, *Scientific Monthly*, July, 1952.

31. Camera With Bait, *Machine Design,* p. 47 Dec. 8, 1966

32. Edgerton, H. E., Uses of Sonar in Oceanography, *Electronics*, June 24, 1960.

33. Edgerton, H. E., and J. Y. Cousteau, Underwater Camera Positioning by Sonar, *Rev. Sci. Instr.*, December, 1959.

34. Cousteau, J. Y. (with J. Dugan), "The Living Sea," Harper & Row, Publishers, New York, 1963.

35. Hopkins, R., D. Rebikoff, B. Littlehales, H. Edgerton, W. Swann, Ball, Bright, and Wakimoto, *Photogrammetric Engineering*, vol. 33, no. 8, August, 1967 (special issue on underwater photography).

36. Pflaum, J. V., L. Winkler, and W. McAdo, Report on Search for the *Thresher, Industrial Photography*, April, 1965.

37. Abstracted from *Technology Review*, vol. 49, no. 5, pp. 273-278, March, 1947 (with additions).

38. Gronberg, F., P. Swenson, A. White, and C. Warner, Xenon Flash as a Light Source for Night Aerial Photoreconnaissance, *SPSE News*, vol. 8, no. 6, November-December, 1965. (Also see *Report* No. B3055, EG&G, Inc., May 12, 1965.)

39. Edgerton, H. E., Airborne Photographic Equipment, *J. Phot. Soc. Am.*, vol. 13, pp. 439-440, July, 1947.

40. Gross, R. A., Reflector-Light Source Requirements for Homogeneous Format Illumination in Night Aerial Photography, *J. Appl. Opt.*, vol. 5, no. 4, p. 672, April, 1966.

41. Wyckoff, C., Camera-light Source Separation Effects in Night Aerial Photography, *Tech. Memo* B-147, EG&G, Inc., September, 1958.

42. Blondel, A., and J. Rey, Sur la perception des lumières brèves à la limite de leur portée, *J. Phys.*, ser. 5, vol. 1, p. 530, 1911.

43. Blondel, A., and J. Rey, Application aux signaux de la loi de perception des lumières brèves à la limite de leur portée, *J. Phys.*, ser. 5, vol. 1, p. 643, 1911.

44. Blondel, A., and J. Rey, The Perception of Lights of Short Duration at Their Range Limits, *Trans. I.E.S., London*, vol. 7, no. 8, p. 625, November, 1912.

45. Toulmin-Smith, A. K., and H. N. Green, The Fixed Equivalent of Flashing Lights, *Illum. Eng.*, vol. 26, p. 304, December, 1933.

46. Hampton, W. M., The Fixed Equivalent of Flash Lights, *Illum. Eng.*, vol. 27, p. 46, February, 1934.

47. Neeland, G. K., M. K. Laufer, and W. R. Schaub, Measurements of the Equivalent Luminous Intensity of Rotating Beacons, *J. Opt. Soc. Am.*, vol. 28, no. 8, p. 280, August, 1938.

48. Lash, J. D., and G. F. Prideaux, Visibility of Signal Lights, *Illum. Eng.*, vol. 38, no. 9, p. 481, November, 1943.

49. Douglas, C. A., Computation of the Effective Intensity of Flashing Lights, *Illum. Eng.*, no. 52, p. 641, December, 1957. (See abstracts on pp. 485 and 486.)

50. Gronberg, F. T., Design Considerations for A Satellite-borne Flashing Light, *Phot. Sci. Eng.*, vol. 7, no. 6, November-December, 1963.

51. Swenson, P. B., Photographic Observations of ANNA, the Geodetic Satellite, *Phot. Sci. Eng.*, vol. 7, no. 6, November-December, 1963.

52. Glass, C. J., Substitution of Gaseous Discharge Lamps for Incandescent Filament Lamps in Existing Lighthouse Optics, *7th Intern. Conf. Assoc. Lighthouse Authorities*, Rome, 1965.

53. Said, Bob, "Let There Be Light!" *Private Pilot*, vol. 3, no. 4, pp. 66-68, January, 1968.

54. Maiman, T. H., Stimulated Optical Radiation in Ruby Maser, *Nature*, vol. 187, pp. 493-494, August, 1960.
55. Kiss, Z. J., and R. J. Pressley, Crystalline Solid Lasers, *J. Appl. Optics*, vol. 5, no. 10, pp. 1474-1486, October, 1966 (94 references).
56. Elion, H. A., "Laser Systems and Applications," Pergamon Press, Inc., New York, 1967.
57. Früngel, F., "High Speed Pulse Technology," vol. II, pp. 182-184, Academic Press, New York, 1965.
58. Miles, P. A., and H. E. Edgerton, Optically Efficient Ruby Laser Pump, *J. Appl. Phys.*, vol. 32, no. 4, pp. 740-741, April, 1961.
59. Edgerton, H. E., J. C. Goncz, and P. W. Jameson, Xenon Flash Lamp Limits of Operation, *Proc. 6th Intern. Congr. High Speed Phot.*, pp. 143-151, H. D. Tjeenk Willink & Zoon, N. V., Harlem, The Netherlands, 1963.
60. DeMaria, A. J., D. A. Stetser, and W. H. Glenn, Jr., Ultrashort Light Pulses, *Science*, vol. 156, no. 3782, pp. 1557-1568, June 23, 1967.
61. Edgerton, H. E., Xenon Flash Lamp Design, *2d Intern. Conf. Quantum Electronics*, Mar. 23-25, 1961.
62. Heynan, H. A., and M. C. Foster, Single-Subnanosecond Laser Pulse Generation and Amplification: The Second Generation of Q Switched Lasers, *Laser Focus*, August, 1968, p. 20.
63. Wilson, C. T. R., On A Method of Making Visible the Paths of Ionizing Particles through a Gas, *Proc. Roy. Soc. (London)*, ser. A, vol. 85, pp. 285-288, November, 1911.
64. Bridge, H. S., M.I.T. Laboratory for Nuclear Science, *Ann. Progr. Rept.*, 1953, 1954.
65. Peyrou, C., and H. S. Bridge, *Proc. Intern. Conf. High-Energy Accelerators Instr.*, CERN, Geneva, 1959, p. 454.
66. Edgerton, H. E., Electronic Flash Illumination of a Large Wilson Cloud Chamber, *Appl. Opt.*, vol. 2, no. 10, pp. 1013-1015, October, 1963.
67. LaPorte, M., "Les lamps à éclairs lumière blanche," Gauthier-Villars, Paris, 1949.
68. Warmholtz, N., and A. M. C. Helmer, A Flash Lamp for Illuminating Vapor Tracks in the Wilson Cloud Chamber, *Philips Tech. Rev.*, vol. 10, no. 6, pp. 178-187, December, 1948.
69. Cerineo, M. A., and A. B. Milojevic, High Intensity Flashtubes for Laboratory Purposes, *Bull. Inst. Nucl. Sci., Boris Kidrich (Belgrade)*, no. 36, August, 1953.
70. Bradner, H., *Ann. Rev. Nucl. Sci.*, vol. 10, p. 109-160, 1960.
71. Pless, I. A., and R. J. Plano, Negative Pressure Isopentane Bubble Chamber, *Rev. Sci. Instr.*, vol. 27, no. 11, pp. 935-937, November, 1956.
72. Sukiennicki, B., and H. Barney, private communication from SLAC, Stanford, Calif., September, 1966. (Also see Burach, *Phot. Appl. Sci. Tech.*, Winter 1967-1968.)
73. Powell, W. M., C. Oswald, G. Griffin, and F. Swartz, Bubble Chamber Illumination Using a Beaded Reflective Screen, *Rev. Sci. Instr.*, December, 1963.
74. Früngel, F., H. Kohler, and H. P. Reinhard, The Illumination of the CERN 2-meter Hydrogen Bubble Chamber, *Appl. Opt.*, vol. 2, no. 10, pp. 1017-1024, October, 1963.

75. Glaser, D., *Phys. Rev.*, vol. 87, p. 665, 1952.
76. Shutt, R. P. (ed.), "Bubble and Spark Chambers," 2 vols., Academic Press, New York. (See especially p. 234, vol. 1, by W. T. Welford.)
77. Sondericker, J. H., Shunt Triggered Flash Tube, *Rev. Sci. Instr.*, vol. 37, no. 12, pp. 1705-1707, December, 1966.
78. Wyckoff, C. W., and H. E. Edgerton, Xenon Electronic Flash Sensitometer, *J. SMPTE*, vol. 66, pp. 474-479, August, 1957.
79. Walcott, C., "The Cell Unit," Educational Services, Inc., Newton, Mass.
80. Rees, S., et al., Pathological Physiology of Microangiopathy in Diabetes, *Ciba Foundation Colloquium on Endocrinology*, vol. 15 (Ciba Foundation Symposium on the Etiology of Diabetes Mellitus and Its Complications London, October, 1963), Little, Brown and Company, Boston, 1964.
81. Van Boort, H. J. T., H. Warmholtz, and J. E. Winkelman, Human Retina with a Discharge Lamp, *Med. Biol. Ill.*, vol. 6, no. 3, pp. 166-170, July, 1956.
82. Donaldson, D. D., A New Camera for Stereoscopic Fundus Photography, *Tr. Am. Ophth. Soc.*, vol. 62, p. 429, 1964.
83. Edgerton, H. E., Concentrated Strobe Lamp, *J. Biol. Phot. Assoc.*, p. 45, May, 1962.
84. Edgerton, H. E., and J. Carson, Motion Picture Photomicrography with Electronic Flash, *J. Appl. Opt.*, vol. 3, p. 1211, November, 1964.
85. LaPorte, M., and O. Roerich-Goussu, Ciné micrographie en contrast de phase, *Microscopie*, 1951, p. 151.
86. LaPorte, M., Les lampes à éclairs de grande puissance et leurs applications à la cinématographie, *Rev. Opt.*, vol. 22, no. 8, p. 281, August, 1951.
87. Gayhart, E. L., An Application of the Libessart Spark Gap to Photomicrography, *Phot. Eng.*, vol. 3, no. 3, p. 129, 1952.
88. Littmann, H., A New Photographic Device, *Phot. Forsch.*, vol. 6, no. 2, April, 1954.
89. Michel, K., The Use of the Electronic Flash Light in Photomicrography, *Phot. Forsch.*, vol. 5, no. 5, April, 1953.
90. Gibson, H. L., Magnification and Depth of Detail, *J. Phot. Soc. Am.*, p. 34, June, 1960.
91. Hansell, P., Retinal Photography Yesterday and Today, *Visual/Sonic Medicine*, vol. 2, no. 4, pp. 13-22, August-September, 1967. (There are 10 references given at the end of this review article.)
92. Paine, S. J., Photon Combination Phototypesetting and Photocomposing Machine Ready for Plant Use, *Printing Equipment Eng.*, October, 1956.
93. Gilbert, G. D., Investigation of Contrast Degeneracy with Increasing Scatter Concentration for a Water Medium When Illuminated with and without a Circularly Polarized Source, U. S. Naval Weapons Center, China Lake, California, *NWC TP 4681*, December, 1968.

APPENDIX *I*

EXPERIMENTS AND EXPERIENCES

There is no substitute for experience, and the following experiments are recommended to those who wish to do more than just read about electronic flash. A series of relatively simple experiences are briefly outlined which, if faithfully and carefully performed, should start the experimenter well on his way into this fascinating and useful field of research. Further experiments will immediately suggest themselves to those with imaginative minds.

Experience 1. The Stroboscope
2. Photography with a Stroboscope
3. High-speed Flash Photography
4. Electronic Flash Unit
5. Vacuum Phototube Characteristics
6. Spectral Response of Vacuum Phototubes
7. Flash Lamp Light-Time Relations and Efficiency
8. Flash Lamp Starting Characteristics
9. Flash Lamp Current-Voltage Relations

10. Shadow Photography from a Spark Source
11. Scotchlite Screen Silhouette Photography
12. Silhouette and Schlieren Photography by the Field Lens Method

EXPERIENCE No. 1

The Stroboscope

Equipment: General Radio Strobotac (1531A); electric fan with small piece of white tape on one blade; smoke (optional, titanium tetrachloride fumes are very effective but slightly toxic); and cardboard discs with motor

Reference: "Handbook of High Speed Photography" and "Instruction Book for Strobotac," both available from the General Radio Company, West Concord, Mass.

Shine the light from the Strobotac onto a running electric fan or a motor which has a single white spot on a blade or pointer. Adjust the

Fig. E-1 *Patterns which when rotated at R rps and observed with a light frequency of F fps = R (K/N) show the original pattern. K is the number of equal angle segments or patterns around the edge of the disc. N = 1, 2, 3, 4, 5, 6, 7, 8, etc. F = frequency of strobe, fps. R = speed of rotation, rps.*

frequency dial so that the object appears to be stationary. Then *double* the frequency adjustment. Does the object appear as a single pattern? If not, increase the frequency adjustment until a double pattern is observed.

Draw a disc, or discs, such as the ones illustrated in Fig. E-1. Adjust the frequency dial of the stroboscope over the entire speed range in order to study the different patterns. List patterns as function of speeds and patterns and attempt to find the mathematical relationships that exist between the light flashing frequency, the motor speed, and the number of elements on the pattern.

EXPERIENCE No. 2

Photography with a Stroboscope

Equipment: General Radio Strobotac (1531A) or Strobolume (1532D) or similar electronic flash light source
Reference: "Handbook of High Speed Photography," General Radio Co., West Concord, Mass.
"Flash, Seeing the Unseen," Edgerton and Killian, Charles T. Branford Co., Newton Centre, Mass.

The handbook mentioned above gives full instructions and many suggestions for using the brief flashes of light from the Strobotac for photography. The book "Flash" shows numerous examples which should encourage the experimenter.

Routine photography of a simple subject, such as water flowing from a faucet, is recommended for the initial experiment. The room lights should be darkened. Operate the Strobotac at its slowest rate. Then open the camera shutter on "bulb" for one flash of light.

The General Radio booklet gives the following guide factors for the high-intensity (low-speed) setting of the Strobotac. (The exposure

Film type	ASA film speed	Guide factor
Polaroid 42 and	200	22
Polaroid 44	400	30
Polaroid 47	3,000	80
Eastman TriX	200	75
Eastman Royal X	1,600	150
Ektachrome High Speed		
(with cc40y filter)	160	14

time is less than 2 μsec with the Strobotac and 30 with the Strobo-lume.) Divide the guide factor by the lamp-subject distance to obtain the camera aperture.

Next look around for other examples of subjects that move so rapidly that the unaided eye cannot study the action. Examples are sewing machines, electric drills, spray guns, bullets, egg beaters, balloons, etc.

Try to photograph a hammer as it smashes an electric light bulb. The timing of the flash instant may be the most difficult part of the experiment. Suggestion: adjust two wires below a piece of sheet metal that will support the bulb before impact. Another method: use a microphone or sound pickup to operate the Strobotac or Strobolume.

EXPERIENCE No. 3

High-speed Single-flash Photography

Equipment: EG&G microflash, type 249 with trigger unit and microphone, .22-caliber rifle and bullet catcher, 4 × 5 cut-film camera (optional), 4 × 5 cut film (Plus X)

Reference: "Flash, Seeing the Unseen" (study photos for suggestions)

The object of this experience is to become acquainted with (1) the microflash lamp, a pulsed light source of approximately 0.5 μsec

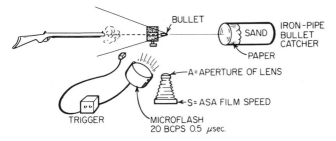

Fig. E-2 *Arrangement for bullet photography with the EG&G type 549 microflash unit.*

duration and an output of BCPS = 20; (2) the technique of synchronizing the light source with a rapid event such as a bullet in flight; and (3) the guide factor equation. The microflash system consists of three units (see Fig. E-2):

1. Microphone, used to pick up the shock wave from the bullet, produce a voltage pulse, and trip the trigger unit.

2. Trigger unit, provides trigger pulse to flash unit when the signal from the microphone is received.

3. Flash unit, contains special short-duration flashtube, capacitor bank, and related circuitry.

The microphone is first plugged into the CONTACTOR jack on the trigger unit. Vary the SENSITIVITY control until the rifle shot will trigger the flash and catch the bullet at the desired part of its flight. If the SENSITIVITY control is set too high, the unit will self-flash repetitively and the lamp will be destroyed by self-heating.

The bullet is easily seen in a darkened room if the flash fires when the bullet is in the light beam. Set the time DELAY to 0. The location of the bullet can then be varied by moving the microphone toward or away from the rifle. Aim the reflector carefully (the rifle too); light falls off rapidly outside the main beam. A sheet of paper held at the event location will be of considerable help when aiming the lamp. A 4 × 5 sheet-film camera can be used for this application. The shutter should be left open ("time" setting). To photograph an event: (1) darken room, (2) pull out film holder slide, (3) shoot the gun, (4) replace film slide (*before* turning on room light!).

Focus carefully at full aperture on *exact* location of event. The depth of field with a 6-in. lens is very shallow at close distances. Do not forget to stop down to the proper aperture before taking the photograph.

Experimental Determination of the
Guide Factor

The guide factor is the product of the lens aperture A and the distance from the lamp to the subject D. Set up the equipment and select an aperture and lamp-to-subject distance for a trial shot. Develop the film according to the manufacturer's recommendations, except for *increasing* the time of development by 50 percent to compensate for reciprocity effects. Examine the negative. A good negative will show detail in the important parts of the scene. In this case the surface details on the bullet should be clearly visible. If the negative is too thin or too dark, try another shot with a different aperture or lamp-to-subject distance. You should also check your developer and film. Carefully note the distance and aperture for the most satisfactory negative. The product of these two numbers is the guide factor.

Theoretical Calculation of the Guide Factor
The guide factor formula is:

$$DA = \sqrt{\frac{BCPS\ s}{c}}$$

where D = lamp-to-subject distance in *feet*
A = aperture of lens
BCPS = beam-candela-second output of lamp
s = ASA film speed (Plus X speed is 50, Tri X is 200)
c = constant 15 to 25, if D is in *feet* (160 to 270 if D is in *meters*)

The light-vs.-time curve for a typical microflash unit as measured with a calibrated phototube shows a peak light of about 40 million BCP with a duration of about 0.5 μsec. The approximate value of BCPS is the product of the peak beam-candela by the flash duration. In this case $(40 \times 10^6) \times 0.5 \times 10^{-6} = 20$ BCPS.

Compare the experimental and theoretical values of the guide factor. Try to explain any discrepancies which may very well occur.

EXPERIENCE No. 4

Electronic Flash Unit

Equipment: GE flash lamp FT-118 or equivalent, battery 510-volt Burgess No. U320, or Eveready No. 497, two capacitors (525 μF 450 volts, electrolytic), Kemlite spark coil No. 4 CM, resistors, small capacitors, reflector (Weber Co., Cleveland, Ohio)

The object of this experiment is to build a dry-battery-powered electronic flash unit. Once the circuit operation is mastered, then the

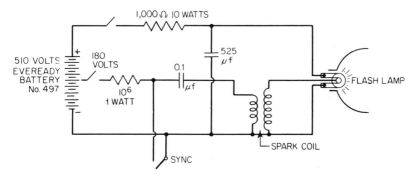

Fig. E-3 *Elementary flash circuit for Experience No. 4.*

experimenter can put the circuit into practical form, if he desires, to use with any camera for single flash photography. Can you think of a simpler circuit for an electronic flash unit?

Measure the HCPS output of the flash lamp. Install the reflector and then measure the beam-candela-second (BCPS) output.

What other design features do you consider to be important for electronic flash equipment?

EXPERIENCE No. 5

Vacuum Phototube Characteristics

Equipment: Vacuum Phototubes RCA 925, 929; Wratten filter No. 106; standard xenon pulsed light source, capable of providing at least 40,000 lm per ft² at a distance of 10 times the largest physical dimension of the light source; General Radio Strobolume (1532D) or other electronic light source; resistors; fast-rise-time oscilloscope, such as Tektronix 545

Vacuum phototubes are used in this experiment for transient light measurement. With proper circuitry and operating conditions a linear response to light is possible. Their fast response makes them useful for observing the output of high-speed pulsed light sources. The circuit to be used is shown as Fig. E-4.

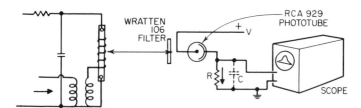

Fig. E-4 *Arrangement for evaluating the capability of a vacuum phototube to measure the peak light from a flash lamp.*

The value of R must be selected so that the time constant of the output circuit is less than one-tenth of the flash duration. Note that R will form a parallel RC circuit with the input capacitance of the scope and the stray wiring capacitance between the tube and the scope input. It is also necessary to select R such that the current will be proportional to the light that enters the phototube.

The peak incident flux density at D feet from a source of peak CP is CP/D^2 lm per ft^2. Different values of flux density are easily selected by changing the distance between the source and the phototube.

1. Obtain the current-voltage relationship for the 925 and 929 phototubes for peak light flux densities of 10,000, 20,000, and 40,000 lm per ft^2. Vary the voltage from 0 to 400 volts. (Note: 10,000 lm per ft^2 corresponds to incident light from the sun.)

2. For at least one value of light flux density obtain the current-voltage relationship for the 929 with Wratten filter No. 106. The combination of the Wratten filter No. 106 with the S-4 surface of the 929 has a spectral sensitivity that approximates the visibility function.

3. From your experimental data and information available in the RCA tube manual, answer the following:

a. At daylight intensity (10,000 lm per ft^2) what minimum anode voltage is necessary to collect all the photoemitted electrons?

b. Indicate the region on each $I-V$ plot where the response to light is linear.

c. What is the sensitivity that you measure of each phototube to xenon light in microamperes per lumen? Compare with the published figures for sensitivity to tungsten light at 2870°K. (Your sensitivity should be *greater* since the xenon spectral distribution is more effective than the spectral distribution from a tungsten lamp.)

d. Which phototube device and filter combination measures lumens?

4. Estimate all of the uncertainties in the experiment. If you were designing an instrument to measure pulsed light, which parameters would have to be most carefully controlled to ensure proper and precise operation?

EXPERIENCE No. 6

Spectral Response of Vacuum Phototubes

Equipment: Light source and monochromator whose output as a function of wavelength is known, microammeter (such as Keithley 610A), vacuum phototubes 929 (S-4) and 925 (S-1), Wratten filter No. 106

The spectral response of any light detector must be known if the detector is to be used in a measurement system. A convenient method for determining this response is to use a monochromator.

A monochromator provides nearly monochromatic light (depending on the width of the exit slit and the internal construction of the device). The strength of the light output as a function of the wavelength must be known. The source strength may be represented as $S(\lambda)$. The meter will indicate a current $I(\lambda)$ that will be proportional to the strength of the light falling on the photocathode of the phototube under test at a given wavelength. The power supply voltage should be about 100 volts to ensure this linear response. The validity of this condition will be examined in the next experience. This proportionality constant $K(\lambda)$ will be equal to $I(\lambda)/S(\lambda)$.

1. Plot the spectral response of the 929 phototube. It is helpful to plot each point as the data is taken so that any irregularities in the data may be immediately spotted.

2. Plot the response of the 925 phototube in the same manner.

3. Place a Wratten No. 106 filter in front of the 929 phototube and plot the spectral response of this combination. The Wratten No. 106 filter is designed to correct the S-4 response to the visibility function. Compare the observed response with the standard response.

4. Which cell would be most useful as a pickup for a tungsten light-operated photoelectric counter? Which cell would be most useful as a pickup in an exposure meter for a blue-sensitive film?

EXPERIENCE No. 7

Flash Lamp Light-Time Relations and Efficiency

Equipment: EG&G FX-1 flash lamp, GE FT-30 flash lamp, 100μF 450-volt electrolytic capacitor, 100μF 450-volt paper capacitor, power supply with variable voltage and capacitance, integrating light meter, photocell pickup, oscilloscope.

1. Set up the photocell pickup to observe the light-vs.-time curve on the scope. For several values of capacitance and voltage find the duration, the time between one-third peak light.

2. Using the FX-1 and the high-voltage probe with the oscilloscope, find the voltage at which the lamp extinguishes. What percent

of the initial energy stored in the capacitor is left in the capacitor when the lamp extinguishes?

3. Measure the efficiency of the FX-1 with the integrating light meter for several values of capacitance and voltage.

4. Compare the efficiency of the GE FT-30 when used with electrolytic capacitors to the efficiency when the tube is used with paper capacitors. Be sure to keep the electrical leads between the capacitor and the lamp as short as possible. Explain the results.

EXPERIENCE No. 8

Flash Lamp Starting Characteristics

Equipment: Xenon flash lamp, such as the EG&G FX-1, power supply with variable voltage and capacitance, trigger transformer with provision for variable voltage on primary side, high-voltage measuring device, 50 kV, such as high-voltage probe and oscilloscope or calibrated spark gap

1. Plot the spark coil secondary voltage necessary to start the flashtube as a function of flashtube voltage. For each value of flashtube voltage there will be three ranges of interest for the spark voltage

 a. Lamp will not fire

 b. Lamp will not fire on every trigger pulse but will fire on some pulses

 c. Lamp fires reliably on every trigger pulse

The experiment may be repeated for different types of trigger attachment to the tube. As the flashtube voltage is increased, the self-flash point of the tube will be reached. No trigger pulse will be necessary to fire the lamp at this point. Be sure to use a small value of capacitance when approaching this point to avoid destroying or damaging the flash lamp.

2. Observe the output voltage from the spark coil secondary directly using the high-voltage probe and oscilloscope. Find

 a. Rise time

 b. Decay time

 c. Ringing frequency

EXPERIENCE No. 9

Flash Lamp Current-Voltage Relations

Equipment: Power supply with variable voltage and capacitance, EG&G FX-1 flashtube, current shunt (noninductive, 5 milliohms), oscilloscope

1. Observe the nature of the discharge in the FX-1 for several values of capacitance and initial voltage. Be sure to wear dark safety glasses. Carefully note the energy loading necessary to fill the interior of the tube completely with the discharge.

2. Flashtube "resistance" is usually defined as the initial voltage divided by the peak current. Determine the "resistance" of the FX-1 experimentally by measurements of the initial voltage and peak current. Use as many values of capacitance and voltage as you can.

3. Calculate the theoretical resistance of the FX-1 during discharge using the relation $R = \rho l/A$ where ρ is the resistivity* of xenon plasma = 0.017 ohm-cm, l is the length of the tube, and A the cross-sectional area of the tube. Compare with the results of part 2. What energy loading is necessary to fill the tube with plasma? Compare this with the result of part 1.

4. When a capacitance C discharges into a resistance R, the voltage and current decay exponentially with time constant $T = RC$. Compare the discharge of the capacitor into the flash lamp with the theoretical discharge of a capacitor into a resistance whose value is equal to the discharge resistance of the flashtube. (Since "light" varies approximately as the square of the current, the *flash duration* time constant is $RC/2$ sec.)

EXPERIENCE No. 10

Shadow Photography from a Spark Source

Equipment: EG&G microflash with *point source adapter*, 8 × 10 sheet film and holder, Eastman contrast process ortho film or equivalent, .22-caliber rifle and bullet catcher

A "point" source (actually about 2 mm in diameter) is used to expose an 8 × 10 film at a distance of about 1.3 meters from the source. The path of the bullet is arranged to be about 5 cm from the

*Approximate value.

film, and the spark is timed to occur at the instant that the bullet is opposite the film.

The conventional microflash flash lamp is removed by first taking off the reflector (with power off!). Then unplug the lamp with an insulated-handle screwdriver. Next attach the *point source adapter* and arrange the light shield so that only light from the point source strikes the film.

The shock wave patterns around an event such as the flight of a .22-caliber bullet are clearly shown by the above photography arrangement. The exposure available at the film plane will be equal to CPS/D^2 meter-candela-seconds if CPS is the candela-second output of the source and D is the distance from the source to the film measured in meters. The exposure necessary for contrast process ortho film may be determined from the characteristic curves for that film available in a Kodak manual. The output of the EG&G point source adapter used with the microflash is about 0.2 CPS. The microphone may be used to synchronize the light source with the location of the bullet as in Experience No. 1.

1. Calculate the required distance from the lamp to the film plane for proper exposure (should be about 1.3 meters).

2. Using the distance calculated in part 1, obtain shock wave pictures for the .22-caliber bullet flight. (Use plenty of development time!)

It is important to agitate the film in the developer to prevent a mottled effect.

EXPERIENCE No. 11

Scotchlite Screen Silhouette Photography

Equipment: EG&G microflash *with lamp extender*, 4 × 5 sheet-film camera, Scotchlite screen No. 244, .22-caliber rifle bullet, dynamite caps or similar subjects

The equipment is set up as shown in Fig. E-5. The camera is focused on the screen. The lamp (on the extension) should be placed as close to the lens as practical but with a shield to keep the light from the lens. The theoretical guide factor equation is:

$$DA = \sqrt{\frac{CPS\ s\ F}{c}}$$

where D = lamp to screen distance in feet

 A = aperture of the lens

 CPS = candela-second output of base lamp \simeq 1.0 CPS

 s = ASA speed of film used in the camera

 c = constant, 15 to 25 if D is in feet

 F = screen factor, may range from 10 to 100 depending upon the properties of the screen and the lamp-lens arrangement

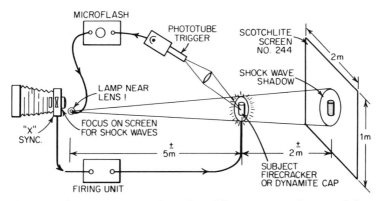

Fig. E-5 *An arrangement using a Scotchlite screen to photograph large-scale shock wave experiments.*

Obtain as many pictures as possible, finding the correct guide factor and determining the best location of event and screen for best results.

What is the maximum distance (lamp to screen) that can be used with the bare microflash lamp as close as possible to an $f/4.5$ lens, using Tri X Eastman negative film?

EXPERIENCE No. 12

Silhouette and Schlieren Photography by the Field Lens Method

Equipment: Optical bench with a field lens, camera, point light source, etc., electronic flash equipment of small size and short pulse duration

Reference: See chapter on exposure calculations

Set up a field lens with a point spark source as shown in Fig. E-6. The image of the source is then imaged on a camera lens. In turn, the camera is imaged on the subject.

The field lens is a most efficient method of collecting the radiant flux from the spark source and concentrating it on a small area on the film. Exposure on the film is

$$IT = \frac{CPS}{D^2}$$

where D is the focal length of the camera lens if the lamp-lens and the lens-camera distances are the same.

It will be observed that the point light source to produce exposure on the film is very much less than required for direct silhouette photography. This is explained further in the chapter on exposure calculations.

Photograph a bullet in flight or a firecracker as it explodes. The shock waves should be sharp and clear.

Schlieren Photography

Close down the aperture of the camera to about $f/11$ and adjust the image of the spark point light source so that it falls on the edge of the iris. Less light will reach the film, but more important, the light will be a function of the refraction in the subject area. Further eclipsing of the image on the aperture will further reduce the light but further increase the sensitivity of the system to refraction.

Observe and photograph the flow of air around a hot soldering iron or the shock waves and hot air around a bullet in flight compared to the uneclipsed light of the field lens shadow system.

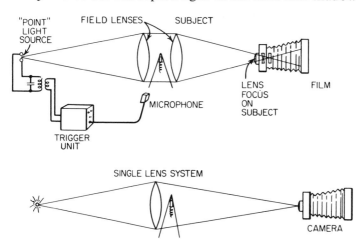

Fig. E-6 *A field lens silhouette system for photographing a rapid subject, especially one with shock waves.*

APPENDIX **//**

MANUFACTURERS AND SUPPLIERS

OF ELECTRONIC FLASH EQUIPMENT

ACR Electronics, 551 West 22nd St., New York, N.Y. (Light sources)

Aerolux Light, 635 11th Ave., New York, N.Y. (Light sources)

Aimes-Hershey Electronics, Inc., P.O. Box 73, Lockport, Ill. (Portables and studio, ring-lights)

Amglo Corp., 4333 North Ravenswood Ave., Chicago, Ill. (Lamps and equipment)

Ascor-Berkey Technical Corp., 25-15 50th St., Woodside, N.Y. (Portables and studio, lightmeters)

Berkshire Labs, 101 Tansy Rd., Milford, N.Y. (Stroboscopes)

Bernard Corp., 3525 W. Peterson Ave., Chicago, Ill. (Viceroy & Kako portables)

Braun Electronic Flash Division of Ehrenreich Photo-Optical Industries, 623 Stewart Ave., Garden City, N.Y. (Portables)

Bruel & Kjaer Company, Naerum, Denmark (Stroboscope)

Burleigh Brooks Inc., 420 Grand Ave., Englewood, N.J. (Portables)

California Optical Res., P.O. Box 2245, La Jolla, Calif. (Stroboscope for flicker fusion)

Calument Mfg. Co., 6550 North Clark St., Chicago, Ill. (Studio lightmeter, flash)

Cellux Electronic Co., 3 Traverse Terrace, Malden, Mass. (Portables and electronic flash)

Central Scientific Co., 1700 W. Irving Park Rd., Chicago, Ill. (Stroboscopes)

Chadwick-Helmuth, 111 E. Railroad Ave., Monrovia, Calif. (Stroboscopes)

Compass Instrument & Optical Co., Inc., 104 East 25th St., New York, N.Y. (Portables)

Ealing Corp., 2225 Massachusetts Ave., Cambridge, Mass. (Stroboscopes)

EG&G, Inc., 160 Brookline Ave., Boston, Mass. (Microflash, high-speed strobes, multiflash, sensitometers, lightmeter, spectrophotometers)

Electro Powerpacs, Corp., 253 Norfolk St., Cambridge, Mass. (Pulse circuits, power supplies, xenon flash lamps)

Electronics Applications, Ltd., 47 Theobold St., Borehamwood, Herts, England (Stroboscopes)

Exakta Camera Co., 705 Bronx River Rd., Bronxville, N.Y. (Portables)

General Electric Co., Nela Park, Cleveland, Ohio (Lamps and circuits)

General Radio Co., 22 Baker Ave., West Concord, Mass. (Stroboscopes)

Graflex, Inc., 3750 Monroe Ave., Rochester, N.Y. (Portable flash equipment)

Hico Corp., 76 Coolidge Hill Rd., Watertown, Mass. (Portables, studio and special equipment)

Honeywell Photo Products, P.O. Box 5227, Denver, Colo. (Portables)

Impulsphysik GmbH, D 2000 Hamburg 56, Sulldorfer Landstr. 400, Germany (High-frequency strobes, short-flash lamps, special equipment)

Iota-Cam, 28 Teal Rd., Wakefield, Mass. (Light Sources, medical and strobes)

Kakostrobe America, Inc., 307 Fifth Ave., New York, N.Y. (Portables)

Karl Heitz, Inc., 979 Third Ave., New York, N.Y. (Ring light)

Kemlite Laboratories, Inc., 1819 W. Grand Ave., Chicago, Ill. (Lamps and equipment)

Multiblitz, Camera Specialty Co., 705 Bronx River Rd., Bronxville, N.Y. (Portables)

Peninsula Assoc., 1447 E. Bayshore, Palo Alto, Calif. (Stroboscopes)

Photogenic Machine Co., 525 McClurg Rd., Youngstown, Ohio (Portables and studio)

Photographic Instrumentation, Ltd., Chipperfield, Kings Langley, Herts, England (Specialized electronic equipment)

Schwarzer, 46 Salmi Rd., Framingham, Mass. (Stroboscopes)

Speedotron Co., 6156 W. Higgins Ave., Chicago, Ill. (Studio)

Strobe Masters, 160 Fifth Ave., New York, N.Y. (Special-purpose xenon flash apparatus)

Sun-Lite Pro, Hershey Electronics, Inc., P.O. Box 33, Lockport, Ill. (Portables)

Sylvania Electric Products, Inc., 730 Third Ave., New York, N.Y. (Lamps and equipment)

ULE, Inc., 21 Spencer Street, Stoneham, Mass. (Eye photography equipment)

Ultrablitz Div. of Allied Impex Corp., 300 Park Ave. South, New York, N.Y. (Portables)

Wabash Instruments, 806 Manchester Ave., Wabash, Ind. (Stroboscopes)

Wein Products, Inc., P.O. Box 34647, Palms, Calif. (Multiflash, lightmeter)

Welsh Scientific Co., 7300 Linden Ave., Skokie, Ill. (Stroboscopes)

Zeus Inst., 295 Central Park West, New York, N.Y. (Light sources)

APPENDIX ///
PATENTS

This section discusses some of the questions that have come up concerning patents in the field of stroboscopes and electronic flash photography.

A patent in the United States of America is a contract between the inventor and the government. The inventor discloses to the public his entire knowledge of his new method, or idea, or device for a patent that, for seventeen years from the date of issue, permits him to exclude others from making, using, or selling his invention. The government does not do this for him. The owner of a patent must enforce this right in the courts against those who are using his invention without his permission.

A patent can be invalid for several reasons. One of the most common ones is that "prior art" anticipates the invention disclosed and claimed in the patent. In other words, the invention is not *new*. If the invention was described or used in printed publications before the inventor made the invention, then it is up to the person who wishes to use the invention in question to convince the inventor, or the judge, that the invention had been anticipated.

The owner of a patent is entitled to do whatever he wishes with his patent, subject to the antitrust laws. For example, he can offer nonex-

clusive licenses to any, or all, who wish to exploit his invention. Conversely, he can offer exclusive rights to one group. This latter system has some distinct advantages. For example, the user can be protected against competition from those who may seek to invade a given market at a later date without incurring the expenses of developing the invention and a market for it. The royalties for an exclusive arrangement are usually larger than for a nonexclusive one. The inventor may also demand a minimum guaranteed income to protect him against possible inactivity of the licensee.

An inventor must file his patent application within a year after he has made a public disclosure or a sale of a product that incorporates his invention. After a year has elapsed, his invention is in the public domain and cannot be claimed by him or anyone else.

The author, with Kenneth J. Germeshausen and Herbert E. Grier, formed a partnership in the thirties to work on stroboscopes, high-speed photography, and related fields. One result was that a number of patents were obtained covering circuits considered to be unique. The General Radio Company requested, and was granted, an exclusive license under these patents for stroboscopes.

Our group also went into the exploitation of electronic flash for studio photography with the Eastman Kodak Company on an exclusive basis. This effort was stopped during World War II. After the war we agreed to license anyone who wished to use the inventions in areas outside of stroboscopes.

The partnership sold its patents to EG&G, Inc., on December 31, 1959, in return for a share of the income derived from them. This agreement is to be in effect until the last patent expires at the end of its seventeen-year life. A list of these patents, including the numbers, a title description, and dates of issue follows. The file wrappers of the patents, which can be obtained from the U.S. Patent Office, are a source of prior art references.

Patent Number	Title	Date Issued	Inventor
Re.22,123	Cutting Machine	6-23-42*	Edgerton
Re.22,260	Switching System for Light-Flash Producers such as Stroboscopes	2-2-43*	Edgerton
2,152,639	Electric Circuit	4-4-39	Edgerton
2,185,189	Gaseous Discharge Tube	1-2-40	Germeshausen
2,186,013	Motion-Picture Apparatus	1-9-40	Edgerton

Patent Number	Title	Date Issued	Inventor
2,201,166	Electric Circuit	5-21-40	Germeshausen
2,201,167	Gaseous-Discharge Device	5-21-40	Germeshausen
2,205,246	Synchronous-Motor-Control System	6-18-40	Edgerton
2,205,247	Synchronous-Motor-Control System	6-18-40	Edgerton
2,205,248	Synchronous-Motor-Control System	6-18-40	Edgerton
2,223,849	Means for Analyzing Motion	12-3-40	Grier
2,269,338	Flash-Producing System	1-6-42	Edgerton/ Germeshausen
2,277,697	Electric System and Apparatus	3-31-42	Grier
2,277,698	Flash-Photography Apparatus	3-31-42	Germeshausen
2,302,690	Electric Oscillator	11-24-42	Germeshausen
Re.22,611	Condenser-Discharge Electric System	3-6-45**	Edgerton
2,329,526	Translator	9-14-43	Germeshausen
2,331,317	Stroboscope	10-12-43	Germeshausen
2,331,771	Gaseous Electrical Discharge Tube	10-12-43	Germeshausen/ Grier
2,341,541	Flash Producing Apparatus	2-15-44	Grier
2,342,257	Electric System	2-22-44	Edgerton
2,358,796	Flash-Photography	9-26-44	Edgerton
2,373,676	Reproducer	4-17-45	Germeshausen
2,380,514	Vibration-Translating Device	7-31-45	Germeshausen
2,382,981	Method of and Apparatus for Testing	8-21-45	Edgerton
2,393,316	Flash-Photography Method and Apparatus for use with Motion-Picture Cameras	1-22-46	Edgerton
2,399,222	Flash-Photography Apparatus	4-30-46	Germeshausen
2,408,764	High-Speed Flash Photography	10-8-46	Edgerton
2,426,602	Electric System for Producing Intermittent or Flashing Light	9-2-47	Edgerton
2,449,063	Electric System	9-14-48	Edgerton
2,478,901	Electric System	8-16-49	Edgerton
2,478,902	Electric System, Including a Vapor Electric Discharge Device	8-16-49	Edgerton
2,478,903	Stroboscope	8-16-49	Edgerton
2,478,904	Light-Flash-Producing System	8-16-49	Edgerton
2,478,905	Electric System	8-16-49	Edgerton
2,478,906	Electric System	8-16-49	Edgerton
2,478,907	Flash-Producing Device	8-16-49	Edgerton
2,478,908	Electric Light-Flash-Producing System	8-16-49	Edgerton
2,492,142	Electric System Embodying Cold-Cathode Gaseous Discharge Device	12-27-49	Germeshausen

Patent Number	Title	Date Issued	Inventor
2,576,934	Flash-Photography Apparatus	12-4-51	Grier
2,588,368	Light Integrator	3-11-52	Edgerton
2,592,556	Gaseous-Discharge Device	4-15-52	Germeshausen
2,677,788	Electronically Controlled Electric System	5-4-54	Germeshausen
2,700,120	Electric System	1-18-55	Germeshausen
2,700,121	Electric System	1-18-55	Germeshausen
2,722,629	Electric System	11-1-55	Germeshausen
2,722,632	Electric System	11-1-55	Germeshausen
2,755,714	Flash-Photography Delay System	7-24-56	Germeshausen
2,756,361	Gaseous-Discharge Device and Method of Making Same	7-24-56	Germeshausen
2,756,365	Electric-Discharge System	7-24-56	Germeshausen
2,781,707	Multiple Light-Flash Producing System	2-19-57	Edgerton
2,794,906	Gaseous-Discharge Apparatus	6-4-57	Edgerton
2,812,465	Gaseous-Discharge Device	11-5-57	Germeshausen
2,872,622	Underwater Flash-Producing System	2-3-59	Edgerton
2,877,341	Liquid Cooled Flash-Producing Apparatus	3-10-59	Edgerton
2,893,289	Microscope Flash-Photography System and Apparatus	7-7-59	Edgerton
2,909,777	Gaseous-Discharge Device	10-20-59	Germeshausen
2,919,369	Flash Tube and Apparatus	12-29-59	Edgerton
2,919,383	Flash Apparatus and Method	12-29-59	Edgerton
2,933,647	Electric Discharge System	4-19-60	Edgerton/ Germeshausen
2,939,984	Flash Device and Method	6-7-60	Edgerton
2,960,380	Flash Photography Apparatus and Method	11-15-60	Edgerton
2,975,397	Surface Indicating Method and Apparatus	4-14-61	Edgerton
2,983,850	Condenser Charging Method and Circuit for Flash Producing Apparatus and the Like	5-9-61	Edgerton
2,989,727	Illumination Landing Method and System	6-20-61	Germeshausen
2,996,966	Underwater Flash Producing and Photography System	8-22-61	Edgerton
2,996,967	Underwater Flash Producing and Photography System	8-22-61	Edgerton
3,033,988	Method of and Apparatus for the Control of Electric Impulses	5-8-62	Edgerton
3,119,092	Distance-Measuring Method and Apparatus	1-21-64	Edgerton

* Original No. 2,181,879 is dated December 5, 1939.
** Original No. 2,351,603 is dated December 5, 1939.

INDEX

INDEX

A-18 (airplanes), 289
A-26 (airplanes), 289, 290
AC charging circuits, 81–84
AC full-wave rectifiers, 84
AC multiflash circuits, 209–211
Ackerman, S., 18
Afterglow:
 short flashes and quenched, 130
 of xenon lamps, 123
Agena Acquisition Beacon, 296
Agfatronic (flash units), 120
Aircraft anticollision beacons, 297
Alphax Wollensak shutters, 100
Ambrose Light Tower, 300
American Speed Light Corporation, 248
Amplitude jitter, 14
ANNA (satellite), 295
ANNA 1A (satellite), 295
ANNA 1B (satellite), 295
Apollo capsules, 296

Arc growth, 18, 20
Arc "holdover," 169–170
Argon (gas), 55–57
Argon flash lamps, 104, 105
Argonne National Laboratory, 309
Ascor Co., 116
Ascor Model M801 light meters, 248, 250
Atlantis II (research ship), 278, 284
Auto-Strobonar (flash lamps), 119

B-17 (airplanes), 293, 294
B-24 (airplanes), 290, 291
B-25 (airplanes), 290, 291
Balloon-borne beacons, 300–301
Bare lamp illumination, 320
Barney, H., 307
Barstow, Fred, 115
Batteries, 72–79
 circuit troubleshooting and, 91-93

Batteries *(cont'd)*:
 dry, 72–74
 for Kodatron, 111, 114
 lead, 78, 79
 lead acid, 76, 79
 lead storage, 74–77
 nickel-cadmium, 78, 79
 power from, 72
 silver-zinc wet, 76, 78, 79
 for underwater photography, 268–269,
 271
 zinc-air, 78–79
Beacons, 297–301
 aircraft anticollision, 297
 balloon-borne, 300–301
 wave, 297–298
Beam spread, described, 257
Beetham, Charles, 110
Bird photography, 140–141
Blood, photographing flow of, 194, 198,
 318, 319
Bogen Photo Corp., 248
Bowens flash meter (English), 248
Boys, 104, 226
Brander, H., 306
Braun F-40 (flash units), 120
Braun F-260 (flash units), 120
Braun F800 (flash units), 152
Breakdown-starting, 10–15
Bridge, H. S., 306
Brooks, E. H., 267
Bull, L., 199
Burgess No. U320 (batteries), 73
Burton, M., 136

Calumet Manufacturing Co., 248
Camera case, underwater, 260, 262
Cameras:
 deep-sea, 260, 276–280
 for high-speed strobes, 185–189
 rack for, 277
Capacitor discharge, defined, 31
Capacitors, 62–70
 circuits for: for AC multiflash circuits,
 209
 charge indicator circuits for, 79–80
 in trip circuits, 85–86
 (*See also* Circuits)
 comparison of, 66–67
 design of, 63–66

Capacitors *(cont'd)*:
 electrolytic, 34, 64, 66, 67, 93, 124,
 149–152
 energy stored in, 70
 equations of, 67–69
 flash duration and, 141–142
 for multiflash equipment, 201, 209–
 211
 for nature photography, 145–152
 paper, 63, 64
 as reservoir, 62
 series, for double flash equipment, 192
 short flash production and experimental,
 136
 short flashes of light and, 128–129
 time constant and, 70–71
 for very short flashes, 133, 136
Cape Henry Lighthouse, 299
Carson, John, 204
CERN chamber, 308, 309
Chadwick-Helmuth Company, 321–322
Charge indicators, 78–80
Charging time, multiflash photography and,
 100
Cineflash, 322
Circle of confusion, 228
Circuits, 61–95
 AC charging, 81–84
 for capacitors: for AC multiflash circuits,
 209
 charge indicator circuits for, 79–80
 in trip circuits, 85–86
 (*See also* Circuits)
 charge indicator, 79–80
 for double-flash electronic lamps, 196
 flash circuits, 191–194
 doubling charging, 84
 electronic flash, 6–10, 61–62
 light frequency strobe, 174–177
 of hydrogen thyratron modulators, 177–
 178
 inductive charging, 80–81
 of Kodatron, 112
 microflash equipment and trigger, 133
 for multiflash equipment, 201, 202
 AC multiflash circuit for, 209–211
 control circuits, 212–216
 power and discharge circuits, 212
 for rapid-sequence light flashes, 206
 short flashes and capacitor discharge, 129
 short flashes and damped oscillations of,
 130

Circuits *(cont'd)*:
 triggering, 17–18
 trip, 85–91
 trigger devices for, 86–91
 troubleshooting and, 91–94
 for underwater photography, 274–275
 of flash unit for underwater, 270
Clarke, G. L., 263
Closeup photography, 221–225
 bare lamp for, 320
 guide factor for, 223–225
 light requirements for, 221–223
 underwater, 266
Cloud and bubble chamber, illumination, 306–309
Commercial Illustrators, 115
Cooling methods, 43
Copy techniques, 313–315
Cornet 100 (flash units), 120
Cornet 220 (flash units), 120
Costa, Joe, 111, 113
Cousteau, Jacques Y., 267, 280–281
Cox, G. C., 136
Cranz, C., 104
Cranz-Schardin cameras, 205

D'Alessio, J. T., 136
Davidson, Treat, 155–156
Deionization conditions of high speed strobes, 171
DeMaria, A. J., 306
Design of capacitors, 63–66
Designs of flash lamps, 35–40
 comparisons of, 36–38
 (See also Flash lamps)
Direct image photography, 227–228
 (See also Photography)
Direct triggering system, 85
Dormitzer, Henry, 119, 140
Double flash equipment, 189–198
 circuits for, 196
 flash circuits, 191–194
 flash lamps for, 195–198
 reflected light and, 194–195
 series capacitors for, 192
 for silhouette photography, 189–190
Doubler, voltage, 84
Doveiko, Vladimir, 101
Dry batteries, 72–74
 (See also Batteries)
Duntley, S. Q., 263, 266
Dyonics, Inc., 321

Eastman Kodak Co., 107–109, 111, 114
Eckhardt, K., 38–39
Effective Series Resistance (ESR), 34–35
 of electronic capacitors, 67
 flash duration and, 142
 special capacitors and low, 149–152
Efficiency:
 defined, 32–35
 of flashtubes, defined, 257
Electrical characteristics, 24–28
Electroencephalographs, 294
Electrolytic capacitors, 34, 64, 66, 67, 93, 124, 149–152
 (See also Capacitors)
Electronic flash equipment:
 circuits for, 6–10, 61–62
 development of, 289–291
 for night photography, 288
 (See also Flash lamps)
Electronic flash units, 337–338
 (See also specific flash units)
Elion, H. A., 301
Energy lost, defined, 71
Engstrom, R. W., 237
ESR *(see* Effective Series Resistance)
Eveready No. 497 (batteries), 73–75
Experiments, 332–345
 with flash lamps, 340–342
 high-speed photography, 335–337
 screen silhouette photography, 343–345
 shadow photography, 342–343
 strobe, 333–335
 with vacuum phototubes, 338–340
Exposure calculations, 219–234
 for closeup photography, 221–225
 derivation of guide factor for, 219–221
 for direct image photography, 227–228
 film, 223–225
 of point source, 228–229
 for schlieren photography, 232–233
 Scotchlite background and, 229–232
 for silhouette photography, 226–227, 229
 speed of photographic negative materials and, 225–226
 for underwater photography, 275–276
Exposure time:
 short, 128–139
 microflash equipment and, 131–133
 short flashes of light and, 128–130
 silhouette photography and, 136–139
Exposure time concept, 96

Eye:
 limitations of, 1
 visibility curve of, 243

Fabric Research Laboratories, Inc., 201
Farber, Edward R., 118–119
Farber, Paul R., 119–121
Field lens systems, 136–139
 schlieren photography and, 232–233
 for silhouette photography, 229, 344–345
1501 light meter (General Radio Co.), 248, 250
1531A Strobotac, 160, 162, 164–166, 333–335
1531-P2 Flash Delay, 165
1538 Strobotac, 165
5727 (RCA), 87
Filaments, tungsten and gas, 6
Films:
 exposure calculations for, 223–225
 501 high-speed strobe and, 188–189
 H & D curves for, 224–225, 233–234
 proper exposure of, 221–223
Filters for underwater photography, 253, 264, 266
Fischer, H., 136
501 high-speed stroboscopes (EG&G), 178–179
 film speed and synchronizing of, 188–189
 guide factor of, 180–181
 maximum operating time in, 181–182
 Red Lake Lab cameras and, 187
 special small lamps for, 182–185
549 (EG&G multiflash lamp), 99
553 (EG&G multiflash light source), 211
Flash duration:
 capacitors and, 141–142
 control of, 30–31
 defined, 27, 30, 141
 experimentally measured, 28
 of FT-220 and FT-214, 147
 of high-speed strobes, 179–180
 with low ESR capacitors, 150
 in underwater photography, 268
 of xenon lamps, 146
Flash lamp life, 20–24
Flash lamps:
 argon, 104, 105
 basic, 7
 circuits for, 6–10
 current-voltage relations in, 342

Flash lamps (cont'd):
 design of, 35–40
 comparisons of, 36–38
 for double-flash equipment, 195–198
 experiments with, 340–342
 handheld, for underwater photography, 268–269
 high-speed strobes and, 175–176
 light measurement and output of, 246–247
 light-time relations of, 340–341
 for nature photography, 145–149
 starting characteristics of, 341
 suppliers of, 46
 xenon: afterglow of, 123
 for airports, 297–298
 breakdown-starting and, 11–12
 calibration of, 244, 257
 characteristics of large, 40
 characteristics of small, 40, 43
 comparing, 244
 development of, 103–108
 experiments with, 341
 flash duration of, 146
 as laser stimulators, 303–306
 life of, 21
 for lighthouses, 298–299
 response of RCA 929 phototube to, 240
 sensitometers with, 309–311
 short duration, 123–124
 for underwater photography, 269
 (See also specific flash lamps)
Flashtubes:
 light measurement of, 253–258
 flash tube efficiency, 256–258
 output, 253–255
 output in reflectors, 255–256
Flash units for underwater photography, 269–272
 (See also specific flash units)
Ford, Tirey, 109
Fraunhofer lines, 58
Frequency, arc "holdover" limit of, 169–170
Fresnel lenses, 190
Fritz, William, 110
Früngel, F., 177, 309
FT-30 (GE lamps), 340–341
FT-106 (GE lamps), 275
FT-110 (GE lamps), 147, 148
 spectrum of, 59
 for underwater photography, 275

FT-118 (GE lamps):
 experiments with, 337
 holdover currents for, 174
 for underwater photography, 275
FT-120 (GE lamps), 146 147, 275
FT-151 (GE lamps), 275
FT-210 (GE lamps), 200
FT-214 (GE lamps), 111, 146, 147, 214
FT-218 (GE lamps), 200, 275
FT-220 (GE lamps), 111, 146, 147, 152
FT-230 (GE lamps), 35
FT-403 (GE lamps), 109
FT-503 (GE lamps), 109, 114, 174, 212
FT-506 (GE lamps), 301, 302
 flashing frequency of, 173, 174
 volt-amp characteristics of, 172, 173
FT-524 (GE lamps), 100, 212, 301–302
FT-617 (GE lamps), 116, 294
 characteristics of, 40
 current voltage and light output of, 41
Full-wave rectifier, 84
FX-1 (EG&G lamps), 10, 24, 40, 123, 244,
 251, 258
 efficiency of, 32–34
 electrical characteristics of, 24–28
 experiments with, 340–342
 frequency limit of, 169
 holdover current of, 174
 multiflash equipment and, 200
 new lamp and, 37–38
FX1A-6 (EG&G lamps), 305
FX-2 (EG&G lamps):
 dimensions of, 179, 180
 horizontal light output of, 185
 maximum operating time of, 182
 multiflash equipment and, 200–201
FX-3 (EG&G lamps):
 dimensions of, 179, 180
 maximum operating time of, 182
 multiflash equipment and, 200
FX5C-9 (EG&G lamps), 305
FX-6A (EG&G lamps), 324, 325
FX-6B (EG&G lamps), 9
FX-11 (EG&G lamps):
 for high-speed strobes, 182–185
 Scotchlite background and, 231
FX-12 (EG&G lamps), 21
 blow up of, 35
 brightness of, 44
 characteristics of, 40, 43
 diagrams of, 42
 for high-speed strobes, 182–185
FX-19 (EG&G lamps), 321

FX-21 (EG&G lamps), 185, 231
FX-24 (EG&G lamps), 321
FX-26 (EG&G lamps), 306, 307
FX-29 (EG&G lamps), 174
FX-33 (EG&G lamps), 10, 14, 16–19, 146–
 148
 flash lamp and, 195, 198
 for small subject photography, 315–316,
 320
FX33C-1.5 (EG&G lamps), 305
FX-38A, 21–23
FX38C-3 (EG&G lamps), 305
FX42C-3 (EG&G lamps), 305
FX-47 (EG&G lamps), 19–21
FX-47A (EG&G lamps), 24
 spectral energy distribution from, 53, 55,
 56
FX47C-6.5 (EG&G lamps), 305
FX51-3 (EG&G lamps), 305
FX52C-3 (EG&G lamps), 305
FX55C-6 (EG&G lamps), 305
FX-60 (EG&G lamps), 305
FX-76 (EG&G lamps), 53, 54
FX77-13 (EG&G lamps), 305
FX-79 (EG&G lamps), 53, 54
FX-80 (EG&G lamps), 299, 300
FX81-8 (EG&G lamps), 305
FX100-2.4 (EG&G lamps), 305
FX-113C-1 (EG&G lamps), 153
FX-239A (EG&G lamps), 212

Gage, H. P., 258
Gases:
 argon, 55–57
 electrical breakdown of, 9
 spark width, radiation density and light
 density for, 50–51
 xenon: afterglow of, 98
 characteristics of, 6–10
 ionization of, 57
 spectra of, 57–59
 (*See also* Xenon flash lamps)
Gates, Val, 252
GE lamps (*see* specific lamps; for example,
 FT-30; FT-118)
Gemini satellites, 296
General Electric Company, 108. 257
General Radio Company, 248
GEOS (satellite), 295–296
Germeshausen, Kenneth, 106, 108, 114,
 167, 177
Glaser, G., 48, 50

Glass, Lt. Comd. C. J., 299
Glowtubes, 86–90
Goddard, Maj. George W., 287, 289
Goldberg, Rube, 121
Goncz, J. C., 21, 23, 32, 48
Greenberg, J., 267
Greenewalt, Crawford, 144, 145, 189
 equipment of, 152–153
Grier, Herbert, 106–108, 111, 114
Guide factor:
 for closeup photography, 223–225
 concept, 96–100
 defined, 219–221
 determination of, 336
 equation of, in air, 262
 for high-speed strobes, 180–181
 for lighting requirements, 96–100
 for portable flash units, 120–121
 theoretical calculation of, 337
 for underwater photography, 275
 in water, 263

H & D curves:
 for films, 224–225, 233–234
 making, 225–226
Half-wave rectifiers, 82
"Handbook of High Speed Photography"
 (Edgerton and Killian), 334
"Handbook of High Speed Photography"
 (General Radio Co.), 165, 333
"Handbook of Stroboscopy" (Van Veen),
 3
Harding, G. O., 59
Heiland Division, 117
Helical flash lamps, 23
Heliotron I (flash unit), 120
Heliotron Supra (flash unit), 120
Hersey, J. B., 267, 276, 277, 284
Heston, W. S., 155
High-power equipment, 114–115
High-speed photography (single flash), 335–
 337
Higonnet, René, 322, 324, 325
Honeywell, Inc., 117
Hooper, L. J., 187
Hopkins lens, 277
Horizontal-candela-second output (HCPS),
 defined, 254
Hosking, Eric, 143–144
Hughes Research Laboratory, 301

Human eye:
 limitations of, 1
 visibility curve of, 243
Hydraulic system, 161
Hydrogen thyratron modulators, 177–179

Illumination Society, 104–105
Index Medicus (reference magazine), 325
Inductive charging circuits, 80–81
Inductor-capacitor discharge, 32
"Instruction Book for Strobotac" (General
 Radio Co.), 333
Integrating light meters, 97, 247–253
Isaacs, John D., 279
ITT Industrial Laboratories, 243

Jackman (photographer), 122
Jameson, P. W., 21
Jitter:
 amplitude, 14
 starting-time, 14–15
Johnson, E. R. Fenimore, 263
Johnson, W. O., 188
Jones, F. P. J., 215

Kane, Henry B., 104
Kaufmann, Charles, 111
Kendall, H., 267
Kerns, Q. A., 136
Kerr, R. J., 188
Killian, James R., Jr., 106–107
Kirstern, F. A., 136
Kiss, Z. J., 301, 306
Kocher, David, 205–209
Kodatron, 35, 88, 108–114
 batteries for, 111, 114
 bird photography and, 140
 color, 114
 history of, 108–111
 origin of, 105–106
 portable, 111, 113, 114
Kohler, H., 309
Krypton (gas), 57
Krytrons, 86, 90–91

L. C. Eichner Instruments (cameras), 187–
 188
LaForge, D. H., 195
Lamp cooling methods, 43
Lamps (*see* Flash lamps)

LaPorte, M., 59
Laser stimulators, 301–306
Lead acid batteries, 76, 79
Lead batteries, 78, 79
Lead storage (wet) batteries, 74–77
Leclanche batteries, 72–73
LeCompte, G., 29
Lee, R., 59
Lemen, J. Winton, 119
Lentcher, Lt. Edward, 288
Leopold, G. R., 281
Life (magazine), 106, 111
Light measurement, 236–258
 calibration in, 244–246
 device for, 238–241
 of flashtubes, 253–258
 flashtube efficiency, 256–258
 output, 253–255
 output in reflectors, 255–256
 inclusion of light absorption in, 263–268
 integrating meter for, 247–253
 output of flash lamps and, 246–247
 of phototube, 235–238
 spectral response in, 243–244
 transient response in, 241–243
Light meters (*see* specific light meters)
Light output:
 defined, 29
 of 1531A Strobotac, 166
 of high-speed strobes, 179–180
 horizontal, 185
 with low ESR capacitors, 150
 nature photography and, 143–144
 of xenon lamps, 146
Lighthouses, 298–300
Lighting requirements, 96–102
 for closeup photography, 221–223
 guide factor in, 96–100
 underwater, 261–263
Limiting wavelength, table of, 236
Linear flash lamps, 23, 45
"Lite-Mike," 248, 251
Littlehales, Bates, 267
"Living Sea, The" (Cousteau), 281
Louis, Joe, 111, 113
Ludwig, P. K., 136
Lumitype, 322

Mach, 104
Maiman, T. H., 3, 301, 302
Mak, A. A., 35

Mallory No. PF497 (batteries), 73
Malmberg, J. H., 136
Manufacturers, list of, 346–347
Marey, E. J., 198
Marine life, 282
Maris, William, 248
Maxwell Company, 65
Mecablitz 117 (flash unit), 120
Mecablitz 118 (flash unit), 120
Mercury-arc flash lamps, 105
Mercury-vapor lamps, 104
Mertens, L. E., 267
Mico Instrument Co. (cameras), 186
Microammeter (Keithley 610A), 339
Microflash equipment, 131–134
 lamp extender as, 343
 spark gap adapter for, 134
Microflash type 249, 335, 342
Microphones in high-speed single flash photography, 335–336
Microscopes, 315–322
 combination lamp for, 320–321
 elapsed-time motion pictures through, 312–313
 lamphouse for, 316–320
Mili, Gjon, 104–106, 121
Milwaukee Journal (newspaper), 119
Mizar (ship), 285
Model 580 light meters (EG&G), 258
Model 585-66 detector head (EG&G), 252
Modeling lamps, 35
Monojet BL (flash unit), 120
Monopak (flash unit), 120
Monoscillatory discharges, 65
Mornick Co., 248
Motion, strobes and, 159–165
Motion pictures, elapsed-time, 311–313
Moyroud, Louis, 322, 324, 325
MP capacitors, 66
Multiflash photography, 198–216
 capacitors for, 201, 209–211
 circuits for (*see* Circuits)
 multi-spark light source in, 205–207
 rapid-flashing sources for, 199–200
 strobe lamp for, 212
 types of light sources for, 199
Multiflash requirements, 100–102
Music, strobes and, 166–167
Muybridge, E., 199

Nature photography, 140–157
 bird, 140–141

Nature photography *(cont'd)*:
 capacitors for, 145–152
 Greenewalt's equipment for, 152–153
 lamp-capacitor combinations for, 145–149
 light output for, 143–144
 reflectors for, 144–145
Naval Research Laboratory, U.S., 284, 285
Neon (gas), 55–57
Neon lamps, 79–80
New York Times (newspaper), 285
Newell, P. B., 48
Nickel-cadmium batteries, 78, 79
Night aerial photography, 286–294
 early development work in, 289
 electronic flash equipment for, 288
 photographing of objective in, 291–294
 two systems of, 287–294
925 (RCA phototubes), 338
929 (RCA phototubes), 240, 244–246, 338, 339
935 (RCA phototubes), 243

OA4-G (gas glow tube), 88
OA5 (glow trigger tubes), 88, 89
Open spark photography, 103–104
Optical results, tables of, 49–51
Outlet power, 71–72

Paine, Sidney, J., 323
Paramecium, 318
Parker, Harry, 116, 119
Paper capacitors, 63, 64
Paschen's law, 9–10
Peak light, defined, 32
Phillips, Robert, 115
Phinizy, 267
Photo Methods for Industry, 103, 119
Photocathode surface of pure metals, 237
Photochromic goggle, system of, 325–327
Photoelectric shutter tripping, 153–156
Photographic arrangement in underwater photography, 273–274
Photography:
 of blood circulation, 194, 198, 318, 319,
 closeup, 221–225
 bare lamp for, 320
 guide factor for, 223–225
 light requirements for, 221–223
 underwater, 266

Photography *(cont'd)*:
 direct image, 227–228
 field lens, 136–139
 schlieren photography and, 232–233
 for silhouette photography, 229, 344–345
 multiflash, 198–216
 capacitors for, 201, 209–211
 circuits for (*see* Circuits)
 multi-spark light source in, 205–207
 rapid-flashing sources for, 199–200
 strobe lamp for, 212
 types of light sources for, 199
 nature, 140–157
 bird, 140–141
 capacitors for, 145–152
 Greenewalt's equipment for, 152–153
 lamp-capacitor combinations for, 145–149
 light output for, 143–144
 reflectors for, 144–145
 night aerial, 286–294
 early development work in, 289
 electronic flash equipment for, 288
 photographing of objective in, 291–294
 two systems of, 287–294
 open-spark, 103–104
 schlieren, 208
 exposure calculations for, 232–233
 by field lens method, 345
 shadow, 342–343
 silhouette, 134
 double-flash equipment for, 189–190
 of dynamite cap, 232
 exposure calculations for, 226–227, 229
 experiments with, 343–345
 field lens, 229, 344–345
 with Scotchlite screen, 343–344
 short exposure time and, 136–139
 small subject, 315–322
 bare lamp illumination for, 320
 combination lamp for, 320–321
 microscope lamphouse, 316–320
 small lamp with high energy for, 321–322
 with Strobotac, 165–166
 underwater (*see* Underwater photography)
Photomultiplier detectors, 253
Photomultiplier (PM) tubes, 14

Photon, Inc., 322
Photon phototypesetting machine, 322–325
Phototube cathodes, 239
Phototubes:
 characteristics of vacuum, 338–339
 measurements of light of, 235–238
 spectral response of vacuum, 339–340
Piano, R. J., 306
"Pinger" sound source, 280, 286
Plane, 306
Plasma, 29, 36
Pless, I. A., 306
Pods for night photography, 291
Point source, exposure of, 228–229
Point source adapters for microflash, 342–343
"Point-Source Strobex," 322
Polar Star (ship), 281
Polaroid Co., 313–315
Portable flash units, 118–122
 (*See also* specific flash units)
Positioning of photograph, 285–286
Powell, W. M., 307
Power required for flash unit, 79
Practical surfaces of phototubes, 237
Preisendorfer, R. W., 263
Pressley, R. J., 301, 306
Professional Photographers Association, 109, 111
Pure metals, photocathode surface of, 237

Quigley, Charles, 110

Radar, development of, 292, 294
"Radio Amateur's Handbook," 92
Raytheon Co., 108, 114, 119
Read, Kenneth, 312
Rebikoff, D. I., 267
Rectifiers:
 AC full-wave, 84
 silicon-controlled, 91
Red Lake Lab cameras, 187
Rees, Searle, 317
Reflector angle, described, 256
Reflector factor, 97
 defined, 255
Reflectors:
 for nature photography, 144–145
 in Scotchlite background, 229–231
Reinhard, H. P., 309
Repronar (Honeywell), 314, 315

Resistance, defined, 25–27, 142
Resistivity of plasma, 29
Robert D. Conrad (ship), 283
Rosenblatt, Richard, 279
Runway approach lights, 297–298

St. Louis *Post-Dispatch* (newspaper), 109
Satellite strobes, 295–296
Sazhenev, Alexander, 215
Schardin, H., 199
Schenck, H. V., 267
Schlieren photography, 208
 exposure calculations for, 232–233
 by field lens method, 345
Schwenker, R. P., 152, 153
Scorpion, USS (ship), 285
Scotchlite background, 229–232
Scotchlite screen, 343–344
Scotchlite screen No. 244, 343
SCR (silicon-controlled rectifier), 91
SCR trigger devices, 86
Self-flash, 15–16
Sensitivity control, 87, 336
Sensitometers, 309–311
Sezhenev, Alexander, 101
Shadow photography, 342–343
Shadow source, 133
Short exposure time, 128–139
 microflash equipment and, 131–133
 short flashes of light and, 128–130
 silhouette photography and, 136–139
Short flashes:
 of light, 128–130
 silhouette photography and, 136–139
 very, 133, 135–136
"Silent World, The" (film), 267
Silhouette photography, 134
 double-flash equipment for, 189–190
 of dynamite cap, 232
 experiments with, 343–345
 exposure calculations for, 226–227, 229
 field lens, 229, 344–345
 with Scotchlite screen, 343–344
 short exposure time and, 136–139
Silicon-controlled rectifiers (SCR), 91
Silver-zinc wet batteries, 76, 78, 79
Single flash, 103–127
SLAC system, 307
631 AG (Mico type cameras), 186, 187
631-B (Strobotac), 88
631-P1 (arc tubes), 88

651 AG (General Radio cameras), 186
6483 (glow trigger tubes), 88
6T-3 Conn device (strobes), 166–167
Sixth International Congress on High-Speed
Photography, 21
"Sled" system for underwater photography,
280–281
Slide copiers, 313, 314
Soundhouses, 285–286
Small subject photography, 315–322
bare lamp illumination for, 320
combination lamp for, 320–321
microscope lamphouse, 316–320
small lamp with high energy for, 321–322
Smith's Photographics Store, 103
Somniosus pacificus, 279
Spark coil No. 4CM, 337
Spark coils, 86, 337
Spectral output, 48–60
of rare gas flash lamps, 55–59
of xenon lamps, 48, 52–55
Spectral response in light measurement, 243–
244
Spectral sensitivity of phototubes, 235–238
Spectroradiometer system, 253
Speed of photographic negative materials,
225–226
Spiralite (flash unit), 120
Sprague Electric Co., 149
Stackpole, Peter, 121–122
Starting, 10–17
breakdown, 10–15
characteristics of, 15–17
Starting-time jitter, 14–15
Storage batteries (*see* Batteries)
Strobo Research, 140
Stroboconn, 166–168
Stroboflash I (flash unit), 120
Strobolume (1532D), 334, 335, 338
Strobonar 400 (flash unit), 120
Stroboscopes, 158–218
for bird photography, 140–141
described, 158–165
double-flash equipment for, 189–198
circuits for, 191–194, 196
flash lamps for, 195–198
reflected light and, 194–195
series capacitors for, 192
for silhouette photography, 189–190
experiments with, 333–335
flash duration of, 179–180
high-speed, 167–189

Stroboscopes, high-speed *(cont'd)*:
arc "holdover" limit of frequency,
169–170
cameras for, 185–189
deionization conditions, 171
guide factor for, 180–181
high-speed frequency strobe circuits,
174–177
hydrogen thyratron modulator, 177–
179
maximum flashing frequency, 173–
174
maximum operating time, 181–182
minimum resistance of charging unit,
172–173
special small lamps for, 182–185
multiflash photography and, 198–216
capacitors for, 201, 209–211
circuits for (*see* Circuits)
multi-spark light source in, 205–207
rapid-flashing sources for, 199–200
strobe lamp for, 212
types of light sources for, 199
for runway approaches, 297–298
study of motion with, 159–165
underwater photography with, 259–286
deep-sea equipment for, 276–285
exposure calculations for, 275–276
flash units, 269–272
handheld underwater flash lamps,
268–269
inclusion of light absorption in light
calculation, 263–268
light requirements, 261–263
photographic arrangement, 273–274
phototrigger, 272–273
positioning of photograph, 285–286
Strobotac (General Radio Co.), 88. 205
(1531A), 160, 162, 164–165, 333–335
(1538), 165
Studio flash units, 122–123
Sukiennicki, B., 307
Sunflash, 115–116
Sunlight, spectra of, 57, 58
Suppliers:
of flash lamps, 46
list of, 346–347
Sylvania, 140
Synchtron, 119

Talbot, 104
Technology Review (magazine), 106

Tektronix 545 (oscilloscope), 338
37.5-watt-sec flash lamps, 38–39
Thomas Instrument Co., 248
Thresher (submarine), 283-284
Thyratrons, 86–87
Time constant, 70–71
Time jitter, 14–15
Transactions of the Seventh International Congress on High-Speed Photography, 312
Transatlantic cable, 282
Transient response in light measurement, 241–243
Trieste (bathyscaphe), 284–285
Trigger circuits, 17–18
Trigger devices for trip circuits, 86–91
Trigger method for underwater photography, 280
Trigger switch, 8
Trigger voltage, 18
Triggers:
 external, 10–11
 phototube, for double flash equipment, 192–193
 for trip circuits, 86–91
 for underwater photography, 280
Trioblitz X-15 (flash unit), 120
Trip circuits, 85–91
Troubleshooting, 91–94
Tungsten lamps:
 Kodatron and, 108–109
 life of, 21
210 (GE tungsten lamps), 316
2307 (EG&G lamps), 193
Tyler, J. E., 263
Type 549 (EG&G lamps), 99
Typesetting, photo, 322–325

Uhl, R. J., 59
Ultima 40-B (flash unit), 120
Underwater photography:
 batteries for, 268–269, 271
 circuits for, 274–275
 of flash unit, 270
 closeup, 266
 filters for, 263, 264, 266
 flash duration in, 268
 general rules for, 267–268
 soundhouses for, 285–286
 with strobe lighting, 259–286
 deep-sea equipment for, 276–285
 exposure calculations for, 275–276
Underwater photography, with strobe lighting *(cont'd):*
 flash units, 269–272
 handheld underwater flash lamps, 268–269
 inclusion of light absorption in light calculation, 263–268
 light requirements, 261–263
 photographic arrangement, 273–274
 phototrigger, 272–273
 positioning of photograph, 285–286
"Unistrut" material, 277, 278
U. S. Camera (magazine), 121
United States of America Standard Institute, 225

Vacuum phototubes, experiments with, 338–340
Van Iderstine, T. J., 321
Van Veen, Frederick, 3
Vanyukov, M. P., 35
Very short flashes, 133, 135–136
Vivitar 40 (flash unit), 120

Wabash Battery Electroflash, 119
Walcott, Charles, 317
Water factor:
 calculated, 265–266
 defined, 264–265
Wave beacons, 297–298
Wet batteries:
 lead storage, 74–77
 silver-zinc, 76, 78, 79
Wilcox Battery Portable Stroblite, 119
Willard No. ER-6-6B (batteries), 77
Wilson, 306
Woodruff, George, 109
"World without Sun, The" (film), 267
Worthington, 104
Wratten 106 filters, 243, 245, 246, 338, 339

Xenon flash equipment, 117
Xenon flash lamps:
 afterglow of, 123
 for airports, 297–298
 breakdown-starting and, 11–12
 calibration of, 244, 257
 characteristics of large, 40
 characteristics of small, 40, 43

Xenon flash lamps *(cont'd)*:
 comparing, 244
 development of, 103–108
 experiments with, 341
 flash duration of, 146
 as laser stimulators, 303–306
 life of, 21
 for lighthouses, 298–299
 response of RCA 929 phototube to, 240
 sensitometers with, 309–311
 short duration, 123–124
 for underwater photography, 269
Xenon gas:
 afterglow of, 98

Xenon gas *(cont'd)*:
 characteristics of, 6–10
 ionization of, 57
 spectra of, 57–59
XFX-62A (EG&G lamps), 52, 53

Yguerabide, Juan, 136

Zinc-air batteries, 78–79
Zip lights, 297–298
ZIP machine, 324, 325